ANGELS
and WILD
THINGS

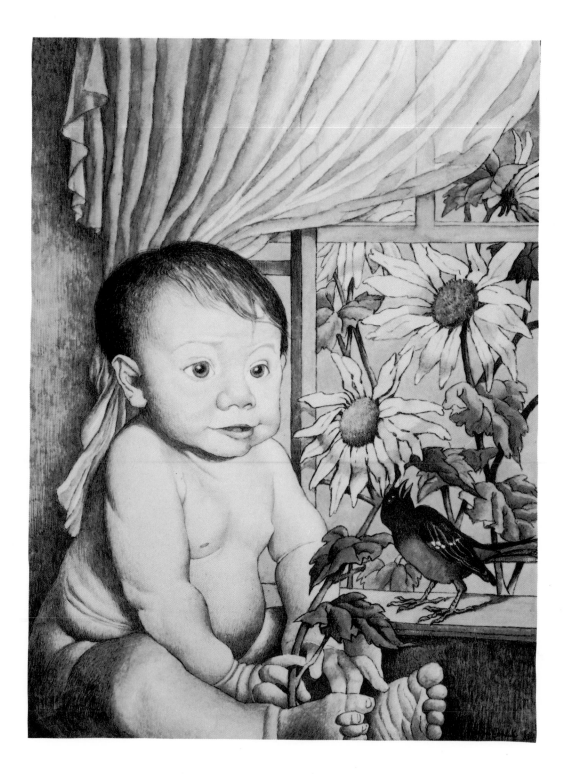

ANGELS
and WILD
THINGS

The Archetypal Poetics of
MAURICE SENDAK

JOHN CECH

The Pennsylvania State University Press
University Park, Pennsylvania

Library of Congress Cataloging-in-Publication Data

Cech, John.
 Angels and wild things: the archetypal poetics of Maurice Sendak/
John Cech.

 p. cm.
 Includes bibliographical references and index.
 ISBN 0-271-00949-7
 1. Sendak, Maurice—Criticism and interpretation. 2. Children's stories,
American—History and criticism. 3. Children's stories, American—
Illustrations. 4. Archetype (Psychology) in literature. I. Title.
PS3569.E6Z64 1995
813'.54—dc20 92-39709
 CIP

Printed in China
Published by The Pennsylvania State University Press,
University Park, PA 16802-1003

FRONTISPIECE: "The Baby by the Window," from *The Posters of Maurice
Sendak*. Copyright © 1986 Maurice Sendak. Reprinted by permission of
Harmony Books, a division of Crown Publishers, Inc.

For Stevie,
who asked the first question,
and
for my father,
who asked the others.

CONTENTS

LIST OF ILLUSTRATIONS

Color Plates (between pages 140 and 141)

Figures

17. David and the tiny people, from *In Grandpa's House* by Philip Sendak. Illustration copyright © 1985 by Maurice Sendak. Reprinted by permission of HarperCollins Publishers

18. Drawing for "A Dream," from *Poems from William Blake's "Songs of Innocence and Experience."* Pictures copyright © 1967 by Maurice Sendak. Reprinted by permission of The Bodley Head

19. The boy and the bird, a fantasy interlude from *I'll Be You and You'll Be Me* by Ruth Krauss. Illustration copyright © 1954 by Maurice Sendak. Reprinted by permission of HarperCollins Publishers

20. "Rosie's Party," drawings from a 1948 sketchbook. Courtesy of the Rosenbach Museum & Library, Philadelphia

21. Rosie's Fourth of July, drawings from a 1948 notebook. Courtesy of the Rosenbach Museum & Library, Philadelphia

22. "Mud is to jump in," from *A Hole Is to Dig* by Ruth Krauss. Illustration copyright © 1952 by Maurice Sendak. Reprinted by permission of HarperCollins Publishers

23. "A face is to make faces," preliminary drawing for *A Hole Is to Dig* by Ruth Krauss. Courtesy of the Rosenbach Museum & Library, Philadelphia

24. "Steps are to sit on," from *A Hole Is to Dig* by Ruth Krauss. Illustration copyright © 1952 by Maurice Sendak. Reprinted by permission of HarperCollins Publishers

25. The child artist, from *A Very Special House* by Ruth Krauss. Illustration copyright © 1953 by Maurice Sendak. Reprinted by permission of HarperCollins Publishers

26. Martin packing, from *Very Far Away*. Copyright © 1957 by Maurice Sendak. Reprinted by permission of HarperCollins Publishers

27. Martin's dream of the four-legged rooster, preliminary drawing for *Very Far Away*. Courtesy of the Rosenbach Museum & Library, Philadelphia

28. The nighttime, morning-time garden, from *Kenny's Window*. Copyright © 1956 by Maurice Sendak. Reprinted by permission of HarperCollins Publishers

29. The baby and the man in the window, from *Kenny's Window*. Copyright © 1956 by Maurice Sendak. Reprinted by permission of HarperCollins Publishers

30. Preliminary drawings for *A Very Special House* by Ruth Krauss. Courtesy of the Rosenbach Museum & Library, Philadelphia

31. Rosie sings alone, from *The Sign on Rosie's Door*. Copyright © 1960 by Maurice Sendak. Reprinted by permission of HarperCollins Publishers

32. Tien Pao and his pig, from *The House of Sixty Fathers* by Meindert DeJong. Illustrations copyright © 1956 by Maurice Sendak. Reprinted by permission of HarperCollins Publishers

33. Rosie as Alinda, under her blanket, from *The Sign on Rosie's Door*. Copyright © 1960 by Maurice Sendak. Reprinted by permission of HarperCollins Publishers

34. Rosie answers Magic Man's questions, from *The Sign on Rosie's Door*. Copyright © 1960 by Maurice Sendak. Reprinted by permission of HarperCollins Publishers

Jung, *Psychology and Alchemy.* Copyright © 1970 by Princeton University Press. Reproduced by permission of Princeton University Press

Illustrations at Chapter Openings and Endings

CHAPTER OPENINGS: **Introduction**—Detail of the "wild rumpus" in the trees from *Where the Wild Things Are*. Copyright © 1963 by Maurice Sendak. Reprinted by permission of HarperCollins Publishers. **Chapter 1**—From the Introduction to *Poems from William Blake's "Songs of Innocence and Experience"* by William Blake, picture copyright © 1967 by Maurice Sendak. Reprinted with the permission of The Bodley Head. **Chapter 2**—"Rosie + Cathy put on a show in the backyard," drawing from a 1948 sketchbook. Courtesy of the Rosenbach Museum & Library, Philadelphia. **Chapter 3**—Preliminary drawing for *Chicken Soup with Rice* from *The Nutshell Library*. Courtesy of the Rosenbach Museum & Library, Philadelphia. **Chapter 4**—Title page from *Where the Wild Things Are*. Copyright © 1963 by Maurice Sendak. Reprinted by permission of HarperCollins Publishers. **Chapter 5**—Jennie, frontispiece from *Higglety Pigglety Pop! or There Must Be More to Life*. Copyright © 1967 by Maurice Sendak. Reprinted by permission of HarperCollins Publishers. **Chapter 6**—Preliminary drawings for *In the Night Kitchen*. Courtesy of the Rosenbach Museum & Library, Philadelphia. **Chapter 7**—Ida and her rediscovered sister from *Outside Over There*. Copyright © 1981 by Maurice Sendak. Reprinted by permission of HarperCollins Publishers. **Chapter 8**—From *I Saw Esau, The Schoolchild's Pocket Book*, edited by Iona and Peter Opie. Illustration copyright © 1992 by Maurice Sendak. Reprinted by permission of Candlewick Press.

CHAPTER ENDINGS: **Chapter 2**—Drawing for "The Boy and the World," from *Somebody Else's Nut Tree* by Ruth Krauss. Pictures copyright © 1958 by Maurice Sendak. Reprinted by permission of HarperCollins Publishers. **Chapter 5**—Drawing for "The Echoing Green" in *Poems from William Blake's "Songs of Innocence and Experience"* by William Blake. Pictures copyright © 1967 by Maurice Sendak. Reprinted by permission of The Bodley Head. **Chapter 6**—Preliminary drawing for *In the Night Kitchen*. Courtesy of the Rosenbach Museum & Library, Philadelphia. **Chapter 7**—Preliminary drawing for *Dear Mili*. Courtesy of the Rosenbach Museum & Library, Philadelphia.

ACKNOWLEDGMENTS

For helping me to make the exuberant start, to endure the arduous middle, and to find the second and third winds to reach the end of this journey, I have many to thank.

First, to my friend Steven Loevy I will always be grateful for striking the spark one Chicago afternoon by bringing up the subject of a book on Sendak. My heart-felt thanks also go to my father, Otto Cech, for all the times he gently inquired, "How is *it* going?" Now that "it" is finally done, we can look forward to new projects with other questions.

My thanks to the numerous friends and colleagues who have read parts of this work between its earlier and later incarnations; they listened, offered comments, argued, corroborated, and their words helped to strengthen what appears here. To Joy Anderson, Francelia Butler, Charles DeFanti, Andy Gordon, Jim Haskins, Sid Homan, Herb Hosmer, Jill May, Jack Nichelson, Barbara Rosen, John Seelye, Jan Susina, Gregory Ulmer, and Jack Zipes—my gratitude for your many thoughtful suggestions and valuable insights.

Some sections and some basic ideas of this book were first tried out as parts of newspaper, journal, and magazine articles about Sendak. I wish to thank the editors who published these early pieces and thus encouraged me to move to the larger work: Nancy Clark, Martha Dewing, Diane Manuel, Kelly Sanchez, Anita Silvey, and John Webber.

Several grants were instrumental in the completion of this book. The Children's Literature Association's Weston Woods Award provided me with the opportunity to travel to the Weston Woods Studios to use the production archives relevant to films based on Sendak's books. Mort Schindel, the founder and director of Weston Woods, generously made available to me these and other materials, along with his voluminous personal knowledge of the field. I am grateful to the University of Florida's Division of Sponsored Research for awarding me the summer grant that supported the final stage of the writing. Many thanks as well to Patricia Craddock, past Chair of the University of Florida's English Department, for her personal encouragement and for helping to make possible additional institutional support.

The Baldwin Library of Children's Literature at the University of Florida was helpful in providing key historical texts and additional primary material for this study. My thanks to its former director, Bernard McTigue, and to its principal cataloger, Rita Smith, for their ever timely, ever friendly assistance. I am grateful to Frank DeTrollio and John van Hook, also of the University of Florida libraries, for keeping their keen eyes open for the latest Sendak volumes and for their attentions to the research needs of this book.

Thanks are due the Washington Opera, the Glyndebourne Opera, and the Houston Grand Opera for supplying publicity photos of their productions of Sendak's works and for making it possible for me to attend rehearsals and finished performances of these works.

For their kind assistance in providing illustrations, photographs, audio, and other materials for this study, I wish to thank: the Audio/Visual Department of the University of Connecticut's Homer Babbidge Library, Barbara Bader, the Bayerische Stattsbibliothek, Dover Publications, Fantasmographics Publications, Guy Gravett, Merle Green Robertson, the Museum of the City of New York, Princeton University Press, and Barbara Rosen and the Children's Literature Association.

Of central importance to this study was the help of the Rosenbach Museum and Library, which serves as the archive for Sendak's papers. My deep appreciation to the Rosenbach's past curator of art, Leslie Morris, and the current curator, Constance Kimmerle, and her assistant, Doug Parsons, as well as to the Rosenbach's director, Stephen Urice, and all its staff for guiding me through this extensive archive, for providing many hitherto unpublished illustrations from this remarkable resource, along with their knowledgeable, cheerful, inexhaustible assistance.

Michael di Capua contributed crucial insights concerning the reproduction of the images that appear on these pages, and I am indeed very grateful to him for his vital advice.

A number of publishers of Maurice Sendak's works were particularly considerate in making materials available for this project. I am very grateful for the help of HarperCollins Publishers, Farrar, Straus, and Giroux, Inc., The Bodley Head, Crown Publishers, and Caldewick Press.

This book has become a reality because of the unflagging support of Penn State Press, beginning with Sanford Thatcher, director, and Philip Winsor, senior editor, and their enthusiastic commitment to this project. Cherene Holland meticulously cared for the manuscript throughout its completion and revisions, Janet Dietz negotiated the complexities of production with great skill and grace and steadfast good humor, Catherine Thatcher's alert editorial perceptions helped bring the manuscript into its final shape, and Megan Youngquist's design gave it visual life on the page. To all of them, I cannot offer too many thanks.

Maurice Sendak has most generously given of his time and reflections for the personal interviews and conversations that inform this study; he has graciously

granted access to his archive of manuscripts and illustrations in the Rosenbach; and he has given his permission for me to use illustrations and to quote from these unpublished materials as well as from his published works. Without his unrestricted and unrestricting support, this study would truly not have been possible. For this invaluable help, I offer him my profound, enduring gratitude.

To my daughter, Koren, who first taught me how to read Sendak with a child's wondering spirit, for her strategic, exhaustive searches for Sendak material, and for her constant delight in the project, I send my loving thanks.

Finally, always, the deepest thanks of all remain for my wife, Eve, my first and last reader, who kept the light burning for me to navigate this journey into wild places and back, who held aloft the four feathers of the four ways and helped me catch this dream.

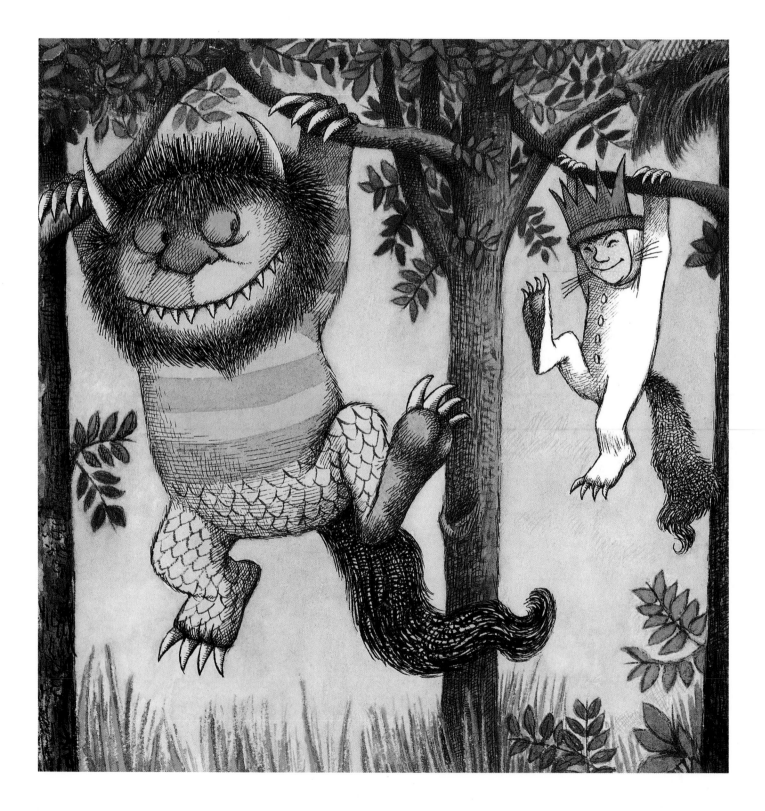

INTRODUCTION

Our whole childhood remains to be reimagined.
—Gaston Bachelard

O N A BULLETIN BOARD at the university where I teach, a flyer recently announced an open house at a local fraternity, proclaiming it would be "a Wild Rumpus" and inviting every "Wild Thing" around to attend. Beneath the gritty surface of the Xerox, one could still trace the outlines of the famous picture of Maurice Sendak's Max and his Wild Things swinging in Dionysian abandon through the branches of the trees. Max now had a Greek logo stenciled on his wolf suit, and the page was crowded with directions for finding this extracurricular habitat of the Wild Things somewhere on the edge of campus.

Perhaps Sendak might roll his eyes over such an appropriation of his images, especially that of Max, whom he called, in accepting the Caldecott Award for this book in 1964, his "truest and . . . dearest creation." [1] Yet these students are Maurice Sendak babies; they grew up with his books and with those Sendak stories and images that have become a part of the mythos of modern childhood. The parents of these students, and the students themselves who are now becoming parents, have made Sendak's a household name, buying well over 15 million copies of his books and propelling *Where the Wild Things Are* by the late 1970s onto *Publishers Weekly*'s list of "the 10 all-time best-selling books for children." [2] The vital, imaginative energy of Max's encounter with the Wild Things had been one of those events that helped ignite the spirit of liberation of the late 1960s: "Wild thing," the Troggs were wailing in 1967, four years after Sendak's book had appeared, "you make my heart sing!"—and rap, hip-hop, and reggae groups are still mining the possibilities of the song. The Wild Things themselves have spawned several generations of furry, toothy, but essentially friendly creatures from the shadows of the

unconscious who, in the shaggy shapes of the Muppets, for example, have long
been doing such things as teaching children the alphabet or how to deal with the
dark. And in another variation that began with the Glyndebourne Opera in 1985
and has continued to the present in American performances, Sendak's creatures
have loped onto the musical stage in an operatic version of *Where the Wild Things
Are,* which shares the evening with another Sendak work, *Higglety Pigglety Pop!,*
making them a kind of *I Pagliacci* and *Cavalleria Rusticana* of the fantastic.

As Sendak reaches his mid-sixties (he was born in 1928), his career as a writer
and illustrator, which spans the past forty years,[3] continues to take new directions.
Along with the sets and costumes for his own works, he has also provided designs
for ballet and film productions of *The Nutcracker* and for such opera classics as
The Magic Flute, L'Enfant et les sortilèges, and *Hansel and Gretel.* In 1990 he
founded a national children's theater, the Night Kitchen Theatre, to "create and
produce material that expands the range of performing arts that reach children"
with the hope of "reinvigorat[ing] all forms of live theater for children."[4] Most
recently he signed an agreement with a major Hollywood film company to develop
a series of movies that would be based, according to a spokesman for the studio,
"not just on his published works but also the many wonderful ideas which are
floating around in his head."[5]

Over the four decades of his career, Sendak's realization of these "wonderful
ideas" has led him to be called, in various places, by various observers "the Picasso
of children's books," "a culture hero," and "one of the most powerful men in the
United States."[6] Indeed, every new book, every new project, becomes the occasion
for a string of articles in most of our major newspapers and national magazines.[7]
Moving effortlessly to the other end of the spectrum of commentary, Sendak's
books are currently subjected to intense, often esoteric studies in those scholarly
journals that acknowledge the arrival of an artist or writer into the land of aca-
demic acceptability—a unique feat of interdisciplinary boundary crossing that few
other figures in the field have achieved. For some time now the spreading ripples
of interest in Sendak's work have been steadily reaching an expanding global audi-
ence; his books easily make the journey into other languages and cultures without
any diminishment of their powers. In recognition of the international importance
of his vision, in 1970 Sendak became the first (and, to date, the only) American
illustrator to be awarded the prestigious Hans Christian Andersen Medal for the
contribution his work has made to the children of the world.

Part of Sendak's considerable fame must surely spring from the surprising
variety and astonishing range of his creations: from illustrations for books of "first
definitions" and manners to a highly sophisticated, haunting series of pictures for
an unusual collection of Grimm's fairy tales, from a book about dog training to a
much-discussed trilogy of picture books, a central theme of which is the explora-
tion of the unconscious, psychological dynamics that inform the lives of children.
He has written what has been called an existential novel about a restless Sealyham
terrier as well as the libretto for a Broadway musical based on a series of his books
about the children Sendak remembers from his own Brooklyn childhood and

youth. As has been frequently pointed out, Sendak's style (or, more properly, *styles*) juxtaposes and, in the process, fuses the refined and the commercial, the polite and the populist, the stuff of comics and glitzy movies and the black and white, pen-and-ink lines of the serenely classical. Opening a given book, one sees allusions to Dürer or Grünewald, Chagall or Winslow Homer; another book suggests the bold outlines of 1930s Disney big-little books or the graphic arabesques of Winsor McCay, echoes of the luminous watercolors of William Blake or the arresting compositions of the nineteenth-century German artist Philipp Otto Runge. The more tradition-bound defenders of the status quo in the children's book world tended to be shocked by Sendak's subversive use of the comic book form in *In the Night Kitchen,* a violation of conventions that was followed by what some considered the even more lowbrow act of allowing the volume to also appear as a coloring book.

In 1981 Sendak again perplexed some of his audience with *Outside Over There,* which contained a text and images that were so thick with symbolic suggestion and visual complexity, so personal, so much an out-growth of Sendak's preoccupations with the late eighteenth and early nineteenth centuries and an homage to the genius of Mozart and the German Romantics, that a number of critics argued it was not a picture book for younger children at all, that it might be a genre-breaking new form or else mere self-indulgence. Change—sudden, dramatic, urgent—has been one of the distinguishing characteristics of Sendak's works and the times in which he produced many of them. In his own public comments on *Outside Over There* (comments that are themselves rare in their number and depth for a creator of children's books), Sendak added to the speculations surrounding the book by talking candidly about how the process of creating *Outside Over There* had led to both "a mini-nervous breakdown" as well as a breakthrough in terms of his own conception of his work: "I'm not saying it was a religious experience, although in fact it was. And did it change my life? In fact it did."[8]

Sendak's willingness to experiment with such varied subjects and stylistic modes contributes to the uniquely defining presence that his work has among contemporary children's books. In fact, it is difficult, if not impossible, to imagine children's literature today without his works and the children who inhabit them, even though Sendak himself has expressed his own bafflement over the power and influence his books have had. As he told one interviewer, "I sometimes think it's amazing I've had success, because [my books] are so idiosyncratic and personal and run against the American grain that says if you persevere, you'll get what you want. . . . my books were . . . pushing and striving for inner things rather than for outer things."[9] Put that way we may also wonder, along with Sendak, why many of these books, with their "hurdy-gurdy, fantasy-plagued" kids from the streets of Sendak's Brooklyn childhood (Fig. 1), these books about what Sendak has called "the *mishigases* of early life" have not only done so remarkably well but, in fact, have become the standard against which we now measure other works for younger children.[10]

But how *are* we to measure Sendak's work? How do we begin to explain the phenomenal popularity of his creations? What is at the heart of the universal appeal of so many of his characters, plots, and pictures? Why does mention of *Where*

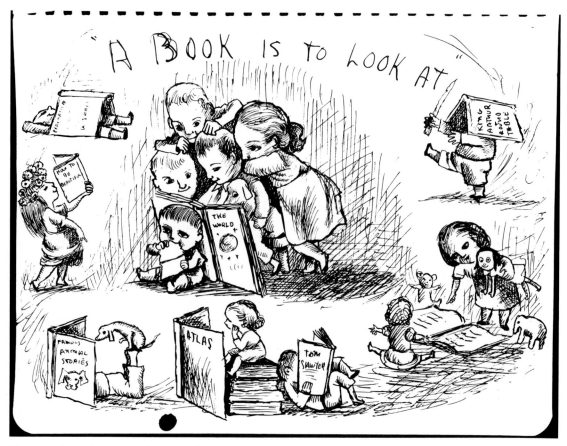

Fig. 1. "A Book Is to Look At," preliminary sketch for *A Hole Is to Dig* by Ruth Krauss

the Wild Things Are, for instance, spark enthusiastic recollections from the check-out clerk at the neighborhood supermarket or a luncheon gathering of the area Kiwanis Club? What is it about his books that intrigues both children and post-modern critics, a high school football coach and a family physician?

Since the mid-1960s, after winning the Caldecott Medal for *Where the Wild Things Are,* Sendak's life and work have frequently been profiled by interviewers and feature writers in order to somehow explain its unusually powerful pull. The most sensitive and probing of these early interpreters—Nat Hentoff in his 1966 portrait of Sendak for *The New Yorker* and Jonathan Cott in his reappraisal of Sendak for *Rolling Stone* a decade later—have been concerned with tracing the relationships between Sendak's life and the sources of his inspiration, making use of Sendak's many autobiographical comments about his work. The culmination of this line of inquiry was Selma Lanes's critical biography *The Art of Maurice Sendak* (1980), which offers the most comprehensive reading to date of Sendak's life and its creative evolution. Despite additional biographical articles about Sendak and Amy Sonheim's recent survey of Sendak's career, *Maurice Sendak* (1992), and despite the need for an updated edition of *The Art of Maurice Sendak,* Lanes's book

remains the definitive study of the role played by Sendak's life in his work, a study upon which anyone working with the importance of Sendak's life in his work must build.

In contrast to these biographically based examinations of Sendak, there has been a steadily growing bibliography of scholarly and critical studies that have emphasized other aspects of his work, such as its aesthetic properties, its generic coherence (what kind of trilogy does *Where the Wild Things Are, In the Night Kitchen,* and *Outside Over There* really constitute?), its "shifting signifiers," and, most recently, in a discussion of Sendak's illustrations for Wilhelm Grimm's *Dear Mili,* its unfortunate use of outdated, punitive forms of storytelling for children.[11] But while many of these analyses have been important in opening a critical dialogue about Sendak, something vital seems missing in nearly all of these discussions: an engagement with the unique energy, what might be called the "soul" of his work.

My own interest in Sendak's work began in the late 1960s, when I first heard him speak to one of Francelia Butler's large, legendary, undergraduate classes in children's literature at the University of Connecticut. I was a graduate assistant in the English Department at the time; my wife and I had just had a baby, and we had naturally become very interested in children's books. As graduate students we were not encouraged by our senior professors to sit in on a class in children's literature—it was, after all, just "Kiddie Lit." and thus beneath the attentions of anyone seriously involved in the profession. A number of us went to Francelia's course anyway; it proved to be a scintillating, unpredictable experience, unlike typical undergraduate lectures and, more relevantly, completely different from our graduate seminars. It was a tonic that left a number of us permanently excited about someday working in the field. How could one resist: one week Margaret Hamilton visited the class to talk about *The Wizard of Oz;* the next brought a championship jump-rope team to reveal the intricate magic of double-dutch; and then there was Sendak—impassioned about his work, hilarious in response to student questions, irreverent about many of the sacred cows of academe and the arts, and utterly in harmony with an audience of young people. His books were all new at the time, and with *In the Night Kitchen* ready to make its appearance, anticipation was in the air, the same kind that crackled whenever the Beatles were about to release a new album.

Later, when I began writing reviews and articles about Sendak, I was struck again by a quality of his work that had been so compelling to me and to many other readers in the 1960s—the capacity of Sendak's books to reverberate on multiple levels of meaning, levels that may take us in a few pages from the most commonplace of occurrences into mythic depths, touching along the way any number of visual or verbal allusions, surprises, ideas, emotions. It was this sheer plenitude of possibilities, this imaginative richness, this intricate weave of evocative textures that gave Sendak's work its distinct aura and universal reach. And what was even more remarkable was that these potentials and expanding symbolic meanings were being carried almost exclusively by children—extraordinary children.

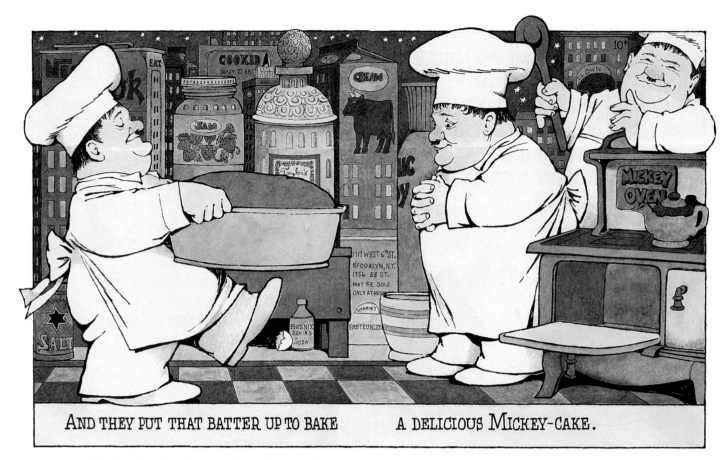

AND THEY PUT THAT BATTER UP TO BAKE A DELICIOUS MICKEY-CAKE.

Fig. 2. The three bakers baking, from *In the Night Kitchen*

Since the 1960s Sendak's books have made dramatic social and, by extension, political comments about the nature of childhood and its singular importance as a vessel of personal memory, a source of creativity, and a cultural symbol. As part of a general movement in the arts, psychology, and social action, Sendak has been a major force in helping give American culture, from the mid-1960s on, a way to perceive its early childhood, freed from the conscious repressions of adults and the natural repressions of what Freud called its "blessed amnesia," ready to make its journey into primordial fantasies, prepared to fall into its own dreams. In returning to his own childhood, Sendak inevitably takes adults back to theirs and makes it possible for children to fully claim their own.

To try to recover and describe in words that unique, galvanizing Sendakian child, to follow it through the labyrinthian passage that it has made in Sendak's work is the purpose of this study. To locate this child one needs to follow a number of possible lines of connection between Sendak the person, his times (and the traditions in which he participates as an American, a Jewish American writer, a creator of children's books), and the archetypal nature of his texts. To explore these arche-

types I have drawn on the ideas of depth psychology, which offers a way of discussing the symbolic richness of Sendak's work that is attentive to the dimensions of the spirit (psyche) that it enters. I have focused on the eight essential works that Sendak has both written and illustrated because in these he has been able to exercise complete artistic control over his materials; and thus we may expect to find here the clearest expression of his artistic vision. I am proposing such a synthesizing, multifaceted approach because it offers the possibility of discovering unity in a poetics that is composed of a daunting diversity of elements and propelled by what seem to be such contradictory forces. Sendak's work is both familiar and strange, a blending of the recognizable and the obscure, the everyday and the evanescent, the personal and the universal. It is a mosaic of influences, from the most sophisticated and, in some instances, esoteric, to the most common and widely shared. He is an American, but, as he also recognizes about himself, he is still an immigrant, an "outsider" observing this new world. He is utterly contemporary and yet his work is fueled with ancient, archetypal energy. Sendak has become one of the principal mythologists of modern childhood. His works weave the intensely felt experiences of his own childhood and his continuing contact with its dynamic forces into the textures of what Carl Kerényi calls a "living mythology" that on some level, at some depth, touches all of us.[12]

Through his many books Sendak has created a kind of map of the emotional and visionary terrain of childhood. His work has often been controversial because he has dealt with subjects that were an intimate part of this experience but were considered to be "taboo" for the writer of children's books: explosive anger, frustration, the polymorphous realm of dream and psychosexual fantasy, intense sibling rivalry, existential angst, death. Sendak has given these feelings a shape, form, and place in our collective geography of the psyche; they are to be found "where the Wild Things are," dreamed "in the night kitchen," located "outside over there." Taken together, they are the closest our culture comes to the kind of visionary map that ancient man once drew for his children, a map locating the powerful forces that would inevitably be encountered in that mythological dimension of human experience, a place that the Australian aborigines named the Dreamtime. Sendak's work serves as a guide through our own modern dreamtime, discovering and depicting its dynamic, potent, primal matter, baking us each, individually and collectively, in its yeasty dough (Fig. 2).

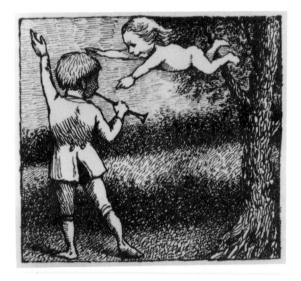

CHILDREN OF THE STREETS AND THE CLOUDS

Variations on an Archetypal Theme

> In every adult there lurks a child—an eternal child,
> something that is always becoming, is never completed,
> and calls for unceasing care, attention, and education.
> That is the part of the human personality which wants
> to develop and become whole.
>
> —C. G. Jung

AFTER *WHERE THE WILD THINGS ARE* appeared in 1963, Maurice Sendak suddenly became much more than one of a circle of well-known writers and illustrators of children's books. And since that time a group of questions about his life and his work has followed him. Some of these questions stem from the need to test the authority that any writer claims for his subject, especially when that subject re-creates the powerful, often impenetrable emotions of childhood with the authenticity and candor that Sendak is invariably acknowledged to have done. Sendak is repeatedly asked about his own childhood in the hope of learning if there are some compelling, identifiable causes or events that link his life to his art. Other inquiries have sought the sources of Sendak's inspiration in less autobiographical places, in the artists and writers who influenced him. What, he is asked, were the effects on his work of reading Freud and having undergone analysis, or the results of studying the pictures of the German artist Caspar David Friedrich, or of immersing himself in the music of Mozart or the novels of Melville? In the end, the questions share a persistent curiosity about the sources of Sendak's creative vision that can somehow explain and possibly account for the feelings that his work evokes. In es-

sence, the questions ask Sendak to explain what Freud called, in writing about the process by which the writer gives public shape to his private fantasies, the artist's "innermost secret"—a secret that he may not, in the end, be able to reveal in a form that would satisfy the curious reader.

As inexplicable as these enigmas of the creative process may ultimately be, over the years Sendak has attempted to reveal them in the form of numerous interviews and public talks about his work, as he did in a prepublication interview for his recent picture book, *Dear Mili* (1988). Based on a widely reported and much-debated "discovery" of a hitherto unpublished manuscript by Wilhelm Grimm, the story is about a child (Mili) whose mother sends her into the woods for safety, while the blue-black, flame-tipped storm clouds of an approaching war are roiling on the horizon and even Mili's guardian angel, hidden in a tree nearby, is frightened (Fig. 3). In his visual interpretation of the story, we discover, for example, that Sendak's pictures are crowded with his homages to those artists who inspire his work, among them Philipp Otto Runge and William Blake, Mozart and Gustav Mahler. In fact, Sendak tells us, the songs of the latter composer were "pouring from the walls" of his studio, providing the auditory tone for the book since Mahler is, for Sendak, "absolutely the concise, precise size of Grimm."[1] There are other references Sendak carefully catalogues, but perhaps most important he explains how he forged his own relationship with the tale. To involve himself emotionally in the story, he enveloped himself in its fantasy, inventing a genealogy for the child in Grimm's tale that makes her the younger sister of one of Sendak's own child characters—Ida in his 1981 picture book, *Outside Over There*. Through an imaginary reversal, Grimm's 1816 tale becomes a sequel to Sendak's: "Ida's died, all the mother's other children have died, she has only one living child left, and that's the baby from *Outside*."[2]

Similarly, Sendak has deciphered many of the key images and stylistic elements in a good number of the eighty-some books he has illustrated over the last three decades, especially in those dozen volumes for which he has provided both the text and pictures. Nearly always there are the acknowledgments to the master artists whom Sendak passionately studies and draws into his own works. But never far away in these interviews are the materials of his own biographical past, which he refers to with equal ease. We learn, for example, that in creating the small pen-and-ink drawings that pirouette across the square, light brown pages of *A Hole Is to Dig* (1952) (Fig. 4), Sendak had gone to the exuberant, animated pictures of the nineteenth-century German artist Wilhelm Busch (Fig. 5). Yet in this book, which effectively ignited Sendak's career and made him a bright new light on the horizon of American children's books, the real inspiration had come directly from his own experience growing up, the son of immigrant parents, in those melting-pot neighborhoods of Brooklyn during the 1930s and 1940s. Sendak rejected that "flat, oilcloth look considered normal in children's books" in the 1950s.[3] Instead he re-created the kids from the streets and stoops of his childhood: "Many of them resemble the kids I grew up with. Most of them were Jewish, and they may well look like little greenhorns just off the boat. They had—some of them anyway—

Fig. 3. From *Dear Mili* by Wilhelm Grimm

Dogs are to kiss people

Fig. 4. From *A Hole Is to Dig* by Ruth Krauss

Fig. 5. Illustration for Wilhelm Busch's "Ker and Plunk, Two Dogs and Two Boys," from *Max and Moritz, with Many More Mischief Makers More or Less Human or Approximately Animal*

a kind of bowed look, as if the burdens of the world were on their shoulders" (Fig. 6).[4]

Other ideas, images, characters, scenes, and objects that appear in Sendak's books find their beginnings there—in his childhood or perhaps in later events but, more often than not, in his childhood. As a young boy Sendak was already at work observing, fantasizing, collecting, shaping the pieces of those mosaics that would later be fitted together in his books. He recalls, for instance, that at a very early age he had begun imagining stories that included his grandmother, parents, and other members of his family; the least favorite of these relatives would be metamorphosed into the famous tribe of child-threatening monsters of *Where the Wild Things Are*. Though his childhood has remained one of the primary resources for his writing and art, Sendak has insisted that these early events are "not very interesting"[5] and that he does not have an unusual number of first memories or the "total recall" of his childhood that many think he must have in order to portray it so credibly. But for him "there is no continuous memory, none whatsoever." Instead, he insists, "there are half a dozen to a dozen things we remember, some of them seem very banal and we wonder, why did I remember that?"[6] Undistinguished as these moments may be, Sendak is amply aware of their importance to his work. "I assume," he notes,

> that every artist's source material—the talent, the gift, whatever—derives from his or her life experience from childhood on. The experience is hardly unique—having been an infant, then a toddler, then a child, and so on. My particular gift perhaps lies in the fierceness with which I've retained those experiences—the feelings of childhood that enrich my life as an artist, that galvanized me into being an artist.[7]

We often see the intensity with which Sendak holds on to some of those pieces from his past, instants that will later have a Proustian unfolding in his work and that lead us with Gaston Bachelard to the conviction that "when a dreamer can reconstruct the world from an object that he transforms magically through his care of it, we become convinced that everything in the life of a poet is germinal."[8] Thus, a favorite toy wagon that was given to Sendak as a child by his Aunt Esther gets attached to the horse in *Very Far Away* (1957), one of the first books he both wrote and illustrated. Ten years later, in 1967, the same wagon becomes the major vehicle for carrying Jennie, the canine heroine of *Higglety Pigglety Pop!*, into the dream world where she can find the elusive satisfaction for which she is searching (Fig. 7). Without this toy milk wagon and its evocative power, Sendak once insisted, however hyperbolically, "none of his books would ever have been written."[9]

Two other examples will serve to illustrate how significant and pervasive these germinal memories, vividly recalled by Sendak, have been in his work. Both emerge from embryonic fantasies. As Sendak remembers in a 1980 interview:

A face is so you can
make faces

A face is something to have
on the front of your head

Fig. 6. From *A Hole Is to Dig* by Ruth Krauss

I was an insomniac; I still am. As a child, one of the things I used to do to get myself to sleep was to imagine myself climbing a hill and finding a cave and going into a cave. It was so snug and comfortable that I'd be very happy and I'd go to sleep. The other image I'd conjure was an island embowered, so laced with trees, so densely webbed with foliage that it gave me great comfort.[10]

These calming, natural images of vegetative, womblike security translate most immediately and pictorially into the caves that appear in Sendak's pictures for *Dear Mili* and in those for his own picture book, *Outside Over There*. But caves and hills, overgrown islands and interlacing trees are woven throughout Sendak's work, from his free-associative "fantasy sketches" of the 1950s (Fig. 8) to one of his most famous sequences of images, the wild rumpus on the jungle island in *Where the Wild Things Are* (1963). Caves honeycomb the subterranean world of *Outside Over There*, and they become a focal point of Sendak's interpretation of the capital city in his pictures for E.T.A. Hoffmann's *Nutcracker* (1984). Hoffmann's original nineteenth-century text says little about the city itself, and this gives Sendak the room that he needs to create an apotheosis of his childhood island, with the buildings of an oriental palace in the background, framed by a cavelike arch of ancient,

vine-covered masonry, all of which is crowned by a wreath of palm fronds dancing against the dark blue, star-flecked sky.

The effects of such primal images are not limited to their expression in the form of a book or a picture; they remain a dynamic part of Sendak's life and the complex ecology of his imagination. As Alexander Liberman points out in *The Artist in His Studio*, the space in which the artist works—the objects that he sees and touches, the furniture, the light, and all those other phenomena that make up the "mystery of environment"—often reveals as much about the process of creation as the actual works that result.[11] The studio provides him with what Bachelard calls a "felicitous space," an enclosing "domain of intimacy" in which the fantasies vital to the creative process are contained and nurtured.[12] It is not surprising, then, to find something of the cave in Sendak's studios, like the one in his Greenwich Village apartment of the 1960s and early 1970s that was described by an interviewer who visited him there:

> The passageway between Sendak's kitchen and his studio is long and narrow and dimly lit. I had the sensation, passing through it, of feeling hemmed

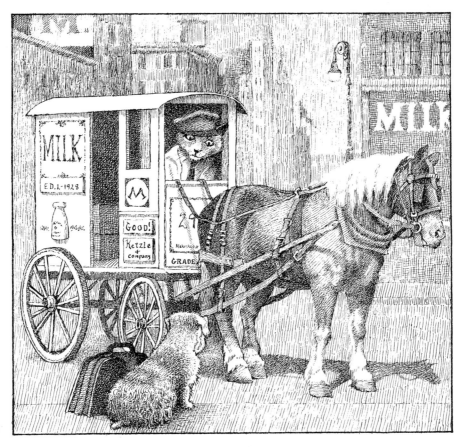

Fig. 7. The milk wagon, from *Higglety Pigglety Pop!*

Fig. 8. From *Fantasy Sketches*

16 ANGELS AND WILD THINGS

in, constricted. Sendak fits himself into it every day to recover the world of his childhood. The studio itself only intensified my feeling. There is no light save for the one Sendak clicks on above his drawing board. The room is small, dark, nestlike and thronged with books, records, drawings and artifacts. Here, time stands still.[13]

Though much bigger and lighter, Sendak's current studio in the country house in Ridgefield, Connecticut, which he moved to in 1973, has that same sense of enclosure. It is also positioned at the end of a corridor off the kitchen at the end of the house, with, as one observer rather ominously described it, "no way of escape."[14] However, giving himself options for escape is hardly Sendak's purpose in choosing a room for his studio; instead, he is interested in building an environment that brings him closer to his work. Here, too, circling his drawing table, Sendak surrounds himself with those talismanic objects that spark his work and manifest its eclectic reaches. In many ways it is a collector's room: rows of rare Mickey Mouse toys wave wildly from the shelves they occupy next to a solemn troop of nineteenth-century tin soldiers; the walls are crowded with pictures that mix, among other ingredients, a small portrait of Mozart with a photo of Sendak's maternal grandfather, whom as a child Sendak imagined to be "the exact image of God."[15] A spectacular Winsor McCay advertising poster from the early part of this century hangs high on the south wall, pouring a cornucopia of color and light into the room. The exotic is casually set in contrast with the everyday: a green, plush, battery-powered monster has stopped "gnashing [its] terrible teeth" and is poised, open-mouthed, listening to the Mahler.

Archetypally, the cave (that dark, primordial, womblike place) is one of the nurturing domains of the imagination (Fig. 9). It is where, tellingly, Greek mythology locates one of its most creative figures, the child-god Hermes, one of whose primary characteristics is his irrepressible, inventive power.[16] In many ways the caves in Sendak's books, like the embowered seclusion of his studios, lead to the ancient grotto where the child and the impulse to create are inextricably joined in what Bachelard has called "the permanence of a nucleus of childhood"—a nucleus that is formed in "its instants of illumination which is the same as saying in the moments of its poetic existence."[17]

Another, seemingly unimportant memory is Sendak's recollection of sitting on his grandmother's lap in the kitchen while his mother baked. "I was convalescing after a long, serious illness," he reports, "and I remember the feeling of pleasant drowsiness. It was winter. We sat in front of a window, and my grandmother pulled the shade up and down to amuse me. Every time the shade went up, I was thrilled by the sudden reappearance of the backyard, the falling snow and my brother and sister busy constructing a sooty snowman."[18]

Sendak has found the event significant enough to comment on in most of the autobiographical accounts he has given of his childhood. In some mimetic way, one can argue, Sendak may have been internalizing, in as quotidian a scene as this, a basic narrative tension and a specific dramatic device that pervades his work. It

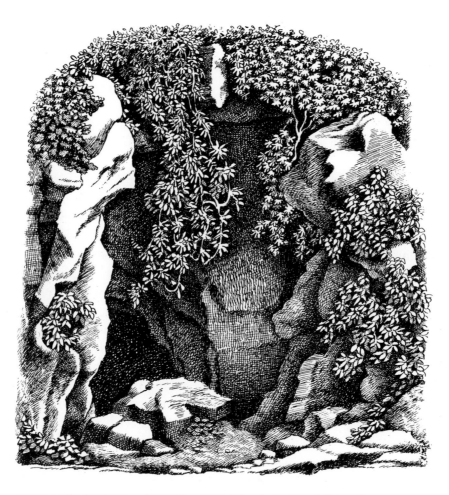

Fig. 9. The bear's cave, from *The Animal Family* by Randall Jarrell

is not as far a leap as it might seem or an unprecedented occurrence for artists: in the autobiography of his creative development, *Poetry and Truth,* Goethe traced his own excitement about drama (an enthusiasm that ultimately lead to *Faust*) back to the elaborate holiday puppet shows that entranced him as a child. The more modest puppet productions that Hans Christian Andersen's father put on with the scraps from his worktable in the tiny cobbler's shop in Odense performed a similar magic on the emerging imagination of his young son.

If one turns to Sendak's works, even in some of his shortest books, such as *Pierre* from *The Nutshell Library,* one finds Sendak lengthening an action that occurs over a very brief span of time by dividing it into individual episodes. Of course Randolph Caldecott had employed a similar technique in his picture books, which Sendak had admired and studied as part of his own education as an illustrator. But for Sendak it was not merely a matter of assimilating the conventions of an artistic form that had reached a first height of its evolution in the nineteenth century; memory, and the emotions associated with it, confirm the personal com-

mitment to the technique, as though grandmother is still raising and lowering the shade, making something highly dramatic and absorbing out of the abbreviated and the everyday. In the animated film version of the same story (1974), Sendak actually has Pierre tell his tale from his window, using its shade as the curtain of his stage. The ending of Sendak's *Higglety Pigglety Pop!* takes the five-line Samuel Griswold Goodrich nursery rhyme of the same name and breaks it up into a series of fourteen short episodes that are presided over by that most grandmotherly of figures, Mother Goose. A window becomes the focal point of the back wall of the set, serving as the chief means by which the characters make their quick exits and entrances in this play within a play that features Jennie the dog, who finally lives out her fantasy and so satisfies the existential hunger that is gnawing at her throughout the story (Figs. 10 a and b).

In these and his other frequent recollections of things past, we can see how Sendak begins the process, the *poesis* that shapes his experience, moving it onto another plane altogether from the purely reminiscential or self-referential. Here are seeds for future stories, lines for a yet-to-be-written dialogue in a play; there an object that will become a prop in the mise-en-scène for an opera; a friend's name, for example, meaningful only to Sendak, becomes the label on one of the food boxes in the cityscape of *In the Night Kitchen*. Sendak's books start as clusters of such associations—an image from a childhood book, a toy, the recollection of that first vision of Mickey Mouse, a fragment of a childhood fantasy, the smell of fresh bread from a particular bakery—that accumulate and expand from those primary, generative moments. Little, it seems, is really lost or abandoned; and these images are continually cycling and recycling through Sendak's work, a spiraling helix of memory and reverie that can become a painting, a line, a book.

Despite his personal connections to these sources and the importance that he recognizes these elements hold in his life and work, Sendak has also been quite critical about his books, asserting that his are not "such original ideas." Sendak claims that he's simply "good at doing variations on the same idea over and over again." All the artist requires, he insists, is "one power-driven fantasy or obsession, then to be clever enough to do variations." [19] Sendak has frequently described his own "obsession" as his "endless fascination and absorption with childhood" and his "great curiosity about childhood as a state of being." [20] Growing out of this overarching interest, the central theme of Sendak's work is much more specific, immediate, and urgent; from his perspective it has to do with "how all children manage to get through childhood from one day to the next, how they defeat boredom, fear, pain, and anxiety and find joy. It is a constant miracle to me that children manage to grow up." [21] The ability of children to survive these daily demands depends upon their displays of courage and, most important for Sendak, on their powers of "invention." [22]

Following this statement of the basic theme and variations in his work, Sendak soon reaches a point beyond which he does not venture further in his explanations of what his books are *really* about and what might lie beneath these autobiographical or more general, thematic surfaces. "Not because it's a secret,"

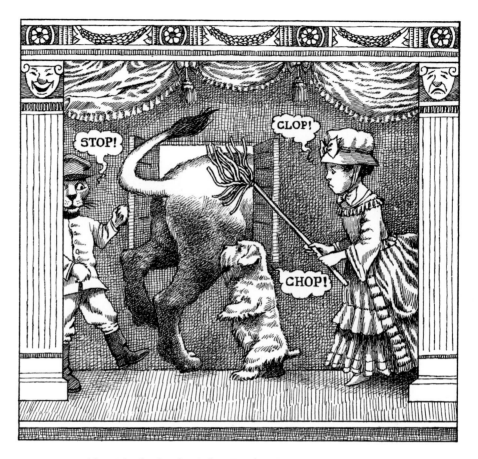

Figs. 10 a and b. The finale of *Higglety Pigglety Pop!*

he told one interviewer, "but because I can't verbalize it." [23] Nor in the end should we expect Sendak, or any artist, to unravel the complexities of his work for us, important and at times essential as these insights might be. As Carl Jung reminds us, ultimately an artist's work takes on a life of its own—it "outgrows him, like a child its mother." [24]

This familiar association of the relationship between the mother/artist and her offspring is an especially fitting one with Sendak, for he has regularly adopted the imagery of pregnancy, gestation, and birth to describe his own experience of the creative process. His 1971 picture book *In the Night Kitchen,* he tells us, issued "from the direct middle of me, and it hurt like hell extracting it" because of the "birth-delivery type pains" of the process. [25] *Outside Over There* was another pregnancy that, while the book was still taking shape, left him feeling "like a woman having a baby, all that life churning on inside me. I feel it every day: it moves, stretches, yawns. . . . it's getting ready to be born." [26]

But if, to continue the metaphor, Sendak is the vessel, the container for these works of art, the artistic womb in which they grow and are nurtured, what engenders them? What is the artistic biology that makes them grow? As I have been

arguing, and as commentators such as Nat Hentoff, Jonathan Cott, and Selma Lanes have all noted in their discussions of his work, memory is an indispensable source of Sendak's creative energy: Mnemosyne (Memory), after all, *is* the mother of the Muses. Most of his books begin their germination with a moment, a fleeting sensory impression, an event from his childhood; painful or prosaic, joyous or inscrutable they belong to that "nucleus of childhood" that Sendak continues to experience. For example, *In the Night Kitchen* gathers its generating premise from Sendak's own bouts with insomnia that began in his childhood. The book's main character, Mickey, is awake late at night, and he does what Sendak himself did on those occasions: he creates a fantasy to help himself fall asleep. Mickey's descent into sleep and fantasy is directly affected by another element in Sendak's imaginative environment, one that reflects not only the unique character of his life but also the general details of the times—the social, cultural, historical contexts in which that life is lived. Sendak remembers how, as a child growing up in the 1930s, he was upset about an advertising slogan for the Sunshine Bakers, whose motto was "We bake while you sleep." Why, he wondered, did adults get to stay up and enjoy themselves while children were trundled off to bed? Through fantasy Sendak's

Mickey finally has the chance to "stay awake" when kids are normally asleep and to fully experience perhaps his first triumphant, transformative dream. Many other elements in the book, as we shall see in later chapters, are drawn directly from the popular culture of the 1930s, Sendak's childhood years. Not the least among them is Mickey Mouse, whose arrival in America's movie houses had a major, lasting impact on Sendak, becoming his "first friend," Sendak recently recalled, and the namesake for the hero of *In the Night Kitchen.*[27]

Like the autobiographical material Sendak draws upon, which can come from early childhood or his most recent concerns as an adult, the field of social and cultural references for many of Sendak's books does not necessarily remain enclosed within the time period in which a given book may be set. Thus, in Sendak's recent illustrations for *Dear Mili,* he inserts in the eighteenth-century context of this tale a number of images that arise directly from twentieth-century circumstances. In one scene, for example, Sendak includes a small drawing of a group of children from the French village of Izieu who were sent to Auschwitz by Klaus Barbie during World War II. Sendak's image is based on a photograph that was published while the trial of Barbie was taking place in France and, synchronistically, while Sendak was also at work on the pictures for the book—a book about war and the suffering of children during such periods of violence. The image from the present thus comments on the past; silently, subtly, subliminally it calls the reader's attention to timeless conditions in the lives of children. The effect here and elsewhere is that the material surfaces of Sendak's books are reverberant with similar references that compound the past and the present, the contemporary and archaic into a new reality that collapses literal, temporal boundaries.

Though one can often unravel the threads of cultural associations and personal references that Sendak weaves through a given book or that become repeated patterns in a series of books, as many of those who have written about Sendak have done, what remains to be unknotted is the line that will lead one to the generative force that animates the creation, the "it" that Sendak refers to as the unifying principle of his work. Though he knows "in [his] gut what it is," Sendak told his biographer Selma Lanes, "it's not easy to verbalize. . . . Whenever I get really close to it, I think, 'no, it's from some deeper part of myself than my head.'"[28] The facet of the psyche that is "deeper" than the rational, analytical "head" is, of course, the unconscious, where words can only represent experiences, where verbal language yields to the language of the emotions. In this respect, Sendak's choice of metaphors is especially apt; those indescribable, "gut" feelings are the children of the unconscious, and they connect Sendak's experience with its most ancient roots in myth and the archetypal vocabulary of the unconscious where, for millennia, the process of artistic and mythopoetic creation has frequently been expressed through images of biological procreativity.[29] At this archetypal depth we can begin to identify the shape of this mysterious "it" that is primary to Sendak's creative process and that leaves him with the intuitive knowledge that he is "definitely with life . . . sitting like a mother on a stump, thinking, Thank you, God, thank you."[30]

The earliest roots for the word "fantasy" are associated with the activity of a "bringing to light" or "making visible" of what is unknown or that has been unconscious—again, an act of birth giving for something that has been previously invisible. The "bringing to light" of Sendak's "power-driven fantasy" thus involves the dynamic participation of unconscious forces, the "guts" of his psyche that know what he is doing and that give internal substance to his art. Sendak surely realizes the significant role his unconscious plays in his creative life. Despite his conscious doubts and questions about what he may be working on at the time, Sendak explains, with acerbic humor, that his unconscious

> knows exactly what it is, only I don't know with my conscious mind, but every day I get a little clue: Listen, dumdum, here's a word for you, see what you can make of it. So it throws it out and I catch it: oh, a word, fantastic! And then I do without for three days, and the unconscious says, This man's too much to believe, he walks, he thinks, sits, he doesn't do anything, he's a bore, throw him another word, otherwise he'll sit there forever and have a coronary. . . . And one by one it throws me words.[31]

Those messages from the unconscious simply "well up," Sendak explains. "Just as dreams come to us at night, feelings come to me, and I rush to put them down. . . . I build a kind of house around them—the story—and the painting of the house is the picture-making. Essentially, however, it's a dream or fantasy."[32]

The vessel that holds the dream, the words that spell out the fantasy, the "it" that Sendak carries to term, again and again, "like a mother sitting on a stump," is ultimately a child. In part the child belongs, of course, to the reality of Sendak's memories, observations, and direct experience; but given the weight of symbolic meaning that he attaches to the figure, it is also an archetypal child whose energy emanates from intangible—indeed, universal—sources. In many ways, Sendak's preoccupation, his "power-driven fantasy," has been to give birth to that mythic child with a thousand faces who, to borrow George MacDonald's well-known phrase, drops "out of the everywhere into the here." These children leap into being across the pages of Sendak's books—from his earliest offspring, those play-consumed Brooklyn children in *A Hole Is to Dig* (Fig. 11), to Ida, the pensive, resourceful heroine of the Mozartian *Outside Over There;* from the dancing boy of *A Very Special House* (1953), who covers the walls of his own cave with the glyphs of his imagination, to the children of the *Fantasy Sketches,* who are in the fluid process of being born, consumed, and reborn; from Rosie, Max, and Mickey—those inventive spirits who fashion fantasies to help them make it through a moment or a day or a night—to Mili, the child tossed on the waves of (mis)fortune who, despite an attending guardian angel, must find her own way to paradise. Sendak may not be married or have children; yet, in reality, he has fathered and mothered a family of children who are pieces of his life and psyche, progeny of his soul.

Sendak first talked about this child to Nat Hentoff in a 1966 *New Yorker*

Fig. 11. Preliminary drawings of children for *A Hole Is to Dig* by Ruth Krauss

profile, explaining that in his books "all I have to go on is what I know—not only about my childhood then but about the child I was as he exists now." He continued, making what have since become among Sendak's most quoted remarks about himself and his relationship with that psychological state that is now so commonly referred to as "the child within":

> I don't believe, in a way, that the kid I was grew up into me. He still exists somewhere, in the most graphic, plastic, physical way. It's as if he had moved somewhere. I have a tremendous concern for him and interest in him. I communicate with him—or try to—all the time. One of my worst fears is losing contact with him. . . . I don't want this to sound coy or schizophrenic, but at least once a day I feel I have to make contact. . . . The pleasures I get as an adult are heightened by the fact that I experience them as a child at the same time. This dual apperception does break down occasionally. That usually happens when my work is going badly. I get a sour feeling about books in general and my own in particular. The next stage is annoyance at my dependence on this dual apperception, and I reject it. Then I become depressed. When excitement about what I'm working on returns, so does the child.[33]

Hentoff mentions being initially puzzled by these remarks, perhaps indicating how strangely unfamiliar the figure of the archetypal child still was, even for *The New Yorker*'s readers. At the end of the article, Sendak also made remarks that were, at the time, highly controversial. In them, Sendak placed his personal concerns as an artist before those of the audience (presumably children) for which he was writing. A more conventional response might have led Sendak to reflect on the central social, developmental, or thematic goals he was trying to achieve in his work. Instead, he claimed: "I really do these books for myself. It's something I have to do, and it's the only thing I want to do. Reaching the kids is important, but secondary. First, always, I have to reach and keep hold of the child in me."[34] Even at sixty, in a press release about a new production of *Peter Pan* that Sendak was asked to direct by Robert Redford's Sundance Institute, he joked about his qualifications for the job: "I still have an unruly and tiresome 4-year-old in me."[35]

The New Yorker profile appeared at a time when the qualities of "the child within" were being embraced by the movements of personal and social liberation in this country and abroad. Not only were psychologists like W. Hugh Missildine in his *Your Inner Child of the Past* (1963) proposing that adults try to understand themselves in terms of their childhoods and "make peace" with this dynamic and often demanding or wounded "inner child," but in other modes, popular artists like the Beatles were celebrating the creative energy of this child both in their music and in the personae they adopted for their public performances—irreverent, playful, mischievously challenging the boundaries of the acceptable. Sendak himself had provided that same, general cultural movement with one of its spiritual harbingers in the form of Max in *Where the Wild Things Are* (1963), whose return,

through the intensity of his fantasy, to the primitive, nonrational realm of feeling serves as an emblem for the latter part of the decade, offering it one of its cries of the heart which the students of Paris painted on the walls of the Left Bank during the demonstrations of 1968: "*L'imagination au pouvoir.*"[36]

Literally and metaphorically, the child claims the imagination. In *The Poetics of Reverie,* which first appeared in 1960, Bachelard widens this view of the child to include what he calls the aura of the "cosmic" as it is experienced in the reveries about childhood that he found in the reflections of poets, painters, musicians, and other artists. These returns to childhood are vital to the creative process, Bachelard argued, because of "the nucleus of childhood which remains at the center of the human psyche. It is there that imagination and memory are most closely bound together. It is there that the being in childhood binds the real with the imaginary, that it lives the images of reality in total imagination." This "cosmicity of our childhood remains within us . . . and introduces us to a being preconditional to our being, a whole perspective on the *antecedence of being.*"[37] In 1971 Stanley Kubrick would use such an image of cosmic origins, of an "antecedence of being," to end his film *2001: A Space Odyssey.* At the farthest reaches of the universe, at the limits of human knowledge and technical achievement, the light-speeding spaceship takes us to our ultimate destination, which is really, of course, our beginning: a human fetus gently sleeping in its diaphanous cocoon.

Just a few years before Sendak's children first appeared in the early 1950s, Carl Jung attempted to chart the dimensions of this archetypal constellation that would become important over the next three decades for a growing group of artists and writers creating works for children and, most especially, for Sendak. Jung's discussion of the archetypes follows from his investigations of the unconscious, that dimension of the psyche which he regards not as merely the center for instinctive impulses and drives (id) but rather as the collective source for those "symbolic images," the archetypes, that have inhabited the dreams, mythology, and art of human beings for millennia. The archetypes, he argued, and thus their meanings, remain dynamic and fluid and should not be treated "as if they were part of a mechanical system that can be learned by rote." For Jung it was "essential to insist that [archetypes] are not mere names, or even philosophical concepts. They are pieces of life itself—images that are integrally connected to the living individual by the bridge of the emotions."[38] The development of an individual's understanding of himself and of a culture's comprehension of itself have to do with both becoming more conscious of the unconscious which, Jung held, contains the full spectrum of human nature—"light and dark, beautiful and ugly, good and evil, profound and silly."[39] Civilization and personal enlightenment, Jung maintained, both depend upon our ability to pay attention to and gain knowledge of those "inner motives" that "spring from a deep source that is not made by consciousness and is not under its control." The spirits of ancient mythology "are as active as they ever were" for modern man, Jung insists. "His gods and demons have not disappeared at all; they have merely got new names" and they demand of him, as they

required of ancient man, much as both might wish to avoid undertaking this difficult task, a commitment to introspection and the process of self-discovery.[40]

Individuation is the name Jung gives to this lifelong process of becoming more aware of the unconscious. Marie Louise von Franz, a protégé of Jung who has written extensively on archetypal psychology and forms of children's literature such as the fairy tale, describes individuation in *Man and His Symbols* as a "slow, imperceptible process of psychic growth . . . the conscious coming-to-terms with one's own inner center . . . or Self."[41] The Self is "an inner guiding factor. . . . the regulating center that brings about a constant extension and maturing of the personality."[42] Through a study of one's dreams and their archetypal content one becomes, in essence, more Self-conscious, more able to assimilate the archetypal material of the unconscious into one's conscious life. "The study of individual, as well as of collective, symbolism is an enormous task, and one that has not yet been mastered," Jung writes.[43] But the important first step along that road is to begin to recognize that "seemingly unending web of archetypal patterns" that give meaning to our individual and collective lives.[44]

Among those archetypal patterns that Jung traced in his study of the collective unconscious, one of the most important elements in "the living tissue of the psyche" was the child. Writing about the myths associated with the child, Jung saw the figure of the child as a symbol of mankind's need to express—in the myths of the group or of individual fantasy and dream—a figure that could reconcile oppositions and thus create a wholeness and make possible an optimistic sense of the possibilities for the future (Figs. 12 and 13). The archetypal "child," Jung wrote, brings together a host of paradoxical, conflicting states and emotions, com-

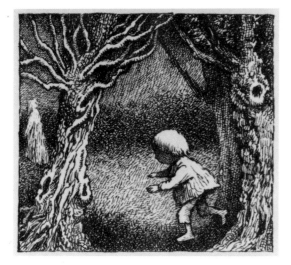

Fig. 12. Drawing for "The Little Boy Lost," from *Poems from William Blake's "Songs of Innocence and Experience"*

Fig. 13. Drawing for "The Little Boy Found," from *Poems from William Blake's "Songs of Innocence and Experience"*

bining as it does "all that is abandoned and exposed and at the same time divinely powerful; the insignificant, dubious beginning, and the triumphal end. The 'eternal child' in man is an indescribable experience, an incongruity, a handicap, and a divine prerogative; an imponderable that determines the ultimate worth or worthlessness of a personality."[45]

From Jung's perspective so much depended on this realization of the inner child because he perceived the appearance of the child in myth or dream to be a positive and crucial factor both in an individual's and a culture's development toward a higher order of consciousness and in an eventual triumph over the darkness of psychological ignorance and repression. The child archetype brought a balancing dimension of futurity to the psyche; in its complex ecology, the child compensates for what Wordsworth called "the world" (of ambition, ego, politics, materialism, Reason) that "is too much with us" and that cuts us off from the other half of ourselves, the realm of feeling. Deny the child as a psychological presence, and a society or an individual denies the future, for the child is both "an initial and a terminal creature" who

> is born out of the womb of the unconscious, begotten out of the depths of human nature, or rather out of living Nature herself. It is a personification of vital forces quite outside the limited range of our conscious mind; of ways and possibilities of which our one-sided conscious mind knows nothing; a wholeness which embraces the very depths of nature. It represents the strongest, the most ineluctable urge in every being, namely the urge to realize itself.[46]

Jung's ideas, of course, are directed at adults, not children, since children are already the living expressions of the archetype and are busy developing other aspects of their personalities—ego, superego—that they need in order to survive and grow up in their society. However, adults require such voyages of self-discovery because they have become, according to James Hillman, "adulterated with rationalistic explanations." Growing up and "maturing," Hillman notes, "has come to mean a process that loses the child in us, leaving us strong—and high and dry."[47] As adults we become emotionally stranded because we tend to think of the real child and literal childhood as the containers for those qualities of childhood (among them, "wonder, imagination, creative spontaneity") that belong to the psychological child and hence to us all, regardless of age. And with the rejection of the child within ourselves, we also dismiss the literature of childhood—especially that body of traditional literature (fairy and folk tales, legends, myths, fables) through which we can be imaginatively refreshed and, as Hillman puts it, "restoried."[48]

Surely one of the reasons why Sendak's work remains so popular and so compelling for both children and adults is because he makes the archetypal child available as story and as a "restorative" medium. Clearly, too, Sendak is aware of the difficulty for adults of returning to "the child within" and of accepting the emo-

tions that arise with the reexperience of the child state of being. For Sendak, the child and childhood are

> nothing you look back on, as though you go through a silly time machine. [Childhood] is imminently available because it has never stopped. Some people ask, "How do you do it, Mr. Sendak? Why do you have this recollection? You must have some special love for children." Nonsense! I can reach back and touch it, but most of us can't either because we don't want to, don't know we can, or are terrified by the mere thought of it. Reaching back to childhood is to put yourself in a state of vulnerability again, because being a child was to be so. But then all of living is so—to be an artist is to be vulnerable (Fig. 14). To not be vulnerable means something is wrong. You've closed yourself off to something. How can you be a good artist? How can you possibly take things that happen in the way that is put upon you as an artist without being vulnerable? It's taking advantage of what we are congenitally—that is, people filled with childhood things.[49]

Fig. 14. A vulnerable artist, from *I Saw Esau, The Schoolchild's Pocket Book*, edited by Iona and Peter Opie

Bachelard reached similar conclusions in *The Poetics of Reverie* when he wrote concerning the fundamental connection between childhood and adulthood that "by certain of its traits, *childhood lasts all through life* and returns to animate broad sections of adult life." Bachelard went on to urge the importance for an adult "to live with the child which he has been" because such a connection offers the adult who is willing to let himself dream back to his childhood "a consciousness of roots, and the entire tree of his being takes comfort from it. Poets will help us find this living childhood within us, this permanent, durable immobile world."[50] This "tree of being" grows often in Sendak's work; its images appear in Sendak's illustration for one of the earliest stories he recalls hearing in his own life, told by his father Philip in *In Grandpa's House* (Fig. 15), and in the metamorphosis of a child into a Christmas tree that Sendak imagined for a holiday card for the Rosenbach Museum and Library (Fig. 16).

Fig. 15. David and the spirit in the tree, from *In Grandpa's House* by Philip Sendak

Sendak's *poesis* and the results of this creative process, the interwoven art of his texts and pictures return us to this world of "living childhood." In part he does this by calling upon the child of his own past, the child of those autobiographical Brooklyn stoops and streets, and by returning to this figure again and again in his work. In one respect, the children that he creates in those books that he has both written and illustrated are self-portraits, and it is not at all accidental that a number of the male children that he has brought to life over the years seem to resemble him physically, though, as Sendak himself often jokes, without the beard or gray hair. That Sendak would have been drawn to childhood as his subject has everything to do with his own childhood, in which he spent his early years struggling to physically survive a series of dangerous childhood illnesses (the measles and double pneumonia when he was two and scarlet fever when he was five) during which he was often left in an enforced solitude that continually threw him back for his emotional survival on his own internal resources, especially on his capacity for imaginative invention. The fantasies that Sendak recalls making up to endure those long hours alone were heightened by the stories that his father told him. "I suppose," Sendak once said, "that's where it all began," with the improvised cliffhangers to which he treated the three Sendak children.[51] His father even told them rather adult versions of stories from the Bible; "he didn't censor anything for children," Sendak recalled, crediting his father with having unknowingly helped in the development of that same trait in his son's work.[52]

Several of Philip Sendak's stories are recorded in his autobiographical work, *In Grandpa's House,* and they give us some inkling of how he brought to his son's child-world a powerful sense of wonder that became an active presence in the

Fig. 16. A transformational Christmas tree

young Sendak's reality (Fig. 17). You might be able to see an angel fly past the window, he told his ill son, if he looked closely enough without blinking; and this would mean that luck and health would soon be returning. When, after long minutes of supreme concentration, Sendak thought he caught a glimpse of the angel and jubilantly announced the vision to his father, Sendak recalls that "he was as thrilled as I was." [53] Appropriately, the same magic of not blinking becomes the monster-taming charm for Max in *Where the Wild Things Are* thirty years later, and the same kind of intensity with which the young Sendak envisioned his own rescuing angel is clearly transferred into other Sendak characters, like Mickey in *In the Night Kitchen* and Ida in *Outside Over There,* both of whose strengths come from their unflinching attention to the demands of the fantasies in which they are the central figures.

Much as Sendak's children are the means with which he has attempted to unravel what he calls the "loose mystery" of his own past, his children are also playing key roles in the quest for some more universal answers, and his search for them has led Sendak through those Romantic "valleys wild" where the cloud child of William Blake's vision is also waiting, like the piper of the introduction to Blake's *Songs of Innocence and Experience,* to inspire the artist who accepts the divine child as a source of revelation. By the time *Where the Wild Things Are* appeared, Sendak acknowledged Blake as "*the* important influence" on his development as an artist. [54] Sendak had been struck by Blake's innovative power, dazzled by Blake's unique graphic instincts and his luminous watercolors. Through his organic relating of pictures and text, Blake virtually invented the art form of the picture book, the form that would become a major new genre of children's books in the hands of such Victorian artists as Randolph Caldecott and, later, the preferred means for unified verbal and visual expression in Sendak's own art. Sendak's illustration for *Lullabies and Night Songs* (1965) offered one of his early homages to the inspirations of Blake (Color Plate 1).

But what seems to have affected Sendak most deeply was Blake's vision of the child as a catalyst for artistic creation and as a representation of what Sendak calls that "miracle" of how children "survive the duplicity of the world," a miracle that would also become a central theme in his own work. [55] Blake did not minimize the importance of the feelings of children; in fact, as a major force in what has been characterized as "the whole movement of the late eighteenth century from Reason to Feeling," Blake presents the potent depths of a child's emotional honesty as a corrective to the frigid, calculating hypocrisies of adult life (Fig. 18). [56] Whether, poetically, Blake's children sang their songs with the sweet, transcendent melodies of innocence or in the bitter, wounded tones of experience, those two oppositional aspects of the human soul, whether they were the accepting victims of adult injustice or raised their voices in accusation, these children serve as moving manifestations of that same divine child.

In writing about the creative process, Jung reminds us that "what is essential in a work of art is that it should rise far above the realm of personal life and speak from the spirit and heart of the poet as man to the spirit and heart of mankind." [57]

Fig. 17. David and the tiny people, from *In Grandpa's House* by Philip Sendak

Such an exchange takes place, Jung maintains, when the artist is swept along by those unconscious, "healing and redeeming" forces of the psyche. These forces claim the artist; they are subtly responsive to the mood of his times, but they are beyond his conscious control or powers of analysis. The artist then becomes a conduit for those works of art that help to maintain a "psychic equilibrium" and to satisfy the deepest needs of the spirit of his own times as well as that of successive generations. Sendak's children are among these vital forces.

As we shall see in the following chapters, Sendak's variations on the theme of the archetypal child free that symbol to appear in children's books without sentimentality or didactic apologies. As Jennifer Waller and others have pointed out, Sendak "emancipated the children's picture book" by showing that it "may actually be about children, not just about lovable steam shovels or cute dogs or shapes—or even about the children we as adults want to remember or imagine."[58] But, as important, Sendak also suggested that adults might unlock their own "mind-forg'd manacles" and allow themselves to experience the presence of the archetype of the child within themselves as they were meeting it in the books that they read with their own children. In revealing and exploring that child essence in the adult, Sendak shows us how it is exactly these vulnerabilities, these "irrational" weaknesses of the child that can liberate the imaginative, spontaneous, emotive qualities of the adult psyche.

"Boredom," Walter Benjamin mused, "is the dream bird that hatches the egg of the imagination." It sat with a cooped-up Sendak during those long, recovering hours of his childhood; it is also what gives wings to Sendak's children, who are left to the devices of their own fantasies on a summer city street or with their tedious baby sister in an isolated eighteenth-century country house. It is what they must overcome to become themselves. The following chapters are meant as studies of the habits of that dream bird and of the fledglings it has hatched, those children who have stepped out of the shells, spread their wings, and flown into our lives (Fig. 19).

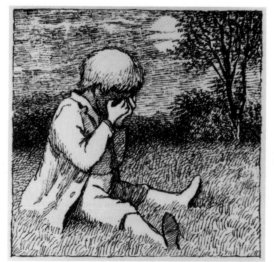

Fig. 18. Drawing for "A Dream," from *Poems from William Blake's "Songs of Innocence and Experience"*

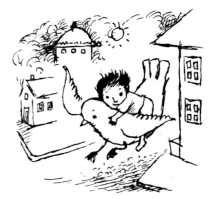

Fig. 19. The boy and the bird, a fantasy interlude from *I'll Be You and You'll Be Me* by Ruth Krauss

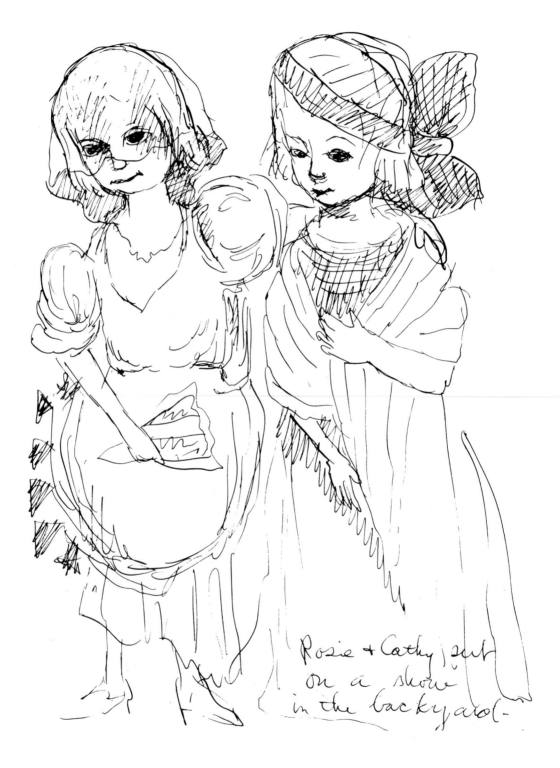

Rosie + Cathy sit
on a stone
in the backyard—

ROSIE

It is a very strange feeling. All I have to do is close my eyes,
and what I see is more real than what is real.
—Mark Helprin, "Mar Nueva"

WHILE HE WAS RECOVERING from one
of those serious illnesses that claimed so
much of his early childhood, a drowsy, housebound, four-year-old
Maurice Sendak once watched his brother and sister playing from
the family's apartment window. Some fifteen years later, Sendak
again was watching while children played in the street below. It
was the summer of 1948, and the neighborhood kids had been
dumped out on the sidewalks to play, a fate the Sendak himself
and numerous generations of inner-city children have shared. But
the Sisyphean task of getting through each of those long days,
enduring the "tedium" and the "enforced imprisonment on an
ordinary block" and somehow finding the imaginative means to
transcend the boredom was, for Sendak, one of the miracles of
childhood ingenuity and, over the next thirty years, a triumph that
he has placed at the thematic heart of his work.[1] From the window
that summer, Sendak discovered on the sidewalk below a girl of
about ten who was a natural artist of the everyday, a gifted prac-
titioner of those transformational qualities of the creative process
that helped a child to survive. Her name was Rosie. Later Sendak
nicknamed her "the Fellini of 18th Avenue,"[2] and had her intro-
duce herself in song as "the Enchanted One," who "can turn
twelve boring hours into a fascinating day."[3] Like that archetypal
child artist, Hermes, she took the plodding turtle's shell of daily
routine and invented music with it. She was the angel who ap-
peared on a cloud, like the child of Blake's piper, and she could not
have materialized at a more propitious moment in Sendak's life.

"It was an awful time," Sendak later recalled. Nothing
seemed to be going well during the summer of 1948. He had
worked briefly in Manhattan after high school, but now he was

"out of a job, out of sorts, and out of money and—worse—having to live at home with [his] parents again."[4] There were grumblings, especially from his father, about how Maurice spent his days—drawing, reading, making books, designing toys with his older brother Jack. Sendak had been doing the same thing naturally, passionately, obsessively throughout his childhood and it was "the only thing," he reports, "[he] ever wanted to do."[5] But his old-world father could not understand those creative urges when they continued beyond childhood; Sendak remembers that his father "was always a little bit uneasy, to put it mildly," that Sendak had chosen to become an artist. Despite his many successes, Sendak later said that "the only joy he ever had in my career was that I illustrated a book with Isaac Bashevis Singer and that somehow made it okay."[6]

In 1948, though, the pressure was on Sendak to do something productive with his time. The subject of art school had come up, but for Sendak, who had barely made it through high school, going to art school was never an option that he wanted to pursue. The simple fact was that Sendak abhorred schools. He carries that antipathy into the present, vehemently insisting: "I hate, loathe, and despise schools. The only part of my childhood that was truly punishing and suffering was school." Just getting himself into the classroom required an act of courage, Sendak explains: "I had to talk myself out of a state of panic nearly every day. I couldn't stand being cloistered with other children—I never did like competition—and I was usually so embarrassed that I stammered."[7]

Most pressing for Sendak in 1948 was to establish his independence, which meant finding a job that would pay him enough to move out of Brooklyn and into New York City. Instead of being able to try his wings, he found himself at his window watching Rosie and her pals, responding from a condition that the poet John Keats had called negative capability, an urgent, instinctive drive that allows the artist to work even during periods of "uncertainties, mysteries, doubts, without any irritable reaching after fact and reason."[8] More than thirty years later and after considerable introspection about his work, Sendak confesses being no closer to explaining why he felt compelled to sketch Rosie and her friends that summer of 1948. "I don't know why I did it," he told a Florida audience in 1982, "but I thank God I did."[9] The results of this beleaguered period were notebooks and sketchbooks that, Sendak recalls, "were filled with a happy vitality and joy that was nowhere else in my life at the time."[10] One might say that Sendak had already discovered that source of invigoration that comes from the practice of the thing that gives one his deepest pleasure, that spirit-sustaining activity that Joseph Campbell has described as following one's "bliss."[11] Though that period may not have seemed at all "blissful" for Sendak, ironically it proved to be one of the turning points in his development as an artist. He was swept along by the dramas that unfolded along Eighteenth Avenue each day and found himself spending "almost every day recording her life. She got dressed up every day in her mother's clothes, grandmother's clothes, anybody's clothes and performed out on the street. . . . I filled roughly 40 notebooks of Rosie dialogue, Rosie plays, Rosie original sayings, and then sketchbooks of Rosie in every conceivable costume and attitude and pose" (Fig. 20).[12]

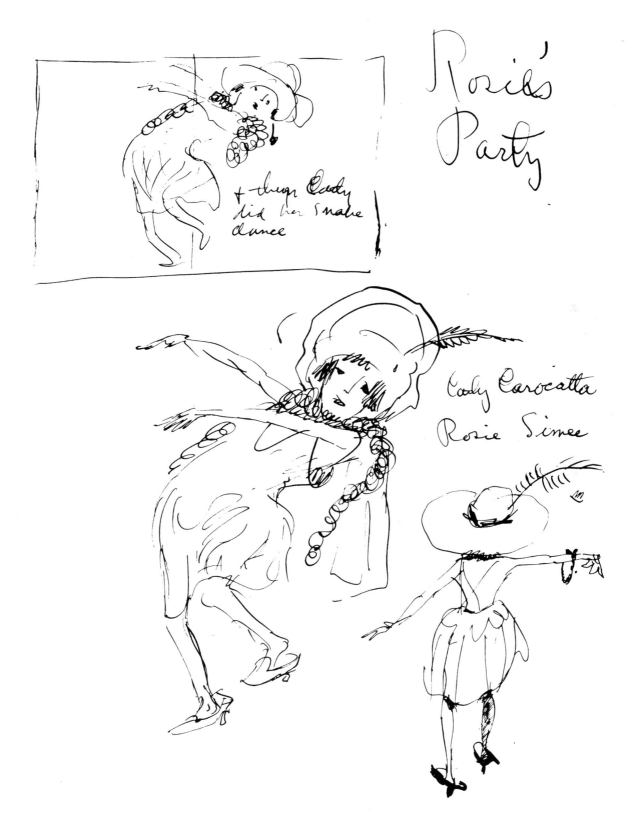

Fig. 20. "Rosie's Party," drawings from a 1948 sketchbook

Surely part of the strength of the immediate bond that Sendak felt with her was one of identification. "She had," Sendak explained, "the same problem that I had as a child in that she was stuck on a street that was probably inappropriate for her, but she'd have to make do." [13] The Sendak family had changed apartments nearly every three years because Sendak's mother, Sadie, preferred to move rather than withstand the disruption and the smell of the paint that the house painters regularly brought with them. So his mother got to "act out her madness," Sendak recalls, "and [he] got to see a lot of Brooklyn." [14] But a move of just a few blocks meant that Sendak kept changing schools and losing friends; he "might just as well have crossed the Atlantic," he remembered years later about the effects of this dislocation. [15] That summer, it seems, Rosie was also in the process of making friends, as Sendak had frequently had to do himself, and she had won over the kids on the block because she "hoaxed them into pleasure" with the same "expertise thing" that Sendak discovered as his way to break the ice—she told them stories about the movies she had gone to see with her parents. [16]

What fascinated Sendak was Rosie's ability to engage her audience through her creative powers, whether she was recounting the plot of a film or inventing an entirely new scenario that involved her (as the star, of course) and her playmates. Sendak observed how she "could control her friends only if she could grab them imaginatively; otherwise they could be very cruel to her. If she didn't have a movie to tell about or an act to do, they abandoned her instantly, as children will do. Or they made fun of her. But once she got hold of something to dramatize, she had them." [17] In short, she was an artist; and, like most artists, Rosie found herself an outsider, a marginal figure in the society to which she desperately wished to belong. The daily struggles of this particular child to exercise her imagination represent, metaphorically, the predicament of the adult artist to continually meet the demands of his art, and thus Sendak's works about Rosie have become, as Selma Lanes has pointed out, "a meditation on the role of art, and on the artist's life." [18] For the young artist in search of himself and his own voice, painfully aware of his own marginal status, Sendak seems to have immediately recognized a kindred spirit in Rosie. While later books would often deal with male characters or with situations far removed from Eighteenth Avenue in Brooklyn, Sendak acknowledges that "a mere change of sex cannot disguise the essential Rosieness of my heroes." [19] She became, he added elsewhere, "the prototypical child of all my books." [20]

Yet one can hardly recognize this prototypical child in Sendak's earliest versions of the stories that he would finally bring together twelve years later as *The Sign on Rosie's Door* (1960). In fact, when we first meet Rosie in Sendak's notebooks, we do not anticipate the important role she will play in Sendak's work: she is more a child of the 1930s, more a Dead End Kid than a liberating force. Take, for instance, the earliest draft for "Rosie's 4th of July" (which Sendak would later transform into the final climactic chapter of his book about Rosie) that appears in a notebook entry for 15 November 1952 (Fig. 21). An intensely serious child comments on her world, a world in which acts of imaginative liberation and the transformation of those stultifying daily events do not seem possible. Rosie has been

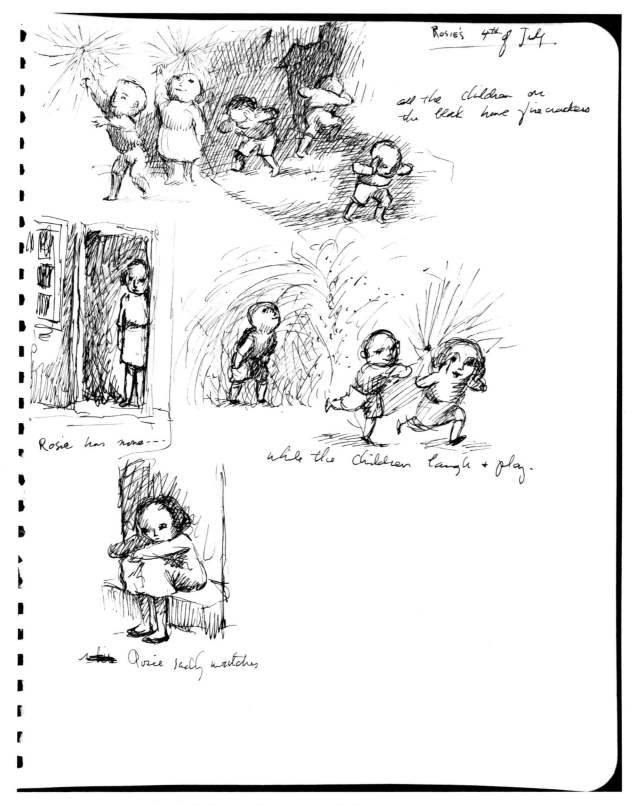

Fig. 21. Rosie's Fourth of July, drawings from 1948 notebook

forbidden any fireworks, and she angrily parks herself on the front steps of her house to wait out the evening. Even though the other children force her to endure the displays of their fireworks, she would rather be outside than inside with her family, where there would be even less to celebrate:

> It was almost pitch-black inside—Grandma had a fit if you put on an old light. She could just see it—grandma + momma huddled around that smelly old kitchen light tearing poor Aunt Lena to pieces cause she married that old Jimmy. Boy—Jimmy was a bum but then Aunt Lena wasn't such a bargain either.... The top floor window shut with a bang! That was grandpa. She shut her eyes + brought a picture of him into her mind. He was wearing his long white underwear—+ now he was moving like a slow old elephant towards his bed—pulling back the blanket + examining the sheets for bed bugs (she had to spray the bed at least 3 times a week—momma blamed them on the lousy neighborhood). Now Rosie held her breath—if he found one—he'd yell + curse so loud the whole house would shake. You'd hear it down in Coney Island! Now she saw him sitting on the edge of the bed—stroking his old yellow mustache + staring meditatively at the little madonna sitting on top of his bureau. He had brought her all the way from Italy. She was all marked up—paint chipped off so badly that her face was just a blank + her blue shawl looked like it was spotted with snow. Wax flowers covered the base of the statue + Grandpa kept 2 rose colored electric lights burning on either side all night long! Rosie wondered if Grandpa was just afraid of sleeping in the pitch black. Grandma never turned these lights off—boy, if she did, Grandpa would really knock her one![21]

This early version of the episode has the hard, realistic edge of a monologue by O'Neill or Odets. These observations might seem more the work of a realistic novelist, someone trying to portray, as Edward Dahlberg had done in his 1929 novel *Bottom Dogs,* the bleakness of the American experience seen poignantly and ironically from a child's point of view. Perhaps, in the form taken by this early draft, it was much closer to Sendak's own experience growing up in the 1930s and to those of the children he had watched, whose often rough, inner-city lives he offered here without any attempt to smooth out their wrinkles or stitch together their worn and tattered sleeves. In his recent comments about the actual Rosie, Sendak said that he once watched Rosie "announce" a fight that took place between her mother and grandfather on the stoop of their house, giving a blow-by-blow account of the action into an imaginary radio microphone.[22] Even if an archetypal wunderkind had not yet appeared, this early experiment reveals how Sendak had begun to develop a character with qualities that would later become a hallmark of his work—in particular, his concern with exploring the inner world of the child, without trying to lighten its dark edges. Sendak's concern is with the child's life as it is lived and felt, rather than with idealized or prescribed forms

for representing a child's experience. Such an approach, of course, made the story a problematic one to present to children, especially to younger children, and Sendak set aside this mode of representation for working with the material about Rosie.

When he returned to the idea of a Rosie book in 1959, Sendak once more told a story about a child who is denied fireworks by her mother. Unlike the earlier version, in which Rosie faces events that are unrelieved by fantasy, Sendak rediscovers a child who can cope with those stultifying moments through small but significant acts of the imagination. He has also located this ability within a broader social context, unlike the two books that he wrote in the interim, both of which also attempted to explore the child's world of fantasy—*Kenny's Window* (1956) and *Very Far Away* (1957). Rosie is the first of his child artists to function in a public sphere, to become, in a sense, a public performer, dealing in the child's world of play activities with the same questions that Sendak, as a maturing artist, had to try to answer in his own work. It is not surprising that Sendak keeps returning to her throughout his career. The evolution of her character—from a struggling, uncertain Brooklyn kid to a confident Broadway star—mirrors his own steady rise to stardom.

After the initial Brooklyn notebooks, Rosie's first appearance in *The Sign on Rosie's Door* came at the end of what Sendak has called his "apprenticeship," those twelve years from 1948 through the 1950s when Sendak became what he has called "an official person" in the world of children's books. Even before he began sketching Rosie, Sendak had his first real commission as an illustrator doing the pictures for *Atomics for the Millions* (1947), a text written in part by his high school physics teacher, Hyman Ruchlis, which was meant to introduce atomic energy to the general public. But Sendak's real breakthrough occurred in 1950, when he was introduced to Ursula Nordstrom, the children's book editor for Harper & Row (then Harper Brothers). The scene could have come from one of those 1930s movies that Sendak remembers going to with his parents, the ones about the struggling, poor but talented young man who finally gets the big break that leads him to fame and fortune. When he was not sketching Rosie and her pals on those long summer days in 1948, Sendak and his brother were busy designing a series of intricate wooden toys based on familiar fairy-tale and nursery rhyme scenes; they had been inspired by the fantastical mechanisms of Gepetto's workshop in Walt Disney's *Pinocchio,* a film that had fascinated Sendak when he first saw it as a boy in 1941. The brothers had high hopes that the famous Manhattan toy store F. A. O. Schwartz would produce the toys. The store declined, but they were struck by Sendak's abilities as an artist (he had carved and painted the figures) and hired him to help with displays for the store's famous Fifth Avenue windows. A friendship soon blossomed between Sendak and the head of Schwartz's book department, Frances Chrystie, and she arranged to bring Nordstrom to the Schwartz workrooms when Sendak would have some of his sketches pinned up on the walls. The late Ms. Nordstrom also recognized Sendak's gifts at once and offered him a

book to illustrate that afternoon, a collection of tales by the French author Marcel Aymé, *The Wonderful Farm*, which Harper published in 1951. Sendak was on his way.

Within the next nine years he illustrated thirty-eight books, most of them with Harper & Row, and most of these were selected for him by Nordstrom, who treated him, Sendak later said, "like a hot-house plant."[23] She encouraged Sendak and served as his mentor. Through her he "acquired his taste" as an illustrator and grew as an artist, learning to adopt, chameleonlike, different styles for different illustration projects. Nordstrom helped to give him his bearings in the field of children's books, hiring him to read manuscripts for Harpers, urging him to do research for the books he did with her, which included trips to Europe and to museums and exhibitions to study the work of the masters. Quite simply, Sendak said, she was his "guardian angel."

Sendak's entrance into the field of children's books at that time was also particularly auspicious. The postwar climate in the United States was receptive to more progressive theories of education, developmental psychology, and the nurturance of children in general. In the wake of the war's devastation, there was, too, a greater sense of the need for international agreement and cooperation concerning the welfare of the world's children. With this global purpose in mind, the newly founded United Nations adopted a sweeping declaration of the rights of the children of the world that included "the right to affection, love and understanding" and "the right to be brought up in a spirit of peace and universal brotherhood."[24] It was within the context of these international ideals and toward these progressive ends that innovative editors like Nordstrom found themselves working during the 1950s. Many children's book departments in major commercial publishing houses were just beginning to be formed, which also charged the atmosphere with a sense of openness and fresh possibilities that affected Sendak and a generation of other writers and artists who began their careers at this time. In describing his own experience during the 1950s and characterizing the spirit of the times in general, Sendak asserts that "it was like being part of a revolution."[25] This revolution—which included such figures as Dr. Seuss, E. B. White, Arnold Lobel, Russell Hoban, Tomi Ungerer, Charlotte Zolotow, Ezra Jack Keats, and Ruth Krauss—made a point of jettisoning didactic modes and safe models, hackneyed conventions and tired looks in order to give the opportunity for a fresh, iconoclastic, idealistic energy to express itself. The result would be what many have begun to call the second golden age of American children's literature.

Among Sendak's earliest projects, since regarded as the first breakthrough in that imaginative revolution, was his work on the illustrations for Ruth Krauss's *A Hole Is to Dig*, which was published by Harper & Row in 1952. Initially, Krauss's manuscript had not been meant for him; but, once again, the moment was right for Sendak. Several well-known illustrators had already turned down the project because it did not have a story line. Instead, the text was a series of statements, "first definitions" collected by Krauss from children themselves, in which they gave verbal meaning to important objects, events, concerns, and people in their world.

The definitions are not meant to withstand the scrutinies of rational analysis; they were the immediate, personal perceptions of young children following their own poetic instincts, making sense of their environment in terms of their active, sensory relationship to it. Thus, from a child's perspective, "A face is so you can make faces" and "A watch is to hear it tick" and "Grass is to have on the ground with dirt under it and clover in it." Other definitions send words somersaulting into pure play: "Mud is to jump in and slide in and yell doodleedoodleedoo!" (Fig. 22). Still others flash with fresh connections: "The world is so you have something to stand on" and "A dream is to look at the night and see things." These fragments, like pieces of some ancient jigsaw puzzle, caught the feeling of that inventive, self-referential world of young children experienced directly, without being filtered through adult consciousness, adult abstractions, adult logic. Sendak has noted that "this was the first time in modern children's book history that a work had come more or less directly from kids."[26] But one might well go further: perhaps more than any other book of the early part of the decade, *A Hole Is to Dig* set the tone and the standard for much of the experimentation that would occur throughout the decade, much of which would involve Sendak.

The project may well have been too open-ended for other artists, but it was precisely the freedom and uniqueness that appealed to Sendak and, according to his account, he was eager to convince Krauss and Nordstrom that he would be right for the collaboration. When he met with them, Sendak brought along those 1948 sketches of Rosie and the neighborhood kids—the same drawings that edi-

Mud is to jump in and slide in and
yell doodleedoodleedoo

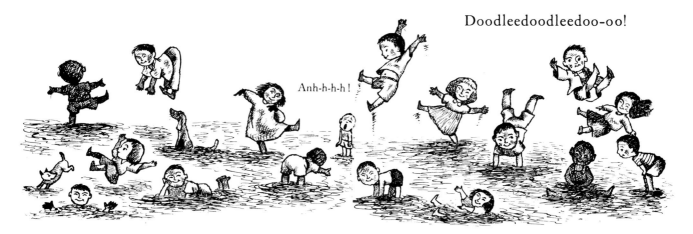

Fig. 22. "Mud is to jump in," from *A Hole Is to Dig* by Ruth Krauss

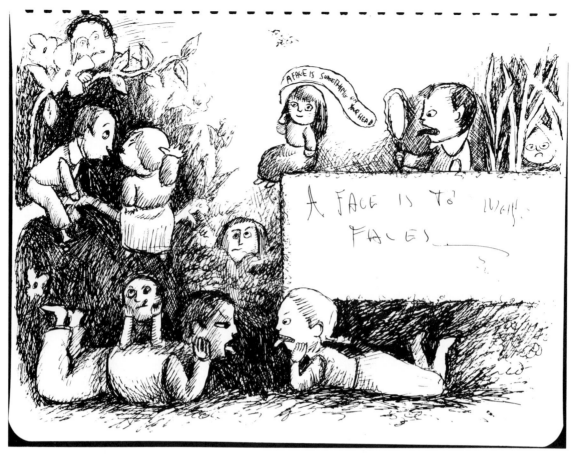

Fig. 23. "A face is to make faces," preliminary drawing for *A Hole Is to Dig* by Ruth Krauss

tors before Nordstrom had turned down as being "ugly" and "too European" (Fig. 23).[27] These sketches were all based on real children who did not, as Sendak put it, have that sanitized, "approved" look that was then so common in children's book illustration.[28] Surely the uncommonness of Sendak's children must have convinced both Krauss and Nordstrom that he was the artist for the book. It is certainly not difficult to imagine how, say, a drawing of Rosie and her friends sitting on the stoop across the street from Sendak's parents' Brooklyn apartment may have led directly to the picture for "Steps are to sit on" in the finished volume of *A Hole Is to Dig* (Fig. 24). But his association with Ruth Krauss helped him to find the means for expressing the ideas that had already begun to emerge in his sketchbooks. Sendak remembers Krauss suggesting many of the pictures for the book; she was, he says, his "school," adding that as a young artist learning his craft, it would be "unimaginable not to have worked with Ruth as closely as [he] did."[29]

This collaboration extended throughout the 1950s and resulted, after *A Hole Is to Dig,* in seven other books. In a number of respects all were variations on the form and spirit of *A Hole Is to Dig;* several, including *Somebody Else's Nut Tree* (1958) and *Open House for Butterflies* (1960), were also collections of children's

stories and, with the latter, more children's definitions. *A Very Special House* (1953), the second book that Sendak did with Krauss, is particularly important in that it shows the emergence of the figure of the child artist who would become a focal point in Sendak's own stories—a child for whom imagination was the way to explore his world and for whom fantasy provided the means for carrying and transforming its burdening experiences. *A Very Special House* does not contain many of the stylistic characteristics that would become hallmarks of Sendak's art—the cross-hatching, the washes, the modeling—but the drawings have, in abundance, the energy, the feeling, the sympathy for the fantasy lives of children that Sendak would exhibit throughout his work.

The book begins with a loose line drawing of animals (a donkey and three squirrels) who follow a child (the first, in fact, of Sendak's solitary child characters to appear in his own book) into his house. Inside we discover that the boy is drawing on the walls of the house, bringing this "special house" into existence with his crayon (Fig. 25). The childlike quality of the poem and the naive expansiveness of the illustrations are a heady and an altogether compelling mixture that builds to a climax in which the reader learns what he has already instinctively known from the beginning of the book: it is all the child's creation. As one critic has observed, the book is "an ode to the imagination."[30] The final lines of the poem make sure the reader will know the source of the artist child's visions:

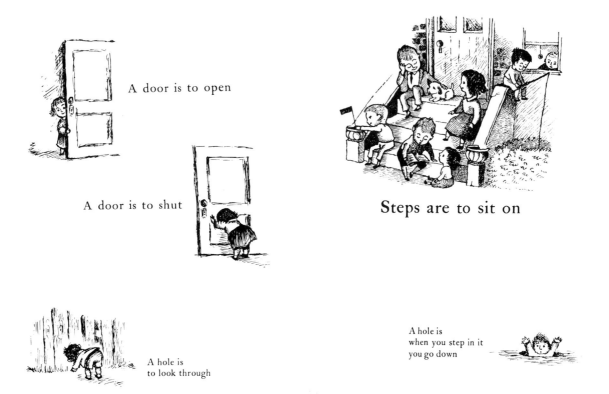

A door is to open

A door is to shut

Steps are to sit on

A hole is
to look through

A hole is
when you step in it
you go down

Fig. 24. "Steps are to sit on," from *A Hole Is to Dig* by Ruth Krauss

Fig. 25. The child artist, from *A Very Special House* by Ruth Krauss

> I know a house—
> it's not a squirrel house
> it's not a donkey house
> —just like I said—
> and it's not up on a mountain
> and it's not down in a valley
> and it's not down in a hole
> and it's not down in our alley
> and it's not up in a tree
> or underneath the bed—
> oh it's right in the middle—
> oh it's ret in the meedle—
> oh it's root in the moodle of my head head head.

Sendak would not be as explicit about the origins of the fantasies that later became central to the works that he both wrote and illustrated, choosing to allow those imaginative processes to remain unstated, oblique, mysterious. At the time, though, it was necessary and, in many ways, crucial to educate an audience that was just beginning to get used to the idea of granting full credit to the creative powers of children. In books like these and others that followed throughout the 1950s, Krauss and Sendak were opening up that unfamiliar, inner terrain of the child's world for further exploration; others followed their example, including Krauss's husband Crockett Johnson, who moved onto the same ground a few years after *A Very Special House* with his own saga of a little boy who draws his adventures: *Harold and the Purple Crayon* (1955).

Krauss and Sendak had not, of course, been the first to examine that domain of children's fantasies which Sendak would later claim as his "obsessive" theme.

Dr. Seuss, for example, had begun his career as a creator of picture books in 1937, with a work that also focused on the secret fantasy lives of children and the impossibility of sharing that experience with the adults around them. In this book, *And to Think That I Saw It on Mulberry Street,* Seuss follows a boy named Marco from another boring day at school along his usually uneventful homeward journey. On this particular day, though, the untypical happens: when Marco sees a horse and wagon, his powers of fantasy suddenly click on, and he transforms the nondescript rig into a riotous parade of contraptions and characters that fill the page as they accompany him down the street. When Marco arrives home, his newspaper-reading father, a well-grounded representative of the real world, asks him what he saw along the way. Marco is suddenly jerked back to earth and can only manage a vague reply that will satisfy a slightly curious parent. His answer avoids broaching the subject of telling an adult what *really* goes on in the minds of children: adults, Seuss suggests through Marco, simply would not comprehend and accept such visions.

Seuss returned to this theme in 1957 in *The Cat in the Hat,* his 223-word celebration of that wild, shadowy side of a child's nature, in which a trickster cat turns the house of two unsuspecting children upside down and just manages to put everything back in order seconds before mother returns from her shopping. Once again fantasy is at the center of the work, but Seuss here distances the children from any direct responsibility for its creation. The cat visits them; the chaos he unleashes in their pacific world is out of their control. Of course, this is also how it can be with fantasies. Some, especially those that seem to break all the rules, are not easily embraced: one is helpless before their rush, their lingering sense of otherness, their surreality, their shadowy, dangerous rebelliousness. Better to blame the behavior on the trickster cat.

Some of the criticism of Seuss—criticism, by the way, that has also been extended to Sendak—may have to do with the way in which fantasy is received in America, and especially how it was portrayed in books for children before the cultural watershed of the 1960s and a general awakening to its positive qualities. In an essay on American children's literature, Perry Nodelman argues, in describing the contradictory qualities of one of the best known early twentieth-century American fantasists, L. Frank Baum, that fantasy is

> something of an un-American activity, an indulgence in impractical foolishness that interferes with the serious business of getting ahead by means of hard work and discipline. Few American writers have avoided either encumbering their fantasies with heavy superstructures of moral allegory or else defiantly indulging in wispy whimsies that avoid meaning altogether.[31]

The cultural roots of our general distrust of fantasy go even deeper than these pragmatic concerns. Constance Rourke traced back this uneasiness to Franklin, who with Adams and others asserted that "nothing is good or beautiful but in the measure that it is useful."[32] Such an attitude spreads out in the cultural subsoil to

offer, for observers like Brian Attebery, other explanations for why "we began as a nation hostile to fantasy":

> First, fantasy is fictional, and our Puritan forebears considered any deviation from sanctioned "truth" to be a wicked deception—unless, of course, they believed the fictions, in which case they became witchcraft, subject to burning. Second, we embraced the Enlightenment as part of our new national identity. An inherited pastime like the fairy tale could hardly hold its own against the initial excitement of scientific and political experiment. Third, and probably most importantly, our attention as a nation is directed primarily toward material things: new scenery, new artifacts, new wealth.[33]

The fairies and the fairy tale, the source of literary fantasy that would appear in England and Europe during the eighteenth century, Attebery notes, borrowing John Greenleaf Whittier's observation, were "unable to breathe in an atmosphere of doubt and suspicion [and] promptly departed for greener shores."[34]

Despite the attempts of contemporary conservative censors to once again forbid fantasy, our national relationship toward fantasy has changed since the onset of the twentieth century, especially since L. Frank Baum, beginning with *The Wizard of Oz* in 1900, "told the fundamental wonder tale about America itself, a tale of opportunity that up to his time had been mistaken for sober fact."[35] As both Attebery and Selma Lanes suggest, this reorientation in America's perception of fantasy could not really have taken place earlier because we had not "realized that we were not living in a fairyland of peace and plenty"; only after this basic recognition of the harsh realities of the American experience "could we begin to draw upon the power of that archetype in our fictions."[36] This animating realization of our loss of innocence that could somehow be recovered, at least partially and temporarily, through the consoling creations of fantasy and its new worlds becomes even more pressing in the aftermath of World War II, and it has led, in the decades since the war, to the establishment of an American fantasy tradition for older readers in the works of such writers as Lloyd Alexander, Natalie Babbit, Ursula Le Guin, E. B. White, and Jane Yolen.

However, there remained a great deal of uncertainty about the role that fantasy could play in literature for younger children. Typically, one of the easiest ways to make fantasy less threatening, from an adult point of view, is to characterize it as being involuntary and ultimately explainable in rational terms. Thus, the opening for the 1951 Little Golden Book *Alice in Wonderland Meets the White Rabbit* begins by eliminating one of the central tensions that Carroll created in *Alice*—the confusion between the real and the dream, between the inventions of consciousness and the unconscious—which was meant to be left tantalizingly ambiguous, unresolved. The reteller of the tale, which was based on the Disney animated film, gave the game away: "Do you know where Wonderland is? It is the place you visit in your dreams, the strange and wonderous place where nothing is as it seems.

It was in Wonderland that Alice met the White Rabbit." A few pages later, after Alice has fallen down the rabbit hole and hit bottom, the text reassures the reader: "Poor Alice! She was all alone in Wonderland, where nothing was just what it seemed. (You know how things are in dreams!)."[37]

The word "fantasy" does not appear in Dr. Spock's elaborate index for his book *Baby and Child Care,* and his discussion of the role of the imagination in a child's development takes only two pages. Even this leading spokesman for "the new model baby" treats the subject rather gingerly and spends part of this brief space warning that "a mother who herself has always lived a great deal in her imagination, and who is delighted to find how imaginative her child is" needs to be careful lest she "overfill him with stories, and they both live for hours in fairyland."[38] He explains to parents, with some notes of caution:

> A little imagination is a good thing. . . . You don't need to jump on him for making up stories occasionally, or make him feel guilty, or even be concerned yourself, as long as he is outgoing in general and happy with other children. On the other hand, if he is spending a good part of each day telling about imaginary friends or adventures, not as a game, but as if he believed in them, it raises the question whether his real life is satisfying enough. . . . If a child is living largely in his imagination . . . a psychiatrist should be able to find what he is lacking.[39]

Which is, of course, almost exactly what Fern Arable's mother does in *Charlotte's Web* (1952) when she learns that Fern is spending much of her days listening at the barnyard fence to the animals talking. Only after the family doctor has Mrs. Arable remember that Fern is an honest, level-headed child can she really be assured that her daughter is not crazy. Yet even having established the validity of his fantasy through the perceptions of a reliable child, E. B. White soon abandons the device, as though he is aware of the problems that it presents for his more literal-minded American audience. He had good reason to be wary of such a literalistic reaction. One of the most controversial American children's books of the 1950s, Garth Williams's *The Rabbits' Wedding* (1958), had begun innocently enough as an animal fantasy about two rabbits, one black and the other white, who play together, fall in love, and get married. Williams thought that, in this picture book, with its gentle, misty watercolors, he was simply telling the tender story of a "soft furry love."[40] Yet the book became a *cause célèbre*, making international headlines because of the racist responses to it and leading to the withdrawal of the fantasy from many library shelves. An Alabama legislator called for the book to be burned, and a Florida newspaper columnist accused Williams of "brainwashing" readers into accepting racial integration and sent copies of his column to every legislator in the state.[41]

Sendak was certainly not following Dr. Spock's advice about exercising the imagination "in moderation" in the two fantasies that he both wrote and illustrated in the mid-1950s, *Kenny's Window* (1956) and *Very Far Away* (1957).

These works could well be seen as a natural outgrowth of Sendak's work with Ruth Krauss, but they also suggest the individual direction that Sendak was beginning to take and the emergence of the concern that would become central in most of his books: how children may rely on fantasy in order to cope with their personal difficulties.

In *Very Far Away*, Martin tries to get his mother's attention so that he can ask her a question, but she is giving the new baby a bath and doesn't listen. Angry, the boy packs his suitcase and runs away in search of a place where there will be time and attention for him and someone to answer his many questions. Now disguised (in a cowboy hat and mustache) and out on the street, Martin meets a trio of animals—a horse, an English sparrow, a cat—whom he questions about how to get to "very far away."[42] Each of the animals gives him a different answer: for the sparrow "very far away is where people are refined"; for the horse it is "where a horse can dream"; and the cat places it "where a cat can sing all day, and nobody says, *hush cat*." Eventually, Martin and the animals do find the place where they can live out their respective fantasies—a nearby basement that the cat knows about. But they quickly find that their dreams are incompatible: the horse can't dream if the cat is singing, and Martin can't ask questions if no one is willing to answer. One after another they stomp off to find a better place, and Martin heads home, hoping his mother is done bathing the baby so that she can answer his new string of questions: "what refined means and why horses dream and why cats ever sing when they don't know how."

This early exploration of the dynamic nature of a child's fantasy is overshadowed by the forced plotting of the book and its somewhat didactic tone. The illustrations are disappointing—without the "European" style of *A Hole Is to Dig* or the graphic complexity and richness of works Sendak would do just a few years later, as in his illustrations for Else Homelund Minarik's Little Bear books (1957, 1960, 1961). The pictures in *Very Far Away* seem rushed and unconvincing; Martin's anger, for example, is little more than a pout (Fig. 26). Overall, the tentativeness of the book lightens the shadows that are cast by Martin's stormy emotions. Still, it was Sendak's first attempt to forge a narrative shape for the principal theme that would become so familiar in and crucial to his work. Martin's angry frustration does find an outlet for possible resolution in fantasy; and

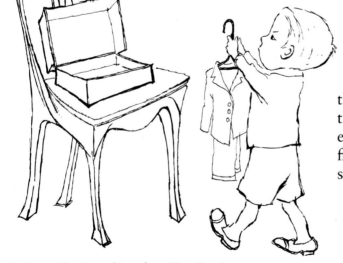

Fig. 26. Martin packing, from *Very Far Away*

Fig. 27. Martin's dream of the four-legged rooster, preliminary drawing for *Very Far Away*

even if Martin is unable to direct his fantasy to a satisfying emotional denouement, he returns home with a new degree of acceptance of the conditions he will have to face. The fantasy has helped him to overcome that moment of emotional chaos and reach at least a temporary solution.

Kenny's Window, which is contemporaneous with *Very Far Away*, plunged more deeply into the world of a child's private emotions and the fantasies he constructs to express them. Like Martin, Kenny is also full of questions. His, though, are posed by a four-legged rooster who leaves them in a dream that Kenny has one night (Fig. 27). Kenny dreams of a garden with "a tree covered white with blossoms. And above the tree shone the sun and the moon side by side. Half the garden was filled with yellow morning and the other with dark green night" (Fig. 28).[43] The rooster's seven questions are as symbolic as the garden itself, a place where natural opposites are united and impossibilities rendered possible—a child's Eden where, Kenny muses, "in the morning I could sit in the nighttime half of the gar-

Fig. 28. The night-time, morning-time garden, from *Kenny's Window*

den and count the stars and at night I could play in the morning-time half of the garden and I'd never have to go to sleep."

The unraveling of each answer depends on Kenny's recognition of some essence in his relationships with those figures, especially his teddy bear Bucky, that hold an important imaginative place in his life. "Can you draw a picture on the blackboard when somebody doesn't want you to?" Yes, Kenny replies to the first of the questions, if you first reassure (with a poem) the person (in this case Bucky) whom you want to see the picture that you haven't abandoned him—even though Bucky has been left in the dark all night and is mad about it. But it hasn't been an easy realization for Kenny: he and Bucky, "oldest and best friends," have snapped at each other; Kenny has hurled his chalk in rage onto the floor, smashing it into "twenty yellow pieces," screaming, as Sendak's Pierre would do six years later, "I don't CARE!" Finally, Kenny consults his two lead soldiers, savvy experts on action and protocol, to find out how to smooth Bucky's ruffled fur. One of them suggests a poem and gives Kenny some tips on how to write it—avoiding rhymes "like bear-scare"—and Kenny finally completes his picture, a Picassoesque sketch

of Bucky riding on the rooster's back while telling him stories, Kenny explains to the bear as he draws, "that only you know."

Through dynamic fantasy play, each of the other episodes of the book carefully unfolds another answer to one of the questions. After leaving a note for his mother, Kenny travels to Switzerland to find out "what is an only goat?" A lonely goat, he decides, because to bring it home to the city with him would mean that the goat would have to give up all the things that it loves. A later chapter asks, "Can you see a horse on the roof?" Yes, Kenny discovers, but like Seuss's Marco, he decides not to tell his parents since "they would say it was a dream or what nonsense or some such thing and of course they wouldn't go up and see for themselves." The horse becomes the starry means of transporting the boy into his imagination: the horse tells Kenny a story, Kenny tells him one in return, and the bond is established. The horse is Kenny's connection with the instinctively creative that is imminently available to him; it will return, the horse tells Kenny, whenever the boy calls for this powerful embodiment of his own imaginative energy.

These individual moments of fantasy all result in a growing consciousness on Kenny's part of the importance of what is going on around him, whether in the pure fantasies of his dreams, in the imaginative projections onto the playthings in his room, or in his own observations. When it snows near the end of the book, as Kenny is "solving" the sixth question ("What looks inside and what looks outside?"), he is drawn to his window, that perceptual opening into and out from his room, his own internal, psychic space. Here he becomes the artist, looking out through his window, watching a man across the street hold a baby, trying to get the baby to look at the snow: "But the baby only laughed and pressed her finger against the man's mouth. And the man kissed the little finger." In that moving instant Sendak seals the relationships between the observer and the observed; artist and subject; baby, child, and man (Fig. 29).

In the end the rooster returns and perches on the window sill as Kenny answers the questions the bird has left behind in the dream that opens the book. Having struggled to grasp the personal, often intuitive solutions to these questions in his own world, Kenny no longer wishes to escape from his room to live in the garden. Thus, when he answers the last question, which brings him back to his room and to its limitations and realities, he is paradoxically freed. The rooster grants him his wishes: "a horse, and a ship with an extra room for a friend." Rather than these being an end to the fantasy, the wishes lead Kenny further, to another, more developed plane of imaginative encounters. As it began, the book ends with a dream in which Kenny and the horse gallop "all over the world and even right up to the ocean" where they discover Kenny's ship, with its extra room for a friend, which will enable them to continue the journey.

We know from Lanes's biography that Sendak's idea for *Kenny's Window* originated with a book by Dorothy Baruch, *One Little Boy* (1952), about the fantasies of a disturbed child named Kenny who had been one of Baruch's patients in psychotherapy.[44] What was of great interest to Baruch, though, was not Kenny's abnormal behavior but rather how much like other children he was:

A child takes little and big things from the world about him and around these he weaves fantasies which are strange and primitive. A child may, for instance, sense his parents' unconscious feelings, as Kenneth did. Or a child may misinterpret his parents' feelings. He may imagine that he is more wronged, more threatened, less preferred than he actually is. In either case, the resentment and anxiety and fear and guilt which color his fantasies then grow out of proportion and problems emerge. Nonetheless, the elements that go into his fantasies are basically the same as those of any normal child.[45]

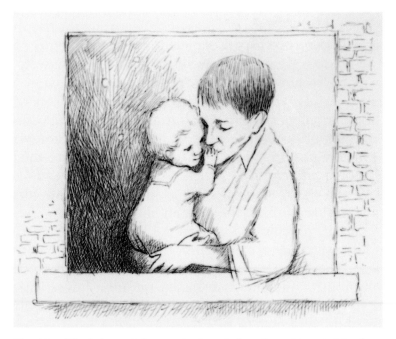

Fig. 29. The baby and the man in the window, from *Kenny's Window*

Baruch closed her lengthy case study with a call for parents to accept the fantasy lives of their children, no matter how strange they might seem to them. "The more firmly we provide a framework of love and understanding in the lives of our children," she concluded, "the more securely are they able to navigate through childhood's bizarre fantasies and to move on to a more realistic footing with things-as-they-are."[46]

Though *Kenny's Window* does not end, specifically, with "things as they are," both *Kenny's Window* and *Very Far Away* nevertheless show Sendak's awareness of this call, a call generally reflected in the clinical literature, for greater adult sensitivity to the importance of children's fantasies. He was all the more sympathetic to the plight of the real Kenny because, at the time, Sendak was undergoing his own psychoanalysis.[47] In many respects the books were an outgrowth of that experience; writing about the "*outrageous* rage" that both Kenny and Martin felt was also, personally, "an act of exorcism" for Sendak.[48] He had not written these

books to "say to kids, 'it's okay to have all these feelings,'" he told an interviewer, but rather "to say it to myself." The books were "an act of finding solutions so that I could have peace of mind and be an artist and function in the world as a human being and a man."[49] Kenny and Martin direct their anger at "inanimate objects" because, Sendak explains, "you don't dare inflict them on your parents or your siblings."[50] But in the private form of his fantasy sketches—those "stream-of-consciousness doodles, dream pictures"—that he began at the same time that these first books were being written he did just that, and he engaged these personal fantasies with an intensity that he could not at the time bring to his public formulations of these psychological quandaries. One thinks, for instance, of Sendak's controversial sequence of drawings of an irate toddler whose tantrum leads to a series of adventures in which he devours and is devoured by several animals. When he returns tearfully to his mother, she spanks him. His rage renewed, the child pulls out a pistol and shoots her into oblivion and then, in a supreme gesture of defiance, turns and sticks his tongue out at the reader.[51]

Sendak's engagement with the psychological dimensions of fantasy in children was part of an awakening in child-rearing circles to the general acceptance of many of Freud's developmental ideas that were beginning to take hold in America after World War II. Baruch, for example, had cautioned her parent readers not to be put off by the fantasies that children had concerning their bodies, sex, or love.[52] She also urged parents to regard as normal a child's violent fantasies, the kind that Sendak was experimenting with in the *Fantasy Sketches* and those that he would later develop for Max in *Where the Wild Things Are*.

In appropriating this material as the subject matter for his books, Sendak brought ground-breaking elements to the exploration of how to treat the psychological experience of children in works that were intended for them. Yet in these images and these poignantly introspective books, he sought something more than merely to reflect the trends in child psychology or mirror his own psychoanalysis. On a much broader level, Sendak's works went to the heart of the problem of most literature for younger children at that time—its lack of an animating inner life. Sendak's attentions were increasingly focused on that crucial passage for children when they "are held back by life, but, one way or another, manage miraculously to find release from their troubles."[53] In that moment of transformation, as we shall see, Sendak would also find the archetypal child, that powerful source of psychological and spiritual balance. To summon that energy, to find the means for expressing it, Sendak returned to the children of the Brooklyn streets (Fig. 30).

Throughout the 1950s Sendak kept coming back to Rosie, that paradigmatic Brooklyn kid. He did a number of dummies involving her backyard or front stoop adventures before finally settling on her as a subject for a possible early reader, an I Can Read book for Ursula Nordstrom and Harper & Row. Unlike Martin or Kenny, what may well have appealed to Sendak about Rosie was her ability to deal with real people and the larger social context of a child's world that exists outside a child's room or the closed circle of her immediate family. *The Sign on Rosie's Door*, while it became another variation on the theme of a child's contact with

Fig. 30. Preliminary drawings for *A Very Special House* by Ruth Krauss

fantasy, was also about friendship and play and the sustaining force of fantasy within a larger community.

As the book opens, Rosie's friend Kathy has come over to Rosie's house to play. Rosie, however, transforms even this commonplace childhood activity into an esoteric event. She has left a sign on her door for Kathy, or anyone else, to find with the tantalizing message: "If you want to know a secret, knock three times." Secret things, as we know, are sacred things (both words spring from the same etymological roots), and what is sacred for Rosie are her fantasies. In the first chapter she announces to Kathy that she is "no longer Rosie" but Alinda, the lovely lady singer who is going to put on a show for the neighborhood kids. Meanwhile, the kids are already waiting on their folding chairs in the backyard for the performance to begin. Rosie brings Kathy into her fantasy, giving Kathy the part of Cha-Charoo the Arabian dancer, and she even gets to do her dance, dressed in a turban and a long, blue plaid bathrobe. By this point Lenny has arrived, dressed as a fireman, looking for a fire to put out, and when he can't find one, he douses the show with his interruptions. When he tosses his hat into the air and the hat lands on Rosie's windowsill, Rosie quickly turns this opportunity to her advantage and invents another kind of game (making a human ladder) to get the hat off the ledge. Of course, Rosie claims the top spot and the hat, but by then the show (and, with it, Rosie's ability to finish her performance) has disintegrated. The kids drift

away and Rosie is left alone. The empowered child is quite suddenly vulnerable, and Sendak portrays this poignantly. We see her thin shoulders from behind; the large dress she's pulled on over her other clothes collapses sadly as she sings to herself the bright song she's been trying to sing to her friends throughout the chapter, finishing the fantasy and trying to place her own spirits on "the sunny side of the street" (Fig. 31).

The second chapter quickly states the condition that had been so familiar to Sendak as he watched Rosie and her friends play a decade earlier. Rosie offers her mother that universal summer lament of childhood: she has "nothing to do." Bored to stupefaction, she covers herself with a red blanket and sits on the cellar door in her backyard. It is a strange, fragmented turn of events after the quick tempo of the opening. Sendak implicitly asked us to identify with Rosie and to feel with her a frustration that is so tangible that even sitting under a blanket is better than facing another, similarly oppressive moment. Sendak conveys this mood less through his text than in the understated style of his drawings. His lines are rushed, rough, unfinished; the scenery is minimal without backgrounds—just

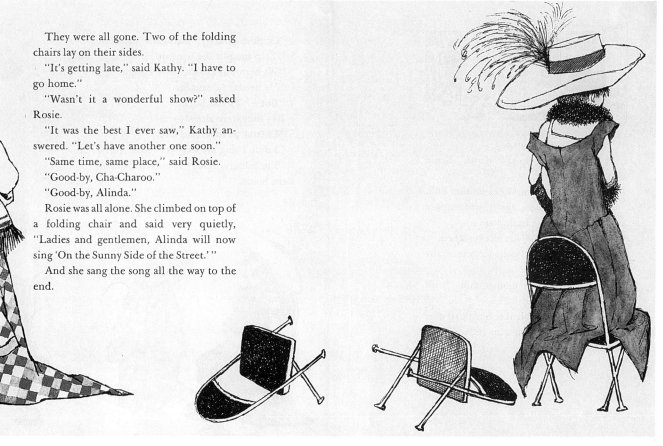

They were all gone. Two of the folding chairs lay on their sides.

"It's getting late," said Kathy. "I have to go home."

"Wasn't it a wonderful show?" asked Rosie.

"It was the best I ever saw," Kathy answered. "Let's have another one soon."

"Same time, same place," said Rosie.

"Good-by, Cha-Charoo."

"Good-by, Alinda."

Rosie was all alone. She climbed on top of a folding chair and said very quietly, "Ladies and gentlemen, Alinda will now sing 'On the Sunny Side of the Street.'"

And she sang the song all the way to the end.

Fig. 31. Rosie sings alone, from *The Sign on Rosie's Door*

a few props, as though this were an absurdist play, a *No Exit* for children. The children themselves are larger versions of those "European" youngsters who appeared in *A Hole Is to Dig.* They are gritty, stubby-legged, knock-kneed kids with cowlicks and socks puddling down around their shoes; their feet are splayed at quirky, impossible angles. For this project Sendak has abandoned the painterly exuberance of, say, Ruth Krauss's *Charlotte and the White Horse* (1956) or the careful cross-hatched modeling that appears in his illustrations for such books as Meindert DeJong's *The House of Sixty Fathers* (1956) (Fig. 32) and the Little Bear books (1957, 1959, 1960). Rather, Sendak's pen is filled with an impulsive urgency that is determined to be as unfussy, as crumpled and erratic and imperfect as the events he is describing—at least until the final chapter. To get there, however, we must slide through an uneventful chapter in which little happens externally except that small domestic drama between Rosie and her mother and Rosie's discovery of a new prop that soon becomes the vehicle for her next fantasy, which begins in the book's third chapter.

Here we discover that the other kids are in the same predicament as Rosie. Kathy, too, has "nothing to do," and neither does Dolly, Pudgy, or Sal. Like Rosie, all of the neighborhood kids are also caught in the circle of boredom and inactivity, and Sendak suggests the rhythms of this "eternal round" in the lives of children in an illustration that is full of circles: the large, round heads of the children, the sun, the balloon one of them is holding, the cement urns on the stoop, the doorknobs. The children quickly realize that the straight line out of this impasse leads to Rosie; and on the next page, they set off to find her. The strong horizontal composition of the page reminds one of E. H. Shepard's graphic designs for the Pooh books, as Sendak leads the reader directly through the text with the children. Half way across the page he uses a blue picket fence to take the reader the rest of the way to the cellar door, where Rosie sits underneath her red blanket (Fig. 33).

She tells them she is "Alinda the lost girl," who lost herself. She is waiting for Magic Man to find her. He is her "best friend" and will "tell [her] what to do." The children wait with her. Even though Magic Man never appears, they all feel it was a successful day and tell their parents "they had done so much there

Fig. 32. Tien Pao and his pig, from
The House of Sixty Fathers by Meindert DeJong

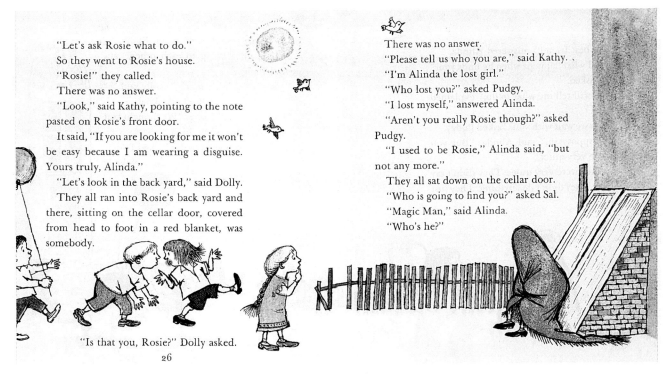

"Let's ask Rosie what to do."
So they went to Rosie's house.
"Rosie!" they called.
There was no answer.
"Look," said Kathy, pointing to the note pasted on Rosie's front door.
It said, "If you are looking for me it won't be easy because I am wearing a disguise. Yours truly, Alinda."
"Let's look in the back yard," said Dolly.
They all ran into Rosie's back yard and there, sitting on the cellar door, covered from head to foot in a red blanket, was somebody.

"Is that you, Rosie?" Dolly asked.

26

There was no answer.
"Please tell us who you are," said Kathy.
"I'm Alinda the lost girl."
"Who lost you?" asked Pudgy.
"I lost myself," answered Alinda.
"Aren't you really Rosie though?" asked Pudgy.
"I used to be Rosie," Alinda said, "but not any more."
They all sat down on the cellar door.
"Who is going to find you?" asked Sal.
"Magic Man," said Alinda.
"Who's he?"

Fig. 33. Rosie as Alinda, under her blanket, from *The Sign on Rosie's Door*

wasn't enough time to do it in and they were going to do it all over again tomorrow.￭" Disbelief has been willingly and happily suspended. Fantasy, again, has succeeded and Sendak ends the day in idyllic, urban tranquility. The children and their parents lean out of their windows or sit outside on chairs, benches, stoops underneath a full moon. It's an intimate, tender page, washed with blue; the only other color is the small red triangle of Rosie's blanket that reminds us of her presence.

Sendak's 1952 study of a realistic Rosie on the Fourth of July, unrelieved by fantasy as it was, ultimately became the basis for the final chapter of *The Sign on Rosie's Door*. In the latter, Rosie also tries to persuade her mother, who is busy in the kitchen, to let her have some fire crackers. Mama refuses, and Rosie goes outdoors to sulk. Here, however, the resemblance between the two versions ends. Rosie's friends have come by, as agreed, to wait again for Magic Man by the cellar door. With the blanket pulled back over her head and her name changed back to Alinda, Rosie leads them in another attempt to make contact with that figure from the realm of fantasy. Even Lenny, who blunders onto the scene (this time dressed as a cowboy, with a stick horse to frighten Rosie's cat), waits patiently, with his eyes shut like the others, for the arrival of Magic Man.

The children are at the limits of their endurance when Rosie goes into her fantasy trance under the blanket and finally reaches Magic Man. Like Rosie's friends, the reader only hears half the conversation that she has with this unseen presence—just a few pleasantries. Sendak stops the forward movement of the nar-

rative momentarily to gain credibility for Rosie, who now has emerged from beneath her red blanket with a serene look on her face. In response to her friends' insistent questions, Rosie recounts Magic Man's part of the conversation, while a skeptical Lenny crosses the page holding out his hand and his play horse like a weapon, set to demolish Rosie's vision (Fig. 34).

The reader cannot help but wonder how he himself might respond to Rosie and her experience since, like her friends, he is also part of her audience. It is a baffling moment in a rather perplexing, episodic story. Sendak seems to be deliberately dropping many of the standard components and familiar plot devices of most narratives for children (the journey motif of his own *Very Far Away*, for instance). We have witnessed some kind of contact with the world of fantasy, but we don't quite know what we have seen. Sendak has not chosen to show that encounter with Magic Man, asking us instead to imagine it with Rosie and her friends. The simple-seeming surface of the book thus becomes highly provocative and the subtle narrative is suddenly alive with dynamic implications.

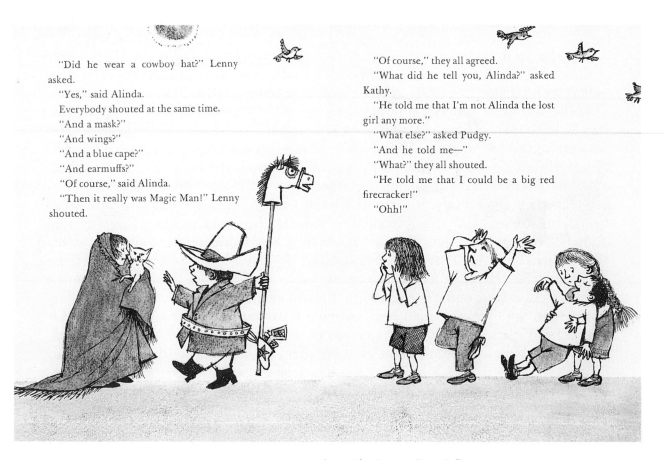

"Did he wear a cowboy hat?" Lenny asked.

"Yes," said Alinda.

Everybody shouted at the same time.

"And a mask?"

"And wings?"

"And a blue cape?"

"And earmuffs?"

"Of course," said Alinda.

"Then it really was Magic Man!" Lenny shouted.

"Of course," they all agreed.

"What did he tell you, Alinda?" asked Kathy.

"He told me that I'm not Alinda the lost girl any more."

"What else?" asked Pudgy.

"And he told me—"

"What?" they all shouted.

"He told me that I could be a big red firecracker!"

"Ohh!"

Fig. 34. Rosie answers the Magic Man's questions, from *The Sign on Rosie's Door*

Beneath its modern language, characters, and context there is something quite ancient about the experience we have just had with Rosie and her friends. After all, Rosie has just conducted and included us in what Andreas Lommel might call a "shamanistic seance"[54]—the kind of spiritual journey that is made by that primordial healer of the tribe, the shaman, as well as by that more recent figure whose vision of the voyage into the other world is meant to have a similar transformational and restorative power: the artist. As Lommel reminds us, the shaman is often the weak or diseased one of the group, and the trance he enters into becomes an act of self-healing that he communicates in the form of transformational symbols that have the effect of "strengthening . . . the group psyche." The shaman's vision thus brings "order through artistic form to the world of ideas, which has become chaotic through debilitating influences or conditions."[55]

Along the way the Shaman meets a "helping spirit" who guides him (or, in this case, her) through the visionary landscape, often providing the necessary power and knowledge to make the journey. Rosie's helping spirit confirms the ancient, nonrational quality of her trance. His very name bespeaks his function: Magic Man. We later learn, through the questions that the children pose, that he is a composite projection of all of their individual fantasies. Lenny, for instance, wants him to have a cowboy hat, and the others add their own touches: a mask, wings, a blue cape, and ear muffs. Rosie's fantasy of Magic Man saves her and her friends from another boring day as well as from the disappointment of not being able to have fireworks on the Fourth of July. Magic Man's solution, the solution of fantasy, is that they can themselves become fireworks, and the result is that, in a preview of the wild rumpus scene from *Where the Wild Things Are* three years later, the children explode with energy across the next four pages, tumbling in and out of the text, pigtails and feet flying. Finally, Rosie becomes the diva of the block as she climbs onto the cellar door (which has been conveniently moved to the far left-hand side of the page), her blanket wrapped about her like a cloak, her mouth wide open to sing a climactic "BOOMM! BOOMM-BOOMM-aWHISHHHH!" Her friends are now ecstatically spilling over the top of the text onto the next page in a line that now has arrived, after its frenzied angular rush, at a compositional grace that has found its way into both this last tableau and the text itself: "They jumped, they ran, they skipped out of Rosie's back yard. They phizzed, they whizzed, they crackled all the way home" (Fig. 35).

Most important, Rosie arrives at the place that the shaman should reach. She "finds" herself at the end of the book; she is no longer "the lost girl," unable to hold an audience with her song—an artist without something to say or sing. Just as suddenly as Rosie's vision has brought unity to the group, the block is once again in chaos. Lenny leads Pudgy and Sal in one direction to find a fire to put out; Dolly, as she waves good-bye, is already half off the page. Only Kathy, drooping in her Cha-Charoo outfit, stays for a few minutes with the exhausted but now serenely transformed Rosie. The archetypal child has moved full circle through its arc of meaning here: beginning vulnerable, weakened, in a state of dis-ease, and

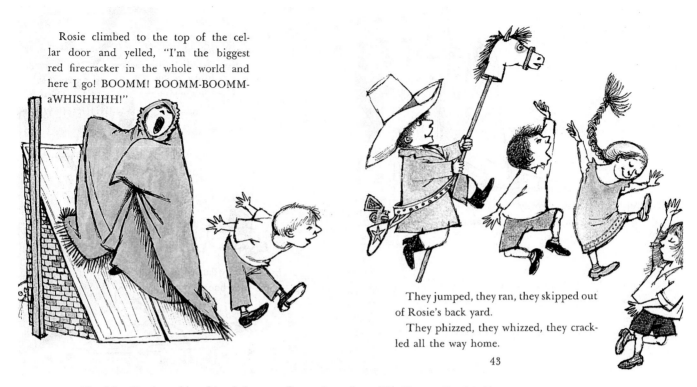

Rosie climbed to the top of the cellar door and yelled, "I'm the biggest red firecracker in the whole world and here I go! BOOMM! BOOMM-BOOMM-aWHISHHHH!"

They jumped, they ran, they skipped out of Rosie's back yard.
They phizzed, they whizzed, they crackled all the way home.

43

Fig. 35. Rosie and her friends become firecrackers, from *The Sign on Rosie's Door*

then, in the process of the story, becoming once again empowered and empowering. It is Rosie's ability to encompass this range of symbolic meaning that makes her the first of Sendak's completed children and that leads him to insist on "the essential Rosieness" in all of his children, regardless of their sex.[56]

In the final pages of *The Sign on Rosie's Door*, Rosie returns home—like Martin and, later, like Pierre and Max, Mickey and Ida—sated by her fantasy and ready to move on to the other creative challenges posed by daily life. Her mother, as an intuitively Spockian mother should, teases her and tries to bring her gently back to reality after the explosive fantasy that has just concluded. But Rosie's impulse to fantasy is indomitable, inexhaustible, and her mother finds her, at the end of the book, "curled up on the rug," pretending to be her cat Buttermilk. Meanwhile the cat is tucked in Rosie's bed, and with one last wave to that other world, she answers her mother's last question with a "Meow."

In a notebook entry dated 2 August 1959, Sendak critiqued his earlier versions of Rosie stories in preparation for the final version of the book that would evolve over the next six months. Analyzing Rosie's actions, he introduced a critical note in his assessment of the "theme" of the story and of Rosie's

> attempt, thru fantasy - to override reality - or, rather, to impose on reality her genius for phantasy - to have things *her* way - to ignore failure + humili-

ation by refusing to admit having been involved - by putting a mask on reality - she purposefully disguises "the facts" - but the facts peep thru + throw her - she shrugs it off - the problem for her is finding a better mask - not in seeing or accepting the facts.[57]

But by the time he finally finished the book's collection of Rosie stories whatever reservations he may have had about her tenacious fantasy life is left behind in his altogether sympathetic treatment of her. In the end Sendak does not accept the adult judgment of her fantasy but rather the validity of *the child's* own experience that has emerged in the book and, most important, the integrity of the symbolic child. Rosie the fantasist/shaman/artist remains true to herself to the end by practicing the innate talent that continues to be her ally and that helps her weather the crisis posed in the book. In not merely accepting reality, she solves what is for her a basic life problem that Sendak identifies elsewhere as coping "with boredom and a sense of personal inadequacy."[58]

Archetypally, she is a direct descendent of the eternal child that George MacDonald describes in *The Golden Key* as "the oldest man of all," who is forever playing and replaying, positioning and repositioning a group of magical balls at "the center of the earth and all its ways," continually seeking new combinations for these basic elements, giving "an infinite meaning in the change and sequence and individual forms of the figures into which [he] arranged the balls."[59] Neither the artist's impulses to fantasy nor those of the child (and, for Sendak, the two are here inextricably linked) can be simply shut off without the risk of destroying something that is vital to the nature of both. As a number of critics have argued, fantasy subverts those "adult" conceptions of the superior nature of collectively agreed upon reality that should take precedence over the fantasies of the "child." Ideally, there should be a reciprocity, a continual exchange between these modes of responding to the world. To borrow conventional archetypal terminology, it is masculine logos, the law-giving, reality-accepting, reason-seeking aspects, that needs to be balanced with its creative, feminine, feeling aspects of the psyche—Goethe's "*ewige weibliche*"—that draws us onward as individuals and as a civilization. Left alone, untouched and unaffected, Lenny will blindly put out the fires of inspiration. That is Sendak's point in the end: despite all the social pressure to compartmentalize these experiences and especially the cultural injunction to reject the "pretend" of fantasy in favor of a supposedly higher reality of the adult world, it is important not to allow fantasy to be subsumed by reality and thus to permit, in Sendak's words, that "particular American equation that [adult]hood spells the death of childhood." For Sendak such a formulation also resulted in the repression of the "joyful vision of imagination as the child in man" that was affirmed in writers and artists who had become extremely important to his own development during the 1950s—particularly in the work of William Blake.[60]

In the following decades psychological theory served to confirm the point that Sendak had reached intuitively in his art at the end of the 1950s with *The Sign on Rosie's Door.* The depth psychologist James Hillman, for one, would broaden the

discussion when he wrote in an essay in 1971 that "childhood is mainly a word we use to cover modes of experience and perception, imaginal modes which we abandon every moment for the sake of more adult behavior, that is more conceptual and more willed."[61] In fact, Hillman takes the argument further when he insists that "the adult" has been "deprived . . . of his imagination. This 'inferior' activity has been relegated to childhood, like so much else unreal, autoerotic and primitive. The adult must go back to childhood to re-find imagination—feeling it unreal, autoerotic, primitive—for lost childhood has meant lost imaginal power."[62] As we shall see, Hillman could have been describing Sendak's purposes in his two works that sought to tap this "imaginal power"—*Where the Wild Things Are* and *In the Night Kitchen*, the latter, as it happens, appearing a year before Hillman's essay.

The Sign on Rosie's Door stands as a closing chapter of what Sendak has called the "million buck education" that he received from Ursula Nordstrom while working on the thirty-some books that he had illustrated for Harper & Row and other publishers by this point in his career. But as much as *The Sign on Rosie's Door* summarized many of the thematic and aesthetic elements that he had begun to explore in *Very Far Away* and *Kenny's Window*, it also created an opening for that recovery of "lost imaginal power" that would be so forcefully represented in *Where the Wild Things Are* and *In the Night Kitchen* as well as in a series of other works from the same period, including Sendak's meditation on mortality, *Higglety Pigglety Pop!*, and the "suite" of illustrations for a collection of Grimm's fairy tales, *The Juniper Tree*. After these and other artistic triumphs, after becoming the first American to win the Hans Christian Andersen Medal and, in essence, being recognized as one of the most important international figures in children's books, Sendak again returned to Rosie in order to make an animated film about her.

This second Rosie project saw a far more confident Sendak than he had been in 1960 and a Rosie who could emerge with authority to serve as Sendak's artistic alter ego, representing his own development as a public performer. The film made use of a number of original songs based on Sendak's lyrics that were set to music and performed for the movie by the popular singer Carole King. The opening song is Rosie's signature number, announcing her presence as the camera pans down from the rooftops to a 1940s Brooklyn street and Rosie proclaims:

> I'm really Rosie
> And I'm Rosie Real
> You'd better believe me
> I'm a great big deal.
> Believe me. Believe me.
> I'm a star from afar
> Off the golden coast
> Beat that drum. Make that toast.
> To Rosie the most.
> Believe me. Believe me.[63]

Rosie immediately takes charge of the production (Fig. 36) in a way that the earlier Rosie was not quite able to do, at least until the final scene. Sendak recalled that the actual Rosie had "always wanted to get into the movies," and here Sendak created a plot that gives her that chance. In many ways it is inspired by the films of the 1930s that Sendak had grown up with—especially the Mickey Rooney/Judy Garland musicals and the Our Gang comedies in which groups of children and young people put on spur-of-the-moment shows. In this send-up of those films, Rosie styles herself as a film director. To play the part she has dressed herself in an enormous hat with a requisite ostrich plume, a feather boa, a long gown and over-sized high heel shoes, all of which give her the authority to "hoax" the other kids into auditioning for her movie. Rosie's friend Kathy is kept for this new variation of Rosie's story, and she gets to do a brief impromptu dance (without her Cha-Charoo outfit this time). Sendak has exchanged Dolly, Lenny, and Sal for characters drawn from three of the four books in *The Nutshell Library:* a child-alligator from the alphabet book, *Alligators All Around;* shy, retiring Johnny from *One Was Johnny,* a counting book; and Pierre, the grouchy protagonist of the eponymous fable that took its title as an homage to one of Sendak's favorite writers, Herman Melville. In an article about the film that he wrote for *Rolling Stone Magazine* shortly before the program was aired in 1975, Sendak noted that each of these characters is actually based on "the men in Rosie's life," and they are each far more evolved figures than the two-dimensional boys—Lenny, Sal, and Pudgy—who appear in the earlier drafts of the Rosie stories from the 1950s.[64]

Fig. 36. Rosie takes charge, from *Really Rosie Starring the Nutshell Kids*

Sendak has also added another character whom he calls "Chicken Soup," a good-natured entrepreneur who sells cups of his hearty broth on the streets of Brooklyn and who appears, much like Magic Man at the end of *The Sign on Rosie's Door,* to replenish the depleted energies of the children and to orchestrate the finale of the show, which is based on the fourth book of *The Nutshell Library, Chicken Soup with Rice.* But the character of Chicken Soup also provides Rosie with one of the darker moments of the film. After being chased into her cellar by a sudden rain shower, Rosie sings the children a song about Chicken Soup for whom they have been waiting throughout the show. "Did you hear what happened to Chicken Soup?" she questions them ominously, as the lightning crashes outside the basement windows and Rosie's shadow jumps across the cellar floor. She goes on to tell the story about how, the night before, their "dear friend" choked to death on a chicken bone, "just a bitty thing, no bigger than my pinkie"; and as she describes his agonies to the enrapt children, her shadow becomes the unlucky Chicken Soup, swallowing that fatal bone.

Sendak had based this particular incident on one that had taken place in 1948, when the real Rosie had used what Sendak calls "that magic sentence" to get the attention of friends who were, on that particular morning, ignoring her:

> "Did you hear who died?" I mean that's going to get anybody including me. I looked up. They looked up and said, "Who?" And she said, "My grandmother, early this morning."
>
> I knew her grandmother. I had seen her out the window all the time, with the brushing of the carpets and the screaming and yelling in Italian at Rosie in the street. And I believed her—we all did. Then she went into a pantomime of what occurred in the early dawn hours when they heard furniture collapsing and mirrors breaking and this rather heavy woman gagging and choking and rushing about. They gave her the Kiss of Life. They hung her head out the window. All to no avail. "Where was the body?" they said. "Gone. Cops came fast—all over." And she told it with a kind of tremulous voice. I mean she was the Eleanora Duse of Bensonhurst.
>
> Now during this telling of the story, up the street comes the grandmother. Two big shopping bags and her carpet slippers, and she goes up the steps cursing the kids violently in Italian, brushing them aside with her feet, waddling up, going into the house. They all separated and said, "Tell us again, Rosie." [65]

Sendak has the children react in the same way to Rosie's story about Chicken Soup: grisly as it is, they demand to hear it again. Like Rosie's grandmother, Chicken Soup finally enters the film at the end of the song, thus changing the mood, turning its last few minutes into a production number that borrows the exuberant, surreal spirit of the Busby Berkeley movies, to which Sendak adds his own touches that include a chorus line of skating snowmen (for January), a pharaoh's barge on the Nile (for September), and even a brief appearance of Moby-

Dick (Fig. 37) to splash along with the lyric:

>In November's gusty gale,
>I will flop my flippy tail,
>I'll spout hot soup,
>I'll be a whale,
>Spouting once, spouting twice,
>Spouting chicken soup with rice!

Fig. 37. "I'll be a whale!" from *Really Rosie Starring the Nutshell Kids*

After this exuberant climax, Sendak ends the film in much the same way that he concluded the first chapter of *The Sign on Rosie's Door*, with Rosie being deserted by the other children—they've all run home to supper without even so much as a backward glance at her. Rosie is left alone to seek solace with her cat Buttermilk. Once more we see how the individual child has energized her world, how the artist/shaman has created something to soothe the frazzled nerves of the group. But those acts of creation have to be continually repeated in the child's world, as Rosie explains in one of the new songs Sendak has written for her. For the individual who has chosen to create fantasies for the group,

>It takes personality
>A lot of personality
>To make them see it my way.
>It takes personality,
>More personality
>To turn twelve boring hours
>Into a fascinating day.

And, for the one who does it, who takes the artistic risks and the imaginative leaps that the others are hesitant or unable to make, there is a price to pay, and that is to be forever on the margins of the group, to experience a kind of otherness from the rest of the children. Sendak does not minimize or ignore the kind of ambivalent role that the child artist or, by extension, the adult artist plays in the life of her community. The play is over, the story has been told, the others have gone home to supper, but the artist remains still a part of the psychic space that she has created. Like the shaman she lingers for a time in the spirit world, unable to completely release the thread that connects her with that strange, fantastic place, and run home like the others. In fact, Sendak does not take us inside Rosie's home in this version, nor does her mother appear to bathe her in nourishing hugs or to provide an anchor for her in the real world. These omissions serve to emphasize Rosie's uniqueness and her isolation; they also reflect Sendak's own sense of isolation. Both his parents had died by the time *In the Night Kitchen* appeared in 1970, and shortly after this celebration of the New York City where he had grown up and spent most of his life as an artist, he had been forced, for reasons of health and for the necessary solitude he needed for his work, to leave the city for a house in the Connecticut countryside.

The solitary nature of the work of a writer and artist remains one of the bonds of autobiographical sympathy between Sendak and Rosie. In a recent documentary Sendak commented on that isolation: "you work for years on your book in your nice country home and it's published and you can hear a pin drop." [66] After working for nearly thirty years primarily on books, what began to appeal to Sendak more and more by the 1980s was the excitement and, as he put it in the same interview, the "instant gratification" of creating for other media—namely, opera, ballet, and the theater. With his set and costume designs for the Houston Opera's 1980 production of Mozart's *The Magic Flute*, Sendak had begun a much-heralded "second career" and an invigorating new direction in his art. Just the year before he had done the sets and costumes for a Brussels production of an operatic version of his *Where the Wild Things Are* with music by the British composer Oliver Knussen; and over the next decade, Sendak quickly followed these works with a prolific succession of other projects that have included an opera based on his own 1967 story *Higglety Pigglety Pop!*, as well as the sets and costume designs for Janáček's *The Cunning Little Vixen*, Prokofiev's *The Love of Three Oranges,* and Tchaikovsky's *Nutcracker* ballet. Sendak had not stopped writing and illustrating books during this time; in fact, the final volume in his picture book trilogy, *Outside Over There,* appeared in 1981. And it was followed by his illustrations for his father's story, *In Grandpa's House;* an exchange of letters with Frank Corsaro, the director, in preparation for their collaboration on the Glyndebourne Opera's production of *The Love of Three Oranges;* a collection of Sendak's essays, *Caldecott and Co.;* and his illustrations for the newly discovered tale by Wilhelm Grimm, *Dear Mili.* Sendak's increasing interest in designing for the performing arts was, in many ways, a natural development of many of the avenues for creative expression that had fascinated him throughout his life. It seems natural, then, that part

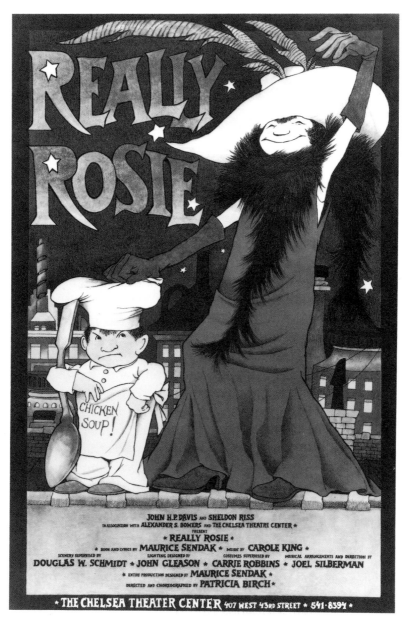

Fig. 38. "Really Rosie," from *The Posters of Maurice Sendak*

of Sendak's movement into the world of the performing arts also, appropriately, included Rosie.

In 1982, Sendak once more returned to Rosie as the subject of a Broadway musical, *Really Rosie,* which was based on his 1974 animated film (Fig. 38). Again she spoke to and, on some fundamental level, expressed Sendak's own concerns as an artist at that particular stage in his career; but in her most recent incarnation, Sendak pushed the idea of Rosie as a portrait of the artist even further than he

had a decade before. Since the 1970s, Sendak had been in a position to pick his own projects—a hard-earned freedom, he insists, after years of apprenticeship. Given his financial and creative independence, Sendak would not have needed to return to Rosie for another reworking of her story unless there was something he felt that remained to be said about her and something that kindled his own energies at the prospects of doing so.

Of course, Sendak had been approached by two producers, John Davis and Sheldon Riss, who were impressed with the animated *Really Rosie* and asked him to consider recasting the work as a live musical.[67] It was a logical progression; indeed, *Really Rosie* was already a musical waiting to be transferred from celluloid to the stage. And Sendak's own creative interests were being drawn more and more to the concert hall, from the two-dimensional dance of characters across the page to the dynamic forms of dance, music, and theater. For Sendak there was also, no doubt, the sheer excitement of working in a medium (the stage) that had attracted him throughout his life in a place (Broadway) that was charged with personal significance. But with Sendak there is always the question of the larger purpose of such an effort. Why bother with the work if, as he put it recently, it does not move beyond merely the artist "relieving himself" and onto some other plane that is "of the highest ethical value we are capable of."[68]

As noted earlier, Sendak's ongoing engagement with Rosie gave him the metaphoric vehicle for continuing to comment on the creative process itself and directly or indirectly on the artist's life. And so the latest chapter of his Rosie story would contain an even fuller statement of his realizations about both. In fact, the Rosie of the 1980s—Broadway Rosie—begins with her reflections on the nature of her role as an artist in the opening moments of the show. She is in full command of the situation and in complete, confident possession of her powers. In fact, she is less a child and more an adult Rosie commenting on her childhood and turning the musical into a kind of flashback about her life. She explains to the audience:

> Why am I here? To make the movie of my life. This is my town. This is my street. A star was born here. Me! It was a long pull, but I definitely made it. Was it hard? Oh, was it hard. The suffering—the hardships, the pain—the laughter—the tears. Oh weary, weary. And all that dancing and singing on the coast.[69]

Rosie's monologue turns suddenly philosophical, away from the self-absorbed, unexamined banter of the earlier Rosies, as she now sets a different tone and different point of focus for the action that is about to unfold:

> What does it all mean? Well, I'm here to find out. To find the real me. . . . You think it's weird someone as classy as me comes from here? You can say that again. But you have to make peace with your crummy past. My town. My street. My little humble street. Ah, yes. Aveune P—the crossroads of millions of stars.

One immediately laughs at Rosie's hyperbole, but beneath her tongue-in-cheek, theatrical rhetoric and the overdramatizing of her position she is sincere about the need for the artist to somehow acknowledge and embrace the past, especially its painful elements. And much as the other children might mock her qvetching about the pain she has to endure as she tries to piece together the film she wants to make of her life, they are also sympathetic to Rosie's plight and that of the artist to somehow realize her fantasies, since they, too, are dreamers. Though they don't hesitate to put Rosie down, to dismiss her role of the anguished *artiste* as nothing more than an advanced case of "coo-cooitis," they also have individual wishes about escaping to someplace where they can be free of their nagging parents and resented siblings. As Kathy puts it in the opening verse of a song the children all sing together:

> Play nice, Kathy, Mama said,
> Or I'll punch your arm and bust your head.
> Play nice, Kathy, with your brother
> Or I'll break one leg and then the other.
> Play nice, Darling, play nice Dear,
> Be quiet, outside, over there.
> If I could wish one wish today
> I'd wish me very far away.

Each of the other children has his individual desire: Alligator would go "very far away" to "jungle swamps," "Tarzan land," where he would "bite [his] dopey sister's hand"; Johnny wants to find a desert island with "just one house up in a tree, a tiny place the size of me"; Pierre wishes he could

> hide inside [his] lion lair
> And think up good ideas in there,
> Like a jungle safari to Sheepshead Bay
> Just me and my lion so far away.

In part, what triggers these responses in the children, these reveries that are not articulated in the earlier versions of the Rosie story, is the collision of the children with the adult world. Though the parents are not physically present on stage, their off-stage voices frequently interrupt the play of the children, reminding the children and, by extension, the audience of how capricious and bullying the interference of these adult presences can be. Rosie is not allowed to finish her opening soliloquy before the abrasive voice of her mother slices through Rosie's meditation on the nature of art. Unlike the two earlier versions of Rosie, we really feel ourselves in a world, as Sendak described it, in which during the summer "you were never allowed to cross the street, walk in the gutter, or come upstairs except at mealtime or to go to the bathroom or to stop profuse bleeding. Food and other

necessaries were dropped out the window, and street fights were screechingly arbitrated by mamas in adjacent windows."[70] In the musical, Rosie's mother asks her to look after her little brother, Chicken Soup, a request that Rosie flatly refuses. "He's ruining my life," she complains and continues to debate the question with her mother:

> MOTHER: Rosie, why do you make trouble? Why can't you be like Chicken Soup? He makes no trouble.
> ROSIE: Yeah, he only makes me sick!
> MOTHER: Don't be smart!
> ROSIE: I can't help it!
> MOTHER: When your father comes home . . .
> ROSIE: He'll go straight to sleep like always.
> MOTHER: That's enough, big mouth! Take your brother downstairs like I told you—right now!
> ROSIE: No!
> MOTHER: Now!

In many ways this treatment of Rosie puts us palpably back in the Brooklyn of 1948 (or 1938), back to those Rosie notebooks that Sendak kept but that he clearly softened and sanitized for the book and animated film versions of Rosie's story. Here the children and their parents interact without a filter, in the unpolished, ethnic rhythms and idioms of Rosie's (and Sendak's own) actual childhood. Sendak's ability to portray the rough, shadowy places of childhood continued to develop in his art through the 1960s and 1970s; here that quality is again unmistakably and sometimes surprisingly present. After Rosie's mother insists that she take care of her brother, we hear a crash off stage, and Alligator, who will once more take his place on Rosie's stoop to perform his alphabet song in a few minutes, asks: "Is Chicken Soup dead now?"

This simple, uncensored remark sets the tone for much of the raucous give-and-take between Rosie and the other kids on the street during the course of the play. In this version Rosie has brought an imaginary reporter into the neighborhood to record the story of her life (as the real Rosie once told a friend that the young Sendak was doing while he was watching, writing, and sketching the children from his apartment window). True to form, the kids will not let her have the satisfaction of foisting off her fantasy on them—at least not without her having to work for it. They try to turn the tables of fantasy on her, but Rosie is more than a match and has the last word:

> ALLIGATOR: If Rosie's such a big shot, how come she's got a kid brother?
> KATHY: Dumb Alligator, who says she's a big shot?
> PIERRE: Rosie's a big nothing!
> ALLIGATOR: Yeah—let's make believe she's dead!
> KATHY: Yeah—let's make believe we can't even see her.

PIERRE: Yeah—like she's invisible!

JOHNNY: Creeps!

ROSIE: Oh, excuse me, Mr. Reporter—that was just a temporary indisposition in my private life. You know . . . the pain part. Even your best friends can give you a big pain.

Soon, though, the kids are asking Rosie if she has any ideas about what they can play, and soon Rosie has them involved, as in the animated film, in making "the movie of [her] life."

Sendak has developed the characters of the other children to a much greater extent in this version than he has in the earlier ones. In part this has to do with the simple fact that he has much more space to fill—a one-and-a-half-hour musical as opposed to a half-hour television program or a short book. But there is perhaps another reason why Sendak lengthens the parts given to the other children the way he has. In a sense all the children have become artists, or at least the producers of compelling fantasies. Their visions are continually in conflict with the dominating world of their parents and the harsh, dismissive, and, at times, troubling tone taken by the adults in their dealings with children. By creating these tensions between the kids and their parents, Sendak establishes a viable, credible context for the fantasies that Rosie and the other children have. By granting the other children their fantasies, he makes Rosie a representative figure rather than an isolated instance of the out-of-place child. Through her and the others we see that there is an artist in every child, though it is through Rosie that we see the flowering of the child in the artist. Her experience may be biting, absurd, frustrating, or funny, but it is because of this experience, and the fantasies that she builds from it, that the child becomes an artist and the artist maintains the child within. Her final fantasy, as Sendak stages it, is not merely a reprise of the *Chicken Soup with Rice* finale of the 1975 animated film, although both productions conclude with the same number.

While the film ultimately isolates Rosie, the musical ends on a note of tender reconciliation; Rosie has found her brother (who disappears early in the show), and she invents the closing fantasy for him—she makes it *his* big chance to shine in his audition for the imaginary producer.

It is a subtle shift of emphasis that dramatically broadens Rosie's archetypal role, in essence passing her artist/shaman's mantle on to him and, in effect, to the next generation of children waiting in the wings (and the audience) for their own star vehicle to transport them from the streets to the clouds.

JOHNNY, PIERRE, AND THE GANG

In a Nutshell

"... we only stand more revealed"
—Charles Olson

WHILE HIS HANDS DANCED like an orchestra conductor's, Sendak, in a recent interview, described with animated intensity the rhythms that he has tried to build into his picture books—the visual and, most especially, the verbal rhythms that will catch his readers up and "trap them" with the kinetic rush of words so that they "can't get out" of the experience.[1] The three books that Sendak had done on his own with the completion of *The Sign on Rosie's Door* (1960) had probed the intense inner lives of children and their highly charged domains of fantasy and physical play, but none of these works had swept the reader along with irresistible, memorizable, hummable syncopations or compelling cadences. *Kenny's Window, Very Far Away,* and *Rosie's Door* were unusual, authentically voiced, and, in their own way, bold, difficult books, but they did not disarm or charm. Years after writing them, Sendak characterized these works collectively as containing "completely idiosyncratic writing and idiosyncratic subject matter."[2] Ursula Nordstrom had been "encouraging me to write very uncommercial books," Sendak recalls. "She wanted me to be me; to become the artist she smelled in me."[3]

By now the bouquet was distinct: Sendak was certainly on his way to becoming, if he had not, in fact, already become, one of the preeminent interpreters of other people's words in American children's books. Take, for example, the projects that he was busy with from 1960 until 1962, the two years between *The Sign on*

Rosie's Door and the publication of *The Nutshell Library.* The same year that *Rosie* appeared, Sendak also completed the pictures for another of the acclaimed Little Bear books, *Little Bear's Friend,* by Else Minarik as part of a series of first readers that Nordstrom inaugurated at Harper & Row; this would be followed the next year by still another: *Little Bear's Visit* (1961). About this time Sendak was making his first ventures into material from the German Romantic movement of the eighteenth and early nineteenth century—a period that would figure decisively in his books of the 1970s and 1980s. Here his explorations took the form of illustrations for two fairy tales by Clemens Brentano: *The Tale of Gockel, Hinckel, and Gackeliah* (1961) and *Schoolmaster Whackwell's Wonderful Sons* (1962). Sendak had done the pictures for Janice May Udry's *The Moon Jumpers* in 1959; it was his first full-color picture book, an extension of the considerable experience he had already had with the black and white pictures that had become his trademark and the three-color process he had used in his own books up to this point. In 1962, Sendak published his second series of picture book illustrations for Charlotte Zolotow's *Mr. Rabbit and the Lovely Present*—an arresting combination of his own impressionistic watercolors and Zolotow's realistic text that won the book mention as a runner-up for the Caldecott Award in the same year (1962) that *The Nutshell Library* appeared.

But of the books that Sendak did during this period, perhaps the most important in terms of the advancement of his own work was the publication of his sixth book with Ruth Krauss, *Open House for Butterflies* (1960), a reprise of their earlier success with "first definitions" from *A Hole Is to Dig.* It contained such crucial, child-invented neologisms as "dogdog"—"a good word to know in case you see a dog and you see it in a looking glass too"—and observations about such objects of a child's world as the safety pin: "Pins never unfit you / you can wear them your whole life."[4] As with *A Hole Is to Dig,* the square pages of Sendak's pictures are choreographed with fine black and white, pen and ink drawings of children: children laughing and yowling, pouting and preening; a dozen (Fig. 39) are somersaulting through the air, having punched themselves in the nose ("A good thing to know is what a punch in / the nose feels like in case somebody asks / Do you want a punch in the nose?"); another dozen rest in the grass, contemplating Easter eggs ("Easter eggs are all different outside / but they're all alike inside").

Again these are Brooklyn kids, Rosie kids. They once more provided Sendak with the patterns for his children in *The Nutshell Library* and, several years later, for Max in *Where the Wild Things Are,* infusing these and other characters with that same spontaneous energy that had become Sendak's source of inspiration since his Brooklyn notebooks from the late 1940s. In *Open House for Butterflies,* one finds Sendak tuning up, experimenting with the prototypical boy—the juvenile hero with a thousand faces whom we meet as he bosses his baby sister around and hangs like a train conductor from the headboard of his bed, shouting "All Aboard!" and rattling the plaster in the house while his dog dives for cover (Figs. 40 a and b). On page after page a tousled, black-haired boy appears, the mercurial, "fantasy-plagued" child who will become one of Sendak's principal subjects. He

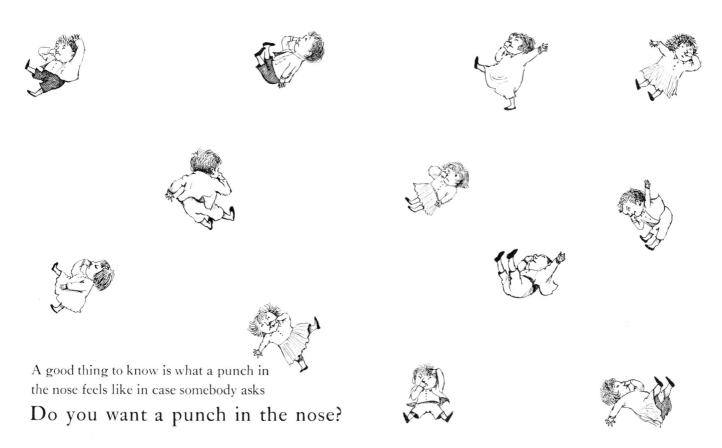

A good thing to know is what a punch in
the nose feels like in case somebody asks

Do you want a punch in the nose?

Fig. 39. A page of nose punchings, from *Open House for Butterflies* by Ruth Krauss

is bold, sassy, pugnacious one moment, and sweet, pensive, loving the next. But whatever his shifting temperament may be, he is thoroughly, topologically (to borrow the term of the Gestalt psychologist Kurt Lewin) at home in the "life space" of his environment.[5] This variety of mood and activity, explored from the child's perspective, had been one of the sympathetic bonds that connected Ruth Krauss's vision with Sendak's. Now, in 1961, Nordstrom was urging Sendak to build on the connection he had with the material that came directly from the experience and language of childhood by converting these affinities into his own original books.

In a speech given in the fall of 1991, Sendak reflected on what had been his own personal journey, beginning as "a terrified child, growing into a withdrawn, stammering boy who became an isolated, untrusting young man, a young man without a proper education."[6] As a developing artist he "depended upon instinct and self-education" and the solid advice of Ursula Nordstrom, who "welcomed us illiterates off the streets."[7] Sendak recalls having "clung like [a] barnacle" to Nordstrom, perhaps the greatest of "the great lady editors of those early publishing days, those grand, shrewd, ingenious misfits who made [Sendak and other artists] feel safe and at home in our new . . . cottage industry."[8] Sendak maintains that the absence of any programmatic training in his career had been a benefit in

I always go to bed
after my bedtime

A good way to get yourself to go to bed
is yell **All aboard for bed!**

When you're very very tired just
throw your tired away

Pink means nightie

Figs. 40 a and b. "All Aboard for Bed!" from *Open House for Butterflies* by Ruth Krauss

his own development, since he was not taught a particular style of illustration.

Nordstrom's insistence that he remain adaptable and receptive to the influence of the widest possible range of styles meant that Sendak had kept the channels open to writers and artists who were not currently in vogue and whose work might be in some way useful in his own approaches to challenging illustrative problems. He had done this with limited success in his 1959 illustrations for a group of Hans Christian Andersen stories (*Seven Tales by Hans Christian Andersen*), drawing on the two-dimensional conventions of medieval illustration. He leaped four or five hundred years toward the present for the radically different impressionism of the *Mr. Rabbit* pictures. In between, especially in his poignant portraits of Meindert de Jong's novels and the Little Bear books, he was returning frequently to the fine pen and ink pictures reminiscent of the engravings of the Black and White school of nineteenth-century English illustrators. He was doing, simply, "everything Ursula Nordstrom . . . threw [his] way." [9] Sendak continues:

She spoon-fed me. I had no taste. There was no way I could have had taste. You're not born with taste. You accumulate it. You learn it. So she taught me. If I wanted to do this, she'd say "No, you do that." And so my entire early backlist is superb, from the variety of things she made me do. Books that I thought were inappropriate for me she said were appropriate. . . . she taught me how to be an illustrator. I learned how to be a chameleon and change my emotional everything to suit the book I'm illustrating.[10]

In 1961, Nordstrom had proposed that Sendak do a series of "very little book[s]" that might somehow evoke, like his books with Ruth Krauss had, the refreshing immediacy and inventiveness of children's impressions of their world. But this was to be a solo flight for Sendak. Perhaps in response to the disappointing free-form of *The Sign on Rosie's Door,* Nordstrom had suggested a more carefully framed idea: a series of standard concept books that would be contained in the small size suggestive of the eighteenth- and nineteenth-century chapbooks that both Nordstrom and Sendak were interested in and that Sendak had begun to actively collect. The books would be both an homage to and a send-up of the forms, Sendak recalls, a group of experimental books that Nordstrom knew he was, in Sendak's words, becoming "good enough and smart enough and complicated enough" to do.[11] But what he came up with was, Nordstrom remembers, "more wonderful than anything we could have imagined."[12] In *The Nutshell Library* Sendak had begun to find the right voice to express those heretofore elusive rhythms of his own vision; with these four small volumes he sang.

At first glance, though, the boxed set of four books that appeared in 1962 does not seem very remarkable at all—certainly by today's standards of book production, but even within the context of those that were prevalent at the time. Each of the four small volumes—*Alligators All Around* (an alphabet), *Chicken Soup with Rice* (a book of the months), *One Was Johnny* (a counting book), and *Pierre* (a fable)—measured only about two and a half by three inches. Sendak's pen and ink drawings are washed with the same flat three colors of his earlier books—blue, yellow, red—and the drawings themselves are simplified almost to the point of austerity. At this time most writers and illustrators were looking for larger formats (as, say, Garth Williams was in his picture books) and more contemporary styles (as in the complex abstractions of Ezra Jack Keats and Leo Lionni), in keeping with the experimental, expansive, progressive tenor that was setting the tone for contemporary children's books. But, as he would do throughout his career, Sendak was busily looking back to historical precedents, to long-forgotten illustrators whose approaches he might "ransack" for his own purposes, to exhausted forms that he might reinvigorate in his own work.

Perhaps more than any other creator of children's books, Sendak has been subject to what Harold Bloom has called the "anxiety of influence," that powerful, conscious or unconscious, positive or negative pull that the works of others can exert on the creative process and that can lead to the total rejection of historical

precedents or, on the other extreme, to slavish imitation. Sendak, it seems, does not suffer from any worry about being influenced and thus losing his claims to originality; quite the contrary. He often insists that he is not an innovator but rather an obsessive borrower, a cobbler of a variety of styles and elements, a creator of pastiches made up of his eccentric, eclectic, autodidactic ramblings through the history of art and literature. He detested schools and never went on, beyond a few drawing classes, with formal art studies because of his deep, personal distrust of and antipathy for the restrictions of organized, institutionalized study. His voice still rises with anger when he describes being made to sit with folded hands in an elementary school auditorium while *Pinocchio* was read to the dutifully cowed student body.[13] Instead, he has continued to "revel in solitude," he told a group of graduating college students at the University of Connecticut in 1990, a vocation-launching style of introversion he feels that he acquired from his artistically inclined, bookish older sister and brother. "They taught me how to draw," Sendak recalls, and "to passionately devote my life to the arts."[14] But, he went on, "it was never perfect, it was never easy." Because of his antipathy for school, he explains, he "depended rather upon instinct and self-education, so I grew up, rough and ready, and have remained so. I don't particularly recommend the method, and yet it isn't all bad. It sharpened my wits and helped me define what success meant and looked like to me."[15]

These instincts, especially Sendak's fascination with the pure physical presence of books, are qualities he recalls vividly from early childhood, those first, primal steps that he took toward acquiring his taste for literature, when he would literally bury his nose in the smells of a book and sink his teeth into its pages. One of the biggest compliments Sendak recalls, with joking seriousness, having ever received from a young child reader of one of his own books was that the child picked up the book and started to eat it. Surely this sensory pleasure that Sendak has continued to associate with his experience of books was crucial to his decision concerning the tactile presence of *The Nutshell Library*.

The four volumes slide snugly together into a small box. They are light books; they fit a child's small hands and can be effortlessly, endlessly slipped into and out of their box. The box itself (Figs. 41 a and b) is decorated on the outside with proscenium arches (another variation of that window from his childhood) in which Sendak sets a number of the characters we will meet in the books: Pierre/Johnny, the lion from *Pierre,* the monkey from *One Was Johnny,* Papa Alligator who appears in *Alligators All Around.* All are reading books, an iconographic allusion Sendak is making (and will frequently return to throughout his books and poster art) to his own love of books and to the ultimate purpose and hoped-for effect of these and the other books that he creates. Jennie, Sendak's pet Sealyham terrier, is sitting below the stage, the audience for the play, as she was in reality the spectator for Sendak's creation of books. On the back cover of the box, another child (again, a version of Sendak's archetypal little boy, who is here bundled up with a stocking cap pulled down over his ears) is happily eating a bowl of soup—the chicken soup of *Chicken Soup with Rice,* of course, but also something that is

Figs. 41 a and b. Slipcase illustration for *The Nutshell Library*

metaphorically nourishing, as books are nourishing, satisfying. The equation between food for the body and food for the mind is direct and explicit. Each of the tableaux that decorate the surfaces of the box serves to generate a child's interest, their *trompe l'oeil* illusion opening up the contents rather than doing what boxes normally do—contain and thus limit. Instead, Sendak is pointing to the inner spaces that await the child within the proscenium pages of the books themselves.

He continues his puns and his allusive commentary on the borders of the box. The nut Sendak chooses for the box's principal ornament is, as one might imagine, the acorn—the royalty of seeds (Sendak even places a crown over a large acorn on the top panel of the box) from which not only "mighty oaks" but, by analogy, strong, sturdy people will grow. Oak branches and leaves are carved into the side pillars of the proscenium, just above the smiling block faces at the base of each column—references to the ornate stage architecture that Sendak grew up seeing in the old theaters in Brooklyn and elsewhere in the New York City area, as well as to the bordering devices of the nineteenth-century children's books Sendak had studied and collected during the 1950s. Sendak puts his own initials at the foot of the pillars; the conceit is, after all, his imaginary construct. Between the two solid pillars, underneath the carved lintel of the title, Sendak has tacked up a banner with his name printed on it—the current performance in this eternal theater of the imagination. This is all subtly done, in light browns and yellows, the boy's blue

suit, and a bit of pink for a book cover and the inside of the lion's ear. One almost doesn't notice this rich, evocative detail until you, the adult reader (the parent, the purchaser), watch, as I did, while my then four-year-old daughter lingered over this box, studying it, peering into it, turning it over and over slowly in her small hands for reading after reading after reading.

Once inside the box—that is, once one has drawn with the tips of her fingers one of the volumes from its home in the slipcase—one is surprised again. Though small, the volumes are made with absolute, respectful consideration: each is carefully bound in a light brown cloth, titled again, this time in dark brown ink on its spine, with a drawing of a cluster of acorns and oak leaves on the front cover, and provided with a dust jacket, each of which has another illustration on the front and a cluster of the same configuration of acorns and leaves on the back. As much as these may be lessons in a number of basic concepts—the alphabet, the first ten numbers, the months of the year, and the moral act of caring—they are also a lesson in the fine art of bookmaking. Every detail is scrupulously attended to: Sendak is obviously concerned with passing along his enthusiasm for well-made books and his joy of reading to another generation of readers.

Another aspect of Sendak's joy is nostalgic. He is asking the reader to reexperience the original magic of the miniature book that, in its earliest forms from the fifteenth century, as Susan Stewart points out, "speaks of infinite time, of the time of labor, lost in its multiplicity, and of the time of the world, collapsed within a minimum of physical space."[16] From its earliest efforts the miniature book was meant as an act of bookmaking virtuosity, and its first subjects included almanacs, calendars, and "small books of hours (measuring two square inches, set in gold, and worn suspended from the belt by a charm or rings) . . . made for the merchant princes of Florence and Venice who prized their gem-like, jewel-encrusted books like a contemporary child treasures hers, physically, as talisman to the body and emblem of the self . . . as an object of person."[17]

There is still more to this attention; it shows Sendak working to bring into complementary balance a series of tensions, opposing or competing forces that might otherwise seem incompatible, mutually exclusive, or irreconcilable. A recurrent and significant part of Sendak's aesthetic is to resolve these problems of form, style, and content artistically and, as we shall see with the psychological forces of *Where the Wild Things Are* and other later works, mythologically. *The Nutshell Library* would provide Sendak with the space to experiment with this complex physics of his imagination, successfully finding in its limitations exactly the formal equations that would allow him to finally solve the problem of the many disparate elements that are configured in his vision.

In the first book of the set, *Alligators All Around,* one can hear the dialogue between many of the tensions that keep "speaking" to each other throughout Sendak's work. Stopping at the book's frontispiece, initially it seems like the book is going to be a simple alphabet, here taught by an alligator mother (in a feathered hat and boa) and alligator father (in a bowler hat) to their alligator son (in his propeller beanie). The figures are drawn without elaboration and printed in flat,

pale blues and greens. But alligators are hardly what we think of as domestic creatures, and the unexpected sight of them on the first page, proudly promenading down the street to the tune of "A alligators all around" is at once awkward, comical, and somehow appropriate. They are Everyfamily, out for a Sunday stroll in the city on a fine spring day. Mom is decked out in her Easter bonnet, Dad in his new topcoat, and Junior in his prized hat (Fig. 42). Sendak plays with our expectations of at least some naturalistic touches; instead, these alligators behave precisely as humans do. With an alliterative text that echoes the sound of each letter, Sendak catches the family in action in the present participle: "bursting balloons," "catching colds," "getting giggles," and "making macaroni." The present tense of the book reminds one that letters (and the act of learning and using them) are a process for a young child, not a past accomplishment.

Junior (Sendak simply names him Alligator when he appears in both the film and musical *Really Rosie*) can be a brat: he willfully punctures balloons, scowls as he dries dishes ("D doing dishes"), and stumbles around in a stupor rather than resting ("N never napping"), brazenly pushes a little boy ("P pushing people"), and pitches a fit ("T throwing tantrums"). But he takes after his parents, whom he joins in horsing around ("F forever fooling"), enduring a migraine ("H having headaches"), engaging in an argument ("Q quite quarrelsome"), and joining in a final dance to close the book ("Z zippity zound!"). Sendak had drawn alligators for another book with Else Minarik, *No Fighting, No Biting!* (1958), in which two feuding alligator children provide a parallel, didactic plot for two squabbling human children who are meant to draw a lesson from the nearly lethal fable. But these had been realistically portrayed, albeit talking alligators, not the fully anthropomorphic amphibians that Sendak would invent for his own book.

It is an odd, nonsensical world that these characters occupy; they try on wigs, imitate Indians and lions, and stand on their heads. But they perform their daily duties as well as their absurd departures from the norm within the fixed, ritualized confines of a thin, bordering line that they never cross. Below these often daffy pictures (like the one for the letter "C" in which Sendak dresses the alligator child and one of his parents in slippers, robes, and scarves topped off by hot water bottles on their heads), Sendak juxtaposes the coolly detached, rational letters and words of the text: "catching colds." In this way Sendak contains and thus limits the eccentric departures of the alligators while at the same time making this spectrum of actions, from the bizarre and quirky to the mundane and predictable, all possible and credible. He even sneaks in the "subversive" notion, to borrow Alison Lurie's term, that the actions of children and adults can be treated with remarkably democratic equality.[18] There are surprisingly few distinctions made between the activities of adults and those of children, and those that do occur are physical rather than ideological, humorously ignoring rather than supporting stereotyped separations between child and adult.

Sendak's alphabet appeared a year before *Dr. Seuss's ABC* (1963), in which Seuss borrowed a similar alliterative effect (and animal) in his opening sequence about "Aunt Annie's alligator."[19] In keeping with his already well-established style,

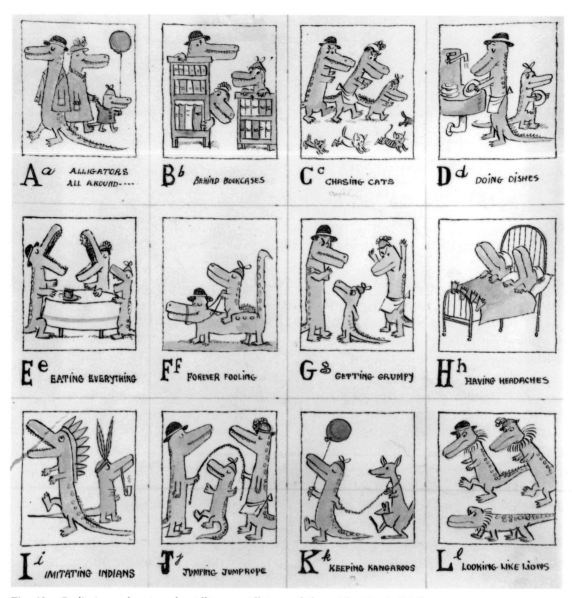

Fig. 42. Preliminary drawings for *Alligators All Around*, from *The Nutshell Library*

Seuss would explode conventional graphic restrictions on his page, opting instead for the distorted, elongated forms of hardly recognizable animals (his alligator, for instance, looks more like a bright green earthworm with feet and a tuft of hair on its head), in order to reestablish the world of fantastical nonsense as the credible reality of his book. While Sendak chose the intimacy and restraint of the small book, Seuss, on the other hand, as Twain might have put it, "spread himself" with a book nearly triple the size of Sendak's and one that verbally and graphically proclaimed its radical departure from the norm.

But if Seuss was prophetically anticipating the ideological breakdown of tradi-

tional forms and expectations in children's books that would take place in the increasingly hallucinogenic, liberated America of the 1960s and early 1970s, Sendak was looking over his shoulder, less dramatically perhaps, but no less prophetically in *The Nutshell Library*, back to forms of children's books that had reached their primes in the eighteenth and nineteenth centuries and were generally regarded as quaintly antiquated at the time Sendak was turning to them. There had been, to be sure, a continuity of interest in the novelty of small books in this century; take, for examples, Margaret Wise Brown's *Little Fur Family* (1946), which even came with a fuzzy cover; Hilda Scott's *The History of Tom Thumb* (1939); and Wanda Gág's graphically innovative *Happiwork Story Box* (1922–23) that told its tales on five successively smaller boxes that the child could fold and tuck inside one another. Perhaps the most famous small books of this century, Beatrix Potter's "little books," which included the classic *The Tale of Peter Rabbit*, had long been among Sendak's favorites, and he considered himself a "true, patriotic Potterite."[20]

But the real ancestral roots of *The Nutshell Library* in general and *Alligators All Around* in particular reached back to the chapbooks and other small volumes of the eighteenth and early nineteenth centuries, that first flowering of children's books, a period during which books were designed especially for the "instruction and amusement" of children rather than for mixed audiences consisting of children, adults, and "innocent readers"—those young adults who often used children's books as the starting point for learning how to read. Many of these chapbooks were even smaller than *The Nutshell Library* volumes, and most of them were inexpensively produced, quickly, if not crudely illustrated, and often full of that experimental energy that occurs before forms become fixed. During this period the emphasis in children's books still fell to a large extent on the didactic, on the adult perception that a children's book needed to edify and improve the character of the child. Both its size and price made the miniature book the perfect, "digestible" vehicle for a "linking of the aphoristic thinking of religious didacticism with the miniature book's materially compressed mode of presentation."[21] But in addition to the moral economy of the small book, it had also become possible, because of the educational theories of John Locke and the application of these ideas by the renowned English publisher John Newbery in such precedent-setting volumes as *The Little Pretty Pocket-Book* (1744), for a children's book to be a purely enjoyable experience. In essence, in the two hundred years between the colonization of New England and the early nineteenth century, the generic alphabet had moved from the grim, theological pronouncements of the Puritans' late seventeenth-century *New England Primer* that warned, after the letter "A," "In Adam's fall, we sinned all," to the free-wheeling fun of *Peter Piper's Practical Principles of Plain and Perfect Pronunciation* (1830) that began its "A" entry with the pomposity-deflating tongue twister "Andrew Airpump ask'd his Aunt her Ailment."[22]

Perhaps the most famous of all these early alphabets, and the one that most influenced Sendak in his, was the omnipresent *A Apple Pie* (also titled *The Tragical Death of an Apple Pie* and *The History of an Apple Pie*), which went through hundreds of editions in a wide variety of forms from the first reference to it in

1671 to its first printing in Mary Cooper's *The Child's New Play-thing* (1743) and its first American appearance in *Tom Thumb's Play Book* (1761) through the many editions produced during the nineteenth century.[23] Its text is skeletally simple, like Sendak's *Alligators,* as it follows the fateful course, traced in verbs, of an appetizingly large apple pie through its twenty-six adventures, as various children and young people "bit it," "eyed it," "gobbled it," "mourned for it," "peeped in it," "upset it," or "warbled for it."

By returning to this source and bringing it forward into the present as an influence for *Alligators All Around,* Sendak was establishing a pattern for the approach he would take later in most of his own books. He sought solutions for the unique creative problems each book posed (in this case, how to make such a clichéd form as an alphabet fresh again) by blending his own childhood as the primary starting point for his creative associations with material from the past: key works, authors, artists, forms, media, images, techniques, compositional structures. Without, of course, realizing that he was doing so, Sendak was tapping what contemporary cultural critics refer to as the *musée imaginaire,* which allows not only the artist but everyman ("thanks to color magazines, travel, and Kodak") to draw eclectically on "a plurality of other cultures," choosing what is valuable and valid rather than simply being "stuck with what they'd inherited."[24] His choice of the miniature book was "valuable and valid" because it offered Sendak the form in which he could, in Stewart's words, "[present] an infinite and fabulous world which had the capacity to absorb the child's sense of reality. The miniature . . . became the realm not of fact but of reverie. After the advent of romanticism, the miniature book frequently served as the realm of the cultural other."[25]

Sendak celebrated the cultural otherness of the miniature book's primary audience, the child, by freeing his book further from the static visual quality of these earlier alphabets. He amplified the uniqueness of his small books by giving *Alligators* and the other volumes of *The Nutshell Library* the energy of the flip books, in which one could fan the pages of a book with one's thumb and watch as the small drawings or photographs came to life. Crude as these were as works of animation, they nevertheless had fascinated Sendak and many other youngsters in the 1930s who were witnessing the phenomenal arrival of the perfected version of that art form in the nation's movie theaters. In his earliest filmed interview from 1967, Sendak explained how he attempted to translate into his pictures and their placement in these books the jerky, dancing movements of Charlie Chaplin movies and the early Disney cartoons—those works that had left such a lasting impression on him. *One Was Johnny,* the counting book in the series, would make this borrowed principle of illustration dramatically apparent.

Instead of shifting the scene of *One Was Johnny* as he had done in *Alligators,* Sendak keeps his focus tightly on the room of the little boy who emerges in this book and in *Pierre* as Sendak's generic male child. He is not what one would describe as a "sweet" child, though he has his moments; more than likely, though, one sees him in movement, in play, and often forcefully responding to the circumstances of his life. He also has his moods: he sulks, flies into rages, withdraws quite

happily (as he does in *One Was Johnny*) into his imagination where, as we will see as his character evolves into Max in *Where the Wild Things Are* and Mickey in *In the Night Kitchen*, he exercises a particularly powerful capacity for fantasy. He is a composite of many of the kids from many of the blocks in Sendak's childhood, and, of course, he is Sendak's personal projection into active line and color and language of his male child self. All of his children, Sendak tells us repeatedly, "are really me." Each is like some holographic piece of an ever-shifting, ever-evolving whole, personal and at the same time universal, archetypal. Though we have seen this child before, in the books with Ruth Krauss and as the focal character of *Kenny's Window* and *Very Far Away*, he has been affected by emotions and, essentially, without a basic story to tell. In *One Was Johnny* and *Pierre*, however, Sendak has begun to find other pieces of his story that would be successfully synthesized a year later in the clear, compelling narrative dynamics of *Where the Wild Things Are*.

In *One Was Johnny*, Sendak keeps our attention fixed on one spot, Johnny's room, the starting point for the flip book. On the dust jacket of the book Johnny is quietly, contentedly reading—as Sendak did as a child, as most children do (Fig. 43). What more could he want? The table on which he rests his elbow has a lamp, a bowl brimming with fruit. Underneath the table his faithful dog (Sendak's Jennie)

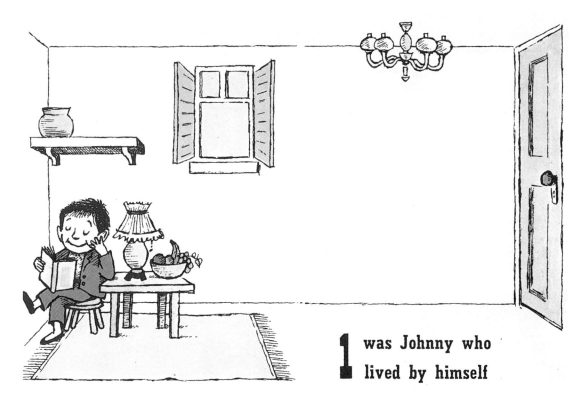

1 was Johnny who lived by himself

Fig. 43. Johnny reading, in *One Was Johnny*, from *The Nutshell Library*

patiently waits. This is his room, his space, his universe. Again Sendak encloses the circular forms of Johnny's head and body, the lamp, and the dog with a bordering square, thus forming a mandalla, that ancient symbol of perfect, harmonious unity. "One was Johnny," Sendak begins the book—a curiously inverted nineteenth-century construction that refers not only to Johnny's numerical value (the subtitle declares that this is, after all, "A Counting Book") but also to his basic completeness, his egocentric identity, his irreducible wholeness. In the last line of the book Sendak explains what we intuitively knew from the beginning: "One was Johnny who lived by himself and liked it like that."

By this point in his life (his early thirties), Sendak, too, had been living by himself for some time in Greenwich Village and "liked it like that." To be out of his parent's house and into his own had been one of his principal goals as a teenager. His autobiographical statements tell us that, because of his early childhood illnesses, he was often alone in his room, often left to his own imaginative devices while his brother and sister were at school or out playing, and one senses that Sendak learned early to prize this solitude and to resent intrusions on it. One certainly is aware of this self-protectiveness if one visits Sendak at his home in the country outside Ridgefield, Connecticut, where the phone answering machine is always on, carefully screening the dozens of calls he receives every day, and where he drives away the sound of these uninvited visitors with the music of Mozart and Hayden from his stereo if he is drawing, or with earplugs if he is writing, where he still manages his own business affairs without an agent or secretary, where, in essence, he continues to lead, as much as it is possible for him to do so with his demanding travel schedule, his own, grown-up version of the circumscribed, satisfied life of *One Was Johnny*.

Like the intrusions in Sendak's own life, which most readers can also identify in their own, the serene and simply furnished space of Johnny's room is incrementally filled with animals. The first to appear is a rat, who suddenly "jumped on his shelf." Sendak paints the creature yellow and gives it an absurdly long tail in order to soften the alarm that is automatically evoked by such a visitation; it certainly gets Johnny's and the reader's attention, interrupting the tranquility of the world that Sendak has established for Johnny on the opening page.

Each successive page quickly adds another intruder: a ferocious cat, claws out, leaps into the room through the window ("3 was a cat who chased the rat"). In the next cell of this minimovie, the door has opened and the white terrier (who wanders in and out of scenes in these four books like Jennie entering Sendak's studio as he was working on their pictures) has trooped in and calmly taken a seat on Johnny's rug. How she managed to reach the doorknob is anyone's guess, and Johnny, like the reader, is baffled. Now that the door is open, a turtle can crawl across the floor and "[bite] the dog's tail"; it has clearly taken a while for it to reach the dog, because the cat, who has been watching the show from its perch on the shelf, has begun to yawn. By the time another animal has entered ("6 was a monkey who brought in the mail"), Johnny is holding his head in utter helplessness. Then it gets worse: for "7," a blackbird, "[pecks] poor Johnny's nose"

while the monkey and his mail pouch take up residence in the chandelier. Then the progression becomes absurd: "8" brings "a tiger out selling old clothes," and "9" ushers in "a robber who took an old shoe." By the time Sendak has reached "10," Johnny's room has been completely overtaken by these characters who have entered from the "outside" world of fantasy, of unknown (and in their case unwelcome) possibilities.

At this midpoint in the cumulative rhyme, Sendak gives Johnny and the reader pause to reflect on the "puzzle" of number 10: "What should Johnny do?" (Fig. 44). The moment is a turning point for Sendak's development of his child characters: like Max in *Where the Wild Things Are* and like Mickey and Ida in their respective books, Johnny takes control of the fantasy. Since he has let these creatures in, so to speak, it must be within his power to make them leave: he exerts his own, fantasymaking will, and, on a pictureless, double-page spread that emphasizes the logical, narrative solution he has found, he announces:

> I'll start
> to count backwards
> and when
> I am through—
> if this house
> isn't empty
> I'll eat
> all of you!!!!

His threat—the same threat spoken the next year by Max, "the most wild thing of all" in *Where the Wild Things Are*—has a dramatic effect on Johnny's house guests. It is, after all, a fierce, aggressive response; and it is, of course, a psychologically appropriate one for someone who feels himself being overcome by events: he finds the strength to turn passive, puzzled victimization into an assertion of his own autonomy and power. Yet Sendak is imposing a conscious, adult realization on the story; in reality, children may often remain baffled by the impasse such circumstances bring on and could use a helpful suggestion or two. But Sendak doesn't introduce the patient, wise adult as the *deus ex machina* that will help the child out of his emotional jam. Instead, he credits the child with the capacity to discover the solution on his own—as Kenny, Martin, and Rosie all do. Sendak throws the child back on his own creative devices: if counting up to ten brings these unwished for troubles, then uncounting back to one will remove them. One by one, as Sendak lets the rhyme and thus the tension of the story unravel on their way back down to one, the animals retreat into the chaotic, irrational distances on the other side of what Yi-Fu Tuan calls in his study of space "the articulated world" of the house.[26] It is clearly a question of preserving one's boundaries— here the sacred precincts of a child's room—from being overwhelmed by these garbled, unsanctified forces that bring with them a number of the nagging anxieties, such as night fears, to intrude upon the child's otherwise tranquil, protected

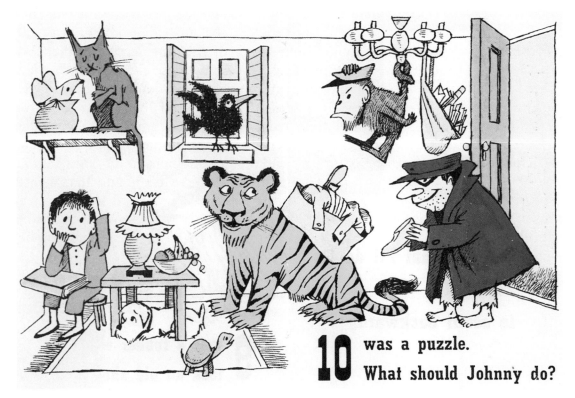

10 was a puzzle.
What should Johnny do?

Fig. 44. "10 was a puzzle," in *One Was Johnny,* from *The Nutshell Library*

environment. Clearly, too, the feelings of frustration and helplessness at the invasion of personal space is also a very adult theme, one that people continue to discuss well beyond childhood, as is witnessed by the attention Robert Bly, in his best-selling consideration of the mythic issues of manhood *Iron John,* pays to the need for men to develop a warrior spirit that is alert to these encroachments.[27]

While our own media are sensitized to and daily raise such psychological issues, it should be remembered that in the children's books of the early 1960s even a humorous, uncomplicated discussion of the sorts of emotional problems that Johnny engages in the book was virtually unheard of. And because Sendak places his psychological study of a young child dealing with the disruption of his world within the context of a counting book, this dimension of the book slipped by the contemporary reviewers unnoticed, unacknowledged. Once more Sendak plays off the unexpected against the predictable; his hilarious comic drawings are juxtaposed against a serious, emotional subtext; that most rational of activities, counting, is seen against the accumulation of increasingly irrational visual events. Taken as a whole, *One Was Johnny* is a microcosm and a mimetic conflation of all dramas, with its mounting pressures, climactic recognition, reversal, and, in this case, happy release. There is the very real sense that the book is taking place within the proscenium confines of a stage. A problem, an *agon,* has been presented and

solved, and harmony brought once more to this small piece of the world. Perhaps the least interesting function of *One Was Johnny* is its ability to provide an introduction to the first ten numbers. By fusing such elements as the traditional cumulative nursery rhyme (as in "The House That Jack Built") with his own personal concerns and the archetypal child he was drawing on to give a universal shape to these concerns, Sendak's counting book adds up to immeasurably more. He reached past the merely didactic and utilitarian to a reverberant dimension of possibilities that includes, along with its psychological mathematics, a metaphysical sense of mathematics itself—the kind of feeling about mathematics that leads many of its devoted practitioners to speak in aesthetic terms of the elegance of a particular equation and the beauty of a formula or topological form.

Chicken Soup with Rice, Sendak's "Book of Months," brought similar challenges to bear on the conventional notion of a child's calendar. While he offers many of the established images for characterizing a given month, Sendak also introduces into each an eccentric element: chicken soup with rice. January, for example, shows Sendak's prototypical little boy (it's Johnny again, though here he remains unnamed) "slipping on the sliding ice" on a country pond. He wears his usual blue coat and, for this frosty month, a scarf and cap. But instead of ice skating, his hands hold a soup bowl and are raised so that he can "sip hot chicken soup with rice." He is poised precariously on one blade while Sendak's text (which in ensuing months we discover is the voice of the child) sings the chorus:

> Sipping once
> sipping twice
> sipping chicken soup
> with rice.

In February, Sendak extends the incongruity: the little boy is celebrating his "snowman's anniversary," having brought his friend inside and sat it down at the table for the celebration (Fig. 45). When the boy announces their choices of party food ("with cake for him / and soup for me!") we realize that Sendak is asking his readers to accept the incredible—that a child would choose a bowl of soup over a piece of cake.

Sendak is, of course, presenting us with a competing idea of pleasure that stems from the generally European, Slavic, and, in terms of Sendak's own roots, the specifically Eastern European folk belief that soup (and, even more specifically, given Sendak's Jewish heritage, *chicken* soup) is the all-purpose, year-round provider of nutritional well-being and, ultimately, basic human contentment. For most of Sendak's American audience, which even by the 1960s had relegated the soup pot to the culinary scrap heap, Sendak's proposition that "all seasons of the year are nice for eating chicken soup with rice" would have been distinctly foreign—unless, of course, they happened to have, like Sendak did growing up, a grandmother, aunt, or neighbor (the Ida Perles to whom the book is dedicated) who always had a pot of soup simmering on the stove. Sendak would make this connec-

Fig. 45. Preliminary drawing for *Chicken Soup with Rice,* from
The Nutshell Library

tion to the soup of his own childhood even more palpable in the animated film version of *The Nutshell Library.* He sets the book like one of those 1930s Broadway movie musicals that had given him an equally important form of imaginative nourishment, and he offers the book as a series of tableaux in which Rosie and her friends sing and dance in "far off Spain or old Bombay," dive under the ocean ("the cool and fishy deep where chicken soup is selling cheap") (Fig. 46), paddle on Cleopatra's barge "down the chicken soupy Nile," and have a closing dance sequence, like one of Busby Berkeley's show-stopping, illusionistic finales, as pieces of a cooking pot on a giant stove top.

Sendak wins the reader over with the energetic resourcefulness of this unlikely fantasy; he asks the reader to spontaneously project himself into a series of animals and objects ("a robin lightly dressed," "a cooking pot," "a whale," a "baubled

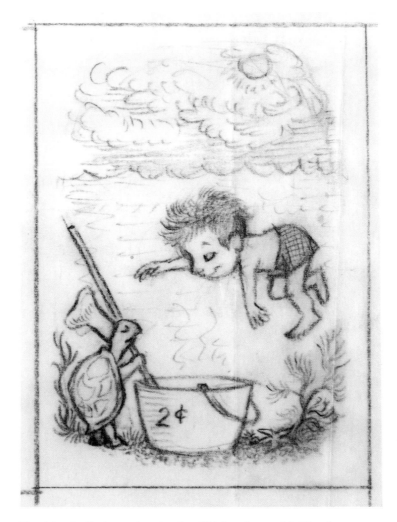

Fig. 46. Preliminary drawing for *Chicken Soup with Rice*, from *The Nutshell Library*

bangled Christmas tree"), and into a wide variety of situations (gardening, swimming, paddling, cooking, serving, eating). These transformations are extended over a global landscape and, from a young child's point of view, over a relatively long period of calendar time. Always there is soup within arm's reach, and, with one exception (March, when "the wind / blows down the door / and spills my soup / upon the floor") the results are blissfully, exotically happy (Fig. 47). But even the accident that occurs in March shows the reader just how powerful this brothy elixir can be; the wind (whose face reminds one of Ruskin's South West Wind Esquire from *The King of the Golden River*) "laps it up / and roars for more." To underscore the fabled, restorative qualities of chicken soup, the hero of the story notices in June that "a charming group / of roses all begin / to droop." By this midway point in the story, having made his fantasy plausible, Sendak has

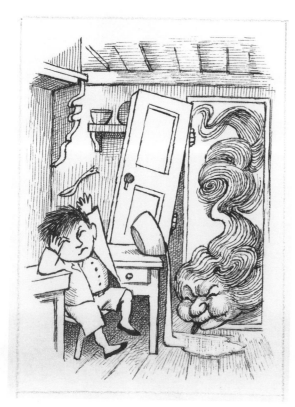

Fig. 47. "March," in *Chicken Soup with Rice,*
from *The Nutshell Library*

his character do the only possible thing that will save the plants: "[pep] them up /
with chicken soup!"

The making and eating in *Chicken Soup with Rice* is of the cooked, tamed,
civilized variety that bespeaks hearth and home with their ordered spaces; the
book is full of dining rooms and kitchens. It also celebrates carefully tended, tamed
vegetation; arbors, rose gardens, and vines used as bordering devices surround or
are featured prominently in a number of pictures. Sendak further includes such
ritualized events as Halloween, with its gifts of food (chicken soup, naturally) for
restless ancestral spirits. These scenes of domestic, cultural tranquility and order
are set in opposition to the raw, instinctive images of aggressive devouring that
occur in *One Was Johnny* and elsewhere with some frequency in Sendak's work,
especially in the last volume of *The Nutshell Library* quartet, *Pierre*.

Of all the volumes in the library *Pierre* tends to be the best remembered be-
cause, as readers have frequently told me in class discussions of the work, it "tells
a story." But not just any story. Like the others, *Pierre* is in verse; like the others,
Pierre is reminiscent of those archaic, didactic literary forms that even contempo-
rary young people are aware of, if only through the many versions of *Aesop's
Fables* that continue to remain in print, as well as through the parodies of these
forms that they have incorporated into their folklore (in skip-rope rhymes and
lampoons of adult speeches) or have seen in the fable parodies of the "Rocky and

Bullwinkle" television show, the verse of Shel Silverstein, and the books of Edward Gorey and Roald Dahl. Before any of these others had appeared on the scene, *Pierre* had gone to primary sources, drawing its rhetoric directly from the didactic chapbook. It puffs itself up with importance as it begins, in its hilariously brisk, attention-grabbing "Prologue":

> There once was a boy
> named Pierre
> who only would say,
> "I don't care!"
> Read his story,
> my friend,
> for you'll find
> at the end
> that a suitable
> moral lies there.

Here Sendak has found a dramatically accelerated rhythm that advances the story and places his audience immediately back in the world of the eighteenth-/ nineteenth-century cautionary tale, which he evokes with his exemplary "There once was a boy." But Sendak is already poking fun at this kind of discourse by the time he reaches *Pierre*—an unusual and, again, a foreign element to introduce in an American children's book. Sendak has said that he took this name from the title of the novel by one of his favorite writers, Herman Melville, but this allusion, of course, does not make the name any more familiar for an average audience. He further disturbs the serious rhetorical surface of the fable with the introduction of the boy's misdeed. Pierre's is not a major shortcoming, to be sure, not on the surface at least, like the famous, gruesomely rewarded carelessness of an early nineteenth-century child, George Manly, who "was thoughtless and giddy, [and] would run across streets when carriages were driving up at full speed, and often very narrowly escaped being run over" [28]; on the fateful day the story tells us about, George doesn't elude the traffic, is struck by a wagon, and loses his leg as a result of the accident. Indeed, Pierre's transgressions would have struck Sendak's contemporary readers as an utterly normal preoccupation for a younger child on his or her way to establishing a sense of personal, verbal, egocentric autonomy.

In the history of children's literature, there have been generations of other children who were allowed to blow themselves up with fireworks, drown in boating mishaps, or tumble to their deaths from rooftops—all for the moral and ethical edification of the young reader, who it was assumed required frequent reminders, if not bone-crushing chastenings, from friendly adults (the narrative tone that Sendak adopts in *Pierre*). By 1844, Heinrich Hoffmann was already lampooning the grotesque punishment that was so often meted out in moralistic tracts for young violators of household laws in his collection of seriocomic verse tales *Struwwelpeter;* Lewis Carroll would satirize the didactic poems of Isaac Watts's

Divine Songs for Children and Robert Southey's "The Old Man's Comforts and How He Gained Them," among others, in *Alice in Wonderland;* and writers like Mark Twain and Hilaire Belloc carried the satirical torch that exposed the exaggerations and distortions of the moralistic tale for children through the latter part of the nineteenth century and into our own. In *Pierre,* Sendak aligned himself with this "subversive" tradition and returned to the droll, dry, sly model provided by Belloc in his *Cautionary Tales for Children* (1908) and to one verse tale in particular, "Jim, Who Ran Away from His Nurse, and Was Eaten by a Lion." [29] Belloc even begins his story with a similar opening line: "There was a Boy whose name was Jim," from which he quickly, surely takes the story into the ridiculous:

> His Friends were very good to him.
> They gave him Tea, and Cakes, and Jam,
> And slices of delicious Ham,
> And Chocolate with pink inside,
> And little Tricycles to ride,
> And read him Stories through and through,
> And even took him to the Zoo.

The ravenous child finally meets his match when, at the zoo one day, having slipped the grip of his nurse, he meets a lion who has also escaped the supervision of his keeper. The lion leaps out of its cage "And hungrily began to eat / The Boy: beginning at his feet."

By the end of the poem, horrific though its contents may be (the lion devours the boy leaving only his head behind), Belloc has the reader howling with laughter, having described these terrible (and terribly absurd) events in clever, lilting verse. Take, for instance, how he asks the reader to identify with Jim's excruciating experience:

> Now just imagine how it feels
> When first your toes and then your heels,
> And then by gradual degrees,
> Your shins and ankles, calves and knees,
> Are slowly eaten, bit by bit.
> No wonder Jim detested it!

He then arrives at the story's moral, delivered in his best, mock-serious tone. His parents, the narrator explains with deadpan understatement:

> Were more Concerned than I can say:—
> His Mother, as she dried her eyes,
> Said, "Well—it gives me no surprise,
> He would not do as he was told!"
> His Father, who was self-controlled,

Bade all the children round attend
To James's miserable end,
And always keep ahold of Nurse
For fear of finding something worse.

Though *Pierre* seems to echo some essential elements from Belloc's text, Sendak gave this paradigmatic situation (of the child disobeying parental or other authoritarian codes of behavior and suffering grievous consequences) his own unique, psychologically informed spin. Beyond doing a send-up of the Victorian morality tale, Belloc's main interest did not lie in exploring the moral and ethical development of his main character. In fact, Belloc seems hardly to be concerned with children at all but rather with puncturing the hot air balloon of adult hypocrisy and with getting his audiences to laugh at the absurd ends to which cautionary tales can quite logically be taken. And that is surely enough. But in his own spoof of these juvenile morality plays Sendak was after a story that might take him closer to a child's experience.

To evoke this experience in the life of a child, Sendak begins at the place where so many first stories begin, with one of the most common acts of a child's day—waking up in the morning. Pierre has gotten up on the wrong side of the bed. While his mother tells him, sweetly, that he is a "darling boy" and her "only joy," Pierre—hair disheveled, eyes narrowed with irritation—snaps back, from the corner of his mouth, "I don't care!" (Fig. 48).

Children and adults alike can recall having had a day like this when, no matter

Fig. 48. From *Pierre*, in *The Nutshell Library*

how solicitous or sincere a parent or other loved one may be, the immediate response has been to swiftly and categorically reject the kindness and attention. Though intergenerational in its relevance, *Pierre* was founded in the facts of actual childhood. Specifically, Sendak was depicting the classic emotional mood swings of a five- or six-year-old who may be "brash and combative in some of his behavior, as though he were at war with himself and the world [and] at other times . . . hesitant, dawdling, indecisive; and then again over-demanding and explosive, with strangely contradictory spurts of affections and of antagonism."[30] This is a time, Arnold Gesell and Frances Ilg explain in their well-known text on child development, when the child is affected by "developmental duplicitness" that creates a "bipolarity" in his awareness, pushing him between extremes of expression. "He sidles up to his mother and says, 'I love you,' but in another breath he may say, 'I hate you, I'll hit you.'"[31] His "alternatives crowd upon him rather thickly. He is at a crossroads where he has to intermediate between contraries. When he does the wrong thing, he is called bad, but there is no use in asking him why he was bad; he has not yet made a clear distinction. He is not fully oriented. He is in new territory. He does not have command of his motor impulses nor of his interpersonal relationships."[32] Often he will simply send "verbal missiles of attack" flying at a teacher, a friend, a parent. These tend to be "short and terse," like "'I won't.' 'I'll scream,' 'I'll hit you.'"[33] Or, in the case of Sendak's Pierre, the rhyming chorus, "I don't care!"

In successive short chapters (it seems, in fact, hilarious to call them chapters until one remembers how Sendak validates and valorizes the "miniature" world of the young child's book), Pierre rejects his mother's attempts to bring him back from the contrary state he is in. Nothing works—not the food she tries to ply him with ("some lovely / cream of wheat"), her scolding ("Don't sit backwards / on your chair"; "you are acting / like a clown"), her appeal to his reasonableness (". . . we have / to go to town"), or even her subtle, psychological play on the anxiety or unhappiness he may feel by being left alone ("Don't you want / to come, my dear? . . . Would you rather / stay right here?"). Pierre's terse, uninflected reply is simply, boringly, agonizingly repetitious: "*I don't care!*" While aggressively contrary, there is not much anger in his stance; his wielding of power seems almost nonchalant, passive in its defiance. While his mother has grown increasingly irritated by his uncooperativeness (Sendak has even drawn her from the back with her hand on her hip, a sure sign of her impatience with his behavior), Pierre remains coolly disengaged (in the same picture he was wrapped himself in a table cloth, put his cereal bowl on his head as a helmet, and taken up a broom as his warrior's lance, thus making himself taller than his mother) (Fig. 49). He is ready to do battle if necessary, but somehow his closed eyes and relaxed mouth suggest that he already knows how she will handle this confrontation: she will give up the battle. And she does. On the very next page Sendak shows her walking away, her arms and legs akimbo. She strolls off the page leaving behind a houseful of unresolved tensions.

In the next chapter Pierre's father arrives and predictably tries a more direct, confrontational, masculine approach that is peppered with militaristic, patriarchal

Fig. 49. "You are acting like a clown," in *Pierre*, from *The Nutshell Library*

elements. At first he simply orders Pierre, who has been literally and figuratively turning things upside down (and is now doing a headstand on a chair), to "get off [his] head" or risk being "march[ed] . . . up to bed." But Pierre is not intimidated; he stays with his mood and in control of the situation. He talks to his father from his inverted position on the chair and again replies with his three-word chorus to his father's attempts to use logic on him ("I would think / that you could see . . . Your head is where / your feet should be"). Pierre has even begun to play within the context of his upside down position, doing a kind of dance in place while he continues to reject all his father's attempts to bring him right-side up and back to earth. Once again Pierre realizes that, in this particular game, he can hold out indefinitely and that even his father will give up. By the end of his attempt to manage Pierre, his father's hands are folded as he beseeches Pierre to let go of his contrary stance. In response to an interviewer's questions about Pierre's seemingly aloof, ineffective father, Sendak explained that with a child like Pierre "you don't get too personal with him. . . . If the father is distanced with him—the father has had to put up with a lot, and he's learned not to push this kid."[34]

Sendak had also moved from a playful and conscious engagement between Pierre and his father by making him simply acquiesce and quickly accept Pierre's mood. In an earlier draft of the story, Pierre's father teases the boy, knowing that he will not be able to offer the child anything that might persuade him. They have the following exchange:

Then his father said, Pierre,
I don't like this "I don't care."
Do you want to come to town with us?
I don't care!
We are going there by bus.
I don't care!
It will be a lot of fun!
I don't care!
You can eat a jelly bun.
I don't care!
I'll show you how the rabbit jumps.
I don't care!
I'll even let you catch the mumps.
I don't care!
Would you rather go outside + play?
I don't care!
Would you rather run away?[35]

To have given Pierre's father this ironic stance regarding Pierre's behavior would be to laugh at Pierre and thus invalidate and diminish Pierre's mood and the hold it has on both Pierre and his parents. Instead, Sendak credits the power of the emotion and grants Pierre his inflexible stubbornness. He'll need help soon enough, but for now Pierre is completely in charge. His parents "go to town" and leave Pierre alone with his emotions—as Max, Mickey, and Ida will all be isolated in later books. Again Sendak provides a flip-booklike repetition of the earlier scene of Pierre's mother's departure—this time, though, both parents are headed out of the book as though they, too, had read Gesell and Ilg and were aware that once a child in Pierre's stage of development "does make up his mind, rarely can anything make him change it, even on those occasions when he has made it up with relative ease."[36] In Pierre's case there is not a triggering event that causes his mood, as there would be for Max and, later, Mickey and Ida. He has simply been moving between, as Gesell and Ilg describe it, "sunshine and shadow" and found himself in the latter that morning. There is nothing left for him to do but to play the crisis through to the end, and that end quickly comes in the third chapter.

Here Sendak sets a more anxious tone ("Now, as the night / began to fall") and in the next line introduces a truly frightening element ("a hungry lion / paid a call"). At this point the confrontation has suddenly turned dangerous, and it would be an altogether terrifying encounter were it not for the "lightening" Sendak can give the mood through his verse, again playing disparate elements against one another. One might expect a "hungry lion" to simply pounce on the child (like the beast does in Belloc's "Jim"), but Sendak gives his lion a kind of awful grace and an intelligence. He is not simply an eating machine; instead, "He looked Pierre / right in the eye / and asked him / if he'd like to die." These are surprisingly funny lines, given the seriousness with which we treat subjects like death, particu-

larly with younger children. No doubt they were more unexpected and even shocking lines for the early 1960s, prior to the revolution in topics of children's books that would take place later in the decade and throughout the 1970s.[37] Pierre, of course, answers with the ultimate punch line that Sendak has set up with sixteen earlier "I don't cares!"

What follows, then, is not a terrifying chase around the house or a blood-curdling eating scene out of the Brothers Grimm but rather, of all things, a discussion between the lion and Pierre. We see that the lion is the embodiment of Pierre's own aggressiveness—the objective correlative of the internal state that is devouring the child—the great, hungry beast of Pierre's unconscious with all its unchecked, instinctive forces. The beast has grown ever more demanding because of Pierre's intransigence and, curiously, compensatorily, because of Pierre's lack of passion—by his fierce withdrawal and detachment from a consciousness that involves his parents in particular and social relationships in general.

Because the lion has sprung full-blown from Pierre's uncontrolled fantasy, it is all the more appropriate he should resemble, at least in his verbal mannerisms, Pierre's parents. Sendak goes so far as to draw the lion with a human face, and he is about the same size as Pierre's parents are in relation to the boy when they appear alone with him. Like Pierre's parents, the lion tries to be sensible and persuasive ("I can eat you, / don't you see?"). He tries to play on what he thinks might be Pierre's unacknowledged attachment to his parents and the isolation he would feel if he were separated from them. But these are arguments that will not work, so committed is Pierre to this course of action that he is willing to play it through to the absolute end. At one point Pierre even reclines against the lion's front leg, his feet crossed, one arm relaxed on his stomach, the other raised as he once again languidly pronounces his three words of dialogue. By the next page the lion has put his arm around Pierre's shoulder and sympathetically asked the boy for his permission to eat him. In the film version of the story from *Really Rosie*, Pierre cartwheels into the lion's open mouth; but in the original *Nutshell Library* book, Sendak leaves out this transitional action and simply gives us the result: a picture of the lion sitting on his hind legs, resting one paw on his now-bulging stomach and picking his teeth contentedly with the other (Fig. 50).

Pierre can find his way into the lion's belly; he can get himself trapped by his consuming emotions (Sendak himself has talked about the "outrageous rage" that he sometimes felt as a young man in his twenties when he was undergoing analysis), but he cannot get himself out alone. In a sense he has made himself sick on himself; his incapacitating stance toward his parents—the cool indifference that he has expressed for their every utterance and act of kindness—has rendered him devitalized. Literally, it has sent him (now contained within the form of that aggressiveness) to bed with a stomachache. When Pierre's parents arrive home and find "the lion sick in bed," they swing into action, doing what parents in reality and as psychological agents of a personality can and hopefully will do: they defend the person of the child even while they are confronting the result of his actions. This, despite his transgressions, despite his obstinacy, despite the fact that he was

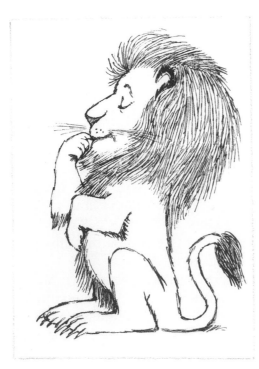

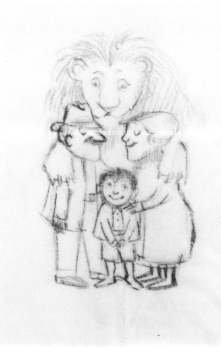

Fig. 50. The full lion, in *Pierre*, from *The Nutshell Library*

Fig. 51. The happy family and guest, preliminary drawing for *Pierre*, from *The Nutshell Library*

a beast only a few hours before. They know that Pierre is inside the now-woozy lion; they know that Pierre and the lion have even begun to speak the same line when the creature answers their demand to know the whereabouts of Pierre with Pierre's own three words.

The parents also do what they have not been able to do earlier, at least not until things reached this crisis—they go for help: they load the lion into the car and haul him off to the doctor. Sendak does not want to alarm his audience or unduly complicate the story, and so he makes this a standard emergency room procedure, as opposed to that of a visit to a psychiatric center or Lourdes. The attending physician treats the removal of Pierre as little more than standard procedure ("the doctor shook him/up and down. / And when the lion/gave a roar— / Pierre fell out/upon the floor"). Pierre has been reborn after his sojourn in the beast's belly, and he even has more than three words to say: "I am feeling fine, / please take me home, / it's half past nine." Though it may be nightfall, he is in the emotional sunlight again, the mood has passed, and he is ready to rejoin his family and civilization. Sendak does not let the story conclude without further emphasizing the normalcy of what has happened and the healing that has taken place; the lion even offers to take the family back home and, we learn, eventually "stayed on as a weekend guest" (Fig. 51). It is not merely a convenient "happy" ending but one that rings with deeper truth.

For basic to the situation of *Pierre* is the problem of transformation, of moving the dark, shadow child through an experience that will somehow yield the lesson that Sendak has promised in the opening lines of the book. Of course, Sendak could decide not to end his fable with a moral, but that would violate the form he has chosen to work with and, in fact, negate the tensions that he wishes to create by playing off and with that form. We have already seen in his earlier books how Sendak has defended the inherent integrity of a child's emotional life by not subordinating it to the authority of parents or other figures of authority. Yet Pierre has openly, consistently flouted those reasonable demands of authority; how, then, can Sendak let him get away with his stubborn resistance and still arrive at a "moral" ending?

Rather than putting Pierre through some forbidding, realistic danger that will literally scare the child into good behavior, Sendak proposes instead a psychological transformation, the kind of alteration that can take place in fantasy. Interestingly, Sendak represents Pierre's transformation in images that are uncannily close to those used by the early precursors of depth psychology, the alchemical philosophers of the sixteenth and seventeenth centuries, to embody in allegorical terms the passage of the youthful, heroic spirit into more substantial, material realms. They chose as their symbols for expressing this union of opposites the images of the sun, the vessel of airy spirit being devoured by the ancient lion of instinct and the material world. The king-father of beasts, in short, devoured the son's sun. The metaphoric "death" that follows, Jung explains, "represents the completion of the spirit's descent into matter"(Figs. 52 and 53).[38] After spending his requisite time in the belly of the beast, Pierre, like Jonah, Jason, and other heroes, is reborn; and like these heroes, he brings with this return back into the world a reconciliation of opposing forces, a renewal of life.

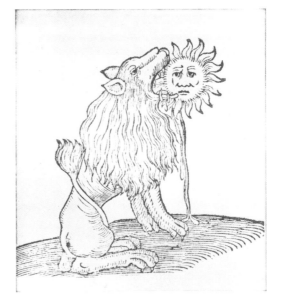

Fig. 52. A lion devours the sun, in a sixteenth-century alchemical drawing

Fig. 53. The king father devours his son, from the seventeenth-century alchemical treatise *Musaeum hermeticum*

However, the descent of the hero into the unknown, lionlike matter of the unconscious is, Jung cautions,

> a delicate and dangerous matter. By descending into the unconscious, the conscious mind puts itself in a perilous position, for it is apparently extinguishing itself. It is the situation of the primitive hero who is devoured by the dragon. Since all this means a diminution or extinction of consciousness, . . . an equivalent to that "peril of the soul" which is primitive man's greatest dread, the deliberate and indeed wanton provocation of this state is a sacrilege or breach of taboo attended by the severest punishments.[39]

Pierre has certainly "provoked" this state he is in, and he has violated cultural taboos against the annihilation of self (consciousness). To get out of the lion's stomach and complete his "rebirth," therefore, Pierre needs some sort of "divine" intervention, as does the mythological hero or the allegorical figure of alchemical invention. This initially takes the form of the intercession that his worried parents can provide and then the wisdom that the physician brings to his treatment of Pierre's problem—just as Jason needs Athena's help, and especially her potion, to be disgorged from the dragon's belly (Fig. 54). The journey down into the unconscious is usually, however, worth the effort and the danger; for like other, older heroes, Pierre also brings back a treasure in his victory over death and with it union

with those forces that had seemed irreconcilable: the male and female opposites represented by his parents, the parent-child opposition embodied in their conflict, and the necessary balance between conscious and unconscious aspects of a personality. "Caring," the moral of the story, becomes possible only when one has experienced and is aware of experiencing "not caring" to its debilitating, consuming conclusion, a state in which one is essentially rendered dead to the world.

In the end, as we can see in the last picture of the book, Sendak returns a changed Pierre to a world that has been restored to balance and harmony between parents and child. To accomplish this unification of opposites, Sendak seems to be saying, it is not necessary to try to reach for a "moral" that will kill off that deep, rich source of ancient energy that resides in the lionlike depths of the unconscious. In fact, this final configuration of forces (Pierre, his mother and father, and the lion) underscores just how related these elements are and will remain. Once more Sendak shows us the child, that agent of future change—like Blake's child in the cloud—here riding atop the lion's head, leading them on with a joyful wave of his arms.

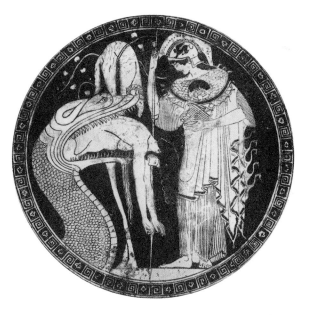

Fig. 54. The dragon disgorges Jason, on an Attic vase painting, fifth century B.C.

Pierre's is one small victory, one solution to that perennial problem of the child being confronted and overwhelmed by psychological forces that he cannot always control. As we have seen, Johnny's response to being overrun by his unwelcomed visitors was cleverly to uncount them—to say the spell in reverse. Johnny does not get farther than the egocentric one that he was when the book began; but, then, the problem that he has been set does not have to reach the larger, transformational resolution that Pierre is called upon to discover.

That larger form of solution took the form of myth in *Where the Wild Things Are* and was just a year away for Sendak. But he might not have found such a bold answer were it not for *The Nutshell Library* which had helped him to finally move beyond the extended, overly talkative, wandering actions of his first three books to the compressed, taut allusiveness of these four small volumes. They were, in some respects, a historical stocktaking, a search for voice in the controlled, retrospective form of the miniature. But they were also a coiling inward to locate that gemlike essence of plot that would give spring to the leap that Sendak was about to make into the miniature's opposite—the large and the new.

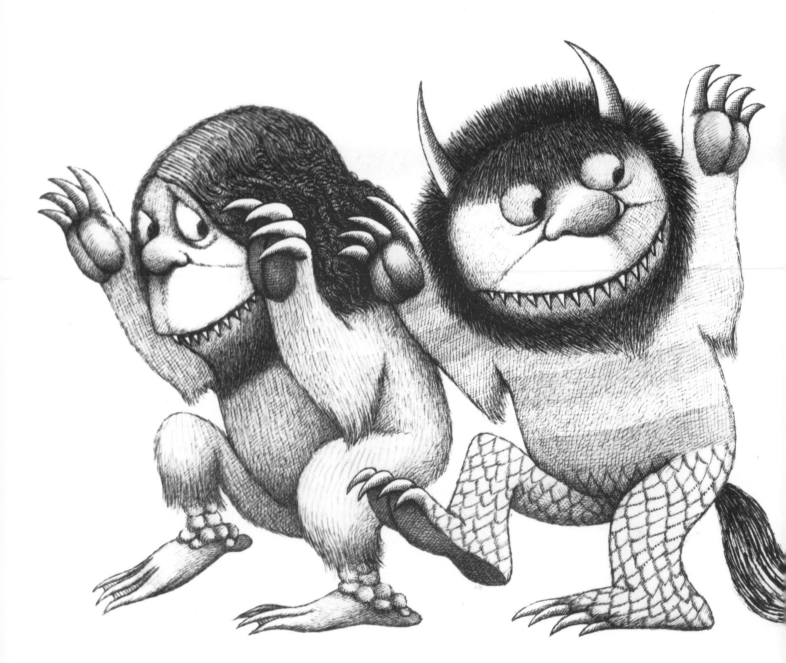

MAX, WILD THINGS, AND THE SHADOWS OF CHILDHOOD

> The great fantasies, myths, and tales are indeed like
> dreams: they speak from the unconscious to the
> unconscious, in the language of the unconscious—
> symbol and archetype. Though they use words, they
> work the way music does: they short-circuit verbal
> reasoning, and go straight to the thoughts that lie too
> deep to utter.
>
> --—Ursula Le Guin

ON THE FINAL VERSION OF SENDAK'S manuscript for *Where the Wild Things Are*, Ursula Nordstrom asked Sendak to please "bear with" her "last few questions" about the text. It was the late summer of 1963 and she wrote to Sendak as their deadline for publication was fast approaching, playfully addressing "Maurice, or Max, or whoever you are" and announcing: "This is going to be a magnificent, permanent, perfect book." [1] She underscored "permanent" with two emphatic lines. Her remarks could not have been more prophetic.

A few months after it was published, *Where the Wild Things Are* won the American Library Association's Caldecott Medal for the best picture

book of the year, a fact that virtually guaranteed its longevity on library and book-store shelves across the country. Even though "I had been around for over a decade, working very hard," Sendak later explained, with the success of *Where the Wild Things Are* "suddenly I was a star on the firmament."[2] Over the next twenty-five years, the book has gone on to sell millions of copies in more than a dozen languages and to leave a lasting mark on contemporary children's literature. The noted children's book editor Michael di Capua, for one, observed that *Where the Wild Things Are* "turned the entire tide of what is acceptable, of what it is possible to put in a children's book illustration."[3] Or, he might have added, in children's books as a whole.

Dramatically and irrevocably, *Where the Wild Things Are* opened up the fantasies of the young child and let the monsters out. In doing so it cast shadows over the "calm and sunny picture of childhood" that the American picture book at that time was trying to project.[4] With regard to the conventions of children's books, *Where the Wild Things Are* crossed a number of unmarked but nevertheless carefully tended boundaries. Most strikingly, it broke a taboo against the expression of the powerful emotions of childhood—whether they were explosions of anger or sudden journeys into fantasy—that were normally kept far away from the pages of the picture book. Such forays into the domain of the child's emotional life were meant to be more restrained, less intense than the experience Sendak had created, and more like the quiet play that involves the child of *The Snowy Day* by Ezra Jack Keats, which had won the Caldecott Award a year earlier than *Where the Wild Things Are*. Only a few months before *Where the Wild Things Are* appeared, one commentator complained that American children's books seemed unable to revise their well-worn formulas that churned out "uniform" books that "strike an average quality which precludes their ever being excellent, eccentric, or bold."[5] Into this well-mannered world where, as Jason Epstein put it, "good bunnies always obey" Sendak introduced Max, whose vital urges made him neither stereotypically good nor obedient, as the hero of a book that was neither timid nor ordinary.[6]

It is perhaps difficult for us to imagine today the full significance that *Where the Wild Things Are* must have had on this world and these assumptions, but an analogy from another art form offers this perspective: the arrival of *Where the Wild Things Are* was the aesthetic equivalent for the picture book that the famous 1913 premier of Igor Stravinsky's *The Rite of Spring* was for modern music—electrifying, controversial, precedent setting—a point of departure from which there could really be no easy return to the same old forms and subjects. The spirit of the times and the creative spirit of the artist were in complete harmony, and together they produced a work that challenged its readers and other creators of picture books to fundamentally change. *Where the Wild Things Are* may not have provoked literal riots in bookstores or libraries, but it certainly generated the major debate about the content of children's books during the 1960s, resulting in a shift in our thinking and a revision of our expectations concerning this art form.

Much as his work was concerned with expressing forcefully a deeply felt personal perspective about childhood, Sendak had not set out with the conscious

intent of revolutionizing the aesthetic of the picture book. In fact, in interviews Sendak often downplays or even rejects his role as an innovator of the picture book, referring to himself instead as a kind of "tailor" whose creative process is one of merely stitching together into a book a variety of borrowed design or narrative elements. A few years after *Where the Wild Things Are* appeared, Sendak said the book had a "more myself look" than any of his previous books—a comment not only on the quality of the book's art but on the book's content, both of which were bound to upset the sensibilities of the status quo. Artists whose works challenge the norm and demand a "revolution in style," as Anthony Storr points out in *The Dynamics of Creation,* frequently meet with a resistance that is as strong as the "aggression" of the force of the vision that produced it.[7] It is perhaps not at all surprising, then, that there should have been such a strong and sustained reaction to the innovations of *Where the Wild Things Are.* As Alison Lurie reminds us, "most of the lasting works of juvenile literature," among which she includes *Where the Wild Things Are,* "are thoroughly subversive in one way or another: they express feelings not generally approved of or even recognized by grown-ups; they make fun of honored figures and piously held beliefs; and they view social pretenses with clear-eyed directness, remarking—as in Andersen's famous tale— that the emperor has no clothes."[8]

Among the many comments about the book, one critic called the story "pointless and confusing," while another warned that "it is not a book to be left where a sensitive child may come upon it at twilight."[9] Alice Dalgiesh argued that "the book has disturbing possibilities for the child who does not need this catharsis" and asked about Max's fantasy, "Is anyone ever really in charge of a nightmare?"[10] The question about the capacity of the book to frighten children, in fact, has followed it since its appearance. Ten years after its publication, and after the wide-ranging social upheavals of the 1960s and early 1970s, the subject came up again as a matter for discussion at the 1976 conference of the Children's Literature Association when a packed special session was devoted to the "disturbing possibilities" of the book and the animated film that had been made from it in 1973. Nordstrom seems to have anticipated at least some of this response and may have been trying to brace Sendak for what was to come when she wrote him, prior to the book's release, that "it is always the adults we have to contend with—most children under the age of ten will react creatively to the best work of a truly creative person. But too often the adults sift their reactions to creative picture books through their own adult experience."[11]

Nordstrom was certainly right. The most vehement attack on the book was launched by the child psychiatrist Bruno Bettelheim who, in his regular column for *The Ladies' Home Journal,* accused Sendak of having written a dangerously flawed book because he "failed to understand . . . the incredible fear it evokes in the child to be sent to bed without supper . . . by the first and foremost giver of food and security—his mother."[12] It had been a curious public position for Bettelheim to take since he had only heard about and had not actually read Sendak's book at the time he wrote the article. Bettelheim revised his opinion a decade later

in his own book about the fairy tale, *The Uses of Enchantment* (1974). With regard to the monsters that children encounter in fairy tales and in their psychological development (the same monsters that had troubled him when Max summoned them up in *Where the Wild Things Are*), Bettelheim now wrote that adults should not try to censor the kinds of monsters children might meet because such intervention shields a child from his necessary confrontations with "the monster a child knows best and is most concerned with: the monster he feels or fears himself to be, and which also sometimes persecutes him. By keeping this monster within the child unspoken of, hidden in his unconscious, adults prevent the child from spinning fantasies around it in the image of the fairy tales he knows." [13]

In contrast to Bettelheim and others, the majority of critical voices had applauded the arrival of *Where the Wild Things Are* and Sendak's emergence as a major force on the children's book scene, among them Brian O'Doherty, the art critic for the *New York Times* at the time when *Where the Wild Things Are* appeared. O'Doherty was quick to recognize Sendak's unique ability to create works that might serve as "a corrective to the many published sins of adulthood against childhood—the sops, the cozy insults, the condescensions. He knows that children live in wonder, a state that opens them nakedly to joy, desire, and a world full of sudden and fearful possibilities" (Fig. 55). [14] This capacity for distilling those volatile components of the child's psyche led O'Doherty to characterize Sendak as "a young alchemist" who was experimenting with elements from "the earliest self." O'Doherty would later extend his praise by declaring the positive value of the very thing for which some had criticized Sendak, for "restoring" in *Wild Things* "the majestic sense of fright and its magical control that have been streamlined out of children's literature." [15]

Time and the vast majority of Sendak's readers have borne out O'Doherty's assessment of Sendak's talents and the significance of one important dimension of his work: rather than a rejection of the kind of fantasy that Sendak proposed in the book, the response has been generally the opposite, and the impact of *Where the Wild Things Are* has been as pervasive and persistent as Nordstrom predicted it would be. To take just one example of this impact, the monster fantasy has virtually become a subgenre in the contemporary picture book. Every year dozens of books use the monster as a metaphor for a child's fears, those creatures of his own invention that he finds in those threatening places of daily life, in the closet or under the bed, lurking outside in the dark or inhabiting the back corner of a dream. The influence of *Where the Wild Things Are* has crossed over into other media as well: Jim Henson's popular Muppets, for example, were directly inspired by Sendak's original characters, and the comedian Howie Mandel bases one of his signature sketches on the going-to-bed monologues of a mischievous, anxious little boy named Bobby. [16]

The spirit of *Where the Wild Things Are* has been "quoted" in some unexpected places, from popular rock songs to novels like William Goldman's *Brothers,* which tries to soften one of its pulpier moments by comparing a monstrous turn in the plot to a "Sendak vision, scary yes, but with a comic intelligence enlightening it

Fig. 55. Preliminary cover design for *Where the Wild Things Are*

all." [17] There have been parodies of *Where the Wild Things Are,* the most notorious of which transformed Max's monsters into a motorcycle gang and Max's meeting with them into a sordid, grisly event. [18] And there have been implicit and explicit homages, like the film *Wild Thing* (1986), in which a Tarzan-like young man (abandoned as a baby and growing up wild in the jungle of an American city) defeats the drug-dealing, Uzi-toting monsters who prey upon that world. Children on *Thirtysomething,* a popular television series of the late 1980s, not only read Sendak's books but one episode follows the problems of a boy who is adjusting to his parents' separation and trying to cope with the night fears that this dislocation has caused. With his mother's help the boy invents a fantasy in an attempt to work through these emotional difficulties. Like Max's, his bedroom becomes a forest that contains a monster—a creature that combines a number of the features of the Wild Things—that the child must face if he is to put his feelings to rest.

These references, allusions, and appropriations suggest the extent to which *Where the Wild Things Are* has passed from the tangible form of a book with its particular audience to the extraliterary forms of popular culture and the un-restricted, "cross-over" audience of the oral tradition. In this regard, *Where the*

Wild Things Are has been a subtle presence for the two generations of children and parents who have read and reread it. Even though some of his readers may not be able to recall Sendak's name or even the title of the book, they vividly and instantly remember the story and the effects it had and continues to have on them. In conversations I have had with dozens of young people who have never taken a children's literature course, and are thus unaware of Sendak's canonical status within the field, they have informed me that they were "just like" Max when they were children and that the book left a lasting impression on them. These confessions have occurred too often to be accidental, and, although anecdotal, they nevertheless serve to confirm the fact that *Where the Wild Things Are* has become something more than simply a very popular children's book. It has become, in fact, part of the collective memory that Carl Kerényi refers to as a "living mythology"— a complexly interwoven, constantly changing cycle of stories that sustains and replenishes the reservoir of a culture's beliefs. For the society that creates them, these myths "form the ground or foundation of the world, since everything rests on them." They provide a culture with its fundamental meanings, with permanent points of reference that, despite surface or even formal changes, "remain ageless, inexhaustible, invincible in timeless primordiality, in a past that proves imperishable because of its eternally repeated rebirths."[19] It is, finally, on this mythic ground that we can begin to fathom the full importance of *Where the Wild Things Are* and its animating hero, Max. Swept forward on the rhythms of the book like a diminutive Nijinsky, the archetypal child of Sendak's imagination becomes an empowered hero making his first full journey in Sendak's work to contend with the shadowy forces of the unconscious. In the process, his adventure has become one of the compelling myths of modern childhood.

The contemporary discourse concerning myth is vast and at times contradictory, and it is not the intent of this study to try to mediate between the spectrum of divergent perspectives on this subject.[20] Instead, my interest is in applying to Sendak's work a familiar idea of myth as an especially significant story that provides "the themes that have supported human life, built civilizations, informed religions over the millennia" because of its capacity to address our "deep inner problems, inner mysteries, inner thresholds of passage."[21] Myths are not only about origins or primordial creation, they are narratives that offer, for commentators on myth as diverse as Joseph Campbell, Claude Lévi-Strauss, and Roland Barthes, "messages" about how to resolve life's puzzling, conflicting, emotionally charged experiences. James Oliver Robinson summarizes:

> Very often, the problem being "solved" by a myth is a contradiction or a paradox, something which is beyond the power of reason or rational logic to resolve. But the telling of the story, or the re-creation of a vivid and familiar image which is part of a myth, carries with it—for those who are accustomed to the myth, those who believe it—a satisfying sense that the contradiction has been resolved, the elements of the paradox have been reconciled. Dramatic retelling provides catharsis, as Aristotle pointed out

about tragedy, which the audience—the participants in the myth—takes to be an explanation, a structured understanding, of the original problem.[22]

As Barbara Bader points out in her discussion of *Where the Wild Things Are,* myths are "a metaphorical statement of the truth,"[23] and like other metaphorical constructions, they make intuitive, extralogical connections to reveal those truths using the "special kind of imagination" that belongs to fantasy.[24] For an artist and his society, myths are the "non-rational, often irrational, embodiment of their experience as a people, upon which they depend as much for their vision and their motivation as they do on their formal ideologies and their rational analyses and histories."[25] The "special kind of logic" of fantasy that informs myth can also "explain the world" and thus help shape our understanding of it.[26]

In all of his works, but particularly in the three works that Sendak would later come to think of as his picture book trilogy (*Where the Wild Things Are, In the Night Kitchen,* and *Outside Over There*), Sendak has explored the capacity of the child to make those myths that help him to "defeat" the dose of "boredom, fear, pain, and anxiety" that he experiences daily. Sendak believes that in *Where the Wild Things Are* he "finally came to grips with" this "broad theme" of his work and found a way to express the "constant miracle" of the child's emotional survival.[27] To make that "miracle" happen Sendak sought a mythopoetic solution that replaced the authority of "daylight," Apollonian morality, with the nocturnal, primitive, Dionysian logic of fantasy—the means of thinking that children actually make use of in order to represent their experience. Like Blake's reaction to the rationalism that he believed only succeeded in producing "mind-forg'd manacles," Sendak was also concerned with a solution that would free the psyche and thus the child's spirit not only "to make it through a day . . . and manage to come to grips with the realities of their lives" but also to "find joy."[28]

On its most immediate level, the myth of *Where the Wild Things Are* is about seeking a solution to one of those everyday problems. Max, the five- or six-year-old hero of the book, is having quite a night of it, a point that is driven home to the reader in the first illustration of the book. Sendak shows Max hammering a spike into the wall, cracking the plaster and pushing the reader's eye irresistibly onto the next page to follow the course of his mischief through the house. In the second illustration, Max threatens the family dog with a fork, chasing it back to the left-hand margin of the picture, holding the reader's attention there to reflect on the extent of Max's "mischief" (Fig. 56). Sendak even dresses him in a wolf suit to serve as an objective correlative of Max's frenzied, uninhibited mood. He is full of himself, driven on by his own instincts, even more animal than an animal: in short, he is a perfect "little monster." A picture that Sendak did not include in the book takes the point even further; in it, he drew Max up on all fours on the dining room table, slurping spaghetti from a plate, to the horror of the family cat and dog (Fig. 57).[29]

Yet despite the apparent horrors that Max is in the process of committing, he is not an abnormal child. Indeed, many of the qualities that he displays in the book

Fig. 56. Max making "mischief of one kind," in *Where the Wild Things Are*

could be drawn directly from the profile of the "affective attitudes" of an average six-year-old that Arnold Gesell and Frances Ilg outlined in their classic text, *Child Development*. Among the characteristics for the typical six-year-old, they list the following:

> Highly emotional. Marked disequilibrium between child and others.
> Expansive and undifferentiated. Good or bad; sweet or horrid; adoring or cruel.
> He knows "everything": boasts, brags.
> Likes praise and approval; resents correction and is easily hurt by a cross word.
> Loves or hates mother.
> Rapidly explosive with crying, strikes out physically or verbally, or has temper tantrums.
> Quarrelsome, argumentative, explosive, rebellious, rude, "fresh," stubborn, brash.
> Noisy, boisterous and easily excitable.

Silly, giggling, grimacing, showing off.
Resents direction, but is also over-conforming.
Domineers, blames and criticises others, alibis.
Glowers and glows; has fire or twinkle in his eye.
At times angelic, generous, companionable. . . .
Uses language aggressively: calls names, threatens, contradicts, argues,
uses mild profanity.[30]

No wonder, given the volatile nature of these normal emotional drives, that
they would lead Max on a collision course with his mother, that he would chal-
lenge and threaten her, and that she would need to take measures to stop his in-
creasingly aggressive behavior. She tries verbal chiding, and when Max escalates
the battle, he forces her into the more drastic action of banishing him to his room.
Sendak was drawn to this drama not because it was extraordinary but rather
because it was such a familiar domestic cycle of events; much as it may not have
been a subject that was brought up in the polite world of children's books, it was,
Sendak insists, a scene

Fig. 57. Another kind of mischief, preliminary drawing for *Where the Wild Things Are*

I've seen in my head a million times—the conflict of the child and his mother, not out of mis-love but out of mis-timing. She is in a bad mood at a moment when he is high and mischievous. . . . Max says, "Catch me, Catch me!" But he says it in a rage, and were she not in a rage—they're both in a rage—she could hear that, and she would hug him. Instead, she hears it as yet another demand on her time when she's cleaning, and she says, "Get off! I don't have time for you!" That's when he assaults her, not because he's so highly in a temper tantrum, but because he is so desperately hurt that she doesn't hear his real message. Now I find that very moving because I think that the conflict between parents and children often is that of mis-hearing because of change of mood or temper at the moment. The reason all is peaceful and tranquil at the end is that they have always loved each other—that's no problem. If only they could have paused at that critical moment . . . but then there wouldn't have been a book or an opera![31]

When Sendak had re-created *Where the Wild Things Are* as an opera in 1985, he introduced Max's mother, who is absent from the book, as a tangible, visible participant in the drama. He also returned to his own childhood memories for a scene that was comparable in its emotional intensity to Max's explosion at his mother. "I was never as brave as he was," Sendak claims. But his mother did occasionally call him the Yiddish equivalent of "Wild Thing" (*Vilda Chaiah*), and Sendak did have moments when, like Max, he was thoroughly upset. For Sendak those regular cataclysms hit when his mother brought out the vacuum cleaner, and he would be so upset that he would have to be sent to the neighbors until she was done. In the opera he included both the machine and Mama to spark the child's tantrum.

Along with these there had been other moments of mistiming between Sendak and his mother. Sadie Sendak had a "gruff, abrupt manner" that led Sendak to think that "any display of feeling embarrassed her." But at other times, Sendak vividly recalls how she would awkwardly try to show her affection for him. She would suddenly yell "Whooooot!" when she came into her son's room. Sendak would be taken completely by surprise: "I'd be lying in bed and I'd yell, 'Why'd you do that?' I'd be angry with her, and she'd be hurt. Or she would come in and start tickling my feet. Now I'm very ticklish and I couldn't stand it. I'd scream until she stopped. It was her constant pain not to understand why I didn't realize she was being affectionate."[32] In one of his best known fantasy sketches from the 1950s, Sendak probed this primal moment of "mis-timing" with a baby that goes on a series of hair-raising adventures only to return to its mother safe and sound. Instead of hugging the baby, the mother expresses her worry through anger and spanks the child who, in turn, ventilates his sense of injustice and rage by shooting the mother (Fig. 58).

This anonymous infant's anger is final and total, but Max's struggle with his mother and the central dilemma that *Where the Wild Things Are* introduces is a more difficult one because it does not end with the bang of a single or simple wish-

Fig. 58. Baby in a rage, from *Fantasy Sketches*

fulfilling act of vengeance. Max is, in fact, in the midst of one of those basic "crises" that, Erik Erikson argues, we all pass through at regular stages in our lives, from infancy to old age; these crises affect the psychological relationships between ourselves, those close to us, and the larger society of which we are a part.[33] Max is poised between his own wild declarations of independence and autonomy and the very real fact of his continuing emotional dependence of the adults around him—especially his parents and particularly his mother. It is a basic problem for a child to express those volatile emotions that are part of an emerging self when to do so threatens to fracture the very bonds of love that he wishes to preserve and upon which he relies. How can the child take charge of these enormous internal forces that make him an "emotional powerhouse" and still maintain his connections to an orderly, secure, domestic world?[34] How can he honor the validity of his emotions when these same emotions are bound to be defeated by the demands of the adult world and his own evolving psyche, which has already begun to internalize and identify with the values of his parents? For the child it is to live a paradox, a Zen koan that demands that he let go while he continues to hold on.

In his acceptance speech for the Caldecott Award, Sendak focused on this problem and the need of the child to invent a host of "necessary games" in order

> to combat an awful fact of childhood: the fact of their vulnerability to fear, anger, hate, frustration—all the emotions that are an ordinary part of their lives and that they can perceive only as ungovernable and dangerous forces. To master these forces, children turn to fantasy: that imagined world where disturbing emotional situations are solved to their satisfaction. Through fantasy, Max, the hero of my book, discharges his anger against his mother, and returns to the real world sleepy, hungry, and at peace with himself.[35]

This solution allows Max a "wild rumpus"—a complete, pre-Oedipal submersion in the child's ecstatic eroticism in which he satisfies his libido's wish to dance with the overpowering beasts of his own creation and to be acknowledged by them as "the most wild thing of all." The importance of this climax is obvious by the weight that Sendak gives it: four double-page, wordless spreads that reach into the nonverbal immediacy of music and dance for their meaning. The compelling, incremental rhythms of the text, the slow opening of the cinematographic "iris" that allows the pictures to get larger and larger until their restraining borders have disappeared altogether and they merge with the reader's world—all build to this primal, orgiastic moment when the child's deepest hungers can be satisfied.

Having reached this place, it seems like the most natural, inevitable end to these events, and Sendak has prepared us so well for it that we find ourselves providing, with our own internal orchestra, the rhythms, the mental "sounds" to accompany the visual rhythms that Sendak has "scored" in his pictures. These are full, forte pictures that insist urgently on their tempo: the large feet of the monsters are setting the beat, making the jungle floor vibrate; the repeated full circles of

their heads, the moon, the half circles of their claws are echoing light (Color Plate 2). In the original illustrations, one can see how Sendak uses white paint to accent these lines to give them a clarity like high violin notes—in contrast to the dark forms of their bodies and the strong, surging lines of their limbs. Against the background of dark browns, greens, and blues, Max stands out in his white suit, the conductor, composer, and chief soloist of this music, leading the ensemble of monsters through these howling, swinging themes and variations of the "rumpus" pictures to the coda of their final, triumphal march. Even with the improved quality of the recent edition of *Where the Wild Things Are* the "aura of the original," to borrow Walter Benjamin's phrase, eludes any printing process. After years of reproductions in books and posters, one gets used to their fuzzy and broken lines, their strangely muted colors, their awkwardly cropped borders. But the originals are another matter: sharp, vibrant, verdant. Put simply, they move; they are alive with a bright, fresh energy and one looks at them open-mouthed.[36]

Having allowed him to go there, Sendak also gives Max the power to make the decision to return from his fantasy without guilt or the need for apologies. The point is not didactic, lesson-driven: good bunnies and good boys do not always obey, and even if they don't there is still a place, an emotional haven, to come back to where, as Sendak puts it, "someone loved him best of all" and the food that nourishes both body and soul is cooked, not raw. The result of weathering this crisis, from an Eriksonian perspective, is the development of the child's ability to practice "self-observation, self-guidance, and self-punishment."[37] True to this model, Max becomes aware of his spent emotions, determines to return home, and sends the Wild Things (those parts of his own libido) off to bed without their suppers. Given the choice, he tucks them back into that region of his own unconscious—a place he has visited before and will no doubt return to again—and comes back to the conscious, "daylight" world of structures and containers.

What Sendak is tracing in the microcosm of Max's experience is the larger process of ego-formation: the slow evolution of consciousness in which the individual, beginning in childhood, starts to make those choices that define him, those things that will become his "I," and those that will be returned to the "not-I," the unacknowledged, rejected, or repressed psychic material that makes up that guardian of the unconscious, the shadow—the first aspect of the unconscious that we confront as we begin the lifelong process of integration, of becoming conscious of the unconscious. Ursula Le Guin describes this archetypal symbol:

> The shadow is on the other side of our psyche, the dark brother of the conscious mind. It is Cain, Caliban, Frankenstein's monster, Mr. Hyde. It is Vergil who guided Dante through hell, Gilgamesh's friend Enkidu, Frodo's enemy Gollum. It is the Doppelgänger. It is Mowgli's Grey Brother; the werewolf; the wolf, the bear, the tiger of a thousand folktales; it is the serpent, Lucifer. The shadow stands on the threshold between the conscious and the unconscious mind, and we meet it in our dreams, as sister, brother, friend, beast, monster, enemy, guide. It is all that we don't want to, can't

admit into our conscious self, all the qualities and tendencies within us which we have repressed, denied, or not used.[38]

Max is still too young to recognize that the monsters are projections of himself and thus to make the moral decisions and conscious admissions that are necessary for the shadow to be "admitted" and absorbed into the conscious sense of self. These are the tasks of the adolescent and, with increasing urgency, the adult. But Max has had a first, dramatic encounter with these forces that are "not simply evil" but

> inferior, primitive, awkward, animallike, childlike; powerful, vital, spontaneous. It's not weak and decent . . . it's dark and hairy and unseemly; but, without it, the person is nothing. What is a body that casts no shadow? Nothing, a formlessness, two-dimensional, a comic-strip character. The person who denies his own profound relationship with evil denies his own reality.[39]

And, in his own unspoken way, Max accepts the reality of the shadow and the unconscious in the form of the monsters and their jungle habitat. Sendak's story goes far beyond Dr. Seuss's walk on the child's dark, wild side in *The Cat in the Hat*. Sendak makes explicit what Seuss had left ambiguous in the chaos the cat brings into the world of the two children he visits in the story. Clearly, the cat is their vision, and yet the children remain strangely detached from the cat's anarchic antics; indeed, they try to prevent them. In the end Seuss offers an unnecessary dilemma: Should children acknowledge such fantasies to their parents or keep them secret? Seuss's rhetorical question assumes that parents will either be upset by such a revelation or that they simply will fail to understand the psychogeography of the place where their children have been.

Sendak let the cat out of the bag; but he, too, was aware of the risks involved with this exposure of the facts of fantasy. He carefully modulates this first encounter with these forces, which initially can be so frightening to the young child and, by extension, may cause such uneasiness for the parents who will often be the first readers of this book to their children. He does this, in part, through graphic signs and cues, as Perry Nodelman has pointed out.[40] The unconscious and its symbol, night, which were so powerfully amplified in the opening sections of the book and registered so forcefully in the central "wild rumpus," are carefully framed by the window in the final picture of Max's bedroom. The "chaotic" vegetation has given way to the linear forms of the furniture, the rug, the room itself; and the whole is surrounded by the wide white border, which lets the reader pull back with Max from the experience and rejoin the conscious, known world of orderly routines and predictable rituals, like eating supper or reading bedtime stories. The last five words of the story ("and it was still hot") appear on a page without any illustrations at all, as though light had suddenly flooded the rooms of both Max and the reader. The dark, fevered dream is over.

As has been suggested earlier in the form of the criticism that was raised concerning the book, the events that Sendak explores in *Where the Wild Things Are* are potentially frightening to children. The story does involve some common fears that for children at this age are expressed in dreams of wild animals, fears of being devoured, or the nearly universal anxiety of children that parents might not be there when the child returns home from school or an overnight with a friend or, in the case of Max, from his transporting fantasy. To reconcile the oppositions that lead to this uneasiness, Sendak deliberately makes Max's adventure as safe an experience as possible. On the cover of the book, before the child even reaches the story itself, Sendak shows a sleeping Wild Thing and nudges the reader to ask if such a creature can be very dangerous, especially one that seems to be wearing an animal suit over his human form like a Halloween costume (we see his large, human feet sticking out from the fur). The title page shows Max at the peak of his monster-taming form, taking care of these creatures with dispatch, as he will do again later in the book. Thumbtacked to the wall in Max's house, in the second picture of the story, Sendak includes a portrait of a monster we will meet later in the book; it has been drawn by Max, further proof that he is thoroughly in charge and has already imagined what we are about to see with him. Sendak is giving the child control of the darkness, thus relinquishing the advantage of suspense in exchange for familiarity, deflating possible fears so that the control of these emotions is clearly possible and expected. No doubt Max will be more than a match for the Wild Things' "terrible roars" and "terrible teeth." Max knows the "magic trick" that enables him to "tame them"; it is a ritual he has practiced before. He has made up that charm, too. After all, it is *his* fantasy, his way of coping, his own myth.

As much as the myth of *Where the Wild Things Are* reassures the child reader that the monsters are tameable through the imagination, and that someone will still love you even if you behave like a beast, it is also reminding the adult reader who may be uncomfortable in the presence of a child's fantasies—the adult who equates monsters with a form of hallucinatory madness, or dismisses them as an escapist means for dealing with substantive emotional realities—that children do return from these experiences intact. They survive otherwise overpowering moments because of their ability to step into fantasy, creating scenarios that compensate for their lack of physical or verbal defenses against the realities of the world they share with adults, freely imagining "invisible" companions and helpers to keep them company on these demanding excursions. In fact, Sendak shows us that children come back restored (Fig. 59). Myths can cure.

During the 1950s, Sendak became extremely interested in the healing power of fantasy and in the myths that it produces. Dealing with his own anger had been one of the factors that led Sendak into psychoanalysis and to experiment with variations on that emotional theme in both of his early books, *Kenny's Window* and *Very Far Away*. Sendak explained to an interviewer that the former had been "about the *outrageous* rage that you inflict on inanimate objects because you don't dare inflict it on your parents or siblings."[41] In *Very Far Away*, Sendak brings the

Fig. 59. Max's return, from *Where the Wild Things Are*

target of Martin's anger into somewhat clearer focus, and he finds a shape for the narrative in an emotional crisis leading to a fantasy that solves the child's problem sufficiently so that he can return to his other world. At that time Sendak was working through his own problems; and, he confesses, he was less concerned in his writing with letting his audience of children know that "it's okay to have these feelings" than with performing "an act of exorcism, an act of finding solutions so that I could have peace of mind and be an artist and function in the world as a human being and a man."[42]

While some of those feelings of anger, irritation, and ambivalence that Sendak had to "exorcise" had to do with his mother, many of Sendak's references to his father are similarly tinged with uncertainties. For Sendak the difficulty lay in the fact that his father "very much wanted to lead what so many immigrants wanted to lead, which was a very typical American life, do everything American as quickly as possible and forget all the hardship of the life he left."[43] Philip Sendak had run away from home to follow a young woman, with whom he was in love, to America, but he and his own father were never reconciled about his having left the family behind in Poland. Sendak thinks that his father "felt his punishment was his children because we were, as he kept saying ad nauseum, unAmerican children. . . . the kind of children . . . he could have had 'back there' because we read and we drew and . . . were not healthy and sound."[44]

In the end Sendak feels that he "went into analysis in order to work better, and it did unblock me creatively."[45] He describes himself as emerging from his analysis as "a green recruit fresh from the analyst's couch" who dismissed "any work that failed to announce its Freudian allegiance."[46] Fortunately, though, Sendak did not take to heart Freud's judgment of the artist (who "like any other unsatisfied man . . . turns away from reality and transfers all his interest, and his libido too, to the wishful constructions of his life of phantasy, whence the path might lead to neurosis") and try to curb or cure such urges in his life.[47] On the contrary, there seems to have been for Sendak a number of fundamental recognitions about the nature of fantasy in the processes of creation, healing, and artistic growth. As Anthony Storr points out in his study of the relationship between creativity and depression in *Churchill's Black Dog, Kafka's Mice, and Other Phenomena of the Human Mind,*

> the three activities, play, fantasy, and dreaming, which Freud linked together as escapist or hallucinatory, can equally well be regarded as adaptive; as attempts to come to terms with reality, rather than to escape from it; as ways of selecting from, and making new combinations out of, our experience of both the external world and the inner world of the psyche. None of these activities is as far removed from "thinking" as they appeared to him; and, as we have seen, Freud considered that a principal function of thinking was to master the material of the external world psychically.[48]

One of the ways that Sendak found for beginning the process of this "un-

blocking" and "making new combinations" was through the fantasy sketches that he began in the mid-1950s. These exercises provide the earliest version of *Where the Wild Things Are,* a thin dummy with only a very few words that he drew sometime during November of 1955 entitled *Where the Wild Horses Are.*[49] At the time a "favorite occupation" was "sitting in front of the record player as though possessed by a dybbuk, and allowing the music to provoke an automatic, stream-of-consciousness kind of drawing" (Fig. 60).[50] It was a way for Sendak to begin to experiment with texts for his own books, allowing his own childhood fantasies to be "reactivated by the music and explored uninhibitedly by the pen."[51] As a child, music had been, Sendak recalls, "the inevitable, animating accompaniment to the make-believe. No childhood fantasy of mine was complete without the ceaseless sound of impromptu humming, the din of unconscious music-making that conjured up just the right fantastical atmosphere."[52] Music would remain Sendak's orphic conduit to the sources of his creative energy, vitally important to his later works like *Outside Over There* and *Dear Mili,* but no less important in the 1950s.

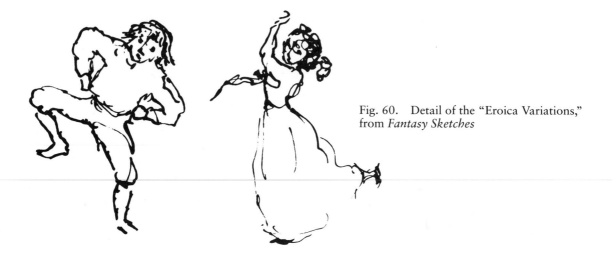

Fig. 60. Detail of the "Eroica Variations," from *Fantasy Sketches*

We do not know exactly what piece of music Sendak may have been listening to when he drew *Where the Wild Horses Are.* Nearly thirty years later, after this draft of the story had become *Where the Wild Things Are* and this book, in its turn, had been revised again as an opera libretto and set to music by the English composer Oliver Knussen, it reverberated with the shimmering, dark tones of nineteenth- and early twentieth-century Franco-Russian music: Mussorgsky, Tchaikovsky, Stravinsky, Ravel, Prokofiev. But there is none of that orchestral complexity in the earliest version of *Where the Wild Things Are. Where the Wild Horses Are* is a much simpler, quieter treatment, almost a piano étude for one hand, done in the quick lines of the fantasy sketches from the same period—a sequence of tiny drawings, much like the cells of an animated movie. This "cartoon" tells the story of a boy's adventures as he goes off in search of wild horses one day. He sneaks up on them, though signs warn him to stay away, only to be thrown out of his clothes by the horses. Naked, he is chased by four creatures (the

first glimpse we have of the Wild Things), and eventually he winds up in water and hauls himself aboard a boat that takes him to an island where he finds a wife and child waiting for him. He has grown up during his journey, and in the end he settles down to a quiet life with his nuclear family.

Many of the elements that would later appear in *Where the Wild Things Are* are present, but one essential ingredient is not: a plot with its accompanying dramatic tensions. The fantasy is unmotivated: no compelling reasons require that the unnamed child of this first draft embark on his journey in the first place. When Sendak took up the *Wild Horses* idea again in April 1963, he had to wrestle with the same problem, the need for a central conflict to justify the story. This time he began with a rush of images and events that are joined to one another less by any organic or aesthetic relationship than by a series of loose, free-associational connections:

> Once a small boy asked where the wild horses are.
> Most people said there was no such place.
> An old man said he'd been there but had forgotten.
> And one person said, "Go fly a kite."
> That seemed simple enough. So he did. He flew a kite and later the kite flew him. It flew him into the very middle of the sky, where, not at all to his surprise, he saw many kites flying many people.
> "Are you all flying to Where the Wild Horses Are?" he asked.
> "Not at all," said an old man, "I am flying to where probably everything will be all right."
> "Where is that?" asked the boy.
> "At the back of the world," said the man.
> "And I," said a girl who carried a small brown suitcase, "am flying where white is the color of everything."
> "Where is that?" asked the boy.
> "A little above and to the left of the moon," she answered.
> "Can anyone tell me where the wild horses are?" the boy asked.
> "Go jump in the lake," answered someone.
> That seemed simple enough. Far below him was a perfect jumping in lake. So he did.[53]

After a few more pages, Sendak gave up the story, leaving it with the note to himself that "the story bogs," losing its "'picture' book quality + gets too literary—so back to the 1955 picture version." Then he reminded himself about keeping the story "simple" and "humorous" and the "allegory in control." Already, though, Sendak was thinking about the circular quality of the story and the possibility of having his boy grow old on his journey, like Mossy in George MacDonald's *The Golden Key*, and ultimately to become a baby again, like Stockton's Bee-Man of Orn. But perhaps the most important awareness Sendak came to was to "think of [the writing] more in terms of being a 'libretto' for the pictures—some-

thing that is shaped for the pictures + comes to life *thru* the pics. but is in itself quite perfect + sound."[54]

Selma Lanes notes that in *Where the Wild Things Are* "all refinement in his illustrations move toward simplification."[55] This is equally if not more true of the story itself. Throughout the spring and summer of 1963, Sendak revised the narrative, working it from a complicated and overwritten story and closer to a finished text that is compressed, taut, devoid of any extraneous detail. The "pretty boat with sails" that the hero finds in a draft from 7 May 1963 becomes, simply, "a boat" in the final version; there is no mention in the completed story of "the flowered rug" in the boy's room; gone is the elaboration that the Wild Things, once tamed, taught the boy "how to fly by moonlight + ride on the back of the biggest fish in the sea + how to call long distance + dance to the music of the wind in the trees." In the end these things are left unsaid in Sendak's spare text.

Recently Sendak described *Where the Wild Things Are* as "too simple"; however, this unencumbered directness also made the story richly suggestive. Sendak's relatively unspecific text leaves openings for both the illustrations and the reader's imagination to fill. His choice of a name for his hero reflects this process of evocation through condensation. Sendak began to give his protagonist names like Kenny and Johnny, but he finally settled on the less familiar, more European name of Max. But "Max" carries with it other intimations—of a "maximum" child—earthy, strong, and as the Latin roots of the prefix tell us, "the greatest," a central meaning that led the American poet Charles Olson to appropriate an ancient version of the name for the mythic persona of his epic *Maximus Poems,* the first volume of which came out just a few years before *Where the Wild Things Are* and began:

> Off-shore, by islands hidden in the blood
> jewels & miracles, I, Maximus
> a metal hot from boiling water, tell you
> what is a lance, who obeys the figures of
> the present dance.[56]

In the operatic version of *Where the Wild Things Are,* Sendak has his character proclaim in his opening aria: "I'm Max! M-A-X the wolf! Watch out! A king! The wild Wolf-king of everything!" (Fig. 61).[57]

As mythographers have pointed out, most myths are relative to a particular time and culture—even, as we'll see later with Sendak's *In the Night Kitchen,* to a particular geographic location. One of the basic functions of myth is to address the pressing issues of a culture and through the power of its narrative to create "life models" and an inherent system of values, an "ethos," that is, as Campbell and others remind us, "appropriate to the time in which [we] are living."[58] Myths, in short, have historical reasons to be. Thus, if Sendak had written *Where the Wild Things Are* several decades earlier, it might have taken the didactic turn of Colette's libretto for Maurice Ravel's 1925 opera, *L'Enfant et les sortileges,* that other story

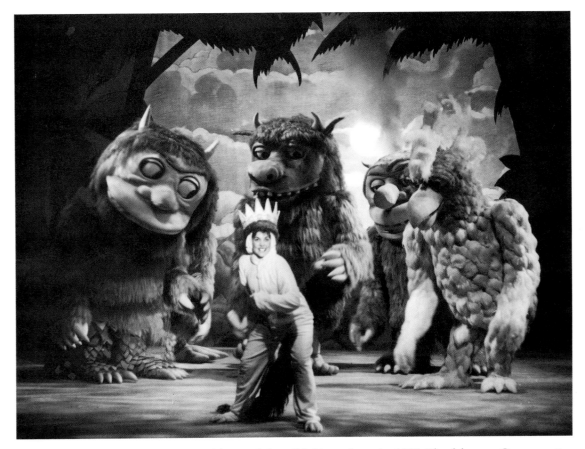

Fig. 61. Max (played by Karen Beardsley) and the wild things, from the 1985 Glyndebourne Opera production of *Where the Wild Things Are*

about a child whose tantrum leads him into an episode of fantasy. The unnamed boy of her story is not granted the same poetic license of fantasy that Sendak gives Max; instead, his fantasies torment and tantalize him, and they appear to be neither his invention nor something that he can control. What ends the fantasy is an act of kindness that he shows toward a squirrel that has been wounded in the battle the boy has started among the animals. His gesture of selflessness serves as a symbolic penance to confirm the change he has undergone since the beginning of the opera.

As we have seen, the emphasis in *Where the Wild Things Are* is not on the morality (or immorality) of Max's behavior but rather on the internal dynamics of his experience and its embodiment of a subtler, psychological solution to the tensions of the story. Some of this contrast has to do, of course, with the differing cultural contexts in which the two works appeared. Sendak's lack of concern over the morality of his main character's actions may well have been shocking to a time like Colette's, though it was not at all out of keeping with the times in which Sendak was writing. In fact, Max's mother is following, at least in part, the non-

judgmental advice that Dr. Spock gave as early as 1946 about how to deal with a temper tantrum. "When the storm breaks," he wrote in *The Common Sense Book of Baby and Child Care*,

> you try to take it casually and help to get it over. You certainly don't give in and meekly let the child have his way, otherwise he'd be throwing tantrums all the time on purpose. You don't argue with him, because he's in no mood to see the error of his ways. Getting angry yourself only forces him to keep up his end of the row. Give him a graceful way out. One child cools off quickest if the parent fades away and goes about her own business matter-of-factly, as if she couldn't be bothered. Another with more determination and pride will stick to his yelling and thrashing for an hour unless his mother makes a friendly gesture. She might pop in with a suggestion of something fun to do, and a hug to show she wants to make up, as soon as the storm has passed.[59]

Sendak's handling of this highly charged situation was also in tune with the movement throughout the 1950s toward a more open, psychologically sensitive kind of children's book, one that would reflect not only the actual experience of children but also what Sally Allen McNall has called "the dream life" of American culture which had been, in postwar America, "enlarged to attribute worthiness to everyone, in an upsurge of conviction in the myth of social mobility, and in the value of tolerance. . . . [T]he image of the American family became more democratic, while children became simultaneously more daring and more sensible."[60] But nothing in this progression through the late 1950s and the early 1960s toward more enlightened children's books could really have prepared the reading public for the sudden reorientation of the imagery of its "dream life" that came with the arrival of *Where the Wild Things Are*.

By pushing a mischievous child onto center stage in *Where the Wild Things Are*, Sendak had set in motion a group of crucial and uniquely American myths. For centuries America has been criticized for the wildness of its citizens, particularly its children. At least one eighteenth-century observer of American life reckoned that was because Americans, particularly those on the frontiers, ate so much wild game. Others have argued that it has something to do with the subtle but tenacious spirit of rugged American individuality and independence that has been indulgently encouraged in our children at the expense of more disciplined, restrained, restrictive behavior. America has a long tradition in its literature of bad boys who are really good boys at heart. A surprising amount of our early children's literature from the seventeenth and early eighteenth centuries has to do with children, many of whom appear wicked at first but who are reformed and, if they do not die, as often happened in those earliest of American children's books like James Janeway's popular Puritan tract *A Token for Children: Being an Exact Account of the Conversion, Holy and Exemplary Lives, and Joyful Deaths of Several Young Children* (1672), they go on to become God-fearing, upstanding citizens of the

community. The devil, in short, became an angel; the little monster turned into a messiah. One can understand why this particular symbol of the child, that of a being able to be transformed and redeemed, was so important to a new country that was itself just being born and was struggling through its own youth to define its character and future. If the child is the symbol of that future, it is certainly fitting that many Americans would be vitally, even obsessively concerned with the fate of the child's soul.

But by the end of the nineteenth century, Mark Twain had begun to present another view of this bicameral child in the characters of Tom Sawyer and Huckleberry Finn, two of the most memorable versions of the figure that has been called "The Good Bad Boy." He is the scamp with the heart of gold, the urchin who possesses the moral and ethical vision that, with few exceptions, is lacking in the rest of his society, especially the adult society that tries to restrict and repress him. Since Twain, American popular culture has created, in books, comics, and, more recently, in films, a steady stream of other more or less bad boys: from Peck's Bad Boy to Dennis the Menace, from the Our Gang kids to Holden Caulfield, from Leo J. Gorcey to Michael J. Fox. Some have been more bad than good; but, like Tom Sawyer's Aunt Polly, we Americans secretly admire their spunk and energy and expect boys to make, as Max does, "mischief of one kind and another" on the way to becoming a "judge or bank president" or "senior editor at Random House."[61] It's necessary to sow some wild oats if one is to have any meaningful harvest to speak of. As Leslie Fiedler puts it:

> The Good Bad Boy is, of course, America's vision of itself, is authentic America, crude and unruly in his beginnings but endowed by his creator with an instinctive sense of what is right; sexually as pure as any milky maiden, he is a roughneck all the same, at once potent and submissive. That the image of a boy represents our consciousness of ourselves and our role is scarcely surprising. We are, to the eternal delight and scorn of Europeans, inhabitants of a society in which scarcely anyone is too grave or mature to toss a ball around on a warm afternoon. Where almost every male is still trying to sneak out on mother (whom he demands *make* him sneak his pleasures); where . . . mothers are also fathers—that is, embodiments of the superego—growing up is for the male not inheriting the superego position, but shifting it to a wife, i.e., a mother of his own choice. No wonder our greatest book [*Huckleberry Finn*] is about a boy and that boy "bad"![62]

Where the Wild Things Are may have tapped many basic American beliefs, but it was also a decidedly European book that was built on much older mythic foundations. Americans certainly do not have a monopoly on the mythology of mischievous children, and Sendak's own study of the classics of children's literature brought him close to a number of these "little monsters" whose stories would influence the book. William Nicholson's 1926 picture book *The Pirate Twins* had given Sendak a model for the pacing of his pictures and text—especially in the

opening lines ("One evening on the sands / Mary found / the Pirate Twins") in which each phrase, even those of only two or three words, is given drama through its isolation and weight through its accompanying picture.[63] Nicholson had belonged to that next generation of English artists following in the tradition of Randolph Caldecott who understood, to borrow Sendak's word, how to "quicken" the tempo of a picture book through the nimble interplay of words and pictures. *Wild Things* has echoes throughout of the cadences of Nicholson's rhythms; one is reminded, for example, of the sequence of pictures for Max's mischief making when reading about how Nicholson's Mary takes the twins home, bathes them, and then feeds them (in three pictures) "on this / that / and the other."

But Sendak's homage to Nicholson runs deeper than the visual or verbal lessons that he learned from the English illustrator. The pirate twins are unruly children who stand in pouty, rumpled, rambunctious contrast to the domestic perfection of Mary, the little girl who finds them. The book certainly would be problematic today given that the pirate twins are two tiny black girls, and their wildness within Mary's white world might well be perceived as undisguised racism. But Nicholson's point, if one takes it on another level, was not about skin color. It went instead to the deeper problem that the myth of the bad child must grapple with: How will the child's wildness, her impulsive, chaotic otherness be acknowledged and accommodated? For the pirate twins (who are bored by Mary's world and flee it one day in a stolen boat, only to return each year like Peter Pan to celebrate Mary's birthday) are parts of Mary, those "dark" children that are unacknowledged, unadmitted, unaccepted in the still unexplored regions of her personal shadow. And we know, somehow, that they will remain zones of self that she will never express and will continue to repress. Their survival depends on their fugitive existence as outlaws of the imagination—a fate that would not be shared by their hairy, furry, feathery cousins, the Wild Things.

Sendak's book had built on other retellings of the bad boy myth in children's literature, among them Beatrix Potter's Peter Rabbit and Hilaire Belloc's Jim and his spoofs of moralistic natural histories in *The Bad Child's Book of Beasts,* which he began with the pompous petulance of an English schoolmaster:

> I call you bad, my little child,
> Upon the title page,
> Because a manner rude and wild
> Is common at your age.[64]

Still other classic texts in the bad boy tradition informed the choices Sendak would make in his own contribution to its mythology, including the grandfather of all revisionings of the cautionary tale, Heinrich Hoffmann's *Struwwelpeter* stories, and Collodi's *Pinocchio,* which had made an indelible impression on Sendak when he saw the Disney version as a child and later read the edition with the compelling Mussino illustrations.

But of all the European influences at work in *Where the Wild Things Are,*

perhaps the most important is that of the nineteenth-century German artist and writer Wilhelm Busch. Busch is generally regarded as a pioneer of the comic book, one of Sendak's childhood enthusiasms that has left a lasting mark on his mature art. Sendak had been thoroughly excited by the graphic genius of Busch's drawings, which were full of such animated life for Sendak that they "seem to blast off the page."[65] He was equally fascinated with one of Busch's favorite subjects, the impulsive, "refractory nature of childhood" that was embodied in those stories that Busch is remembered for today—the seven tricks played by two archetypally bad children, Max and Moritz (Fig. 62).[66] Like Heinrich Hoffmann in his tales of juvenile crime and punishment, Busch was also pushing the limits of parody and conventional morality: his kids are so outrageously, hilariously, unredeemably bad that there is finally no normal way to punish them, and Busch eventually has them dropped into a millhopper, ground into tiny pieces, and gobbled up by a miller's hungry ducks.

Fig. 62. From Wilhelm Busch, *Max and Moritz, with Many More Mischief Makers More or Less Human or Approximately Animal*

As an avid collector of classic works of children's literature, Sendak would have known about the new American edition of Busch's *Max and Moritz* that had been published in 1962, just a year before *Where the Wild Things Are*, with the subtitle that explained that the volume contained *"many more mischief-makers more or less human or approximately animal."*[67] Sendak was, no doubt, delighted that this collection made use of and noted the fact that the first (1871) and, until then, the standard English translation of these stories by C. T. Brooks was entitled *Max and Maurice*. Busch's Max gave Sendak a precedent for the naming of his character, and the high-spirited misconduct that Busch had celebrated also offered Sendak the energizing circumstances for his own book. Indeed, "making mischief" served as a linking metaphor for Sendak, Busch, and Hoffmann; and though

Sendak would take his chapter in the bad boy's misadventures in a different direction (for one thing, he allowed Max to come home unscathed), all three are united by the obvious relish they take in sending the "bad" child over the fences of conventional morality and established literary forms with a dynamic, satisfying abandonment.

But deeper, older streams of myth run through the text and pictures of *Where the Wild Things Are.* Max in his wolf suit is not only a good bad boy, he is also a feral child—an image that summons up a vast body of lore and speculation about wild children like the Wild Boy of Averyon, Kaspar Hauser (the enigmatic presence who had intrigued one of Sendak's favorite writers, Herman Melville), or the fiftysome other documented instances of *les enfants sauvages* from the fourteenth century to the present who had been abandoned, often to be nurtured or befriended by animals before being returned to civilization.[68] Over the past two centuries the wild child has been seen as a missing link between the animal and human worlds; as the ontological being who could recapitulate the philogeny of the group (thus showing civilized, adult observers what they had lost or gained along the road of their evolution); and as a living laboratory for testing theories of behavioral conditioning, language acquisition, and progressive education. The wild child has also served as an emblem of the untamed, forbidding darkness that lay outside civilization in the natural world as well as in the unknown interior of the psyche, and most recently it has been used as an example of how the primal and nobly savage has been victimized by civilization. The recurrent interest in this symbolic "other" child has led to his being placed at the center of books like Kipling's *The Jungle Book,* Burroughs's *Tarzan of the Apes,* and Golding's *Lord of the Flies,* and at the heart of films like *The Emerald Forest* and *Where the River Runs Black* or François Truffaut's *The Wild Child* and Werner Herzog's *Every Man for Himself and God Against All.*

Images of the wild child ultimately take us deeper still into the "natural history" of the Renaissance and the Middle Ages that gave him a name and what was then the scientific classification *Homo ferus.* He was considered a "human subspecies, hairy, dumb, and able to walk only on all fours"[69] and thought of as a close relative to that general family of creatures *Homo monstrosus*—the monsters that one would encounter if he ventured, as explorers had begun to do, into the unknown New World, the terra incognita both of geography and the imagination. The pages of geographical treatises of the sixteenth and seventeenth centuries were filled with portraits of such "real" creatures as the goat-limbed boy and the cat-headed child[70] or others with an even more fantastical physiognomy, like the Sciapodes who have only one large foot and use it as an umbrella, or the headless Blemmyae whose faces are on their chests.[71] Closer to home, in the European forests that one did not have to travel half way around the world to visit, the wild man became an active part of the fantasies of the Middle Ages. In his study of this mythological figure, Richard Bernheimer explained the wild man in terms that did not limit his relevance to the Middle Ages but rather connected him to our own experience and to Max's wild man–releasing tantrum. Indeed, Bernheimer could

have been describing the circumstances of the fantasy of *Where the Wild Things Are* when he argued that

> the notion of the wild man must respond and be due to a persistent psychological urge. We may define this urge as the need to give external expression and symbolically valid form to the impulses of reckless physical self-assertion which are hidden in all of us, but are normally kept under control. These impulses, which are strongest and most aggressive in the very young, are restricted slowly, as the child learns to come to terms with a civilized environment which will not tolerate senseless noise, wanton destruction, and uncalled-for interference with its activities.[72]

Unlike civilized man, whose origins could be accounted for and whose impulses were held in check, the wild man was "free as the beasts, able and ready to try his strength without regard for the consequences to others, and therefore able to call up forces which his civilized brother has repressed in his effort at self-control."[73] The word "wild," whether in Old German or Sadie Sendak's twentieth-century Yiddish, stood for what lay outside social norms, representing "what was uncanny, unruly, raw, unpredictable, foreign, uncultured, and uncultivated. It included the unfamiliar as well as the unintelligible . . . in the widest sense [it] is the background of God's lucid order of creation."[74] Thus, the woods—where the medieval Wild Things are—was the place where one met with "the ever present threat of natural and moral anarchy."[75] One such figure that the medieval mythologist envisioned residing there was King Nebuchadnezzar (Fig. 63); because of his evil deeds he had been changed from a man into a wild thing, with flowing white hair covering his body, and banished into the wilderness, where we meet him, in an illustration for a fifteenth-century chronicle, in a forest uncannily like the one that Max creates for his own journey in *Where the Wild Things Are* (Fig. 64).[76] As Bernheimer demonstrates in his profile of this archetypal figure, what we relegate to the shadows we often become. By the end of the Middle Ages there was such fascination with the power of the wild man that it was a noble act "to identify oneself with savage things, to slip into the wild man's garb, and thus to repudiate that very principle of hieratic order upon which medieval society was founded."[77] In many ways the scene that Bernheimer describes sounds similar to the liberating flights into wildness of the American cultural revolution of the 1960s, when to "drop out" and move "back to the land" where one could lead an uncontaminated life was considered by those who took it to be a moral choice.

This rich field of mythic connections in *Where the Wild Things Are* opens further if one considers those other wild children of antiquity such as Romulus and Remus and Zeus, who were nursed by animals in the wilderness and who also became kings of a world inhabited by its own monsters such as the Sphinx and the Cyclops, Medusa and the Minotaur. Sendak includes a minotaurlike figure on the front cover—the sleeping guardian to the labyrinth that Daedalus/Sendak has created and that Max and the reader will be exploring in the book itself. The

labyrinth leads, to borrow Barbara Bader's phrase, to "the beast within," the chaos the hero must confront and, having defeated it, find the way back through its deceptive passages to light, order, civilization, cosmos. Here, too, in *Where the Wild Things Are* is the bacchic goat that joins the "wild rumpus," helping to make its scenes resemble nothing so much as the friezes on those bas reliefs and amphoras that depict ancient Dionysian processionals, that capture, if only in their fragmentary form, the rhythms of the dance that Sendak sought for his own book; a rhythm so intense that like the dithyramb it holds you enthralled, so that "you're caught and you can't get out."[78]

Sendak has frequently told the story about where he discovered the models for his monsters in *Where the Wild Things Are*. Because he could not draw horses, he eventually changed the name of the book from the original *Where the Wild Horses Are* and settled on "things" since "no one could challenge his ability to draw" these creatures. In the end he returned to the figures that had scared him as a child:

> I remembered how I detested my Brooklyn relatives as a small child. They came almost every Sunday. My mother always cooked for them, and, as I saw it, they were eating up all our food. We had to wear good clothes for these aunts, uncles, and assorted cousins, and ugly plastic covers were put over the furniture. About the relatives themselves, I remember how inept they were at making small talk with children. There you'd be, sitting on a kitchen chair, totally helpless, while they cooed over you and pinched your cheeks. Or they'd lean way over with their bad teeth and hairy noses, and say something threatening like "You're so cute I could eat you up." And I knew if my mother didn't hurry up with the cooking, they probably would. So, on one level at least, you could say that wild things are Jewish relatives.[79]

Fig. 63. A fifteenth-century wild man: King Nebuchadnezzar

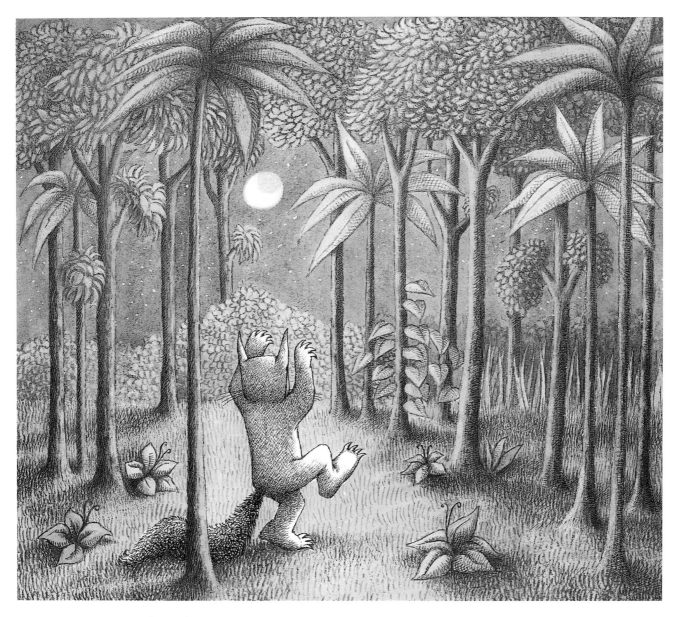

Fig. 64. Max's forest, from *Where the Wild Things Are*

This half-comic exegesis could not be more charged with mythic significance. For the monsters *are* our relatives. In their most primitive form, as Theodore Thass-Thienemann points out in his linguistic analysis of the origins of religion and myth, they are adults dressed in horrible masks who represent rapacious, often cannibalistic ancestral spirits that frighten the child who is uninitiated into their mysteries.[80] With Max, Sendak's own ancestral spirits have reenacted their ritual of initiation in which they "roared their terrible roars and gnashed their terrible teeth and rolled their terrible eyes and showed their terrible claws" in order to

evoke that mixed feeling of fear and reverence in the child who has not yet made what Thass-Thienemann describes as that "crucial transit from the outside world to the community of the mystagogues who are in the possession of a secret knowledge that cannot be conveyed to the profane people."[81] That Max is not afraid during the initiation he undergoes in *Where the Wild Things Are* reminds us of the fact that he has been around this block before. He knows the proper charm to use to quell the monsters' fury, and thus he makes this a smoother transit for the uninitiated reader. What's more, Max lets us see behind the masks to "the twinkle in the eyes of the adults" who have performed this ritual on terrified children for millennia, pretending to be the boogeyman or the ogre or some other child-devouring monster.[82] Behind the mask is not some hideous demon or a vision of the ancestral godhead but simply a group of Aunt Goldas and Uncle Bernards, pinching your cheeks and wailing, again from behind their half-serious, half-comic masks, "Oh please don't go—we'll eat you up—we love you so!"[83]

This is, of course, a spoof on the ancient game of scare the children (Fig. 65)—here played from the child's point of view, as one of those "necessary games" that children create and ritualistically perform to express and resolve their ambivalent relationship to this potent emotional material. In this respect, their playing at these games is a serious, even a sacred act—a recognition that led Jean Cocteau to observe: "Children's rites are obscure, inexorably secret; calling, we know, for infinite cunning, for ordeal by fear and torture; requiring victims, summary executions, human sacrifices. The particular mysteries are impenetrable, the faithful speak a cryptic tongue; even if we were to chance to overhear unseen, we would be none the wiser."[84]

As we have seen with his works about Rosie, Sendak was fascinated by the rites that he observed from his parents' Brooklyn apartment. In his acceptance speech for the Caldecott Award, Sendak recalled an equally mesmerizing performance of the neighborhood children that he witnessed just a few months after finishing *Where the Wild Things Are,* and it confirmed once more in reality the quality of the child's experience he had attempted to re--create in the book. The episode involved a "tubby, pleasant-faced little boy" named Arnold "who could instantly turn himself into a howling, groaning, hunched horror—a composite of Frankenstein's monster, the Werewolf, and Godzilla. His willing victims were four giggling little girls, whom he chased frantically around parked automobiles and up and down front steps." Sendak describes the game in detail, especially Arnold's breaking its inviolable rule—that he not catch any of the girls. He is

Fig. 65. Baby and Wild Thing, cover drawing for *When I Was a Child*

chastised for it, and the game continues as Sendak notes that "they had the glittery look of primitive creatures going through a ritual dance" until "the game ended in a collapse of exhaustion" as though "a mysterious inner battle had been played out, and their minds and bodies were at rest, for the moment."[85]

These remarks draw us back to other rituals whose sources lie in our prehistoric, shamanistic past—to the dancing deer man at the cave of Trois Frères, for example—when to gain control of the animal meant to take on its qualities, to wear its antlers, its feathers or fur, to dance its dance. Max, Sendak tells us in his notes to himself about one of his drafts for *Where the Wild Things Are*, wants to be a Wild Thing. His complete identification with that mask is what gives him the *mana*, the power he needs to dance through this rough passage in his life between those contrary, conflicting states of being "wild" or "tame."

This fall down the rabbit hole into the depths of mythic connections with *Where the Wild Things Are* ends with, arguably, the oldest of our archetypal patterns, the myth of the hero. As Anne Moseley and other interpreters of this story have observed, Max is another incarnation of the figure that Joseph Campbell has named "the hero with a thousand faces" who is called to adventure, leaves his normal world for a magical land where he must withstand trials, tests, and a climactic confrontation with a powerful force (usually some kind of monster).[86] The hero returns from this journey to the world he left with treasures or secrets from that other world which transform his community by altering the fragile balance between what is known and unknown, first impossible and now remarkably possible.

In Max's journey Sendak offers a narrative that participates in this ancient tradition, albeit in a form that we might not initially recognize as heroic or mythic. Suddenly, unexpectedly, the fight that Max has had with his mother precipitates his "call to adventure" and the necessary leaving of his (and the reader's) conventional reality for a place that is unfamiliar and unpredictable. There is a journey and a test (he must "tame" the creatures) leading to an "apotheosis" in which Max becomes the king of these forces and joins, ritualistically, in a dance with them. Finally, he returns to the ordinary reality of his bedroom, his supper, and a place "where someone loves him best of all."

Like Gilgamesh, the hero of one of the oldest myths of Western culture, Max is also on a quest for solutions for ancient dilemmas, for that magical gift that will give us some joy and tranquillity in the face of life's relentless, bruising defeats. Gilgamesh thinks he will find these answers by discovering the secret of everlasting life and thus some way to resolve the terrible problem of our mortality—a problem that he feels acutely after the death of his friend and alter ego, the wild man Enkidu. Like Max, Enkidu also wears a wolf suit, and once Enkidu and Gilgamesh have become friends they too "make mischief of one kind and another"—killing the monster Humbaba, destroying the sacred bull of heaven, and bringing the wrath of the gods down on them. It is Enkidu, the instinctive side of our nature, that is sacrificed to appease the gods, and this loss sends Gilgamesh on his grief-driven quest. What Gilgamesh brings back from his journey is not a tangible an-

swer but rather the consolation of myth. The gift he bestows on the people of Uruk takes the form of a story—the account of his exploits in the dusty underworld of the dead, inside the mountain of the spider monsters, and among the immortals in the land of Dilmun. The story of these remarkable adventures, the sheer wonder of the tale itself will remain fresh and immortal; it alone, the epic tells us, offers healing relief for the life-sick heart.

Similarly, Max does not bring back a tangible boon to his society from the land of the Wild Things. Instead, he returns with a small piece of the puzzle about surviving and learning one of the principal lessons of the hero: how to control the "irrational savage within him"[87] and to be reconciled once again with his world where he is not always the powerful "wild wolf-king of everything" but where human, civilized love awaits him in exchange for his abdication. Joseph Henderson draws a psychological conclusion about the importance of the heroic quest; its "essential function," he believes, "is the development of the individual's ego-consciousness—his awareness of his own strengths and weaknesses—in a manner that will equip him for the arduous tasks with which life confronts him."[88] However, *Where the Wild Things Are* does not push moralistically or didactically at this lesson. It allows Max's discovery to become a matter of adult consciousness taking over from what Max could reasonably, credibly be expected to have realized from his experience. Max simply leaves on his own terms the game that he has constructed, and that in itself is a major victory for the emerging ego of the child. He does not have to give up his vision and its satisfying conclusions; he gets to have his tantrum *and* his cake.

In part this occurs because Max is the hero at his youngest stage of development, as the trickster. In this early form the trickster/hero often appears as an animal or, as in Max's case, in an animal costume. It is appropriate that Max should have this dual role because both trickster and six-year-old are creatures "whose physical appetites dominate [their] behavior." He is a phallic spirit whose growth-spurts were a subject of numerous jokes in ancient societies, from the Greek to the American Indians. And because he is "lacking any purpose beyond gratification of his primary needs, he is cruel, cynical, and unfeeling."[89] We can certainly see the examples of this archetypal characteristic in Max's initial mischief making as well as in the cool, almost blasé expression that he wears at most points in his adventure: he can seem at times to be aloof, detached, indifferent to the volcanoes erupting around him. Yet the trickster shows more than simply an id-driven side; he is also a supremely creative figure. Hermes, for instance, invents writing and music, and other tricksters like Max and Raven literally have the power to create their worlds.

Max returns to his room with a vision of this imagined world and with a resolution for the problem of the trickster's survival in the adult world of laws, orders, and daily compromises. This question needs Sendak's attention because Max has shown his abundant power to disrupt, and most children and adults are sure to wonder about the problematic fate of "the spirit of disorder" that he represents.[90] Max as trickster introduces the wild card into the game; he recapitu-

Plate 1. Dust jacket painting for *Lullabies and Night Songs*

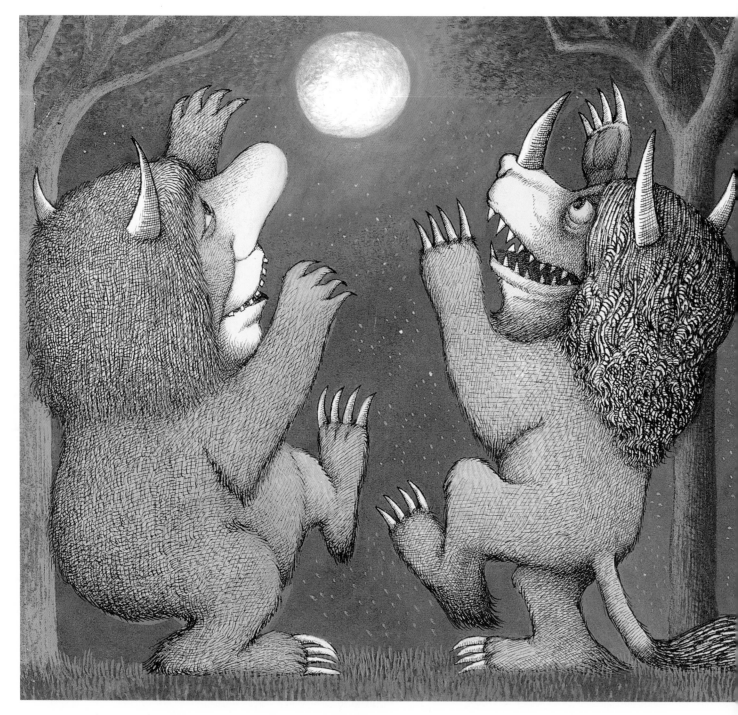

Plate 2. The Wild Rumpus from *Where the Wild Things Are*

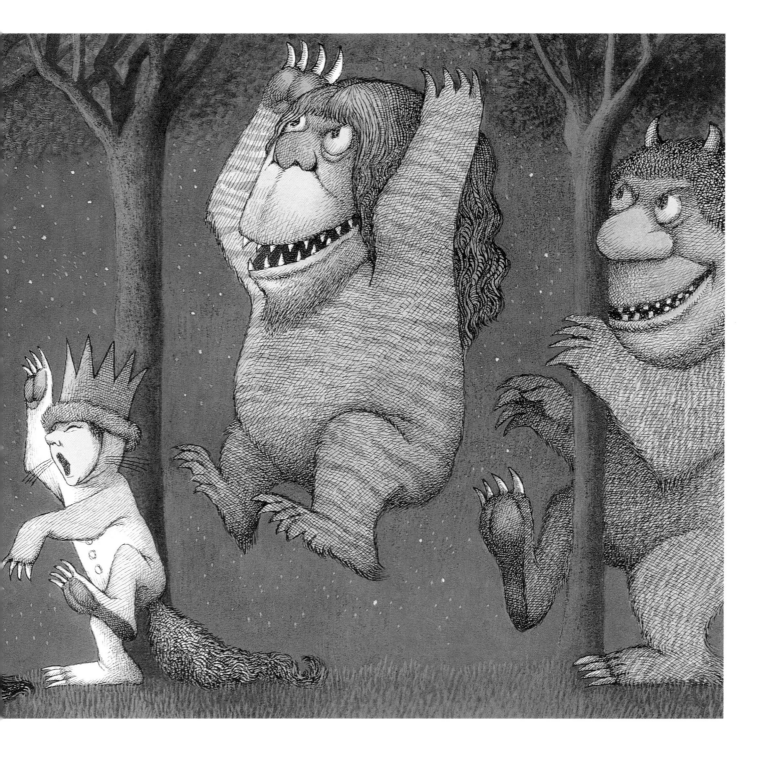

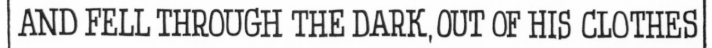

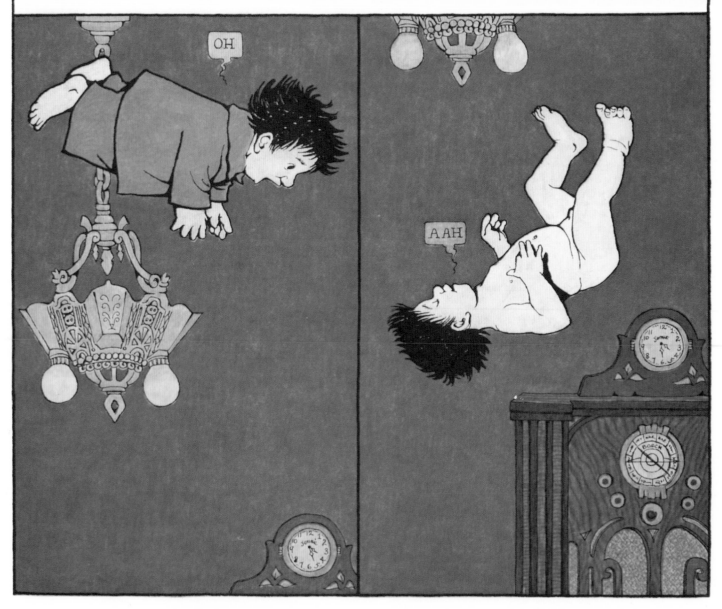

Plate 3. Mickey's fall into the Night Kitchen

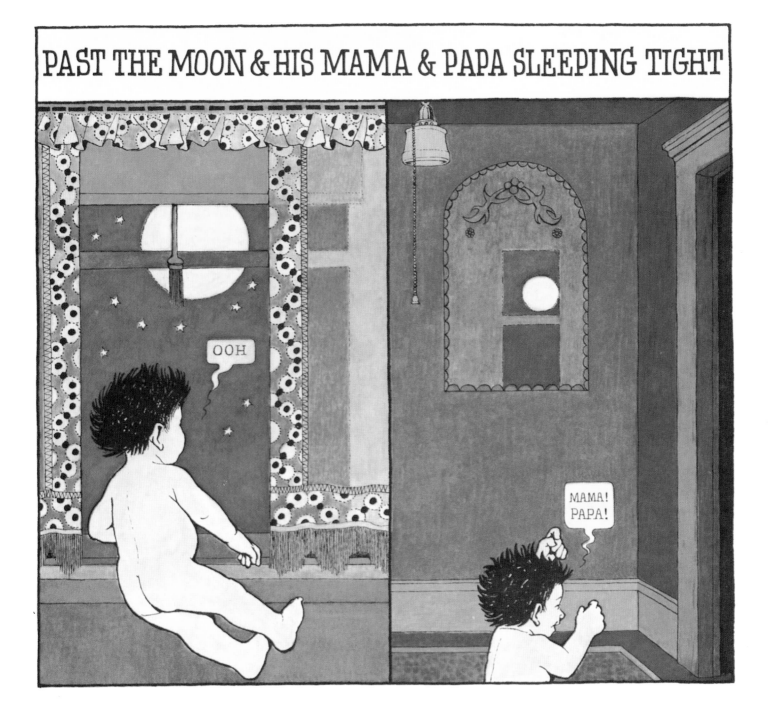

Plate 4. From *In the Night Kitchen*

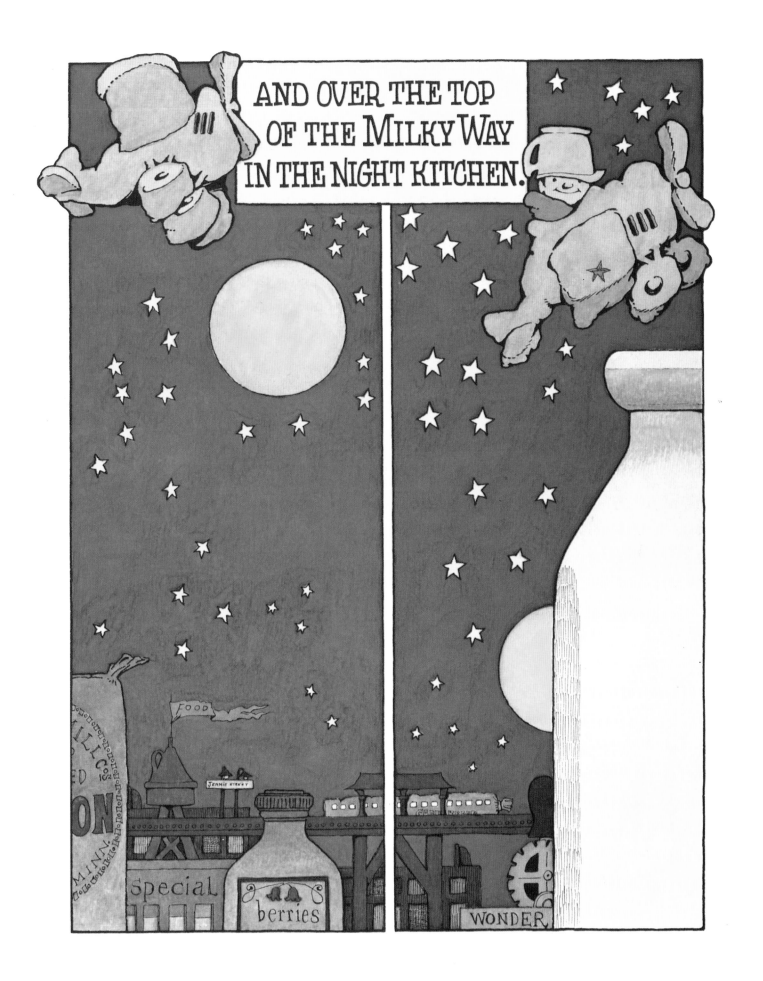

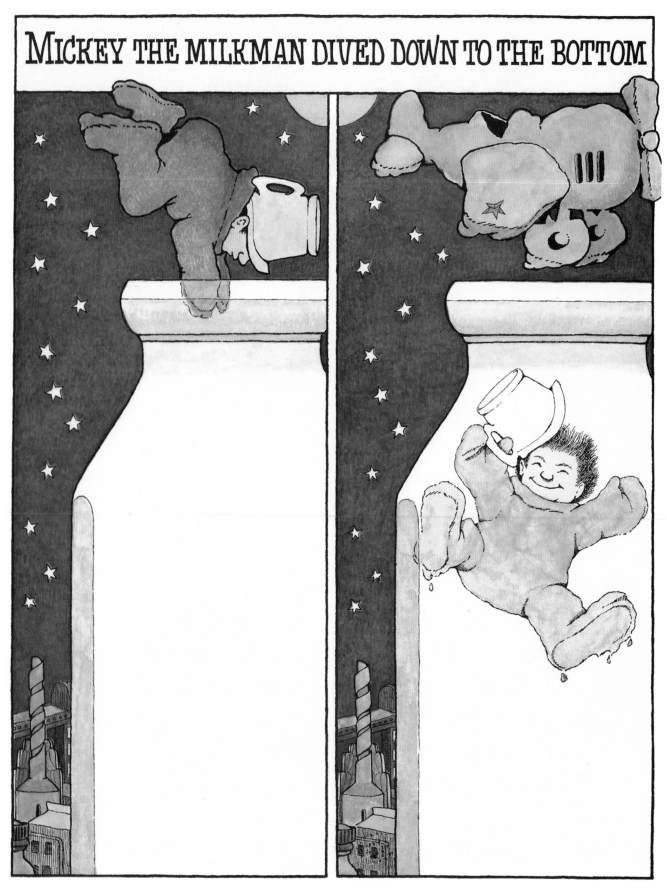

Plate 5. From *In the Night Kitchen*

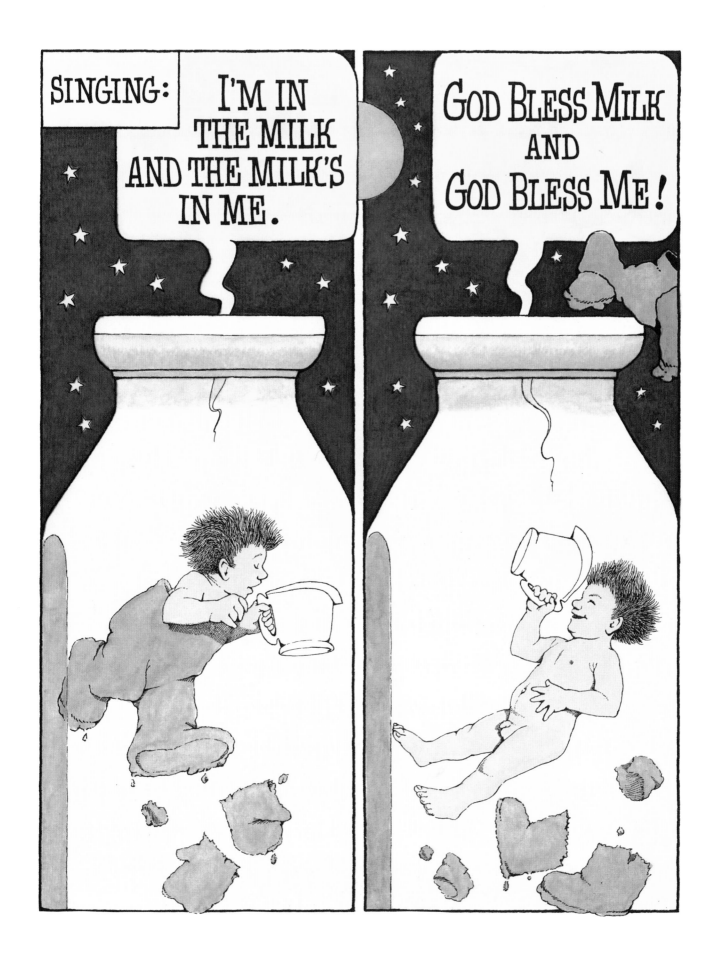

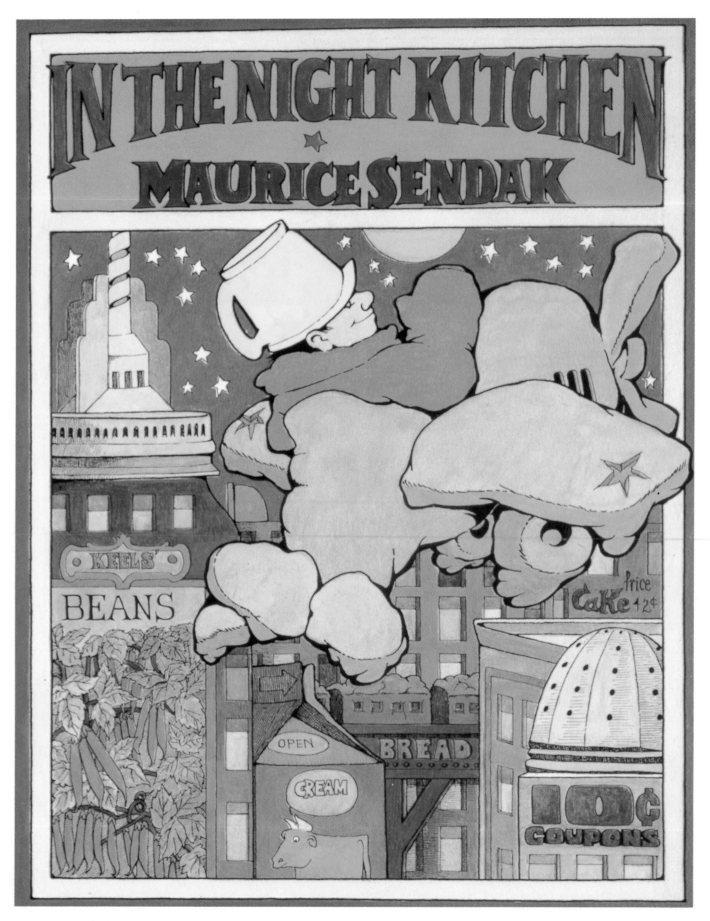

Plate 6. Dust jacket painting for *In the Night Kitchen*

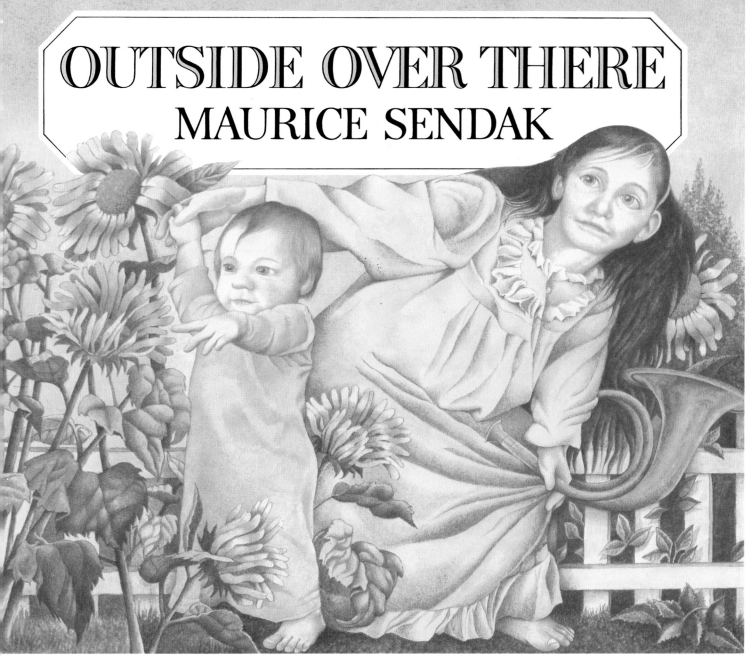

Plate 7. Dust jacket painting for *Outside Over There*

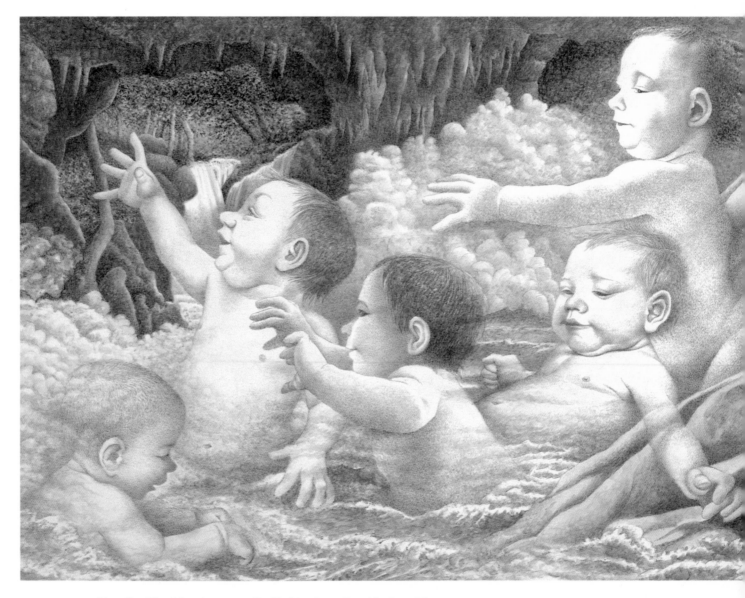

Plate 8. The "dancing stream" of babies from *Outside Over There*

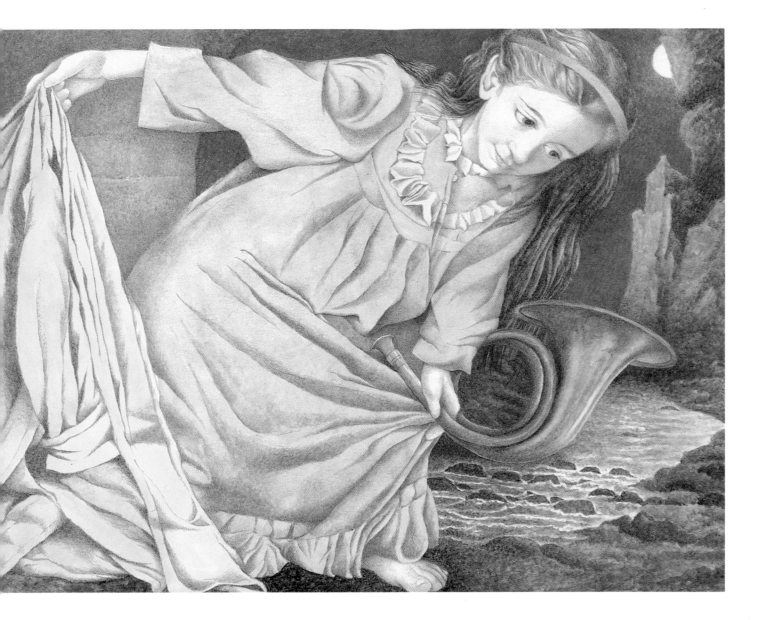

Plate 9. From *We Are All in the Dumps with Jack and Guy*

Plate 10. Front dust jacket of *We Are All in the Dumps with Jack and Guy*

lates our wildest impulses, and we are reminded that this is "the function of his mythology, of the tales told about him . . . to add disorder to order and so make a whole, to render possible within the fixed bounds of what is permitted, an experience of what is not permitted."[91] But there is more to Max and the trickster figure. By the end of the story, or a group of tales like the Winnebago trickster cycle, a human being has begun to emerge from the disruption. Similarly, at the end of his story Max pushes back the top of his suit and we see the head of the little boy, not the wild wolf.

Myths are temporal constructions. Their initial energy and reason to be belongs to their immediate world and not to some far away past, much as they may draw on images from that past to tell their stories. *Where the Wild Things Are* is a product of its times, and not simply a reverberant reminder of other mythologies and other times. Because of the historical moment in which it appeared, *Where the Wild Things Are* represented a new chapter in the myth of the American child. Sendak may have thought he was composing another variation on his theme of how children "get through a day" when he released the book in 1963. But he was also announcing along with Max the arrival of those tumultuous, activating times in which the spirit of the child—playful, inventive, irreverent, headstrong, iconoclastic—suddenly and dramatically appeared to play a major role on the cultural scene. These were, of course, the sixties; and, as we know, within only a few years after the publication of *Wild Things,* there were people walking the streets of most cities in the Western world who looked quite a bit like Sendak's creations. As has so often been said, the time was surging with an intense fervor—political, social, artistic—and with the vitalizing energy of youth. The nation's youngest president had been elected only a few years earlier, and the White House had young children in it for the first time in decades. Whether in Paris or Chicago in 1968, the call for an empowerment of the imagination, for "making mischief of one kind and another," was releasing a force that might be able to shift the tectonic plates of cultural change. Like Sendak, the Zeitgeist had also been reading William Blake.

It is possible to dismiss this movement toward the child that was central to the Sixties as simply another manifestation of what George Boas has rather disdainfully called "The Cult of the Child," viewing it as a kind of "cultural primitivism" that occurs with some historical regularity as an anti-intellectual reaction to the authority of reason, rationality, positivism. At various times in history, from the Middle Ages to the present, the worshipper in this cult, Boas argues, "has gone for his exemplar to primitive man, to the peasant, to woman, to the Unconscious, and . . . to the child, each of whom is supposed to possess untaught wisdom."[92] But in characterizing the movement as a type of philosophical fad, Boas misses the powerful, compensatory content of the symbol of the child and the important message that the Sixties was trying to send. Max was one of the first bearers of that mythic message—that the child is the way down and into the unconscious and the guide to the healing sources of fantasy, the spontaneous spark that lights the shadows.

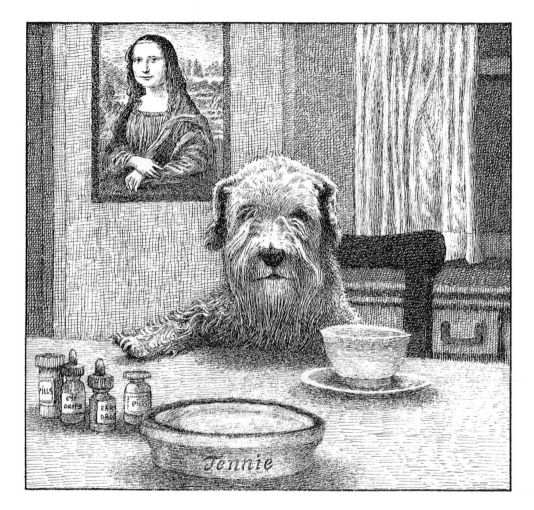

JENNIE
Of Animals and Archetypes
Rhymes and Reasons

> . . . for all created things there is needed not only a
> creator, but a piece of life, life itself, which is somehow
> withdrawn from its proper destiny with death and fixed
> in an intransient existence.
>
> —Otto Rank

IF *WHERE THE WILD THINGS ARE* was an ecstatic "Rite of Spring" in the Sendak repertoire, the quiet, black-and-white line drawings of *Higglety Pigglety Pop!* (1967), the next book that Sendak both wrote and illustrated, suggest more contemplative, even autumnal music. The ash tree, the ancient world tree, sheds its leaves while it awaits "the empty, frozen night" of approaching winter that also occurs during the dark night of the soul for the book's main character, Jennie, the next of Sendak's children to reach the page. Romantic declarations of the visionary rights of the child such as those we saw in *Where the Wild Things Are* are not pressed with such urgency in *Higglety Pigglety Pop!;* instead, the latter concentrates on more personal, existential questions. Max's leap into fantasy is instantaneous, the result of immediate, explosive emotional pressure and release, but Jennie's crossing of the threshold to her adventures is a careful, even conscious choice. While *Where the Wild Things Are* was an intense mythic moment—what Melville might have meant when he called myths those "luminous scenes grasped in flashes of intuition"[1]—that inscribed the child's heroic journey into the unknown and back, *Higglety Pigglety Pop!* was a long voyage outward, away from home and its familiar ground, a *bildungsroman* that etched a portrait of the artist as a small, white dog.

Like the planes of cross-hatched lines that give such astonishing definition and depth to the pictures for *Higglety Pigglety Pop!*, the book as a whole is built from layers of meaning and referential possibilities. On one level it was immediately responding, with uncanny accuracy, to the spirit of its particular time, just as *Wild Things* had done a few years earlier. *Higglety Pigglety Pop!* was published in 1967 as the cultural revolution of the 1960s had begun to crest (the Yippies, or Youth International Party, was founded later the same year). As a longtime resident of Greenwich Village, Sendak was daily reminded, on the streets outside his townhouse on Ninth Avenue or in nearby Washington Square, of these challenges to the status quo that had begun with the Beat Generation in the early 1950s and had blossomed into the Flower Children of the late 1960s. To most establishment observers, the younger generation that was busily declaring its biological, experiential, and spiritual independence was subverting the very culture that nurtured it—literally and metaphorically biting the hand that fed it. But from the point of view of the counterculture, it was time to reject the hypocrisies and stifling controls of a society that had gone into moral and ethical bankruptcy. Mythologically, the cultural conflict framed itself in classically Nietzschean terms as a clash between the Dionysian, the revolutionary, and the visionary on the one hand and the Apollonian, the conservative, the repressive on the other.

Though Sendak has often rejected political readings of his work, one cannot help but hear, however subdued or unconscious, the leitmotif of social commentary running through his books, and such a connection is inescapable in *Higglety Pigglety Pop!* Here Sendak offers us a heroine who shared distinct similarities with the generation that, at the time, was the focal point of so much public attention. Like them, she "had everything"—especially the material advantages that were missed by parents who had struggled through the Depression and the war years, as Sendak's parents certainly had. But comfortable as she may be, Jennie decides to leave her home. There is no compelling, external reason for her departure; rather, she is moved by some deep, internal discomfort, some restless existential malaise. She confesses to an inquisitive potted plant: "I am discontented. I want something I do not have. There must be more to life than having everything." [2] Little wonder she feels such dis-ease and so alienated from her present condition. "We live in an age in which the ground is shifting and the foundations are shaking," R. D. Laing proclaimed in *The Politics of Experience,* a touchstone work of the Sixties that was published the same year as *Higglety Pigglety Pop!*: "we scurry into roles, statuses, identities, interpersonal relations. We attempt to live in castles that can only be in the air because there is no firm ground in the social cosmos on which to build." [3] Sensitive children of privilege across the country were also fleeing (incomprehensibly, from their parents' point of view) their own comfortable homes to embark on a variety of spiritual quests—for the antimaterialistic promise of communes in Arizona or Vermont, the hallucinogenic and sexual liberation of California, or the relative political freedoms of, say, a Madison, Wisconsin, or a New York City—wherever this expanded significance in life might be found.

Synchronistically, the same year that Jennie set off on her spiritual quest, the

Beatles released a plaintive ballad about a young woman who is also disillusioned, packs her bag in the middle of the night while her parents are asleep and quits her unhappy life to the haunting chorus, "She's leaving home . . . bye . . . bye." Given the milieu in which it appeared, it is understandable that Sendak's book quickly became a cult classic among college students, who saw in Jennie's search for significant experience a mirroring of their own yearnings and the trips they were in the process of taking, and in Sendak a prescient advocate for the concerns of their generation.

The Beatles do not tell us what happened to the heroine of their song; there is a lingering sadness to this leave-taking that is left deliberately unresolved—an ambiguity that the indefinite quality of the times also demanded. A similar ambivalence would find its way into Sendak's book, even though he was working under different aesthetic constraints in *Higglety Pigglety Pop!* than those of the popular ballad or the song of protest. He could not be quite as open-ended in his approach in a children's book, but once again he would experiment with formal structure and reader expectations to challenge the established boundaries of children's literature. One of these general demands in children's books is for narrative resolution and thus emotional closure, preferably for an ending that strikes a positive, if not a thoroughly happy, concluding note. By this point in his career, Sendak was well aware of this nearly inviolable convention. Still, he would take this *donnée* to its limit, leaving his heroine performing "happily ever after" with a theatrical troop but in a place (Castle Yonder) far removed from her original home and the "master who [loved her]," with only the most tentative, vague hint that they might see each other again. In the letter that she writes to him at the end of the book, Jennie cannot even tell him how to get to Castle Yonder because she does not "know where it is." However, she assures him that she is all right, asks him not to worry, and, if he is ever in the neighborhood, to look her up. At the end of her adventure she has arrived "in a new place," to borrow that expression from the Sixties; she has been liberated by the discovery and practice of her art from an "old master," a benign, absent figure of authority who nevertheless defined the terms of her existence and from whom she needed to separate herself if she was ever to develop as an individual. Even though it seemed to offer a palatable solution to Jennie's struggle within the traditional context of children's books, politically and psychologically *Higglety Pigglety Pop!* could easily be read as a cleverly disguised, unorthodox, liberationist argument.

Though we may see these implications in his work, Sendak does not—or at least he will not publicly embrace them. For him the most important level of meaning in his work is invariably that of his personal experience; it is to this that he keeps returning in his public statements about his work; it is what he understands, has thought about, and chooses to address in his reflections on his own creative process. In interviews he has spoken about the significance of *Higglety Pigglety Pop!* in his development as an artist, calling it an attempt to wrestle some personal sense from what he has called "that Brooklyn nightmare, that fever that has appeared in all [his] books" and thus to give expression to his "deepest feelings about

life."[4] On a primary level for Sendak, *Higglety Pigglety Pop!* was an act of personal mythmaking, another chapter in the ongoing performances of his own archetypal experience, and especially one for that recurrent actor in its public dramas, the child. In 1966, Sendak called *Where the Wild Things Are* "a personal exorcism" in what has become a much-quoted *New Yorker* profile that appeared while he was finishing *Higglety Pigglety Pop!* "[*Wild Things*] went deeper into my childhood than anything I've done before," Sendak explained, "and I have to go even deeper in the ones to come."[5] In order to reach those "deepest feelings" in this book, he once again drew upon "the *mishigases*" of childhood and tried, he said, to "[stuff] in all the things that happen to me in my life."[6]

Once more in Sendak's work it is possible to understand the fantasy of *Higglety Pigglety Pop!* as a fusion of crucial, Proustian objects, people, and recollections that Sendak recycles from his own "rag and bone shop of the heart": the talismanic toy milk wagon given to him by his Aunt Esther, the famous family photograph of himself as a scowling infant, fleeting glimpses of those childhood Brooklyn streets from the 1930s and 1940s. Again, the window that Sendak's grandmother used to create her small dramas of the outside world for the young, housebound Sendak appears at the back of the stage in the performance of the play, *Higglety Pigglety Pop!*, that concludes the story. Most of all the book drew, literally, on the figure of Sendak's pet dog, Jennie, a Sealyham terrier whose nature, Sendak thought, might well lead her to embark on a fictional adventure because she believed that there "must be more to life" than "having everything" (Fig. 66).

The extent of the importance of Jennie to Sendak has been well documented

Fig. 66. Preliminary drawings of Jennie for *Higglety Pigglety Pop!*

in Selma Lanes's biography of Sendak and elsewhere; for Sendak she was, Lanes tells us, "baby, child, companion, and best friend," or, as Sendak put it simply, "the love of my life."[7] A fantasy sketch that Sendak did in 1953, just a few months before he brought her home to New York as a puppy from a kennel in Connecticut, shows how completely he equated her with a child. In several quick drawings the human infant that begins the sketch grows a snout, whiskers, and a tail and is transformed into a puppy.[8]

Sendak continued to draw Jennie into nearly all of his own books over the next thirteen years: she naps under the bed in *Kenny's Window* and gets taken for a walk in *Very Far Away;* she sits on a bench outside a Brooklyn bungalow in *The Sign on Rosie's Door* and, in her most famous previous appearance, she is chased by Max in *Where the Wild Things Are.* But as she was growing older and had actually begun to need the medication that Sendak would describe in the opening lines of *Higglety Pigglety Pop!* ("two different bottles of pills, eyedrops, eardrops"), he became ever more anxious about her inevitable, approaching death and decided to make her the central character of *Higglety Pigglety Pop!* Though it might not fully resolve the problem of her death, at least this act of mythmaking would help to ease the loss of her for Sendak. By placing her in one of his books, Sendak could let his art confer on her a state of immortality. Preserving her in this form allowed Sendak to imagine Jennie "in her future life . . . as being an actress, always eating a mop and performing that idiotic nursery rhyme forever in some kind of artist's heaven where you can continue to work."[9]

A similar idea—that the relative permanence of art provides a kind of immortality, a way in which memory could be rescued from oblivion and losses restored—lay behind Sendak's illustrations for a collection of Isaac Bashevis Singer's stories, *Zlateh the Goat* (1966), which he had done just a year before *Higglety Pigglety Pop!* The pictures for the Singer volume were rendered in the same, finely cross-hatched style that he used later in *Higglety Pigglety Pop!* More important, Sendak peopled Singer's tales with images drawn from old Sendak family photographs of their Jewish relatives who had been killed in the Holocaust and whom Sendak's parents had mourned for two decades (Fig. 67). Sendak meant his pictures as "a gift to [his] parents," a memorial to that family tragedy, as well as a means of assuaging his own guilt about having survived and even, at the time, having resented the deaths of these distant relatives—the news of which had arrived on the day of Sendak's Bar Mitzvah, leaving Sendak's father in a barely ambulatory state of shock and ruining the celebration that Sendak and his family had been eagerly awaiting.

While *Higglety Pigglety Pop!* was nearing completion in the fall of 1966, other shadows of mortality had begun to cross Sendak's life. He was anticipating a much graver loss in his mother's battle with cancer, which was occurring at the time of the book's composition (she would eventually succumb to the disease in 1968). So Sendak gave Sadie Sendak a role in the book as well—as Mother Goose, the presiding divinity of Castle Yonder and the inspiration for the company of nonsense-chanting cherubim that Jennie joins at the end of the book.

Fig. 67. Illustration for "The Mixed-Up Feet and the Silly Bridegroom,"
from *Zlateh the Goat* by Isaac Bashevis Singer

Nearing forty at the time of the composition of *Higglety Pigglety Pop!,* with fifty-seven books to his credit, and the preeminent leader of the revolution that was taking place in contemporary American children's books, Sendak seems to have been looking at his own future with a restlessness that cemented the autobiographical bonds between himself and Jennie, the struggling artist at the center of the story. Though by external standards Sendak certainly "had everything"—fame, fortune, fulfilling work—internally he was having one of those periodic existential crises that he has frequently alluded to in his interviews. Such a period of soul-searching is, to be sure, an essential part of the creative process, the psychiatrist Anthony Storr reminds us: "the really original person is invariably 'inner-directed' and no amount of material comfort or security of tenure will deter him from pursuing his quest." [10] In *Higglety Pigglety Pop!* Sendak was probing these personal circumstances, and he was asking Jennie to speak for him when he has her sigh, "There must be more to life." It is a comical observation coming from a dog but one that becomes ever more pertinent the closer one gets to middle age, which is to say, the closer one gets to one's own mortality. Sendak would be dramatically reminded of his precarious physical limitations in the form of a near-fatal coronary that occurred while he was visiting England in the summer of 1967, only a few months after finishing *Higglety Pigglety Pop!* Always the keen observer and analyst of his own internal states, Sendak may well have sensed this growing internal pressure. One can see in the first film interview to be done of Sendak, which appeared early in 1967, that he looks haggard, pale, agitated—ill at ease in front of the camera and in some ways like the main character of this next book, restless, driven. [11]

The death that had already affected Sendak profoundly was that of his friend and collaborator Randall Jarrell, who had died suddenly and unexpectedly in 1965. Sendak has spoken movingly about his association with Jarrell, regarding it as one of the most meaningful collaborations in his career. There had been unusual sympathies and an almost telepathic order of communication between Jarrell and Sendak—Jarrell's wife Mary referred to it as an "inexplicable empathy"—and this influence led Sendak to create what is, at least on one level, an homage to their friendship. [12] That is to say, when Sendak himself once more took up the plight of the artist, he decided to do so in the pen and ink, cross-hatched style of illustration that he had perfected in *The Bat-Poet* (1963) and his other collaboration with Jarrell during the 1960s, *The Animal Family* (1965). Along with the choice of a subject similar to that of *The Bat-Poet, Higglety Pigglety Pop!* marked Sendak's return to a more discursive form that he had not worked with in his own writing for nearly a decade—since, in fact, the longer chapters in *The Sign on Rosie's Door*—but that Jarrell had used exclusively in his children's books. *The Bat-Poet* dealt explicitly and exactly with the emergence of the artist in the child as it followed the young bat's struggle to find his poetic voice and subject matter and thus his place in a world that understands neither his ambition nor his efforts to "[make] up songs and words all his own, that nobody else had ever said or sung." [13] This had been, of course, Rosie's plight, too. This, along with many other points of consonance led to an immediate rapport between the two men when they began

to work together in the early 1960s; Sendak later remembered that, when Jarrell would come to New York City with his wife Mary to mix work with Jarrell's passion (which was also Sendak's) for opera, they would often get as much work done in a few hours as it would take Sendak and another collaborator months of continual communication to complete.[14]

The bat-poet's problems in coping with the grumbling, often insensitive critics he meets during his artistic education parallel the process by which any poet learns his craft and then presents its finished results to an audience that can often be oblivious to or dismissive of his particular gifts. In writing about the bat-poet's development, Jarrell was reflecting on his own experience as a poet, particularly on his own attempts to write about one artist (Hart Crane, the model for the cardinal in *The Bat-Poet*), as well as on his own ambivalent feelings toward two others (Robert Lowell and Robert Frost, who are combined in the figure of Jarrell's narcissistic mockingbird).[15]

In *Higglety Pigglety Pop!* Sendak also selected an artist whose efforts might mirror his own concerns; Jennie becomes involved, as Sendak did in *The Nutshell Library* and *Hector Protector and As I Went Over the Water,* with the production of that most basic form of children's literature (indeed, of all literature), the nursery rhyme. But what Sendak also associates with Jennie, aside from the practice of an art form identical to his own, is that unique, often painful position of the artist as outsider. Whether on the inside looking out or the outside looking in, the artist does not perceive things through his window to the world in the same way as do the "normal," sleeping, unobsessed inhabitants of this same world. As he did with Rosie's dilemma, Sendak also portrayed in Jennie those feelings of isolation and frustration that he has often voiced about his own experience as an artist.

Both *The Bat-Poet* and *Higglety Pigglety Pop!* begin with similar images. The bat-poet, Jarrell explains in the opening of the story, "felt the way you would feel if you woke up and went to the window and stayed there for hours, looking out into the moonlight." The same lunary spell holds Jennie in the first picture for *Higglety Pigglety Pop!,* where Sendak depicts her gazing from her window at a landscape that has been lit by the full moon (Fig. 68). In both, the artist is a wonderer whose activity is associated with that archetypal symbol of the creative, the full moon of the anima, the feminine principle in the human psyche—the side that belongs to "the unconscious night realm of the moon in which the spirit world is revealed in shadowy, dreamlike visions."[16] Indeed, the whole of *Higglety Pigglety Pop!* seems to take place in this crepuscular spirit world, one that Sendak projects with meticulous care in the hazy, pen and ink, black-and-white illustrations for the book, many of which are set under and bathed in the light of the full moon, that highly charged creative landscape that Jung has called "the realm of Mothers."[17] The moon appears at crucial points in the story—at the beginning where it is small and fragmented behind banks of clouds; when Jennie is "called" on her adventure; and later in the story's moment of recognition, while "the night hummed" and "stars whirled in the full-moon sky," when Jennie is asked to take her place in the theater company she has aspired to join. In the latter instance,

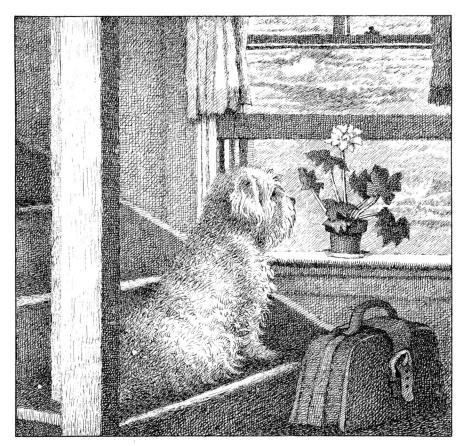

Fig. 68. Jennie at the window, from *Higglety Pigglety Pop!*

Sendak turns the moon into that most archetypal of mothers and source of our earliest connection to the creative, Mother Goose.

Before this recognition occurs, Jennie, like the bat-poet, is sent in search of experience that will be helpful to her in learning her art. But Jennie follows a different, less literal path than Jarrell's artist; her tests have less to do with the gaining of wisdom about her particular artistic practice than with acquiring the kind of discipline and restraint and having the transformative experience that prepares any artist for any art form. Finally, though, both books reach similar ends in which these budding artists are able to settle in with their respective communities: the bat-poet returns to roost with the other, now-hibernating bats, where he can rejoin their (and his own) natural cycles and fall asleep as he "snuggled closer to the others"; and Jennie takes her place with the cast of the World Mother Goose Theatre at Castle Yonder, where she at last finds contentment performing the play *Higglety Pigglety Pop!* "every day and twice on Saturday."

In his review of *Higglety Pigglety Pop!* for *Life* magazine, Robert Phelps, the biographer of Colette and Cocteau, was surprised by what he regarded as a new expression of Sendak's child, and described the work as "a fresh, tender, very so-

phisticated story—being, among other things, the first 'children's book' I have ever read which deals with so adult a matter as the artist's vocation." [18] As we have seen, though, years before he had met and worked with Jarrell, Sendak was concerned with the problems of the emerging artist, particularly the child artist, and he placed this subject at the center of *The Sign on Rosie's Door.* In *Where the Wild Things Are,* which Sendak was at work on the year before *The Bat-Poet,* Sendak makes Max an artist who has already begun translating his experience in the land he visits into a recognizable work of art (the drawing of the Wild Thing that appears in the opening picture of the book). Clearly, too, Phelps had missed Leo Lionni's *Frederick* (1967), which came out the same year as *Higglety Pigglety Pop!* and was a runner-up for the Caldecott Award. Lionni's picture book was a fable about a nonconforming field mouse who stores up memories and images instead of stomach-filling nuts and seeds; by the end of the story Frederick has become a poet who can bring a nourishing joy to his community and thus make Lionni's point that we need to gather *both* food and inspiring fantasies if we are to be properly sustained through any real or metaphorical winter. The subject, as they say, was in the air in the late Sixties, a decade that was busy valorizing the artist who created against the conventional grain. But no one working in the field of children's books had attempted to frame it in quite as unusual or complex a way as Sendak had.

The journey Sendak mapped for Jennie is a typical one for the artist, which is to say for one of the most familiar manifestations of the post-Romantic hero. Quickly she finds that she needs to gain experience if she is ever to arrive at her heart's desire—that elusive "something" she alludes to in the opening lines of the book. When Sendak revised this 1967 text into the form of the libretto for the 1981 operatic version of *Higglety Pigglety Pop!,* he would phrase her questions lyrically for a mezzo-soprano:

> Why am I longing
> To be away somewhere
> When everything's here?
>
> Why am I longing
> And lonely for someone
> When someone is here?
>
>
>
> What is this hunger—
> This fierce appetite
> For something out there
> When everything's here?
>
> What is this longing—
> This craving—this pining
> And incessant whining
> For something out there? [19]

This reconstructed, self-reflexive Jennie is not the "rough and ready" impulsive acquirer of experience in the first *Higglety Pigglety Pop!* Some twenty-five years had passed and now she was speaking for a Sendak who had weathered his fair share of storms and entered his sixties, having "gotten on with it," and thus, while he remained sympathetic, he had perhaps a bit less patience for the "incessant whining" of the younger artist.

Despite this added, ironic perspective concerning Jennie's plight in the opera, both the book and the opera plot the same narrative steps to help Jennie reach the particular, mythological resolution that she seeks. Jennie's predicament sounds like it could have been one of Kenny's questions: What are you missing if you "have everything"? What is the point of leaving if you don't have to and if you don't know where you are going to go if you did? Jennie's adventure leads her immediately into a world of ambiguous events and presences (the magical world that is encountered as soon as the threshold is crossed that separates the hero's normal world from what Campbell calls the "zone of magnified power"[20] in which his adventure takes place). As Alice discovers on her own trip through this world, ordinary logic and everyday reasonableness are quickly left behind. Instead, in Wonderland or the world that exists on the other side of the window in *Higglety Pigglety Pop!*, paradoxes abound and language itself becomes eel-slippery. Like Carroll, Sendak builds a world that is interwoven with puns and double entendres, underscoring the elusive reality that Jennie has ventured into, with its shifting, multiple meanings.

In the second chapter, for instance, Jennie meets a pig who, while offering her the curious, irresistible enticement of free and unusual sandwiches, also wears a sandwich board that advertises for that other alluring, enigmatic "Something Different" with its lapel-grabbing exclamations: "Wanted! Leading lady for the World Mother Goose Theatre!" (Fig. 69). All Jennie needs is experience, but how is she

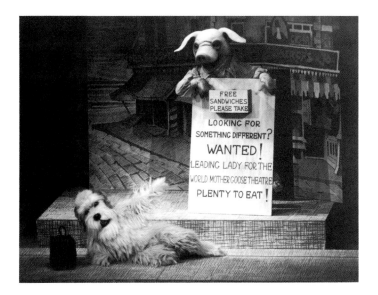

Fig. 69. Jennie (played by Cynthia Buchan) and the Pig (played by Andrew Gallacher) from the 1985 Glyndebourne Opera production of *Higglety Pigglety Pop!*

(how is anyone?) to get experience if she doesn't know what it is? In fact, Jennie is so naive that when the matter of experience comes up in her conversation with the pig, she replies nonchalantly, unconsciously, while "[sniffing] a liverwurst and onion on white bread, 'Never heard of it,'" as though it were just another sandwich she might sample. Jennie, the artist who doesn't know she is going to become an artist, has been "called," as mythic heroes are—to quests, to solve mysteries, to answer riddles. But in the fantasy Sendak has constructed for her rite of passage into this domain, she won't know who to contact when and if she manages to get experience. Like some cigar-chomping movie mogul, the pig tells her: "Don't call us, we'll call you." There are magical forces at work, as there always are in myths, fairy tales, and fantasies; and, though she and the reader do not know it at the time, Jennie has just met the first of those helpers who will guide her to Castle Yonder, that artist's paradise, that realm of spiritual fulfillment that is only reached after the hero has undergone his testing.

Yet there does not seem to be a clear path for Jennie to her existential enlightenment and her starring role. After the episode with the pig, she meets a milkman/cat who is making his morning deliveries. "The most terrific place on [his] route" just happens to be Baby's house on the outskirts of town; he guesses this is where Jennie is going and offers her a ride. Though she has not heard of the house, or Baby, or the lion that devours all the nurses who can't make Baby eat, Jennie nevertheless accepts the ride and agrees that she is, indeed, Baby's new nurse. She'll also make Baby eat, Jennie brags, while she greedily gulps down the contents of the cat's milkwagon. "*That* will be an experience," the cat tells her, using "experience" in its vernacular sense. However, this time Jennie hears another, more resonant meaning in the word and, thus, the hopeful resolution to the dilemma she was left with at the end of the previous chapter. As happens so often in the hero's journey, accidental meetings are not accidental at all: the cat, too, is one of her guides, literally conveying her to the threshold of her ultimate test and appearing again at the end to become one of her colleagues at the World Mother Goose Theatre.

Jennie, of course, finds it impossible to imagine "not wanting to eat," a characteristic that she has demonstrated in great gustatory detail in the story thus far and that she shows again in Chapter 4, when she meets Rhoda, the cook at Baby's house, and proceeds to con her into preparing a breakfast of pancakes and syrup to ease Jennie's "jumping stomach." Jennie's appetite does not flag, even in the face of the imminent danger of being eaten by "the downstairs lion" if she fails at her one chance with Baby, and this makes the challenge of feeding Baby all the more perplexing. Most healthy babies are known, at least in part, for their capacity to eat to the burping point of bursting, after which they fall happily to sleep. But Sendak does not take a conventional approach in his representation of the baby who appears in *Higglety Pigglety Pop!* His baby is at once more strange and more hilariously credible than the sweet, compliant creature of stereotypical habit, who coos happily as it trails its clouds of glory "out of the everywhere, into the here." Instead, Sendak gives us a suspicious, headstrong, demanding infant who is more destructive than divine, more Wild Thing than angel. When Jennie sips Baby's or-

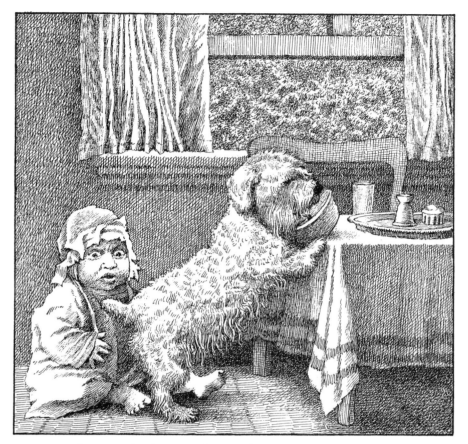

Fig. 70. A hungry Baby, from *Higglety Pigglety Pop!*

ange juice and says it is "yum, yum" in order to lure the baby into eating, Baby replies, "NO YUM!" When Jennie warns the baby that she won't grow if she doesn't eat, this unusually sentient baby replies, "NO EAT! NO GROW! SHOUT!" Finally, as the baby notices Jennie wolfing down her breakfast, she suddenly decides she wants to eat, but Jennie mistakes Baby's "EAT!" in this case as an invitation to Jennie to finish up the baby's cereal. Oblivious to this opportunity, Jennie snatches defeat from the jaws of victory and carries on her own, driven course of action. All that's left for Baby to take a bite from is Jennie's stub of a tail and for Jennie to snarl at the infant: "My tail isn't breakfast" (Fig. 70).

Sendak's image of Baby in *Higglety Pigglety Pop!* is taken directly from an early picture of himself, in gown and bonnet, standing on his mother's lap, fighting for his own sense of balance while she awkwardly tries to hold him steady in her hands. Sendak returns frequently to this specific picture of infancy in his work ("I love to draw babies," he told a lecture audience, "Given any opportunity, I draw them")[21]—from his illustration for Frank Stockton's *The Bee-Man of Orn* (1964) (Fig. 71) to the final volume of his picture book trilogy *Outside Over There* (1981). This is not the blessed babe of "The Luck of Roaring Camp" that had

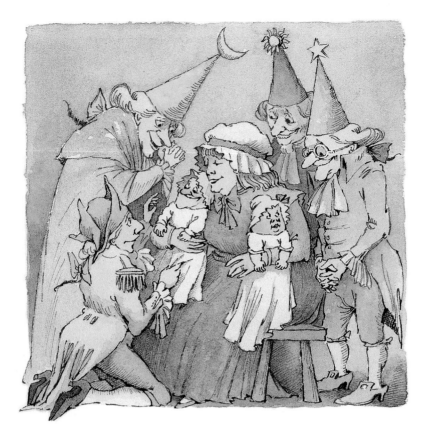

Fig. 71. The Bee-Man is transformed into a baby again, from *The Bee-Man of Orn* by Frank R. Stockton

fascinated Sendak when he read the story in high school, nor is it the blissful infant of George MacDonald's *The Light Princess* (1969), whose hovering shape (Fig. 72) Sendak illustrated several years after *Higglety Pigglety Pop!* Instead, Sendak shows us the other side of the baby archetype, a dimension characterized by the baby's contrary spirit, by its all-consuming demands, its inexplicable expressions and often explosive bodily functions. One of the best-known illustrations from Sendak's collection of Grimm's fairy tales, *The Juniper Tree* (1973), is his picture for the short, enigmatic tale "The Goblins," about the abduction of a human child by a group of tiny men who substitute a changeling "with a thick head and staring eyes who did nothing but eat and drink."[22] Sendak's illustration shows a large-eyed infant being carried along by six small goblins, who are straining under the weight of the gigantic child (Fig. 73). On seeing this picture one reader was evidently confused and asked Sendak whether he had drawn the real or the changeling child. Upon reflection Sendak "realized that [he] honestly didn't know. Because if you watch a normal, healthy baby, it *is* somewhat idiotic looking—no offense meant to newborn babies. They dribble in much the same way as one imagines a changeling would."[23]

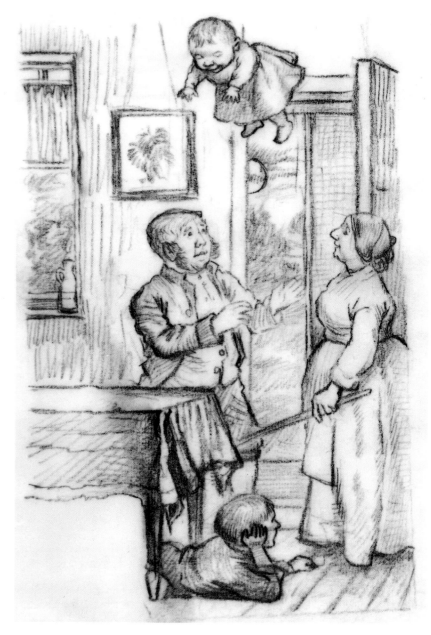

Fig. 72. Preliminary drawing for *The Light Princess* by George MacDonald

Importantly, in the late 1960s, at a time in the recent history of children's books when the child, and particularly the baby, tended to be portrayed in uncompromisingly bright terms, Sendak has acknowledged in *Higglety Pigglety Pop!* (as he did with older children in *Where the Wild Things Are*) that compensatory dark side which is unacknowledged and thus remains sequestered in the shadows of the unconscious. When we meet this shadow child in the form of Baby in *Higglety*

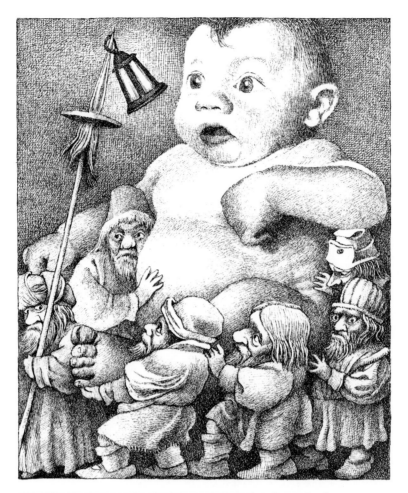

Fig. 73. Drawing from *The Juniper Tree and Other Tales from Grimm*

Pigglety Pop!, we may initially reject her as some grotesque parody of a baby until we also realize Sendak's point: babies can be exactly this impossible—in fact, we all were, to hear our parents tell the stories of our first months. One of the baffling mysteries of earliest childhood is that babies can appear to be both terrible and terrific, divine and demonic; and these states can shift in a matter of seconds. Every child is a changeling, and as adults and parents we must all, like the mother in the Grimm story, find the charm that brings the real baby back.

For millennia this charm has been located in what we collectively call Mother Goose rhymes, one of whose most ancient forms was an incantation that was meant to protect the sleeping child from Lilith, Adam's first wife according to Jewish folklore, the child-stealing spirit "bent on destroying any progeny that might be born to Adam by a second wife, or . . . to any of his descendants."[24] In a broader sense, lullabies and other Mother Goose rhymes served a function that extended beyond the defense of babies in the cradle. As perhaps the first forms of literature that the infant hears, or at least those for which they are the intended

audience, the vast oral library of nursery rhymes (which includes everything from nonsense verse, work songs, and topical ballads to tavern ditties, political squibs, and mnemonic devices for such purposes as counting the months of the year or predicting the weather) effectively "tunes" the child linguistically to the rhythms of her world and thus helps her to establish a verbal location in that world.[25] Nursery rhymes, and the sense of auditory order they provide, are one strand of those "songlines" that we "sing," to borrow Bruce Chatwin's metaphor, to bring our world into being, verbally, metaphorically, rhythmically.[26] Whenever we chant (a word, as it happens, that also supplies the roots for both "incantation" and "enchantment") those old songs to children, we are once again participating in the same ancient, oral power of language that offers a sheer pleasure of repetition and a final, satisfying release of completion; the evocative newness of unexpected images, names, actions; the healing balm of their sibilant poetry; and, not least of all, a sense of safety and protection, of familiar, encircling words that are unrehearsed, instantly available, endlessly repeatable. To spell out these words aloud is to lay down a spell.

Sendak finds in the figure of Mother Goose—the archetypal purveyor of this word magic—the charm that will protect Jennie at the climax of her ordeal and will give purpose to both her life and her art. But before this happens Jennie must first make her descent into the depths of the house, where the roaring lion is waiting. It is her final test and one that she again has stumbled into by accident. Having failed to make Baby eat, Jennie has crammed the child ("kicking and punching and yowling") into her "black leather bag with gold buckles" in order to escape from the house before the lion (which has been roaring louder and louder from the basement) does, in fact, eat her. Jennie has spoken with Baby's mother by telephone; she has already taken up residence at Castle Yonder, and she asks Jennie to send Baby along by way of the lion in the basement, but she hangs up before she can tell her Baby's name—the only word that will prevent both Baby and Jennie from being consumed by the beast.

With Baby now snoring away inside the valise, Jennie tries to slip quietly out of the house. She has decided, for the first time in her journey, to think about someone other than herself and to take responsibility for the welfare of another living creature; "I am personally taking Baby to Castle Yonder," she writes in a note she leaves for Rhoda the maid, because the lion "would only eat her up along the way." She is not even bothered by Baby's destruction of the personal treasures that Jennie has been carrying with her in her bag. But Jennie takes the wrong corridor in her descent from the nursery ("she turned left instead of right"). Again Sendak uses food imagery to describe the ominous course the story has taken: "The butter-yellow windows had darkened to bean-soup black." Sendak would return to these windows over a decade later in *Outside Over There*, using them there, as here, to provide the tangible containment for the subjective turmoil of emotions. In this more recent work he would also revisit the primal situation of an older child, being asked to serve as a nurse for a much younger child, ultimately having to find the charm that works to rescue the infant from threatening forces

(the five goblins), as Jennie is called to do in her encounter with the downstairs lion.

In this confrontation Jennie has finally met her match in a creature who, perhaps more than any other, epitomizes the devouring essence of animal nature. He is the ogre/giant/monster/beast that the hero meets when he takes "the perilous journey into darkness by descending, either intentionally or unintentionally, into the crooked lanes of his own spiritual labyrinth" where he encounters "symbolical figures (any one of which may swallow him)."[27] Surely he is Jennie's symbolic father, the king of beasts from whom she can be said to inherit her own voracious appetite along with other traits, like her initial lofty indifference to others: the lion talks to her as he is preparing to devour her just like she nonchalantly converses with the plant in the opening chapter, all the while nibbling away on its leaves until there is nothing left to talk to. In short she is meeting in the lion the dark, insatiable heart of her own drives that propel the child-trickster-hero along her egocentric road to this crucial point "when the senses are 'cleansed and humbled' [in] . . . the process of dissolving, transcending, or transmuting the infantile images of our personal past."[28] Jennie's confrontation with the lion is much like Ged's turning to face his shadow in Ursula Le Guin's *The Wizard of Earthsea;* the psychological truth of both encounters is that for us to have any hope of "finding" ourselves, as Jennie seeks to do in her quest for meaning, we must ultimately come to terms with whatever it is that we reject or repress about ourselves. For Jennie her weakness is a trickster's appetite that is not tempered, a hunger that is without restraint and one that gobbles up the edible things of her existence without returning anything to it.

She must face the unmitigated ferocity of this appetite the moment she steps into the basement. At once the lion bellows "Another nurse, and a fat one too!"; Jennie can only muster a comic whimper in reply. "I can only stay a minute," she tells the lion. Yet the intensity of the lion's bellowing triggers an unexpected response in Jennie. When the lion threatens the baby, sniffing at the bag and exclaiming, "Ah, . . . I haven't eaten a baby in such a long time," Jennie immediately shows her pluckiness again, only here, in this context, the quality is an act of courage instead of self-absorption. Jennie places herself between the lion and the once cantankerous, now terrified child, who has begun to crawl out of the suitcase, all the while screaming "NO EAT!" Baby's stock phrase has remained the same, but the change in context makes her exclamation simultaneously funny and frightening. Sendak intensifies the paradoxical quality of this moment in the story through the illustration that accompanies it in which he shows the lion in seething fury, its fangs bared in a snarl, hovering over the absurd baby in its bonnet who is trying to haul itself out of the suitcase (Fig. 74). Jennie tries to bribe the lion with the contents of her suitcase as compensation for not eating Baby, but all of the prized material possessions she has carried along with her on her journey have been broken or torn apart. Her own drives have left her with no other option but to offer herself as the victim of the lion's appetite, which is, of course, the distorted mirror image of her own appetites. The trickster has finally been tricked.

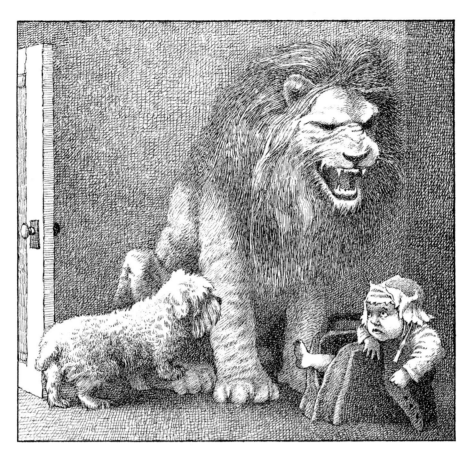

Fig. 74. Baby and the lion, from *Higglety Pigglety Pop!*

However, Sendak can't seem to stop his characters from joking, even at this crucial moment. He has Jennie tell the lion, "Please eat me. I need the experience anyway." And we wouldn't want Sendak to stop the wisecracks: this continual interplay between the serious and the comic, the frightening and the funny gives the book its unusual balance, much as Sendak's choices about how to depict the monsters in *Where the Wild Things Are,* as Perry Nodelman has noted, prevent those creatures, suggestively described in the text, from becoming visual terrors for the young reader. And like *Wild Things, Higglety Pigglety Pop!* is a fairy tale with a happy ending, a comic and not a tragic plot, even if Jennie barely gets her head out of the lion's jaws before they snap shut, leaving "the tip of her beard" behind.

What has saved her from the lion's jaws is her mentioning the name "Mother Goose," in what she thinks may be her last words about her dream of becoming the leading lady in the World Mother Goose Theatre. In her act of apparent self-sacrifice, she has magically (and, again, accidentally) stumbled on the formula that will save her. Ironically, she thinks that being eaten will get her the experience that she needs for the part. But this is only the most literal side of the truth; the fact is

that she must simply be willing to let herself be eaten for there to be some chance of a breakthrough in her search for experience.

Still, Sendak gives Jennie another chapter to contemplate what has happened to her in the basement. In fact, she does not even know whether or not she has successfully saved Baby or gained the enigmatic experience she needs. Upon her mentioning the name of Mother Goose, the lion grabs the baby in its jaws, presses a button to a secret exit, and springs out of the house and "high into the night." Jennie is left alone again—the house has suddenly disappeared—while, Sendak tells us, "the stars were shining" and "the moon was full." To emphasize her isolation and to pique our sympathies, Sendak gives the reader a simple, unbordered sketch of her at the end of the chapter, the end of her beard trimmed, staring off at the white margin of the page (Fig. 75).

With this image Sendak leads us into the next chapter where he returns his heroine (and the reader) to a world that parallels the one she left at the beginning of the story to embark on her adventure. Once again, Jennie converses with a representative of the vegetable world—this time an ash tree who, like Jennie at the beginning of the story, "has everything" but bemoans the fact that she is going to lose everything—her leaves, contact with her friends, her life force—with the approaching winter. Jennie is puzzled and she wonders aloud, reversing the phrase she used at the beginning of the story, if "there must be more to life than having nothing." Whether one has everything or nothing does not seem to matter; life is a grim, absurd affair. The world, in the bleak words of the house plant from the first chapter, is anything but "a clean, well-lighted place": it's "dark and deathly cold" and only leads to the "nada" that Hemingway described in his famous short story, where the lonely, isolated individual contemplates, like Sendak's geranium in the operatic version of the story:

> [W]hose love will warm you when you're old
> And wandering still, until you reach
> The nothing which is everything?

As the ash tree showers its dead leaves, all the while keening over the coming winter that will leave it "nothing but the empty, frozen night," Jennie curls up under them and goes to sleep. It seems like nothing has been accomplished by her quest; if anything, she seems even closer to the existential abyss than she was at the beginning. Life passes; cherished friends, parents, and pets die; and none of it makes any more sense now than it did at the start of Jennie's adventure.

Yet there is a difference. Jennie has had ex-

Fig. 75. Jennie, from *Higglety Pigglety Pop!*

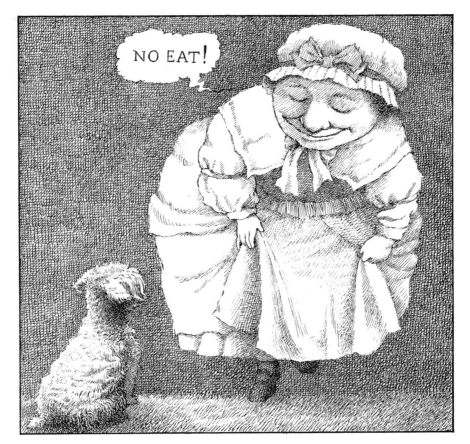

Fig. 76. Jennie and Mother Goose, from *Higglety Pigglety Pop!*

perience; she has put her head in the lion's mouth and lived to tell the tale. True to her indomitable character, she even dreams in the next chapter of catching a lion, who tells her, "Please eat me up, there's nothing more to life." But she still has not recognized the qualitative shift that has occurred in her life because of what she has been through. She is pulled out of the involuntary, wish-fulfilling world of the dream by substantial voices—those of Rhoda, the pig, and the cat—that call her name and, when she wakes up and comes running to them, welcome her into the company of the World Mother Goose Theatre. Most magical of all, Mother Goose arrives herself, metamorphosing from the shape of the full moon that has been hanging over the landscape of this scene, floating ever closer like the bubble of Glenda the good witch in the film version of *The Wizard of Oz* (Fig. 76). In the libretto for the opera of *Higglety Pigglety Pop!* Sendak titles this scene in formal dramatic terms as the "Recognition," the point in the play when disguises are dropped, loose ends are neatly knotted, and the audience discovers, along with the characters, the point of the drama it has watched unfold.

Sendak, however, does not offer the reader tidy, obvious solutions. There is no blinding flash of realization on Jennie's part about what her adventure has

meant—there is, in short, no moral. Sendak leaves conclusions unstated, implicit; Jennie (or Sendak) does not tell us what she has learned or what we are expected to take away from the story. We are not surprised that the pig, the cat, Rhoda, and even Mother Goose and the lion would all reappear in their true identities; indeed, it would be strange if they did not. Initially it may strike one as unusual that this recognition scene would include Mother Goose's revelation that she has also been playing the role of Baby. But then it makes perfect sense: Baby and Mother Goose are inextricably linked: not only does Baby come from Mother Goose but Mother Goose comes into being through Baby, through her physical presence and emotional demands. In his *Fantasy Sketches,* Sendak had explored the idea of the child incorporating the mother and the mother incorporating the child—neither to a mutually satisfying end. But in *Higglety Pigglety Pop!* he gave this complex, symbiotic relationship between mother and child a positive, symbolic form. Indeed, it is through the power of Mother Goose and her company that Jennie is finally able to realize her full potential as an artist, when it is announced that she has become the leading lady in their production of *Higglety Pigglety Pop!* After she hears this, Jennie can only exclaim, "How beautiful," at the aesthetic wonder of it all, just before she, along with Mother Goose and the rest of the cast, are transported on the lion's back (like the family in *Pierre*) to that edenic world which awaits the hero after his adventures and where in Jennie's case she will bring the boon of her performance to an eternally interested, eternally grateful audience. It is also through Mother Goose that Sendak finds the resolution for the existential dilemma that he has set up for the reader in the book.

Readers of *Higglety Pigglety Pop!* often remark on the oddness of the final play that ends the story. Is it really necessary, they ask, to see a peculiar play about a dog who swallows a mop, collapses, and is attended to by a pig physician, after which the dog bravely regurgitates the mop just in time to drive away an escaped lion before it can devour her, Dr. Schwein, the lion-tamer cat, or Rhoda? Perhaps not. We do, however, need to see a performance by the World Mother Goose Theatre if the promise of our earlier expectations about this unlikely troupe is to be kept. We especially need to watch Jennie's performance if we are to be satisfied that she has finally arrived at the end of her quest and found her artistic calling— that, in short, Sendak isn't simply punning when he has the other characters in the story "call" Jennie and thus signal the resolution of her vocational and existential dilemma. But even with these justifications, the nursery rhyme play seems an unusual ending—at least until one examines it more closely in terms of Sendak's fascination with nursery rhymes, their rich artistic possibilities, and their ultimately transcendent quality.

Throughout his "apprenticeship" of the 1950s and in those flowerings of his vision in the early 1960s, Sendak was drawn back to the nineteenth-century roots of the contemporary picture book. Following Caldecott's lead, Sendak had been experimenting for some years prior to *Higglety Pigglety Pop!* with the form of the picture book that took as its occasion the traditional nursery rhyme, using those anonymous texts to provide the stimuli for fantasies that would make narrative

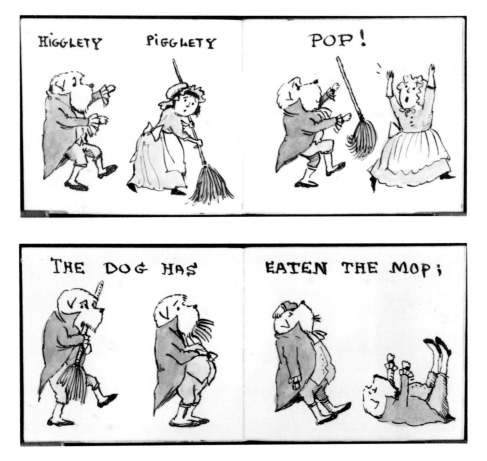

Fig. 77. Preliminary drawings for an early version of *Higglety Pigglety Pop!*

sense out of the generally opaque meanings of these verses (Fig. 77). Sendak claimed his poetic license, as Caldecott had done in his classic picture book settings of such nursery rhymes as "Hey Diddle Diddle" and "Baby Bunting," by arguing that "a nursery rhyme from Mother Goose, which might have meant something quite specific in an earlier century, means nothing now. You can make of it what you will."[29] Sendak was struck by the narrative richness that Caldecott found in these rhymes, especially those darker emotional tones that entered Caldecott's books, "like a shadow passing over very quickly," bringing to them an "unexpected depth at any given point within the work."[30] Sendak was attracted to the powerful human dramas that Caldecott had surprisingly compressed in his treatment of the rhymes rather than to any historical explanations, such as those arcane explications that Cecil Baring-Gould had published in *The Annotated Mother Goose* (1962). Sendak let that imaginative independence take precedence over academic arguments in *Hector Protector* and *As I Went Over the Water*, two nursery rhymes that he illustrated and published together in one volume in 1965.

In his notes on the first of these rhymes, Baring-Gould identified Hector Pro-

tector as the Earl of Hertford, who was meting out punishment to Scotland's Queen Regent because she had rebuffed Henry VIII's efforts to match his son with the then child princess Mary Queen of Scots.[31] But Sendak tells us a very different story, of a little boy (a close cousin to both Pierre and Max) whose mother dresses him "all in green" (Fig. 78) in order to have him take a cake to the queen, a prim and proper Queen Victoria. Along the way Hector meets and tames a lion and a snake and, riding the former and waving the latter, bursts with unbridled, phallic aggressiveness into the queen's throne room (Fig. 79) where he and his equally pugnacious animals threaten her, the king, and their pet dog—a small, white terrier (Jennie again). Here Sendak plays variations on the theme that he had developed in *Where the Wild Things Are;* Hector is driven from the palace under a hail of pots, pans, and rotten tomatoes, and, upon arriving home, is sent to bed without supper. This time, though, the good bad boy doesn't manage to have both his fun and his cake; he can't convince the blackbird, which has acted the part of a moral chorus throughout the story, to give him a crumb from the cake that he unceremoniously kicked along the ground instead of taking it to the queen. Ironically, the "no!" that Hector screams whenever he is asked to do something in the story is sent sailing back to him by the cake-filled blackbird.

However, even the historical gymnastics of Baring-Gould's extensive, esoteric notes cannot unravel the perplexing *As I Went Over the Water,* and so Sendak's solution is all the more ingenious: another Max-like little boy sails his boat (aptly dubbed *Victor*) onto a sea monster. The leviathan swallows the boat but not before the boy jumps into the ocean ("the water went over me"), punches the creature, and safely swims ashore, giggling to himself. Like Max, he knows the way to

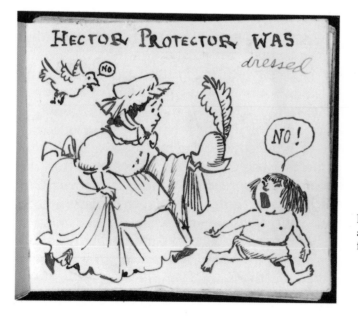

Fig. 78. An uncooperative Hector and his mother, preliminary drawing for *Hector Protector*

Fig. 79. Hector's entrance, from *Hector Protector* and *As I Went Over the Water*

handle monsters or insulting blackbirds ("One called me a rascal and one called me a thief"). In the end he again tames them all (Fig. 80): the sea monster returns his boat, and the two birds, dazed and toothless from the beating he has given them, join him as they all continue to sail across the green, transparent ocean (Fig. 81). Once more the child triumphs in the sometimes brute struggle between the piloting awareness of the ship of the ego and those powerful, submerged forces of the unconscious that can unexpectedly surface. In keeping with the tenor of many nursery rhymes, Sendak does not opt for delicacy or magic tricks; his little boy simply and surely asserts his authority and summarily whips these rebellious elements back into line. Though every one seems happy in the end, including the birds, Sendak does not return to such explicitly fierce images in his later work, even in his illustrations for the Grimms' fairy tales that he selected in *The Juniper Tree*; here he left any moments of overt violence discreetly unillustrated. Sendak's brash approach to the nursery rhymes did not cause then the kinds of objections that might be raised today; in fact, quite the opposite: his treatment of the rhymes was welcomed as an exhilarating tonic. In her study of the American picture book, Barbara Bader credits *Hector Protector* and *As I Went Over the Water* with having "opened the floodgates to the independent illustration of rhymes—in part because of the possibilities for elaboration it suggested—and also to the disinterring of obscure and/or unlikely material, often for unusual treatment."[32]

In order to mine more of this tantalizingly untapped material, Sendak had for a time toyed with the idea of doing a volume of nursery rhymes. Eventually he abandoned the project because nearly all of the rhymes he selected, he later told Selma Lanes, repeated a similar motif *ad nauseum*—eating. Instead of a food-fixated Mother Goose anthology, Sendak chose a single verse as the inspiration for his next book, Samuel Griswold Goodrich's "Higglety Pigglety Pop!" which contains one of the most incongruous eating scenes of all juvenile literature in the

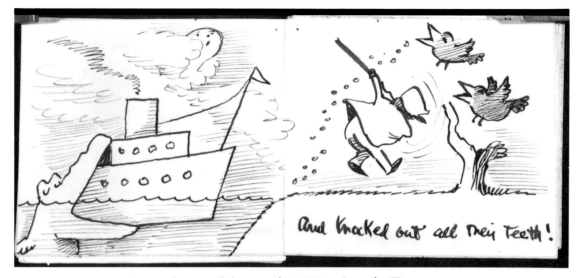

Fig. 80. Preliminary drawing for a small dummy of *As I Went Over the Water*

flat, clipped syllables of its second line: "the dog has eaten the mop." It struck Sendak as an all-too-appropriate line to describe his dog Jennie, who had a peculiarly ravenous appetite and might "in real life . . . abandon her owner if the food was not good—or if the food elsewhere were better."[33] Of course, Goodrich had meant his lines to be absurd; he had made them up in a few minutes as part of his spirited "campaign against make believe."[34] He was convinced they would demonstrate the meaninglessness of such frivolous inventions as nursery rhymes and remind other nineteenth-century adults of their responsibilities as the guardians of the minds of children and thus of their literature. After all, Goodrich reasoned, "do not children love truth? If so, was it necessary to feed them fiction? Could not history, natural history, geography and biography become the elements of juvenile works in place of 'fairies and giants and mere monsters of the imagination?'"[35]

The presence in Goodrich's rhyme of a dog and an eating scene may have been the decisive factors in Sendak's choice of the verse as the vehicle for his story about Jennie, but there is a deeper connection between Goodrich and Sendak that was formed through this verse and that makes Sendak's choice of it especially fitting. Goodrich had made up the rhyme as part of a short conversation between a mother and son entitled "Nursery Rhymes: A Dialogue" that appeared in *Merry's Museum*, the magazine that Goodrich was editing and writing for in the 1840s. In this short play, a boy named Timothy has invented a rhyme ("Higglety Pigglety Pop!") and begs his mother to "stop a minute, and hear me say my poetry." After his recitation his mother replies that she doesn't "see much sense in [the poem]," despite the fact that she has just given Timothy a book of nursery rhymes that, though "silly as they are, might induce you to study your book, and make yourself familiar with reading."[36] Timothy, however, rejects her rationale. It is precisely the "silliness" of the poems in the book that he responds to, and he insists on repeating

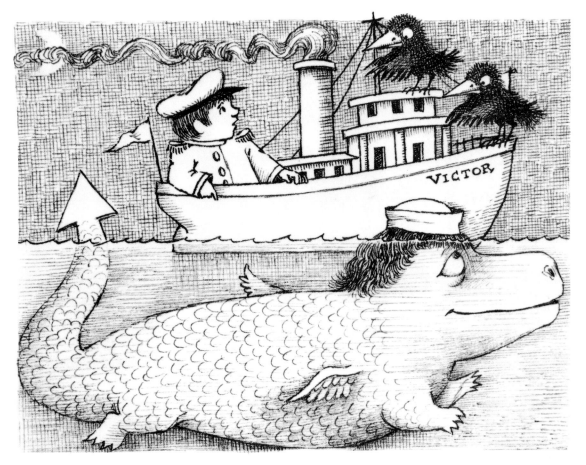

Fig. 81. Smooth sailing on the *Victor,* from *As I Went Over the Water*

them, with growing, delighted mischievousness. Half a dozen poems later his mother has become increasingly agitated—like Max's mother in *Where the Wild Things Are.* She is at the end of her rope when she confides to the reader: "Dear, dear, what shall I do? The boy has got his head turned with these foolish rhymes. It was really a very unwise thing to put a book into his hands, so full of nonsense and vulgarity. The rhymes seem to stick like burrs to his mind, and the coarsest and vilest seem to be best remembered. I must remedy this mistake; but I see it will take all my wit to do so."[37]

Timothy is unrelenting, even though she threatens to take away his book ("I don't care," he tells her, "I know all the best of it by heart") and box his ears if he doesn't stop. Finally, she settles on sending him to bed and, Pierre-like, Max-like, off he goes, still reciting his poem while his mother has become apoplectic. Sendak would delight in drawing such a scene, of an adult driven to utter distraction by a demanding chorus of chanting children, for the Opies' collection of children's folklore *I Saw Esau* (Fig. 82). The good bad boy offers Goodrich and, presumably, his audience little cause for merriment or reason for indulgence; but it is interesting

Fig. 82. A chorus of reciters, from *I Saw Esau: The Schoolchild's Pocket Book*, edited by Iona and Peter Opie

to note in his creation of Timothy, the Wild Thing of *Merry's Museum* who over-turns the didactic specimen cases of good behavior, that Goodrich is unable to completely stifle the boy's energy and make his conduct reprehensible.

The book that evolved from this rhyme became, then, a parody of Goodrich's position—in effect, a parody of his parody. Sendak would not let the reader off the title page of his own book without making this satiric point in the weighty subtitle that he attached to his version of the verse (*There Must Be More to Life*), poking fun at a didactic device that was so common throughout the eighteenth and nineteenth centuries as to become a cliché but to which Sendak gives a fresh turn in this modern context. He took this allusiveness further by deliberately echo-ing the illustrative style of such nineteenth-century artists as Arthur Hughes, George Pinwell, and George Cruikshank (see especially Cruikshank's 1860 comic-strip-like presentation of the puppet play *The Tragical Comedy or Comical Trag-edy of Punch and Judy,* which has some striking similarities to Sendak's closing drama, including a window at the back of the stage) and by making *Higglety Pigglety Pop!* more verbal than visual, a conventional illustrated book rather than a picture book. The pictures themselves, in which Sendak models his figures from thousands of tiny cross-hatchings, are carefully held within borders; they are the antithesis of the surging, emotional, bled-to-the-edge pictures of *Where the Wild Things Are.* Nothing, it seems, can disturb the placid, disciplined quality of the book. Everything seems completely in order, as a properly rational, right-minded nineteenth-century volume for youth should be—until one looks carefully at Sen-dak's opening picture.

In his frontispiece for the book, before we have had the philosophical problem of the book stated for us, Sendak introduces us to Jennie. She is seated on an ordinary chair in a thoroughly human posture, one paw placed casually on the

table, looking directly at the reader. Before her are the bottles of pills and the dishes that we will hear about later when she packs them up prior to setting off on her travels. Behind her Sendak has hung a picture of Leonardo da Vinci's *Mona Lisa,* a personal joke about the original name of the real Jennie that the reader will not get if he has not read Lanes's biography or some other account of the evolution of the book and its allusions. But it does not matter whether or not we possess this specific piece of information. In fact, our *not* knowing that Jennie was originally named Mona Lisa makes this a much more provocative picture. For Sendak is inviting us to compare the famous, enigmatic smile and flowing coils of hair of Leonardo's subject with that of Sendak's unexpected subject; the mystery of la Giaconda is being echoed in the strangeness of this composition, which, though it appears on its surface to be so convincingly commonplace, is at the same time surreal, hallucinatory, extraordinary. Before one has even begun the text, he is immediately caught up in one of the basic strategies of Sendak's books, which is to make the fantastical so real that it becomes instantly credible, so much so that we are not initially aware of the strangeness that Sendak has already persuaded us to accept. "Life is real, life is earnest," Longfellow, Goodrich, and countless others reminded their nineteenth-century readers, but Sendak has already proposed that there is something "more" to it than such simplistic, joyless assertions. And he will go on to suggest in the opening chapter, in which we meet in Jennie a character who has had enough of this weighty seriousness and predictability in her life to want to make a change, that even the possibility of an unstable world outside, with its existential uncertainties and dangers, is preferable to the oppressiveness within.

Higglety Pigglety Pop! asks the reader to give up these serious expectations, to set aside conventions for a few minutes, and, with Jennie, to jump into an unfamiliar world and do what life sometimes frustrates in us: to play—to play with language, artistic form, images, paper, type, visual images—all the things that a book allows the writer and his readers to do. The controlling metaphor in *Higglety Pigglety Pop!* is play—play as the "something more" in life that helps us to make whatever sense we can of life's absurdities. In opposition to the seriousness, the rational control, and the logical orderings of material things, play provides the unexplainable, irrational element. Voltaire's advice in *Candide* was to cultivate one's garden; Sendak's in *Higglety Pigglety Pop!* is to cultivate the spirit of play.

This sense of "play" includes not only the drama that is performed at the end of the story (though this is surely a crucial, formal moment of play in *Higglety Pigglety Pop!*) but also the general activity which serves as a philosophical alternative to "seriousness," to the attempts of rationality and logic to provide the answers for our most profound questions. In his classic study of "the play element in culture," *Homo Ludens,* Johan Huizinga maintains that play has "permeated . . . the great archetypal activities of human society . . . from the start."[38] Much as we may dismiss the importance of play as a "childish" activity in order to elevate more "adult" enterprises, Huizinga reminds us that most of the elements we regard as fundamental to our ideas of civilization (such as language, mythology, philosophy, law, politics, and art) begin with play:

[A] certain play-factor was extremely active all through the cultural process and . . . it produces many of the fundamental forms of social life. The spirit of playful competitions, as a social impulse, is older than culture itself and pervades all life like a veritable ferment. Ritual grew up in sacred play; poetry was born in play and nourished on play; music and dancing were pure play. Wisdom and philosophy found expression in words and forms derived from religious contests. The rules of warfare, the conventions of noble living were built up on play-patterns. . . . civilization is, in its earliest phases, played. It does not come *from* play like a babe detaching itself from the womb: it arises *in* and *as* play, and never leaves it.[39]

Though it touches nearly every aspect of our lives, actual play exists outside the sphere of ordinary activities, in a special, often a sacred space (the playground), with secret language and rules and often with masks or other disguises. Within this separate world, Huizinga reminds us, play creates its own order and protocols that do not follow those of the real world—in fact, it runs counter to the spirit of play to try to impose the rules of the skeptical, nonplay world on it, for "play lies outside the antitheses of wisdom and folly . . . outside those of truth and falsehood, good and evil."[40]

In this regard Sendak creates in *Higglety Pigglety Pop!* a play space that exists outside ordinary, daily experience, and he is keenly aware of its boundaries and rules. In interviews Sendak frequently alludes to the personal "games" that he plays with his books (using the names of friends in pictures, incorporating objects that are especially important to him into his illustrations, devising elaborate connections between characters in different works)—games to keep himself fully engaged in the process of creation (which is done separate and apart in that sacred play space called the studio). Sendak communicates this spirit of play to his wide audience of readers on multiple levels: in the ways he plays with reader expectations and the conventions of a given genre; in his juxtaposition of contemporary language with a style of illustration from the historical past, recombining the elements into strikingly new patterns, as in his playful democratization of images that fuses in one frame Jennie and the Mona Lisa.

The impulse to play with the forms of both the picture book, like *Wild Things*, and the illustrated book, like *Higglety Pigglety Pop!,* pervades Sendak's work from its beginnings, but it gains added confidence and authority from the 1960s to the present. Like Jennie, restlessly looking for that "something more," like the child in MacDonald's *The Golden Key* (which Sendak had illustrated just the year before *Higglety Pigglety Pop!*), ceaselessly creating new arrangements with a group of magic balls in his sacred play space at the center of the earth, Sendak is also in search of new forms and combinations in his works. This aesthetic playfulness in Sendak may help to explain why he has continued over the twenty-five years to resist being caught in a particular style of illustration or form of composition, or why in a given work Sendak's drafts will usually play through his repertoire of visual and verbal styles before he settles on a specific interpretative tone. Similarly,

Sendak's creation of *Higglety Pigglety Pop!* does not stop with a book; he plays it into an opera in the 1980s, with an expanded text and an enlarged sense of the absurd, and it might well play in still another form if it becomes the subject for one of the films that Sendak plans to be making in the 1990s.[41]

Though it is often overlooked in discussions of Sendak's work, *Higglety Pigglety Pop!* was crucial to his development. Jennie's quest gave shape to Sendak's own search for that nourishing "something" that transcends the absurd limits of life. Into Jennie, Sendak could project the artist's appetite—what Samuel Johnson called the "hunger of the imagination"—showing how it can be turned, at the climactic point of the book, from a weakness to the strength of her art. Once Jennie is willing to let herself be consumed, she is freed from her compulsion and free for the first time to experience purposeful consummation—to do the play in which she gets to eat a mop made of salami "every day and twice on Saturday."

Unlike the ending of *The Sign on Rosie's Door,* in which Rosie remains isolated and can only perform her song of herself for herself, Sendak has found a public forum into which Jennie may channel her creative energies. In this regard, Jennie is the first of Sendak's children to mature, to resolve not only her immediate problem but also to move on to a conclusion that is not conditional and temporary. Max will have to go through his battles with the Wild Things many times; Pierre will continue to get angry—with his parents, his friends, his circumstances. But Jennie goes further than any of the previous characters; she sets off in search of no less a grail than the meaning of life, and she finds it in the power of the imagination to play with meanings and thus define new boundaries for our experience. The world of art, we (the adult and the child readers of the book) learn through Jennie, is a world of play—of playing at art and learning the art of playing, of finding the sense of nonsense.

Most of all we discover with Jennie that play "creates order, is order," and that "into an imperfect world and into the confusion of life it brings a temporary, a limited perfection."[42] This perfection steals a piece of eternity to sweeten the bitter taste of the now—for Sendak in his own "fevered" attempts to construct a meaning in the midst of his dark night of the soul, for us (adults and children alike) in ours. "Eh, Doc, don't take life so seriously," Bugs Bunny says in one of his most philosophical moments, "'cause you ain't getting out of it alive." Which is all the more reason, Sendak seems to be suggesting in *Higglety Pigglety Pop!,* why we need to take it seriously enough to play with and at its profoundly absurd, funny, frightening elements, fusing them into a new, unexpected whole—which is why the show (and the artists who perform it) must go on, and on, and on.

MICKEY
"In Dreams. . . ."

The dream was marvellous but the
terror was great; we must treasure
the dream, whatever the terrors.
—*The Epic of Gilgamesh*,
translated by N. K. Sandars

HE NEXT OF SENDAK'S CHILDREN—
Mickey of *In the Night Kitchen* (1970)—
emerged nearly seven years after Max, his closest picture book
sibling, and a full three years after Jennie began performing her
perpetual role with the World Mother Goose Theatre. Those two-
and-a-half years from 1968 to 1970 were the worst times Sendak
had encountered in his life. He suffered a coronary in 1968, while
in England, and after recovering and returning to New York later
that year, he realized that he would have to have Jennie put to
sleep, a loss that was soon followed by the death of his mother
from cancer, and then by the news that his father, too, was also
afflicted with terminal cancer. In mourning, he had reached his
early forties, he told a friend, and was "fast becoming an or-
phan." [1] Ironically, though, the other half of Dickens's phrase also
held true for Sendak; it was the best of times. In 1970, Sendak
won the equivalent of the Nobel Prize for children's literature, the
Hans Christian Andersen Medal, for his lifetime contribution to
the children's literature of the world.

Though these were bleak, depressing days, Sendak had man-
aged to keep working. Between *Higglety Pigglety Pop!* and *In the
Night Kitchen,* he had done a small group of illustrations for a
limited edition of selected poems from Blake's "Songs of Inno-
cence"; the final volume of the Little Bear series, the touching *A
Kiss for Little Bear* (1968); and the suite of pen and ink illustra-

Fig. 83. Drawing from *The Light Princess* by George MacDonald

tions for a new edition of George MacDonald's *The Light Princess* (1969), which included as its frontispiece a picture, done in Sendak's nineteenth-century "black and white style," of the princess as a little baby, an angelic Sendak child floating naked past a window while her mother, lost in thought inside (like Ida's mother would be years later in *Outside Over There*), remains oblivious to the child's ascension and her rather surprising predicament (Fig. 83). The princess and Mickey (the latter who also appeared airborne in *In the Night Kitchen* a year later) are closely related, masculine and feminine halves, as it were, of the same child; both are figures of archetypal becoming: the princess in her discovery of gravity, of an emotional weight that would give her substantial humanity; Mickey in his deter-

mined flight to find the missing ingredient for the morning cake, thus heroically reversing the dark, downward pull of his dream. These two children marked another advancement in Sendak's public iconography in the form of those naked flying children whose ancient origins return us to the angelic *putti,* who have been the helpers of Dionysus, the attenders of Christ and the Virgin Mary in such Renaissance imagery as that of Raphael, and the source in the Romantic tradition of a mystical union with nature in the paintings of the German artist Philipp Otto Runge, whose drawings and portraits of children would have a decisive, pervasive effect on Sendak's depiction of the child in the final part of his picture book "trilogy" *Outside Over There* (1981).

The seven years that had passed between *Where the Wild Things Are* and *In the Night Kitchen* are an indication not only of Sendak's slow working habits when it came to the writing of his own picture books but also of his determination to wait until he had a story that would be distinctly new. He spoke about *Night Kitchen* in an interview with Virginia Haviland, then the head of the children's division of the Library of Congress, noting that he had spent "two years of concentrated work" on the book, being "completely absorbed in this dream, this fantasy."[2] When Mickey finally took his place among Sendak's children in October of 1970—in a book "as much awaited as any picture book has been" and in a form that "was, as touted, unlike anything Sendak had done before"[3]—he had mixed together Max's boldness and Rosie's creative resources, Pierre's pugnacious tenacity and Johnny's aplomb, to reach a synthesis of qualities and elements from his earlier characters (Fig. 84). Unlike Jennie, who plays a part in a drama she did not invent, Mickey is a heroically empowered child who composes his own "music." Mickey successfully drew together Sendak's biographical obsessions and his creative concerns with a now more conscious interest in mythmaking since he had released Max to sound this impulse with his original, precedent-setting "barbaric yawps."

In the Night Kitchen was meant to be a "more universal" book than he had done before, he told Gene Deitch, the filmmaker, as they were preparing to make an animated version of the book in 1984.[4] But to reach those "universals" Sendak found that he had to dig still deeper into his past than he had done in the previous books. *In the Night Kitchen* had come, he reported, from "the direct middle of me, and it hurt like hell extracting it. Yes, indeed, very birth-delivery type pains, and it's as regressed as I imagine I can go."[5] But if birth was the metaphor Sendak again chose for talking about the creative process of bringing another of his books into material reality, what lay at the heart of the book in its conceptive moment— at the unfathomable "navel" of Mickey's dream, to borrow Freud's term—was something at the other, the dark end of the spectrum.[6] For Mickey's journey down into the Night Kitchen was Sendak's fullest exploration to date of the unconscious and the primordial material (the *pâté imaginaire* of Bachelard) that lies in its deepest reaches and that can be shaped into images that offer us the psychic experience of both life and death.[7] In a 1976 *Rolling Stone* interview with Jonathan Cott, Sendak compared his journey down into his own psyche to find *In the Night*

Fig. 84. Preliminary drawings of Mickey for *In the Night Kitchen*

Kitchen with the experiment of the scientist-hero in the film *Altered States* (1975) who uses a special environmental chamber to "go back and go back and go back to the very origins of man . . . [becoming] a fetus, a cell, a sperm."[8] In *In the Night Kitchen,* Sendak takes this journey through his archetypal child whom he sends spinning "back" into the underworld. Sendak's child makes this descent with such good company as Alice, the most famous of the falling children in children's literature; Little Nemo, who fell into Slumberland every Sunday (beginning in 1905) in the Winsor McCay comic strip that was a major inspiration to Sendak; Tom Kitten, who tumbles through a rotten floor board in the attic and into the clutches of two hungry rats in Beatrix Potter's *The Roly Poly Pudding* (1908); and uncannily, inescapably, with those ancient mythic figures whose falls took on cosmic, symbolic importance for their respective cultures: "descenders" like the Mayan god-king Pacal, who tumbles balletically backwards from his throne into the Mayan underworld (Fig. 85);[9] Hermes in his magic cap, who can "fall" between the heavens, earth, and the land beneath earth and who, in one of his principal roles as psychopomp, escorts the soul to these dark realms; and Orpheus, the grief-stricken Dionysian artist, who "falls" into Hades in order to find his dead wife.

The myth that Sendak sets out to create in *In the Night Kitchen* is not, of course, about the recovery of a lost love gone to the realm of the dead, but from the point of view of the child reading this book, and from the perspective of the audience made up of emerging or "grown" child archetypes that are touched by the book, it is about something equally important: the confrontation of intensely fearful, potentially annihilating forces that are defeated through a triumphal act of choice and creativity. The primal material of the unconscious into which Mickey tumbles at the beginning of his adventure and that appears to be like an enveloping quicksand is reshaped by the child into something of sweet and permanent value. Mickey finds the secret ingredient for the dough and, Sendak claims, "that's why . . . we have cake every morning." Literally, of course, we do not have cake every morning; but then again we *do* on the level of imaginative possibilities. My daughter, who was three when *In the Night Kitchen* appeared, insisted that she should have a piece of Mickey's cake every morning; and when that wasn't incorporated into the family's breakfast menu, she promptly decided that the cake could be invisible.

Night—with its dim, strange, often upsetting sounds and shapes—gives way to a day that Mickey, encircled by bright sunbeams, brings into radiant being. "Here comes the sun," the Beatles sang on their *Abbey Road* album from 1969, providing a kind of musical counterpart and accompaniment for the descent and return of Sendak's Mickey. With its images of warmth and light, "Here Comes the Sun" became an anthem of renewal in households (like ours) that contained a young child, Sendak's books, and the Beatles' music. In fact, though other, most probably classical, music was on the turntable in Sendak's studio during his composition of *Where the Wild Things Are, Higglety Pigglety Pop!,* and *In the Night Kitchen,* the cultural sounds against which these books were first "heard" are those of the Beatles whose works balanced, like Sendak's, the same strong elements

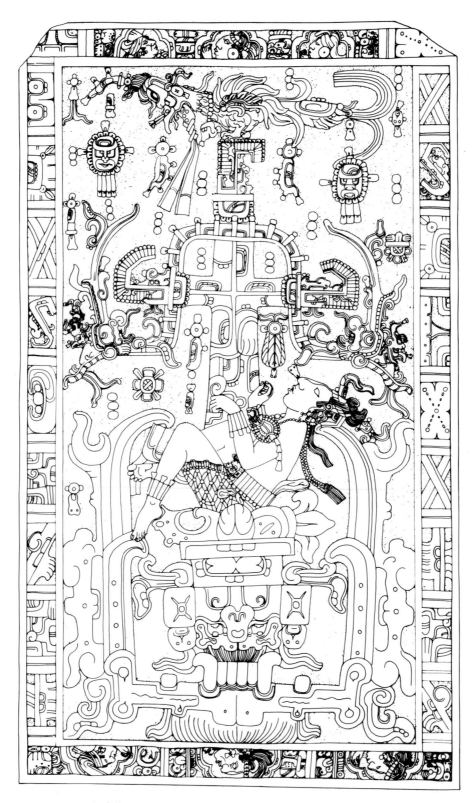

Fig. 85. Pacal's fall, drawing of the sarcophagus lid from the Temple of Inscriptions,
Palenque, Chiapas, Mexico

of the playful and the cerebral, the fantastic and the ordinary, the highly controlled and the outlandish, the classical and the experimental. At any point in the journey through the world of a Beatles record, as happened in the famous instance of their song "A Day in the Life," when the first-person narrator of the song falls "into a dream," the everyday can suddenly take a surrealistic turn.

Sendak frequently alludes to the many letters about his books he received during the late 1960s and early 1970s from older readers—college students in particular—who ask him whether or not he was under the influence of hallucinogenic substances when he produced books like *Higglety Pigglety Pop!* Sendak laughingly dismisses this speculation, pleading a simple but organically overactive imagination. But what also remains certain about that period is the eagerness of the countercultural context to valorize all forms of exploration. Mickey was falling into and soaring through the stratosphere of the Night Kitchen at the same time that Carlos Castenada was experiencing the residue of mushroom-induced hallucinations, in which he found himself listening to the sound of airplane engines and being drawn by it "to the point where I felt I was following the plane as if I were inside it, or flying with it." [10] Don Juan, the Yaqui teacher of Castenada's *Teachings of Don Juan*, explains that the hallucination is caused by the narrator's "loss of soul," and the rest of the book becomes a search for this essential missing ingredient in the life of the young narrator. Similarly, synchronistically, *In the Night Kitchen* was also about soul and how it gets made in the cryptic, elusive, at times unsettling world of sleep and dreams. The elusive component that will complete the recipe for that sweet cake of the soul is to be found in the depths of the psyche, in the mysterious kitchen in which dreams are cooked. And where a special kind of child is born.

On an immediate and personal level, Sendak was speaking directly and sympathetically to all those child readers who, like himself, had suffered from the anxiety associated with going to sleep—which is to say, most children at one point or another in their young lives—because of the association of that nightly loss of consciousness with the experience of death. Parents are certainly not immune to the same dis-ease, in which they may equate sleep with their own or their children's possible death; mothers have sung lullabies for millennia to ward off the lethal effects of the Lillu-demon that had visited sudden infant death syndrome upon the ancient Sumerians and every other society ever since. [11] One writer of works for children before Sendak, Hans Christian Andersen, was so concerned when he was traveling that his sleep might be mistaken for death that he pinned notes to himself as he slept, alerting the hotel staff to the fact that he was still alive and should not be accidentally buried. The cartoon artist Winsor McCay, whose work dramatically and directly influenced Sendak's *In the Night Kitchen*, built several of his comic strips around the similarities between sleep and death. In *The Dreams of a Rarebit Fiend*, McCay drew one of his best known and most macabre stories in which a dreamer who is having a nightmare after eating welsh rarebit imagines himself in his own grave, surrounded by his family and friends, while the earth is pitched onto his own as well as the reader's eyes, since they are also seeing the

events from the "dead" man's point of view. Because of such deeply rooted connections between sleep, with its nightly annihilation of consciousness, and the disturbing possibility of death, adults have tried to equip children with their own charms to help them keep their night fears at bay—such as the supposed consolation of the famous prayer:

> Now I lay me down to sleep,
> I pray the Lord my soul to keep,
> If I should die before I wake,
> I pray the Lord my soul to take.

In her biography of Sendak, Selma Lanes proposes that *In the Night Kitchen* had its genesis in a series of Mother Goose rhymes that Sendak had collected after writing *Higglety Pigglety Pop!* for possible use in a volume of these verses that he was thinking about illustrating; he would eventually set the project aside but not without reworking several of the rhymes and incorporating them into the text of *In the Night Kitchen.*[12] While these are surely important to our understanding of the sources of some of the rhythms and phrasings that Sendak later wove into the book, it misses locating a more crucial point of beginning for the book, which is to be found in Sendak's childhood. The source that speaks to us mostly clearly about these matters is Sendak's recollection of hearing, like Mickey, muffled sounds in the night outside the door to his bedroom—perhaps in the apartment on Sixty-ninth Street in Brooklyn where, Sendak remembers, mysteriously, that "very strange things happened," where the sounds in the night left him "afraid of death as a child. . . . afraid because I heard it around me. I was very ill; I had scarlet fever. There was always the possibility I might have died. I must have heard this, my parents were afraid I wouldn't survive."[13]

It would probably offer little consolation to the child, squirming uneasily at bedtime, to learn the lesson that James Hillman posits in his mythic interpretation of dreams and the psychological terrain in which they occur: "the deformative, transformative work in dreams constructs the House of Hades, one's individual death. Each dream builds upon that house. Each dream is practice in entering the underworld, a preparation of the psyche for death."[14] But it is exactly this kind of difficult work, Hillman argues, that helps our souls to find depth, through our attempts to develop what he calls a "deeper intelligence" that is based on our willingness to discover and grant importance to how we shape our own individual "soul-matter." He describes this process in terms that echo and corroborate Sendak's imagery: "The morning brings us each his and her own dream of cast and hardened images like fresh-crusted bread. . . . This cooking of psychic stuff that goes on in the night, because it is a soul-making, that is as fundamental to culture as are the other forms of cooking and crafting that anthropology upholds."[15]

It is not, however, always possible to get to the bottom, to the "unfathomable depth" of every dream. But what we can try to do is

[k]eep the depth of the dream intact. What we take out of dreams, what we get to use from dreams, what we bring up from dreams, is all to the surface. Depth is in the invisible connection; and it is working with our hands on the invisible connections where we cannot see, deep in the body of the night, penetrating, assembling and differentiating, debriding, stirring, churning, kneading—this constitutes the work of dreams. Always we are doing precision work, but with invisibilities, with ambiguities, and with moving materials. What we know about life is here relatively secondary. Our knowledge is of that field most like the dream, that is, mythical realities, where too everything is sharp but ambiguous, apparent only to the imagination.[16]

Sendak wishes to work on such a fluid level of mystery in *In the Night Kitchen*. In his first draft of the book, which he titled "Trouble Cap," he brushed all expectations of realism aside, along with any nods in the direction of Prufrock's existential angst, by giving us a Mickey who boldly, unapologetically "disturbed the whole world / by wearing a cap at night."[17]

Pursuing those ambiguities and mysteries means to fall into the depths of the collective dream that Sendak has created for his readers in *In the Night Kitchen*. Doing this dream work on Sendak's vision is not a straight and direct process but rather a circuitous unfolding of the book's strata of personal particulars and its pastiche of allusions to reach those universals that are at its complex, "moving" center, and once there to try to hold them still in language for a moment before they fade back, like the Beatles' song, "into a dream."

The presence of Sendak's child is immediately declared in *In the Night Kitchen*'s "peritext," which is made up of those "'peripheral' features such as the cover, title page, table of contents, chapter titles" that are supposed to be the first things we read but that, in the child's actual approach to the book, as Margaret Higonnet points out, may be the last: "for a child familiar with books as objects of play will often look at the last page, or check out the illustrations going from back to front, before entering into the narrative."[18] Sendak is certainly aware of the anarchic "reading" procedures of young children, as one can see in the often-quoted descriptions of his own reading processes, which included smelling and actually biting into the pages of the books he had as a young child—an approach that he considers a compliment when children practice it with his books. Given his awareness and acceptance of the child's playful, unstructured, sensory involvement with books as objects, Sendak does not insist that the cover of his books—presumably the first thing that the child will see—should preserve suspense with regard to the content of the book or support what Higgonet refers to as "the tyranny of narrative concatenation."[19] Instead, the cover of *In the Night Kitchen*, like that of *Where the Wild Things Are*, gives the reader a glimpse into a crucial moment of the story when the child hero, in this case a smiling Mickey, has taken command of his own destiny and is serenely in flight in an unlikely aircraft, made from lumpy, light

brown material against the background of what looks like a city, one with unusually shaped buildings and signs, which Sendak renders here in dull grays and browns, with the lighted windows offering small rectangles of yellow and blue (Color Plate 6). It is nighttime, the stars are out; they surround the plane like fireflies. A yellow harvest moon (an appropriate touch given the October publication date of the book) hangs halfway into the picture, almost touching the boy's hand, which is covered by some kind of brown flight suit.

The focus of our attention is the child. Sendak's heavy, magic marker outline of the shape of the boy with his measuring cup helmet and the plane with its strangely bent propeller is taken beyond the border of the picture, creating a three-dimensional effect: the boy is flying past conventional barriers—breaking through not just one but two border lines that would normally hold the subject in visual restraint. The double border of this cover picture turns it into a window frame, the reader's window to the world of the book, and Mickey is flying through it, from his into the reader's world, into his or her Night Kitchen. Sendak is telling us subtly that this will be an unusual book—but don't worry: as you can see from Mickey's expression, you're going to love the experience. The effect is multiple: it serves to relieve tension and to acknowledge (by adult standards) the unorthodox ways in which children experience their books, all the while using Mickey's plane to lead the reader's eye to the far right margin of the dust jacket and, thus, to turn the page and begin the book.

The cover also announced a new style for Sendak's drawing—what Virginia Haviland described in her interview with Sendak just a few months after the book appeared as his "fat style," with its heavy outlines, overstuffed forms and squat characters, and overcrowded compositions. Sendak explained that he "worked very hard not to get trapped" in a particular style, thus allowing him the freedom to "walk in and out of all kinds of books. It is a great bore worrying about style. So, my point is to have a fine style, a fat style, a fairly slim style, and an extremely stout style."[20] What Sendak does not say about this style, though, is that it was also echoing the convention of heavy outlining that appeared in the comic strips that he read growing up in the 1930s (particularly the early Walt Disney comic books) and that he was so powerfully reconnected with when he saw Winsor McCay's comic pages on display in the mid-1960s. There was, too, in this "fat style" a look that Sendak wanted to borrow from "the tight snug look" of the big-little books that he also read as a child, books like *Mickey Mouse in Pigmie Land* that provided him some of his first exposures to "literature."[21] It was this "tightness" that made Mickey "very big," he explained to Gene Deitch, noting that the film they had begun to make of *In the Night Kitchen* needed to preserve the same "trick" that Sendak had worked on the audience in the book. This illusion was to get them to see Mickey as smaller than the "gigantic, humongous quality of the chefs filling the whole [page]," while at the same time thinking he is "also Tarzan big, heroic."[22] Of course, this explanation of a dualistic graphic effect also was addressing the seemingly contradictory qualities of the child archetype, oppositional characteristics that Sendak's myth was interested in reconciling.

There were other stylistic ancestors that Sendak was quoting on his cover, one of which was referring to the flat primary colors of the comic strips and comic books that were produced in the late 1920s and 1930s, as well as the visual look of many children's books that were being produced while Sendak was a young child. Take, for example, a boxed set of five paperback Mother Goose books with the pictures of an unnamed illustrator that appeared in 1929, the year after Sendak was born. The cover of one of the volumes, *Mother Goose Jingles,* shows a clownlike figure descending a staircase, behind which we can see an evening sky, done in light lavender and outlined in a dark blue border, which contains the same stylized stars of Sendak's Night Kitchen sky.[23]

Turning past the cover of *In the Night Kitchen,* the title page presents another large image of the same airborne child; again he waves, a broad smile on his face, from beneath his blue hat (later we will discover that it's made from a measuring cup), seen against the same golden moon and surrounded by purple stars. He is in complete control, saluting the reader with one of his mittened hands, like a barnstorming pilot from the 1920s, another historical association with the heroic that Sendak folds into the mythic dough of the book. To make this vision of the child plausible and thus interesting to the child readers of the book, Sendak gives his hero a less than perfect vehicle for his adventure: his airplane seems even more impossible than it did in the first picture of it—a wheel is running into a brown puddle, the tip of one propeller is bent back, and a rear wing was folded on itself. Clearly, it is the imagination of the flyer, the artist, and the audience that is meant to give the aircraft lift. Once the imagination has been engaged, especially in returning to this page after earlier readings, Sendak's plane has no problem pulling its banners—made up of the book's title, Sendak's name, and the publisher—onto the page, holding the reader's attention there for a moment. Here Sendak interrupts that conditioned response (in the West) of moving one's eyes from left to right in order to "read" a page. Instead, the flow of these two pages moves in the opposite direction, from right to left. Again, the effect is to reverse expectations, to leave the reader guessing, curious (at least the first time through), and just a tad off balance.

When one pushes on to the dedication page, the child is trailing another banner behind his plane with the names of Sendak's parents, Sadie and Philip. Still smiling, he is much smaller in this picture, as though he has begun to fly into the background to await his later return now that his introductory duties are over. He has turned to the audience to exclaim, in a cartoon dialogue balloon, "Mama Papa!" It is a gentle, touching picture that connects Sendak with his parents while also serving to identify Sendak with the child we are about to meet on the next page of the book. Once more he made the autobiographical connection between his main character and himself. As he explained to an interviewer just a few months after the book had been published, concerning four of the male children he had featured in his books thus far:

> They are the same child, of course. Three of them have the initial "M." I
> don't think that's an accident, although I thought of that only while I was

working on the last book. The first boy was Kenny, and he was named after a specific person. But a thread of meaning connects all the children. . . . Kenny is a frustrated and introverted child. And Martin is fussy and sulking and not very brave. Max is tremendously brave but in a rage. And Mickey is extremely brave and very happy. . . . but in the characters there is a kind of progress from holding back to coming forth which I'd like to think is me, not so much as a child or pretending that I'm a child but as a creative artist who also gets freer and freer with each book and opens up more and more.[24]

This "coming forth" had meant, for Sendak, plunging into more material from his childhood than he had tapped in previous books and, for that matter, even more pressing circumstances from his present life, with their intimations of mortality, than he had faced before. It meant another experiment with picture book aesthetics that involved drawing together into a fresh, new statement a number of older, disparate elements. Finally, though, it represented a plunge, a free-fall for Sendak, with the child again acting as the guide into the unknown, mythic underworld of dream, into what he referred to as "the direct middle of me," to the place, as Frances Wickes explains, where the "Great Dreams" come from. These are the dreams, she writes, that "spring from the depth of the psyche, where archetypal images move, and through such dreams, if they are left in reverent admission of their numinous quality, the child becomes aware of the unknown and unknowable truths of the soul."[25] One would hardly guess from a first look at the preparatory pages of *In the Night Kitchen,* which serve as a reassuring overture to the story, that Sendak was moving the reader right to the edge of a drop-off into these depths.

Once we have turned the page and entered the story itself, the mood shifts dramatically. The next two pages, which contain four panels for pictures and words that are laid out like an oversized comic strip, ready the reader for this plunge into dream. Above the first two pictures, in a thin, horizontal bar of text, like a lintel over a doorway, Sendak begins a question that will take him five pages to complete: "Did you ever hear of Mickey, / How he heard a racket in the Night. . . ." It's the storyteller's question; it's Rosie's and Sendak's own tantalizing "expertise thing" beginning to build its kinetic head of steam. Below this legend, in muted grays and earth tones, a little boy with an unruly thatch of black hair lies somewhere between sleep and waking, between awareness and unconsciousness, his eyes half open, his eyelids and mouth pulled down by the weight of the mood that hovers in the room (Fig. 86). A model airplane hangs from the chain of the light fixture above the boy's bed, a faint reminder of the cover and other opening images of Mickey in flight, though it appears less capable of flight than Mickey's dream plane. A muffled sound seeps through; it's hardly "a racket," just a faint, light gray "THUMP" that is set off in a small dialogue balloon on the dark gray wall of his room.

In the next frame the boy is sitting bolt upright in bed, wide-awake, it seems, with his eyebrows knitted in anger as he listens to more sounds being registered

against the wall—a "DUMP, CLUMP, LUMP"—his wake-up call to adventure. They're ridiculous, suggestive sounds that don't imitate any of the realistic squeaks and creaks that occur when a house settles, expands, or contracts during the night. After all, *what* makes the "lump" sound? Sendak leaves them unexplained, improbable, mysterious, hallucinatory.

Biographically, this is Sendak's own bed, in one of the family's many apartments, where he spent insomniac nights, half in and out of dreams, imagining stories, doing his homework for what he will create for Mickey, thirty-some years later. The "fat," big-little book style gives the frame a confined, restricted quality. Mickey seems too large for his bed, for the conventional physical boundaries allowed for sleep; it is claustrophobic, restrictive, in juxtaposition, as we shall see, with the spatial and sensory freedom that Mickey will experience in just a few pages. Here again Sendak is also quoting from other children's books that were around when he was a young child and that also dealt with a child's night journey into a fantasy world. One in particular, Vernon Grant's *Tinker Tim the Toy Maker*, shows a little boy (Buzz) who is awakened one night while he is in bed by a "strange little fellow [who] perched himself on Buzz's bedpost."[26] It's Skoot, a mercurial helper of the Sandman who wears a bowler hat with a feather in it and promises to guide the boy from "the Land of the Real . . . through the land of Shut-Eye to Behind-the-Clouds-Town." Buzz is crammed into his bed like Mickey—he even has a blanket with fringe on it; and on his journey (for which he is also given a cap with a magical feather) Buzz meets a friendly giant who serves him a meal of "hot muffins, honey, sweetmeats, and everything a boy likes" and describes whom he will meet on the rest of his adventure, including one "Mr. Mixie Dough the Cake Maker." Strangely though, Grant doesn't keep that promised meeting between the child and the baker in this book; rather, the focus stays on Buzz's visit with the toy maker and his attic full of living toys.

About the same time that Tinker Tim was tapping out his toys, Sendak and his brother Jack were making their own balsa wood model airplanes and "hang[ing] them over [their] beds until they rotted away."[27] But the airplane we see in Mickey's bedroom, while it echoes the airplane of the cover and the one that will come later, is not a vehicle of exhilarating transport: it is a static copy that doesn't seem to have any propulsive power at all. That is hardly the case with Sendak's choice of a name for his main character. Mickey's name also came directly from Sendak's autobiographical "rag and bone shop of the heart," specifically from Walt Disney's Mickey Mouse, whom Sendak has called his "best friend" from childhood. Sendak could have been describing a religious experience—like the vision that was supposed to come to those who were initiated into the ancient Eleusian Mysteries—when he recalls how, as a child, the sight of Mickey Mouse appeared to him "in the darkened theater, the sudden flash of his brilliant, wild, joyful face—radiating great golden beams—filled me with unalloyed pleasure."[28]

Sendak has mentioned with obvious pleasure that he was born the same year (1928) as Mickey; and Mickey Mouse was the subject of one of Sendak's first drawings, made at about the age of six, which his mother carefully saved.[29] In the

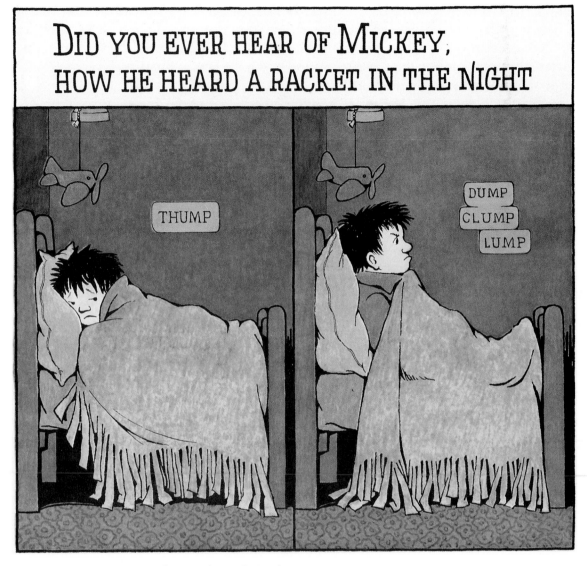

Fig. 86. Opening pictures from *In the Night Kitchen*

1930s, Sendak became a fervent fan not only of the Mickey Mouse cartoons but the Mickey Mouse comics and the Disney big-little books, along with other comic books, movies, radio programs, box-top premiums and product-driven paraphernalia that were, by this point, pouring onto the newly emerging mass market of children's popular, material culture. These objects, images, and media strongly shaped Sendak's early imaginative life, as they would for millions of American children; and Sendak, like so many others, continues to be under their potent pull, much as he tried to counter it with more sophisticated influences. But *In the Night Kitchen* was a turning point, a "coming forth" in this regard, and Sendak shocked elitist defenders of high culture in children's book illustration with his newest book

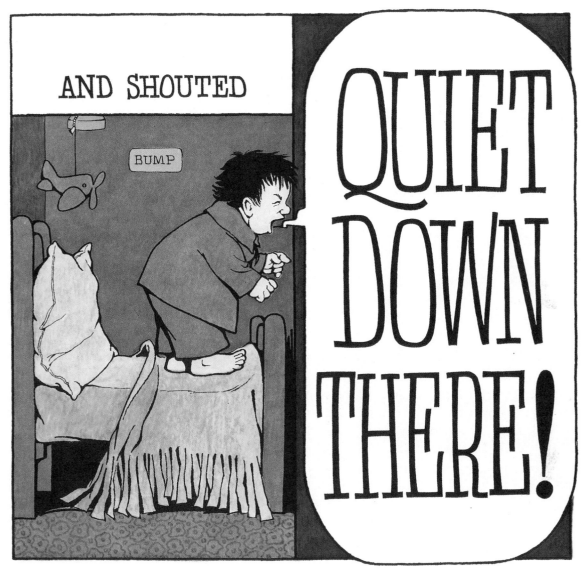

Fig. 87. From *In the Night Kitchen*

and the public admissions that Sendak used to further assert both his roots and independence:

> Over the years I've been feeding myself artistic, culture things—Blake, the English illustrators, Melville—but those crappy toys and those tinsel movies are much more directly involved in my life than certainly William Blake ever was, although Blake really is important, my cornerstone. . . . But this stuff now, this is the only art I grew up with. And for some reason I find it very important. The cheap crap I had to grow up with is what made me. Those movies and Mickey Mouse. And I love it! I love it! I love it![30]

When he was asked to do a cover for *T. V. Guide* in 1978, Sendak drew himself standing opposite a full-length mirror that reflected a Sendak-sized image of Mickey Mouse waving in greeting to the artist. Seen the other way round, of course, Mickey Mouse is reflecting Sendak, projecting Sendak as the cartoon character's alter ego—this in recognition of the influence that he exerted on the artist as well as of the fact that Sendak carried on the bold, experimental energy of the Disney cartoons in his work. But whichever way one views it, Sendak credits Mickey Mouse with having affected him profoundly in vocationally formative ways. Mickey was "one of the stronger memories" of childhood, and Sendak remembers how the very "sight of him, the sheer graphics of him, the black, white, red and yellow of him violently excited me as a child and probably touched those then-unconscious springs that I wanted to be an artist he made me happy. He stood for making me happy."[31]

There is nothing happy, though, about these opening images, which eventually take us, in the discontinuous, elliptical rhythms of a comic strip (another variant on his grandmother's window shade), onto the right-hand page, drawing Mickey from under his fringed blanket to bellow over the foot of his bed (in response to one last sound, a "Bump" in the night) "QUIET DOWN THERE!" in huge, 72-point type that completely fills the last of the four panels on these pages (Fig. 87). Like Max, Mickey has also reached the point of rage; and like Max, he seems to have visited this, or some similar place before—at least he knows enough about where the sounds are coming from to know where to direct the irritation that has suddenly exploded and, like Max's anger, taken over the book.

In part, Sendak was simply borrowing from and expanding upon the graphic thematic innovations of Winsor McCay in his comic strip "Little Nemo in Slumberland," which ran in American papers from 1905, off and on, until 1926. Sendak had seen an exhibit of McCay's comic pages in 1966 at the Metropolitan Museum and recognized at once a kindred spirit. "McCay and I serve the same master," Sendak later wrote, "our child selves. We both drew not on the literal memory of childhood but on the emotional memory of its stress and urgency. And neither of us forgot our childhood dreams."[32] One of the qualities that had struck Sendak about McCay's work was the latter's sense of graphic style and, in particular, his willingness to break cartoon conventions to suit his unique dramatic purposes. According to Sendak, McCay's "originality is confirmed by his innovative method of visual narrative (he ignored the comic strip's traditional arrangement of panels, stretched them vertically and horizontally to get his dreamlike effects) and a radically personal iconography."[33] For Sendak in *Night Kitchen,* this iconography includes the angry child declaring himself in a full, unrepressed voice that was pushing at boundaries in this loud dialogue balloon, which presses through the restraint of the final, right-hand border.

But in *In the Night Kitchen* Sendak had appropriated more than a graphic twist or a number of images from "Little Nemo in Slumberland"; the comic strip virtually gave Sendak the basic structure of his plot. McCay's main character, a little boy dressed in a nightshirt, begins most of the hundreds of episodes McCay

drew for him asleep in his bed in the upper left corner of the page. From this safe starting point, he falls in the central panels of the story into expansive, often surreal, gravity-defying dreams that become, more often than not, nightmares. In 1905, for example, Nemo is taken to the murky bottom of the sea where he meets up with the monstrous, red-eyed Magoozla; and in another episode he falls through the frame of his bed and onto the tongue of the man in the moon. In 1906, an elephant sends Nemo, at the end of his dream, crashing back through the wall of his room, and later George Washington's father chases him home after Nemo and George have chopped down the cherry tree; in 1907, on the way to Jack Frost's palace, Nemo's toboggan loses control and goes over an ice cliff, and in still another dream he clambers over the rooftops of a strangely miniaturized city followed by two red giants. He is lost in a blizzard and taken captive by cannibals, trapped in the fun house mirrors of Befuddle Hall, crushed by an avalanche of giant raspberries, chased by a polar bear, and melted into a puddle in front of the kitchen stove—only his head is left on the chair, calling out for help. Yet in the last frame of every strip on the lower right corner of the page, Nemo returns to his bed where he awakens, often twisted in his bedclothes or dumped unceremoniously onto the floor, crying frantically for his parents. No wonder he says, on more than one occasion, "I don't want to go to sleep again. No! No! Oh!" [34]

When Mickey falls into his dream in the next sequence of four pictures, again spread over two pages in *In the Night Kitchen,* it is reminiscent of one of the earliest Little Nemo strips (from 15 October 1905), in which McCay shows Nemo somersaulting through space as he calls for his mother and father (Fig. 88). [35] But while McCay has Little Nemo cry out at the end of his adventure (he has literally been thrown by the nightmare pony Somnus he has been riding at breakneck speed across the sky), Sendak places this exclamation at the beginning of Mickey's journey, just as he is about to enter his underworld. Like Mickey, Nemo also hears sounds, and often they serve as the triggers for his dreams (as when he listens to a lion snoring underneath the bed)—a device, as we have seen, that Sendak adopts in *In the Night Kitchen.* In many of the earlier Little Nemo episodes, Nemo stands up in his bed and looks over its edge as the bed sinks through the floor, or becomes a raft floating on the ocean, or develops long, rubbery legs and takes Nemo riding through town. Sendak makes a similar, though simpler use of the bed in his opening pictures, establishing it as a platform of solidity from which Mickey can make his dream-dive.

Much as Sendak owed the inspiration of the book to McCay, he also made it his own by offering a central character who is not, like Nemo, the relatively passive dreamer being acted upon by overwhelming, arbitrary forces. Instead, Mickey acts, and he shows flashes of irritation at the outset that McCay, for the sake of keeping his main character pure and innocent, delegates to Nemo's alter ego, a little boy with a green face named Flip, who smokes cigars and turns the most beautiful and promising dreams into disasters. Yet it is exactly this dark otherness, this "Flip side" that gives the adventures their tensions and compensatory balance—and their substance as psychological journeys. By joining these brightly lit and shad-

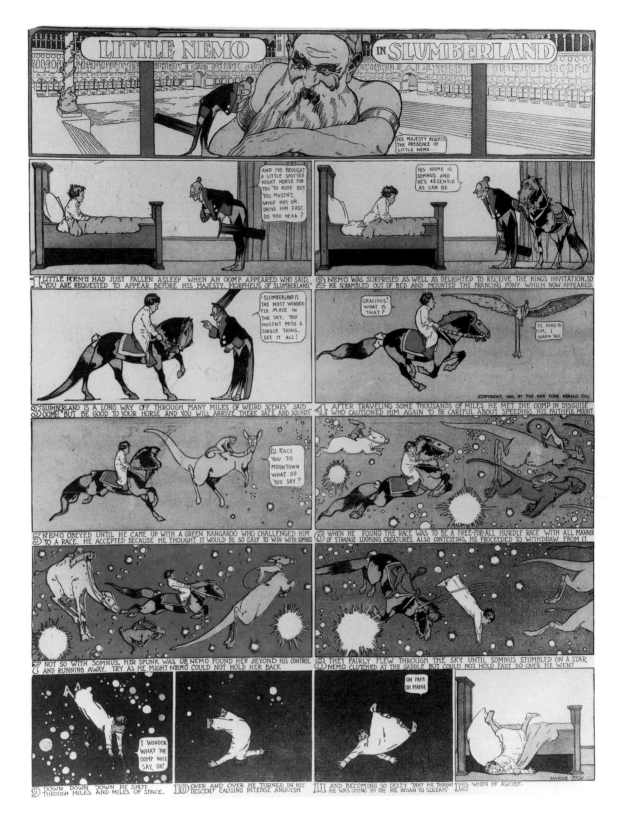

Fig. 88. Little Nemo's fall, from the Winsor McCay comic strip "Little Nemo in Slumberland" (15 October 1905)

owy elements in one character, Sendak gave Mickey's personality multiple dimensions and, with them, a more plausible life, a vitality that cannot only cope with the gigantic, threatening components of a dream but can also shape these elements to some larger extra-eidetic purpose. And while Nemo usually ends up disheveled, twisted in his bedclothes, scratching his head, puzzled by his dream, Mickey goes back to sleep smiling.

Before this peaceful sleep occurs, in the next four-picture sequence of the book, Mickey needs to fall into his dream. The first frame of this fall shows the boy's face in profile, capturing his shock while sparing us the full terror of this vertiginous drop. Sendak is all understatement here, giving Mickey an exclamation of surprise—a short, quick "OH"—as though he is gasping for air. He is not as brave or courageous as he was when he first became aware of the noises that led him to shout for quiet over the foot of his bed, as if he were chastising some noisy neighbors in the apartment below or reacting, as some critics have suggested, in unconscious, Oedipal fury to what may be the sounds of his parents making love in another, downstairs room of the house as he falls "through the dark, out of his clothes past the moon & his mama & papa sleeping tight." One is reminded, of course, of the long-standing literary metaphor that has connected lovemaking and dying for the past four centuries. Sendak admitted such a primal possibility in his discussion of the book with Gene Deitch but insists that his conscious thoughts were of his own parents and their " 'sleeping tight' as meaning 'in the grave.' Mother and father dead, together."[36] Among Sendak's early drafts of the story are sketches that show Mickey's parents, their arms around each other in a primal embrace in their bed (Fig. 89). But the bed appears to be almost a coffin that has awkwardly intruded onto the right side of the page.

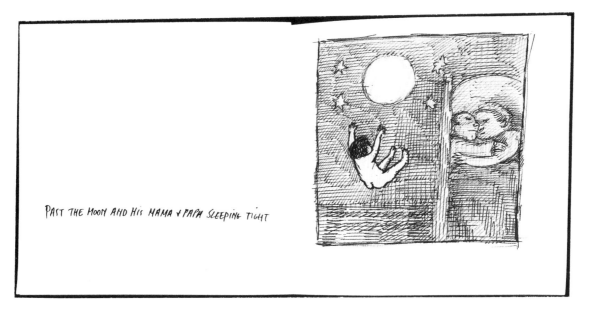

PAST THE MOON AND HIS MAMA & PAPA SLEEPING TIGHT

Fig. 89. Preliminary drawing for *In the Night Kitchen*

The point, though, is that Mickey falls "past" this scene, to some deeper part of his own psyche. A transformation is taking place, and we see it begin to happen in the second picture of this sequence, after the initial "slam" of falling asleep, as Mickey floats free from his clothes and as he turns a languid somersault in the air, slowly floating through the rooms of his house for the next three pictures. Several minutes have passed, as we see by the hands of the clock on the radio that bears Jennie's name—enough dream time for Mickey to let himself go and for his initial horror to change into an orange "AAH" as he experiences the pleasurable sensations of his fall. Sendak instructed Deitch to linger here in his translation of the scene to film so that he could hopefully re-create what Sendak intended as a "marvelous, touching, dissolving, magic moment"[37] in which familiar things—a chandelier, an old clock and radio, curtains, a window sash—take on the air of the unfamiliar, the uncanny (Color Plate 3).

Clearly, Mickey is falling into "impossibilities," a realization that Sendak underscores by the graphic inconsistencies in the last two frames of this sequence. The gauzy, fringed, 1930s curtains that frame the moon in one picture do not match the window or the moon reflected in the mirror in the next, nor can we account for Mickey's trajectory—it is an imaginary fall, and so the laws of scenic or graphic continuity no longer apply. By the end of Mickey's descent what we do know is that the child has bunched up his hands in delight, and there is a faint smile playing across his face that we are here seeing in profile from behind, as the boy's body sinks through the carpet and the final floor of his house before he arrives in the Night Kitchen proper on the next page. Like the series of double-page illustrations of Max with the Wild Things, this is another of those remarkable sequences in contemporary children's picture-book art, not because of its presentation of a child's nudity, although this is what was and continues to be the most commented upon aspect of the book, but rather because of its powerful evocation of that transitional state between worlds, between the known and the other. Max's journey to Where the Wild Things Are seems forced in comparison to the astonishing ease with which Mickey sheds the "clothing" in which waking consciousness wraps itself and falls into the unknown otherworld, the parallel universe of the unconscious. Mickey's nakedness makes perfect sense because, as Hillman explains, our experience of the dream demands a completely different perception of things, for

> [w]hat one knows about life may not be relevant for what is below life. What one knows and has done in life may be as irrelevant to the underworld as clothes that adjust us to life and the flesh and bones that clothes cover. For in the underworld all is stripped away, and life is upside down. We are further than the expectations based on life experience.[38]

Still, Mickey falling naked across the pages of a book in 1970 (Fig. 90) in front of tens of thousands of young, impressionable minds was no small thing to many of the unimpressionable adult minds that saw these pictures, recoiled with

Fig. 90. Preliminary drawing for *In the Night Kitchen*

shock, and reflexively picked up a magic marker or some opaque tape to cover Mickey's genitals. There are anecdotes that quickly circulated at the time about teachers and librarians drawing diapers on Mickey or of their quietly removing the book from the shelves. These testimonials to that puritanical facet of the collective American consciousness continue to surface today in the form of local challenges to this and other Sendak books and as a persisting denial of Freud's theories of infantile sexuality. In the late 1960s and early 1970s, nudity had reached a number of successful Broadway musicals and plays, including *Hair* and *Oh, Calcutta!* This spirit of liberation had certainly not spilled over into the children's books before *In the Night Kitchen;* but that climate of daring, Dionysian experimentation also helped make *In the Night Kitchen* possible.

Whatever the causes, it was a bold move indeed for Nordstrom and Harper & Row to take—a chance that probably would not get taken today. For despite our stereotypical idea of the Sixties as a time of universal openness, these years were essentially, even belligerently conservative. Take as just one anecdotal example the following episode that will serve to illustrate the predictability rather than the peculiarity of the reaction to Mickey's nudity in *In the Night Kitchen.* Around the time the book was published, my wife and I and our two-year-old daughter lived on a small lake in the Connecticut countryside. One hot summer day my wife and daughter were at the lake's community beach when our toddler, tired of having sand in her wet bathing suit, peeled it off and began splashing naked in the water

and filling buckets of sand on the shore. Another two-year-old—a little boy, as it happens—joined her, and they both happily continued to play. Within an hour a state policeman had appeared on the beach, summoned by another mother whose children were at the beach, and told my wife (who was born in Europe) to put a swimming suit on our daughter. "I've tried," she said. "But she keeps taking it off." The policeman responded that she had better find a way to keep it on the child or he would arrest my wife for contributing to the "indecency of a child."

Sendak has frequently declared that he had not intended to be deliberately controversial in *In the Night Kitchen*. If he had wished to comment on his times, he would surely have avoided the obvious statement and done so obliquely, not in the direct way that, say, Louise Fitzhugh was approaching the subject of violence and of how the idea of war can spread among children in her then much praised picture book *Bang Bang You're Dead* (1969), which showed in savage terms what can happen when gangs of young people actually fight. Sendak's concern had been an aesthetic one—namely, how messy the landing in dough of a pajama-clad Mickey would be. Barbara Bader notes that Sendak uses a naked child so that he can be "figurative," in the same way that artists for millennia have made use of the naked form as pure form itself. But there is another kind of classicism that Sendak recalls in his use of the nude figure—it effectively removes the child from the constraints of historical time, freeing him from literal connections with the viewer's present and thus granting him a kind of mythic timelessness. Further, nakedness serves as a metaphor for psychological nakedness, as Hillman suggests, and the appropriate way to separate him from the socialized, "clothed" world of waking reality to travel down into the underworld.

Mickey's fall finally ends happily (at least Mickey is smiling pacifically now) in a huge mixing bowl in the Night Kitchen, as Sendak finishes the question that begins the book, running this final bar of words vertically down the middle of the page into the same bowl. In the background Sendak gives us a larger view of the cityscape that we had a glimpse of on the cover. Again, Sendak is following the lead of McCay, who set many of the Little Nemo episodes in spectacular, monumental cities with ornate architectural detail that is often repeated or enlarged to the point of distortion. Sendak, however, stayed close to his own roots, constructing the Night Kitchen out of bottles, packages, jars, and cooking implements that were familiar sights in any 1930s kitchen. Sendak built this fantasy world out of familiar things, the sorts of detritus of everyday life that fascinates us as young children: the egg beaters, whisks, funnels, and other utensils that, if turned upside down, could well become a tower of a building; the packages of baking soda and jars of jam and pickles that, if lined up on a shelf or counter and viewed from the diminutive perspective of a four-year-old in a dimly lit kitchen, could well resemble the skyline of a city.

This nocturnal fantasy transformation of the kitchen is based, of course, on Sendak's composite memories of the family's kitchens where Sadie Sendak made her own version of a "morning cake." Sendak filed a copy of her recipe among his

notes and drafts for *In the Night Kitchen,* and Selma Lanes includes a picture of his mother baking in *The Art of Maurice Sendak.* In many ways the kitchen was the real center of most American households for Sendak's generation, and very often in older apartments from that era a smaller bedroom, often a child's bedroom, would be set right off the kitchen, bringing the inhabitant of that room even closer to such significant daily activities as cooking and eating, as well as to those nightly rituals of conversation, uninterrupted by television, that offered an experience of the oral/aural culture with its regular summoning of ancestral spirits—the giants from a family's past, be they cooks or Wild Things. In short, the kitchen is charged with a family's literal and psychic history; it's the place where most anything can be "cooked up," the perfect setting for a story about mixing the ingredients of memory and fantasy, cultural and personal facts.

Along with his introduction of biographical elements, especially those materials from the 1930s, Sendak was also affected by the influence of pop art on the cultural scene in the 1960s, with its cheeky, ironic elevation of the everyday to the level of the highbrow. One thinks, of course, of Andy Warhol's use of commercial packages as the subjects of painting and the objects of sculpture. There were, too, Saul Steinberg's drawings of buildings that attached incongruous elements (a pipe organ, the pediment from a chest) to the facades of buildings and created whole buildings out of unlikely material: stacks of wooden alphabet blocks, the open drawers of a dresser. Around this same time Claes Oldenburg was doing sketches that proposed giant monuments for specific American cities made from such things as a clothespin, a doughnut, and a hot water bottle. But Oldenburg, Steinberg, and Warhol had all been preempted in their approaches to this material by the fanciful nature of some vernacular American roadside architecture that had used packages and other objects as building forms—largely to catch the eye of the traveler and to advertise a given product—like a refreshment stand shaped like an ice cream cone, an automobile that was meant to look like a hotdog, or a dairy bar housed inside an enormous bottle of milk.

In presenting the packages that run throughout his depiction of the dream world of *In the Night Kitchen,* Sendak includes names of his family and friends, important dates in his life, as well as send-ups of real products, all of which filled with personal meaning these containers that are normally void of any special attachments. Here again, Sendak plays the allusive "game" that keeps him immediately connected to his work; for example, the game allows him to incorporate in the creative process an old friend, the noted collector of children's books Herb Hosmer, whose name is emblazoned on a container of sugar. Hosmer, an extremely kind and generous man with a most gentle disposition, had introduced Sendak to a good number of those figures from eighteenth- and nineteenth-century children's books for whom Sendak would later serve as a passionate advocate— among these was the great nineteenth-century maker of toys and books Lothar Meggendorfer. Hosmer is a direct relative of John Greenleaf Chandler, the American publisher who printed the first edition of "Chicken Little"—which Sendak spoofs hilariously in the operatic version of *Higglety Pigglety Pop!* and from which

he would also draw the first interrogatory line of *In the Night Kitchen*.[39] When Sendak was discussing the animated film version of *Night Kitchen* with Gene Deitch and deciding on how to approach these packages, Deitch wanted to leave out "the addresses, names and all the personal quips," since he felt they added extraneous detail to the film and could not be read anyway. But Sendak had insisted on the packages:

> I would be very sorry to see them go. . . . If they are peculiar, if people wonder what they are, that doesn't bother me a bit. They do that when they look at the book, and yet they are as acceptable as would be the name of Campbell's Soup or Farmer Cheese or any other name on a product. And I choose to think that those personal names and personal references are and become those same emblematic names as just mentioned.[40]

And Sendak also argued that using them "in this conventional 1930s kitchen setting with 30s implements" contributed to an effect that could be "alarming, right? Familiar objects suddenly become mystifying and alarming. And that's the whole purpose of the book, the trick of using commonplace things in uncommon-place atmospheric settings. We must achieve the same thing in the film."[41]

Also contributing to this mood of estrangement is Sendak's use of the three Oliver Hardy bakers, who are patiently waiting on the facing page for Mickey to fall into their dough. Actually, these two pictures are a double-page spread that Sendak has separated into sequential comic book/big-little book frames; they also have the appearance of animated movie cells, and one feels that Sendak here has drawn the reader into a tight close-up—so much so that the three bakers, the epitome of Sendak's "fat style," are spilling over the boundaries of the frame in their glee to be finally making their morning cake.

Sendak has said that he based these three characters on his childhood recollection of the advertising logo for a bakery in the New York City area. The slogan

> read "We Bake While You Sleep!" It seemed to me the most sadistic thing in the world, because all I wanted to do was stay up and watch. And it seemed so absurdly cruel and arbitrary for them to do it while I slept. And also for them to think I would think that was terrific stuff on their part, you know, and would eat their product on top of that. It bothered me a good deal, and I remember I used to save the coupons showing the three fat little Sunshine Bakers going off to this magic place, wherever it was, at night to have their fun, while I had to go to bed. This book was a sort of vendetta book to get back at them and to say that I am now old enough to stay up at night and know what is happening in the Night Kitchen![42]

Perhaps children in the South are wondering the same thing today when they see a Merita Bakery truck go by that uses an almost identical slogan, "Baked While You Sleep," to sell their speciality, a "Mickey Snack," underneath the picture of an

impish, black-haired boy. Whoever designed their advertising seems to have mixed Sendak into the campaign.

Regardless of the smiles at this point in the book, Mickey is in the same predicament that Max was in in *Where the Wild Things Are:* he is threatened with extinction, with being devoured by gigantic figures that surround him. In Mickey's case they are more familiar, and their rounded bodies and white baker's uniforms suggest a somewhat more benign presence, but they are also oblivious to what is really happening, and they mistake Mickey for the milk that they need to complete their recipe. Indeed, they seem almost blind; their eyes are closed in this scene, as if they are in a somnambulist's trance. In his comments on the book to Deitch, Sendak compared the bakers to the three Norns or Fates from Teutonic mythology—Urd, Verdandi, and Skuld—who represent one's past, future, and ultimate destiny. Usually they are depicted as females, wise women who are "learned in the old customs, the ancient precepts" and who later evolve into the fairies who appear "at the child's cradle to offer him magic gifts or, on the contrary, like the fairy godmothers in *Snow White* or MacDonald's *The Light Princess,* to utter maledictions which would shadow him the whole of his life."[43]

The *Night Kitchen* cooks are, at least on the surface, unthreatening—unlike, for example, the baker in the German Max and Moritz story who bakes the two bad boys after they, like Mickey, have fallen into his dough.[44] Along with being an inherently comic figure, Hardy is, on a more immediate level—especially for a young child who will not be familiar with his screen roles—asexual, soft and rounded, dainty, even effete. Sendak left out Stan Laurel, Oliver Hardy's partner, he told Deitch, because he wanted a character who could fill the page. One Ollie, though, only calls attention to Stan's absence; two seems arbitrary and incomplete; while three, the magic number, makes them an impressive group—a trio of forces that control, at least initially, Mickey's fate. For Sendak they are more visitors from the thirties, the time in which Sendak's urge to become an artist was "fated." In particular, they suggested the movies and represented the excitement for Sendak of going *to* the movies in New York City with his sister Natalie. These were unforgettable, sensory experiences for the young Sendak, and when he talks today about the act of film going and the movies themselves that were "blazoned on [his] brain forever," his voice rises with the same elation that he reports feeling fifty years earlier:

> Those trips were ravishing. It was going to a 1001 Nights, it was going to a seraglio, it was going to the most devilish place in the world. It was crossing the Manhattan Bridge, and as you crossed the Manhattan Bridge, right along the river there was a bakery. The aroma of fresh bread poured into the subway trains, and it was like an aphrodisiac. It made me wild, so that the connection of wonderful bread or foods and New York City was fixed in my mind. New York was a place where you went to eat—at Schrafts or Longchamps, marvelous, exotic Arabian names, where you had sandwiches, where you had grilled cheese—I mean, incredible things you could

never get at home. But more to the point you spent the day in New York City. You bought ice cream on the street, you went to Radio City Music Hall, you went to see the newest Walt Disney.[45]

These powerful impressions have become key events in Sendak's early life, moments of supreme pleasure that mark the passages of his childhood. Sendak remembers places where his family lived in terms of the Disney movies that he saw while living at a given address. Indeed, Sendak's "last happy memory" of his childhood, before World War II broke out and "discolored" it with the arrival of the paralyzing news that the Sendaks received about the annihilation of their relatives in Europe, was of seeing *Pinocchio* when he was twelve, knowing that "terrible things were happening to people" and "feeling bad that [he] was enjoying [himself]."[46] In some respects, *In the Night Kitchen* was meant to retrieve that joy that had been lost with the war and to celebrate a New York that, in the late 1960s when Sendak created the book, was fast turning from a magical place to one that was increasingly more difficult, dangerous, and pressure-filled—one in which, for reasons of health, Sendak in fact could no longer live.

The effects that New York and the popular culture of the 1930s in general had on Sendak stood in sharp contrast to the world of his parents and gave him an "American childhood composed of strongly concocted elements."[47] They were poles of experience that often pulled in opposing directions at Sendak in his life and art, exposing basic, conflicting forces in his personality. In accepting the Hans Christian Andersen Medal the year after *In the Night Kitchen* was published, Sendak explained this dialectic of influence:

> I had a conglomerate fantasy life as a child, typical of many first-generation children in America, particularly those in a land called Brooklyn, a regulated, tree-lined ghetto-land separated only by a river from the most magical of all lands, New York City. . . . Mine was a childhood colored with memories of village life in Poland, never actually experienced but passed on to me as a persuasive reality by my immigrant parents. On the one hand, I lived snugly in their old-country world, a world far from urban society, where the laws and customs of a small Jewish village were scrupulously and lovingly obeyed.[48]

In contrast to and compensation for a sickly childhood and old-world parents who did not always fully understand or appreciate Sendak's temperament, talent, or interests, and who were suspicious of the seductions of American popular culture, Sendak was

> bombarded with the intoxicating gush of America in that convulsed decade, the thirties. Two emblems represent that era for me: a photograph of my severe, bearded grandfather (I never actually saw him) that haunts me to this day and which, as a child, I believed to be the exact image of God; and

Mickey Mouse. These two lived side by side in a bizarre togetherness that I accepted as natural. For me, childhood was shtetel life transplanted, Brooklyn colored by old-world reverberations and Walt Disney and the occasional trip to the incredibly windowed "uptown" that was New York—America.[49]

Having to contend with these and other cultural and psychological forces could easily have swallowed him up and left Sendak permanently in the kitchen, at the mercy of his mother or other bakers—being passively suffocated in dough—a pure nightmare, even if the cooking is being gleefully, lovingly done to their merry capering. The nightmare almost occurs in *In the Night Kitchen* as we see that the bakers have gone placidly to work, and all we can still recognize of Mickey are his angry eyes as he is nearly completely submerged in the batter. He is unable at this point to extricate himself; and as the cooks celebrate with their monotonal ditty ("Milk in the batter! Milk in the Batter! Stir it! Scrape it! Make it! Bake it!"), Mickey's small hand reaches up from the quicksand-dough in one last gesture of helplessness (Fig. 91). Bad as it seems, the label for a baking soda can that the bakers have stirred into their batter suggests that some phoenix will rise from these ashes.

Of course, it is Mickey's, Sendak's, and everychild's fate to be submerged in

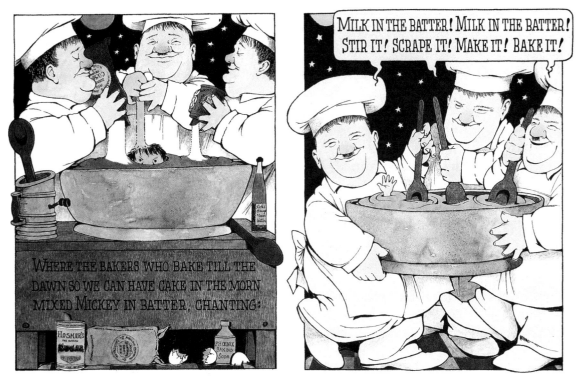

Fig. 91. The bakers stirring, from *In the Night Kitchen*

the stuff of the unconscious, in the dish that is always being cooked up in this nocturnal realm of Psyche's kitchen, and it is within these ingredients of past and present and future that a child initially loses individual identity, "dies," and is reborn; his destiny is shaped from this stuff. In both words and images, Sendak's text speaks to us in these double entendres, these archetypal puns. Surrounded by the moon and stars, the three strange bakers sing an ancient incantation of making—seemingly misapplied at this point (since it appears to be Mickey's un-making)—that serves to emphasize once more the ambiguous condition of both real and archetypal children. Here those circumstances are all vulnerability. Those oblivious ancestors who pinch the child's cheeks are here doing the child in, albeit with great ceremony (Sendak gives the bakers' trip to the oven of the completed cake a full, uninterrupted double page spread on the next two pages) and the full weight of the past on their side: the child is to be the next meal, a prospect that won't be lost on the contemporary child reader of the book, no matter how unfamiliar or obscure Sendak's intertextual quoting from his own biography and the popular culture of the 1930s may be. There is a palpable suggestion of death at the center of the Night Kitchen. In Sendak's first version of the story the bakers tell Mickey when he arrives in their midst: "You fell out of bed—on your head—so you're dead." [50] One is reminded of the haunting "Broadway Lullaby," one of Busby Berkeley's famous production numbers from *Gold Diggers of 1935* and one of the films that Sendak has frequently spoken about, in which an earlier "Broadway Baby" suddenly falls to her death in the "Night Kitchen" of the film's dreamlike metropolis. Interestingly, this disquieting sequence in the movie both begins and ends with the close-up of a milk bottle.

Dicey as things have become, Mickey's fate is not a grim one: in fact, Sendak quickly brings the suspense to a head in the next two pictures when he has Mickey pop out of the oven and declare, playing off one of the Mother Goose rhymes that he had collected prior to *In the Night Kitchen:* "I'm not the milk and the milk's not me! I'm Mickey!" [51] In Sendak's first draft, Mickey simply replies in street slang: "Nuts!" But then Sendak has Mickey add, self-consciously, "I gave myself a push—that's the only way to get ahead in this world." [52] And in some respects that's just what Mickey has done in the final version of the story, too. As Sendak told Deitch: "Mickey has to care about himself in every possible way, because I think he's in the land of the dead, for the most part. His parents are not to be found to help him. So then, with his nerviness, his sensibility, and his basic mind, he makes himself an airplane . . . he does something to sustain himself during his very suspenseful, strange, mystifying experience." [53]

The turning point of the book is Mickey's rejection of the fate that the bakers would consign him to: he gives himself that "push." The young child's ego takes command, asserting, as with Max, his autonomy. He doesn't simply, passively accept his fate, but instead struggles to claim his identity and thus his true nature in the underworld. Mickey refuses to be "reduced" in the oven, to simply become lost in some nameless primal material that the bakers, like modern versions of medieval and renaissance alchemists, are trying to convert into a magical (and in

Fig. 92. Alchemists stirring in their kitchen, from an early eighteenth-century manuscript

their case edible) substance (Fig. 92). Clearly, though, their experiment has not gone well in its early stage, thanks to Mickey, the hermetic trickster-child and his sudden interruption of the process in the alchemical bakery. It is a comic scene, as we see Mickey, now recovered from his ordeal, happily announce his presence while smoke fills the kitchen and batter drips onto the floor, and the three bakers finally open their eyes. The "blind" Fates have been stopped by some new, magic words—the charm of individual identity that we teach to our children to keep them from being lost, swallowed up by an underworld composed of generic, primary materials. Names matter, mythologically. They are the secret words (and here we must also remember that the words for "secret" and "sacred" share the same root meaning) that distinguish us from other matter; the sacred name defines and saves us. Here it is the name of the irrepressible child archetype that should not be confused with something else—especially not the milk for cake batter.

Mickey's assertion is, too, the artist's declaration of purpose, and in the next frames Sendak returns to the comic book format and shows Mickey, now full of mercurial magic and dressed in a suit made from the dough, springing into action. Sendak says he based Mickey's costume on the diving outfit worn by Buster Keaton in *The Navigator*: an "old-fashioned, humongous thing, with a helmet and grid in front." [54] Sendak especially wanted it to look "big and thick and lumpish" so that when it dissolves a few pages later in a giant bottle of milk it would stand out in contrast to Mickey's "mobile little body in the milk." [55] But one is reminded here of those oversized aviator's suits, like the kind worn by one of Sendak's heroes from childhood, Charles Lindbergh. A picture of the smiling Lindbergh (with the caption, "Lindy"), who became an international hero for his solo crossing of the Atlantic Ocean in 1927, appeared in an early Mickey Mouse cartoon, "Plane Crazy" (1929), and became the role model for this earlier Mickey's aeronautic aspirations. Mickey Mouse tousled his own hair to look like Lindbergh's (Sendak's Mickey has the same rumpled look), and Disney included a sequence in which

Mickey "pulled" and "punched" a plane into shape from an old Model T in the barnyard.

But while Mickey Mouse does not stop for a second to reflect before he acts—he is all frenzied, high-energy impulse, improvising madly, grabbing whatever is at hand that can be used on the plane—Sendak gives his Mickey a frame to pause and consider what he wants to make from the pile of dough "ready to rise" that he has landed in after leaping from the mouth of the oven. *Then* he sails into frenzied action, as he "kneads," "punches," "pounds," and "pulls" an airplane from the lumpy dough. It has been suggested that this is a masturbatory fantasy, that Mickey is really pulling on something phallic (see for example the long propeller blade in the last picture) that is also "ready to rise" in dreams. But to leave the image at that point is to flatten the metaphoric suggestiveness of Sendak's premise in the book. Mythologically, metaphorically, Sendak is describing a process of making, of creating, using the archetypal child once again as his literal embodiment of this human capacity. Indeed, *In the Night Kitchen* is centrally and crucially about the myth of making, of making something from unlikely materials. It is a magical process, whether it be a cake appearing from its nondescript ingredients, an airplane emerging like a piece of sculpture from its initial amorphous mass, or the surprising, satisfying form of a picture book story crystallizing from these odd references, memories, and free-associational connections. The essential problem for all myths of creation is how to put it all together to get gold—as the alchemists, those scientist/mystic/philosopher artists, hoped to do by combining in their laboratory/kitchens the primary materials of creation. The bakers in *In the Night Kitchen* don't get the formula right; it takes the mercurial force of the archetypal child, a spirit that can move between the upper and lower worlds of the gods and the middle world of mankind (here, in an airplane!), to find that indispensable missing ingredient.

In the next sequence of the book, Mickey takes off blissfully in his plane. Once again he is airborne, but now he is flying in a device of his own creation, not falling uncontrollably into the unknown. His plane hardly seems airworthy but, then again, neither did Mickey Mouse's or Charles Lindbergh's, and it would be unconvincing and less heroic if it were. Appropriately, it looks childmade: lumpy, droopy, like the clay projects lovingly hauled home from nursery school that have been invested with boundless four-year-old *mana*, or like one of Claes Oldenburg's soft sculptures from the late 1960s that were intent on reconstituting our normal expectations concerning form and material. If the fantasy of the book has worked thus far for the reader, the plane will fly, regardless of how it looks. It may be shaking a few extra drops of dough from its tail, but as Mickey takes the plane for its blissful spin, Sendak bathes the Night Kitchen with warm pinks and reds, leaving little doubt as to the secure, happy outcome of this visionary flight: he even labels one of his "jar" buildings "Safe Yeast."

Mickey's peaceful ascent is interrupted by the bakers "howling" for milk. There is, after all, still the matter of the cake, and ancestral forces like the Wild Things or the bakers have to be appeased. Besides, there is, as we shall see, an

added, mythic purpose to Mickey's journey into the underworld that Sendak will declare on the last page of the book—an outcome that cements the connection between Mickey and his child audience.

Now that Mickey has become empowered, he has no hesitation about how he should handle the bakers, who have become florid with their demands. As he flies by in his plane, he simply offers a snappy salute and grabs the measuring cup that the first baker is holding. Mickey turns the measuring cup into a hat—a fitting thing to do since Hermes is also the god of the market place, of weights and measures and of "packaging," and as we have seen, the Night Kitchen is made of packages of one kind or another.

Mickey's cap is Sendak's way of introducing, finally, the "terrible cap" of the first draft of the book that Mickey insisted upon wearing to bed, thus "disturb[ing] the whole world": it's the hat that "will only make trouble." [56] It is, of course, the trickster's hat: Hermes is the only one of the gods (except for Hades) to wear a hat, and it renders him invisible and thus able to move unseen between earth, heaven, and the underworld; it is also the cap that Hermes wears when, as psychopomp, he leads the souls of the dead down into Hades' realm. With his cap, Mickey can literally go "over the top of the Milky Way" in the next four-panel sequence (Color Plate 4), as Sendak shows us a Mickey climbing vertically into the Night Kitchen sky, past a banner that announces "Champion"—an obvious comment on Mickey's condition but also a private allusion Sendak was making to the first words that he remembered hearing from his nurse when he "woke up" from his coronary a few years earlier in an English hospital. Within two panels Mickey has climbed over the moon, which is tracing an unusual, though graphically convenient downward arc as more stars appear to fill the sky around Mickey's airplane and thus suggest his ascendance. It is a quick journey to his destination, a giant milk bottle, and when he reaches its top, Mickey turns to the reader and smiles broadly beneath his "trouble cap." As our eye follows the line of the outer surface of the milk bottle down to the bottom of the page, Sendak provides us with another sign that, like a chorus, objectifies part of the reader's complex emotional state at this point in the book: "WONDER."

When we turn the page, Sendak provides us with a complete, wide-angle view of the Night Kitchen cityscape—our first view of it, in fact, that has not been broken into smaller pictures. Sendak bleeds this double-page spread to the edges, finally removing the graphic boundaries that separate the world of the book from the reader's world, and the two merge as Sendak stops the action here and allows the reader to contemplate the scene. Finally we can take in the full scale of the Night Kitchen, and Mickey's heroic act within that perspective, as he climbs higher than anything else within it; the moon, which was setting just a few seconds ago, has been rehung in the middle of the sky next to the Champion banner that now flies freely, uncrowded by the earlier, narrow frames. The cooks, who once filled the page, now are comically small; they wait expectantly, deferring to the child at this new pinnacle of the action. And over the whole kitchen the enormous, monolithic form of the milk bottle now "takes dominion everywhere," like Wallace

Stevens's jar in Tennessee or the giant megalith that exerts such mysterious attraction in *2001: A Space Odyssey*. Its smooth, unembellished form is distinct from all the other containers in the Night Kitchen. For Sendak and those old enough to remember milk being delivered in these cool, white bottles, it is a powerful souvenir of an earlier time; but even for those young enough to know only today's waxed containers or plastic jugs, its sculptural shape has the capacity to suggest something from the archaic past that cannot be claimed by the omnipresent semiotics of product labels.

The giant milk bottle is, on one level, another Proustian symbol of the late 1920s and 1930s for Sendak, who woke up to their clinking sound when he was a child and who has tried to reconnect with that sensory experience in this and other works, such as the milk wagon in *Higglety Pigglety Pop!* Once again in his exploration of a given symbol that is particularly charged, Sendak reaches unexpected depths that lie below this purely biographical frame of reference. And with Sendak it is always a matter of following those references to their general, archetypal sources. Thus, the milk bottle that Mickey dives into in the four panels that span the next two pages (Color Plate 5), with its transformed Mickey floating in it, resembles nothing as much as it does the process by which the medieval alchemists sought to render the mercurial spirit, the hermetic child, in the bottles and retorts of their "kitchens" (Fig. 93). This process, which has been frequently compared to that of artistic creation as we generally think of it today, meant tak-

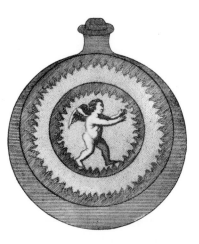

Fig. 93. Hermes/Mercurius, in an alchemical vessel from an eighteenth-century manuscript

ing "the commonest or most despised of substances," including "decaying matter of all kinds, various herbs which had a reputation for magic, some kinds of rock, milk, semen; all kinds of things thought to represent the beginnings of nature," and through stages of distillation transforming this dark, chaotic matter into something rare and clear.[57] In the course of the alchemist's experiments, "all the mythological archetypes appeared. . . . the green dragons and the white and red lions were, at the same time material substances and visionary figures. [The alchemist] was in no state of mind to hold strictly to the narrow path of rationality. All his work was in quest of a mystery."[58] His undertaking had special importance: "To the alchemist the whole process was a living myth which was purifying the worker as it purified the sad, undifferentiated, and yet uncombined, *materia prima* with which he sought to work."[59] It was hoped that the alchemist's attempt to unite and to "cook" opposing materials together in one of his retorts would result in the production of a pure white elixir: "everything moved towards the appearance of a most beautiful whiteness."[60]

In *In the Night Kitchen*, Sendak's own creative alchemy was tapping these archaic, mystical roots and moving his story toward its vision of that "whiteness."

Sendak brushed aside Gene Deitch's questions about specific meanings of images in the book, claiming that he could not explain them and, even if he could, he preferred the book to retain an aura of "mysterioso" that is not dispelled by any obsessive need to know, concretely, rationally, specifically. Still, we cannot help but express *wonder,* as the sign at the bottom of an earlier page asks us to do, why he would have Mickey dive into the giant milk bottle, the top of which he has just reached? And then, as Mickey sinks into the milk and his suit falls to pieces and he is once more a naked child, why he should sing from inside the bottle—once more adapting a nursery rhyme as his personal anthem: "I'm in the milk / and the milk's in me. / God Bless Milk / and / God Bless Me!" These images are unusual, to say the least, for an American audience of the early 1970s.

Sendak's point in taking Mickey to the underworld is, clearly, to go deeper than the conventional and expected, the approved and familiar. On the one hand, the trickster breaks boundaries. But on the other, as we have seen throughout Sendak's work, he is also a source of creative energy who can reshape the chaos he causes or encounters—a subject at the core of Sendak's concerns about and interest in his own creative process. He is forever redefining boundaries and limits, forming bridges between unlikely territories, solving the mythic problems of incomplete recipes. The Hermes/Mercury spirit that Sendak evokes through Mickey was thought to be an agent of synthesis, whether of antithetical materials, forces, states of mind, or genders in nature (Fig. 94). Thus, one treatise from the seventeenth century depicts the child Hermes in an alchemical vessel hovering above a man and a woman locked in a symbolic sexual union (Fig. 95).[61] Sendak had earlier drawn a hermaphroditic figure in one of his fantasy sketches, but in a book that he knew would surely be read by children and parents together, he suggests this *coniunctio* more obliquely, as he would also omit the scene of Mickey's parents' primal embrace from later drafts of *In the Night Kitchen*. Instead, he leaves this archetypal bridging implied for the child to absorb unconsciously from the "logic" of the book's images and language.

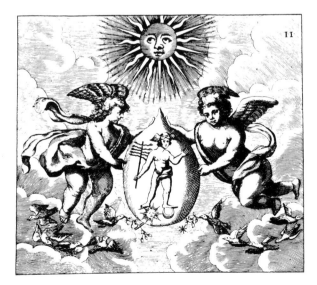

Fig. 94. Hermes/Mercurius as homunculus "ripening," in an alchemical vessel from an eighteenth-century manuscript

Inside the milk bottle one might think Mickey would be out of his natural element, and yet he could not be more at home; he metamorphoses again, shedding his doughy cocoon, and sings about the connection between himself and the milk: he is both contained

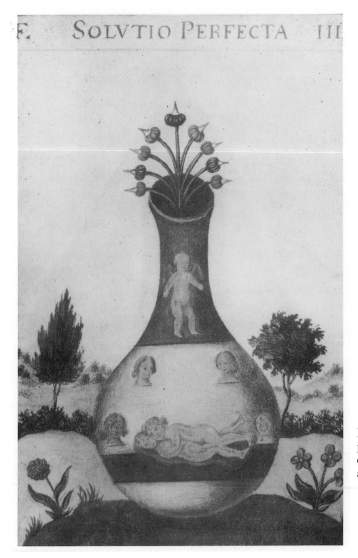

Fig. 95. Hermes/Mercurius
joining oppositions, from an
early eighteenth-century
alchemical manuscript

and container. Sendak's simple words are rich with other possibilities: Mickey is an ingredient in milk, that ancient source of nourishment, as well as a product of it. Mickey, it must be underscored, *sings* these words; they act as a charm, as does his song to the bakers earlier in the story, holding them transfixed while it frees him from the cake in the oven. This small detail is nevertheless important because it reveals yet another of Mickey's mythic relatives—Orpheus. Orpheus was known for his journey to the underworld and his abilities as an artist to enthrall the Wild Things to be found there. He held additional, perhaps even more important, powers for those who established the Orphic mysteries of the ancient world, which were sparked by the realization that

> Orpheus journeys down and up: down to the depths of the psyche, to the depths of being, to death's realm, and back up to life and creation and thence into death and song—this servant of Dionysus and pupil of Apollo,

architect of the troubled soul and peacemaker for the distressed mind. For Orpheus is truly a reconciler of opposites: he is the fusion of the radiant solar enlightenment of Apollo and the somber subterranean knowledge of Dionysus.[62]

In Sendak's Orphic Mickey swimming in the milk bottle, such a reconciliation is certainly taking place between masculine and feminine aspects of Mickey's character; the phallic energy that animates his creative shaping may also be associated with ancient ideas of the masculine father, the "potter" who gives form to the "matter" provided by the maternal feminine.[63] Interestingly, this uniting occurs in a vessel that is curiously androgynous, phallic in shape, while at the same time it is a womblike chamber containing a child. It holds a white, quintessentially feminine fluid, and yet the color of the liquid is the same as sperm. In finding the milk and reveling in it, Mickey has combined two of the most basic components of our common humanity, bringing together in this image the "opposites" of the masculine and feminine. One of Sendak's favorite authors, Herman Melville, found a similar reconciliation late in *Moby-Dick* when Ishmael is given the job of squeezing the whale's sperm and is similarly lost in the experience:

> I squeezed that sperm till I myself almost melted into it; I squeezed that sperm till a strange sort of insanity came over me; and I found myself unwittingly squeezing my co-laborers hands in it, mistaking their hands for the gentle globules. Such an abounding, affectionate, friendly, loving feeling did this avocation beget; that at last I was continually squeezing their hands, and looking up into their eyes sentimentally; as much as to say,—Oh! my dear fellow beings, why should we longer cherish any social acerbities, or know the slightest ill-humor or envy! Come let us squeeze hands all round; nay, let us squeeze ourselves into each other; let us squeeze each other into the very milk and sperm of kindness.

The Orphic quest in modern literature, Walter Strauss reminds us in his study of that theme, is "for the lost, dimly-remembered or forgotten, repressed self—recovery of the authentic self underneath the incrustation of material and historical existence."[64] Such is, of course, the reclamation that Sendak hopes to achieve through Mickey, and his interest is that of "the Orphic poet, once more at the beginning of a journey, confronted with the task of sacralizing time, space, and language before the Orphic spell can take place. His task is to face the Nothingness, to overcome (abolish) it in order to make poetry once more possible."[65] We see that poetry bubble to the surface of the Night Kitchen a few pages later once Mickey has delivered the milk to the bakers, who can now finally bake their cake and celebrate their accomplishment with a song: "Milk in the Batter! / Milk in the Batter! / We bake Cake! / And Nothing's the Matter!" Indeed, "nothing" has now been transformed into the stuff from which poems and picture books are made.

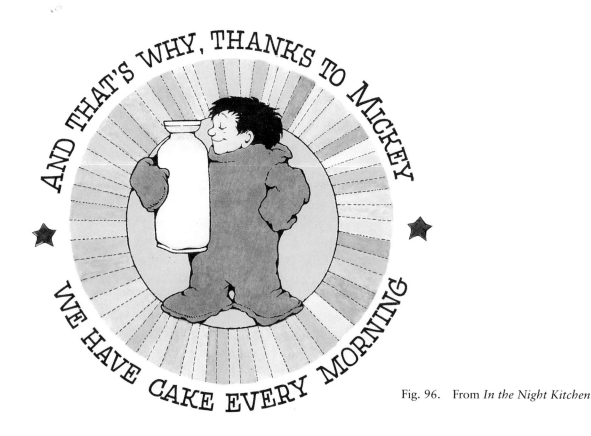

Fig. 96. From *In the Night Kitchen*

Once Mickey has found that primal, magic ingredient, Sendak concludes the story with sequences that mirror earlier passages in the book, though here, at the end, everything is reversed from its previous state. The bakers happily make their cake—they even get a final song and dance number that, when the book became a film some eighteen years later, Deitch renders as a ragtime tune, with the bakers as Rudy Vallee crooners who provide the musical accompaniment for Mickey's flight home to his bed. But while he had fallen into darkness and the effect of initially overpowering forces that he tries to quiet at the beginning of the story, he is completely empowered at the end, standing near the top of the milk bottle and making his famous phallic proclamation to the now-lightening Night Kitchen: "Cock-a-Doodle Doo!" He slides down the side of the bottle in a scene that parallels his earlier fall, but by the next frame he is yawning as he passes the same curtained window of his house (as the sky outside gets lighter still) and finally reaches his own bedroom.

Sendak has brought the story full circle. In fact, he has Mickey fall down into his room from the higher point to which the dream has elevated him. After all, Mickey has climbed above the stars in his dream, becoming the divine child who travels "out of the everywhere into the here." At this point Sendak does not call any further attention to this extraordinary identity—though the suggestions of it are subtly managed in the last two pictures of the story where Mickey acknowledges his pleasantly transcendent experience with a broad smile and a reversal of

his anxious "OH" to a satisfied "HO," and where he curls up to sleep until breakfast with one last comment on his adventure—a simple "YUM!" Interspersed with these moments of complete relaxation, Sendak provides more realistic touches that bring Mickey, as well as the reader, back down (or up) to earth. Mickey is slightly startled to be falling into his bed again, and in the first of these four pictures, as well as in the next to last picture of the book, Sendak shows him, back in his pajamas, settling into bed with an undistinguished, yawning "HUM." Like Pierre or Max, he has moved through a troubling moment in his life in which he has had to work things out for himself, and he now returns to his other world ready to take up that life again, strengthened, nourished by his experience in the underworld, remembering the delicious cake that he held the key to making.

Once again, Sendak's myth solves a basic problem for the reader who may be frightened or dismissive of the material that is offered nightly to us by the unconscious. Why bother exploring something as potentially unsettling or overwhelming as the "ancestors," those ancient powers that are stirred up when we make that descent into our personal underworld? How can these seemingly chaotic, life-threatening, absurdly cryptic materials be seen as valuable, important, interesting—let alone life enhancing? For Sendak, the archetypal child provides the mythic solution, combining as it does the mercurial spontaneity, plucky determination, and creative confidence with an innocence and an openness to the experience itself in order to lead the dreamer's soul through these dark regions.

Sendak provides us with one final view of Mickey on the last page of the book to remind us of these qualities and of the mythic light in which he wished the book to be cast. Mickey is dressed again in his hero-of-the-underworld outfit, holding a bottle of milk and surrounded by radiant yellow, pink, and orange sunbeams. He is Sendak's logo, his advertisement for himself and his imagination's answer to both Disney's Mickey Mouse and the Sunshine Bakers (Fig. 96). Sendak reminds us, as tellers of myths often do, what lesson of origin or of mankind's condition is meant to be derived from the story: "And that's why, thanks to Mickey we have cake every morning." But, as we have seen, it is not an ordinary sort of message, cheerfully matter of fact as it may seem; the cake is not literal cake, the Night Kitchen has an ever-shifting geography, and the trip itself—well, that trip is a plunge into everything that is usually repressed in children's books: death, the body, sexuality, the dynamics of the unconscious, and the work of the soul. And so it was, for Sendak, also a courageous book that left behind conventional expectations, an artistic "coming forth" on behalf of that divine child at a time in our cultural history when we sought a fresh spirit that could move us into the future. *In the Night Kitchen* was a crucial practice of that visionary alchemy.

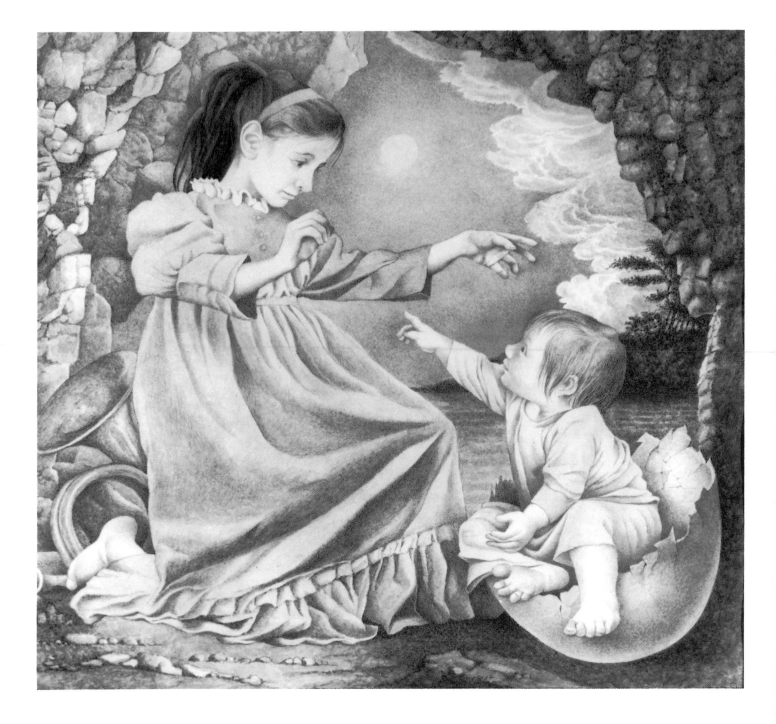

IDA, MILI, AND THE BABIES
Inner Harmonies

Lasst uns der Armen Trost bereiten,
fürwahr, ihr Schicksal geht uns na'.
—Die drei Knaben, *Die Zauberflöte*

Life is probably round.
 —Van Gogh

SINCE ITS APPEARANCE IN 1981, *Outside Over There* has been widely viewed as Sendak's stunning, enigmatic magnum opus. There would be two other books, *Dear Mili* (1986), based on a celebrated rediscovery of an unpublished tale by Wilhelm Grimm, and *We Are All in the Dumps with Jack and Guy* (1993), which drew once again on obscure Mother Goose rhymes for its text. *Outside Over There*, though, was all Sendak's: his idea, his narrative, his illustrations, the latter done in a style that had once again metamorphosed because of Sendak's contacts with a new configuration of inspirational sources that included the familiar palette and compositional ideas of William Blake as well as the more esoteric German Romantic painters Philipp Otto Runge and Caspar David Friedrich, the drawings of Arthur Hughes for George MacDonald's *The Princess and the Goblin*, and the 1939 film version of *The Wizard of Oz*.[1] By the late 1970s in lectures and interviews, as part of what Michael Steig describes as "at least a five-year buildup" of media interest in the book,[2] Sendak was referring to *Outside Over There* as the final volume in a trilogy of works that began with the revolutionary rumpus of *Where the Wild Things Are* and continued with the nocturnal heroics of *In the Night Kitchen*. Together, Sendak noted, these three books were all "variations on a theme" that he had been "tracking" since the mid-1950s in such early books as *Kenny's Window* and *Very Far*

Away.[3] Variations tend by their nature to become increasingly more complex, as Perry Nodelman has observed; and *Outside Over There* would be, in many respects, the most elusive, allusive, and critically demanding and debated of the works in this trilogy of mythic investigations into how children cope with their daily, internal pressures by finding solutions through fantasy.[4] In an often-quoted statement that he made during the early stages in the creation of *Outside Over There*, Sendak waved aside what he now regarded as the "simple" conception of *Where the Wild Things Are*, opting instead for the doubled layers of meaning in *In the Night Kitchen*. He was only a few years into the five-year process that would lead to *Outside Over There*, but he already felt that the intricacies of this book would overpower the others and "reverberate on triple levels."[5]

Despite the complexities of *Outside Over There*—or, perhaps, because of them—Sendak felt he had located that elusive "it" he had been searching for in his work. In this book, he said, he finally "had it trapped in a corner . . . like Sherlock Holmes, sniffing it out in myself."[6] Having made this personal discovery, he ventured that it "probably is unlikely I will do another picture book. . . . It was definitely the end of a certain kind of book that I would do."[7] Even though, "psychically and physically the pictures drove me crazy," Sendak called the book his "masterpiece."[8]

Not all of Sendak's critics would regard the book with such absolute certainty. In fact, while *Outside Over There* was widely praised and was one of the runners-up for the Caldecott Award (the medal itself went that year to *Jumanji* by one of the new stars of the next generation of picture book fantasists, Chris van Allsburg, who had, in his turn, been significantly influenced by Sendak), it also baffled many critical expectations. Some commentators on the work had difficulties with the style of the text, especially the curious syntactical inversions of such lines as ". . . and Ida mad knew goblins had been there."[9] Others predictably aired the frequent complaint about Sendak's images (a position that continues, as one discovers, when examining the book with a children's literature class or a group of parents) that, like the monsters in *Where the Wild Things Are*, children might find the baby-snatching goblins upsetting. Perhaps the most thoughtful of these mixed commentaries was Geraldine DeLuca's assessment of the book's allegorical dimensions, which led her to conclude that "the book has its achingly beautiful moments. It is often richer and more risk-taking than anything else around. But it is also overworked, self-conscious, its surface meanings sometimes disturbing and absurd." Despite Sendak's attempts at a resolution, she concluded that "we nevertheless still feel oppressed" and "are left at the end of this work with too much pain."[10]

Though Sendak alludes to the personal "pain" he experienced in the creation of the book (it had caused him, he told an interviewer, a "mini-nervous break-down"), the five-year ordeal led him to a different, indeed a cathartic end. For Sendak the book represented another kind of breakthrough, one that took him consciously into the domains of spirit, much as he seemed to hedge on this significance of *Outside Over There*: "I'm not saying it was a religious experience, al-

though in fact it was. And did it change my life? In fact it did."[11] He told one interviewer: "I believe in this book as though it were a factual thing that happened. . . . I believe in it in the way some people believe in spiritual things. When I was dreaming this book, what I was imagining was the most real thing I've ever felt. It seemed as if nothing that would occur after this book would be as real or as intensely wonderful."[12]

The depth psychologist Marie-Louise von Franz could have been describing Sendak's experience in the lengthy composition of *Outside Over There* when she outlines the process of self-realization or "individuation" that occurs when a man follows the feminine aspect of his psyche—his anima—"as a guide to [his] inner world." For a man this archetypal figure offers compensatory balance for the rationalistic, unemotional, empirical qualities of his masculine nature in the form of a representation of his "feminine psychological tendencies . . . such as vague feelings and moods, prophetic hunches, receptiveness to the irrational, capacity for personal love, feeling for nature, and—last but not least—his relation to the unconscious."[13] Von Franz reminds us that ancient traditions, from prehistoric shamans to the classical Greeks, have regarded the feminine in the form of priestesses as those best able to "fathom divine will and to make connections with the gods."[14] Given these ancient precedents, Sendak's choice of a female child as his symbolic guide into his own "inner world" was especially appropriate, as we hear in Sendak's own analysis of the importance of the child archetype in his art. After all, Sendak explains, it is the "child me" that "is most intact." He calls this child "the most trustworthy part" of himself even though "it gets [him] in trouble, and it's slightly incoherent, and it's embarrassing in middle age to stumble over that part." Still, he maintains, "as an artist, as a listener, as a feeler of things. . . . [the child] is the part I trust, that gives, the part that deals with the work. That's the part where the work comes from."[15]

Clearly, too, his years of exploring these psychological interiors as an integral part of his own creative process had already taught Sendak the route that von Franz goes on to chart for reaching the deeper understandings so important to "the dreamer's" psychological development. For a man such awareness can occur when he takes

> seriously the feelings, moods, expectations, and fantasies sent by his anima and when he fixes them in some form—for example, in writing, painting, sculpture, musical composition, or dancing. When he works at this patiently and slowly, other more deeply unconscious material wells up from the depths and connects with the earlier material. After a fantasy has been fixed in some specific form, it must be examined both intellectually and ethically, with an evaluating feeling reaction. And it is essential to regard it as being absolutely real; there must be no lurking doubt that this is "only a fantasy." If this is practiced with devotion over a long period, the process of individuation gradually becomes the single reality and can unfold in its true form.[16]

Though some critics have dismissed the personal, psychological experience that informs Sendak's books, arguing that these are irrelevant to our individual understanding of Sendak's texts, the fact remains that with some of his works, particularly with *Outside Over There,* we are aware of this inner dimension because Sendak, believing in its importance, insists on telling us about it. He acts as a public scholar and critic of his own work—an unusual role for the artist to play perhaps, but one that cannot be disregarded.

Thus, if we listen to Sendak's own reading of his psychological reactions to *Outside Over There* we learn that, in some fundamental way, he felt he had come full circle, completing real and invisible, conscious and unconscious connections. Despite his generally gloomy disposition, he told an interviewer that the book made him deeply happy. In *Outside Over There* he identified completely with Ida and her journey: "What she did is what I did and what I know for the first time in my life I have done. The book is a release of something that has long pressured my internal self. It sounds hyperbolic but it's true; it's like profound salvation. If for only once in my life, I have touched the place where I wanted to go, and when Ida goes home, I go home, too." [17]

One hears in these and the many other remarks Sendak has made about *Outside Over There*—whether to Jonathan Cott for a *Rolling Stone* interview, Walter Clemons for a *Newsweek* feature, or Selma Lanes for biographical posterity—a depth of response regarding this book and its central character that is qualitatively unlike the observations Sendak has made about any of his other book children. It is certainly common for writers or artists to have works which, for inexplicably subjective reasons, they claim as their favorites, often to the puzzlement and sometimes to the disappointment of their audiences. Michael Steig points out in his interesting reading of *Outside Over There* that much of the mixed criticism that attended the book's publication may have had to do with the expectations that had been built up by Sendak during the years of interviews he gave before the book appeared, even though Sendak himself may have thought of these comments as a necessary preparation of his readers for another unusual book, one in which he had made a very large psychic investment. This time Sendak hoped that a book of his would not be automatically categorized as a children's book, thus relegating this multileveled breakthrough to the isolated realm of "kiddie book land." He wanted, more than any of his other books, for *Outside Over There* to be taken seriously on its own terms, and to that end he had even insisted that Harper & Row market it as both an adult and a children's book.

Immediately one can tell that by most standards *Outside Over There* is not an ordinary children's book; something holds the audience from the moment that we look into the soulful eyes of Ida in the cover portrait of the book's dust jacket. As we meet her calm, steady gaze, we are aware that we are being drawn into a very different place and style and mood than in the earlier two books of the trilogy. In this portrait Sendak offers a serene, painterly, classical pose. As Jane Doonan points out, it is all balletic grace. [18] And, one should quickly add, building on Jonathan Cott's insight, all hushed music. Sendak is asking us to experience the tones

of this book as though we were listening to a form of music, and Ida is expectantly alerting us to the first plaintive notes of the piece that Sendak is about to conduct for us.

The analogy between a musical performance and Sendak's presentation of his picture book is not merely illustrative but rather reflects Sendak's basic compositional habits and methods. We know that Sendak draws and paints to music, which he ranks as "tops" among all art forms, that his pictures are, literally, accompanied into creation *by* music and are often intended to be the visual accompaniment *to* music. Sendak has frequently spoken about how he draws to music as though he were composing music, calling that aspect of his creative process his "secret game."[19] "It's as though some part of me is permanently grieved and grief-stricken that I am not a composer."[20] The musical element and its pervasive, affective presence is intentional and integral to *Outside Over There,* in which he was trying to write, he explains, "an opera with pictures."[21] He draws the reader's attention to this musical dimension of the book by making his heroine Ida a musician and includes music in his *mise-en-scène.* In this first picture that we see of her, she holds a hunting horn, which she will later play both to lose and to find the other child, her baby sister. The climactic moment of the story features Ida's music, a "fierce, in a frenzy, almost orgiastic" dance that separates the goblins from Ida's sister.[22]

But the influence of music plays to the heart of Sendak's entire aesthetic for the book, which he describes as being "just barely held together, like a musical phrase—if one note is out, then the whole line collapses." In fact, he felt the whole "surface" structure of *Outside Over There* was

> so tenuous—this bit of a plot, of a mother lost in thought and a child playing and a baby being taken away—just the barest bones, but the counterpoint is perfect because you can see into the music; you can see the underneath part of this book. . . . both musical lines are going and they're both transparent. The subliminal line is very clear, and the external line is very clear, but they are now even, they're of an equal transparency.[23]

As has been so widely reported and commented upon, Sendak's musical background and inspiration for the book is, of course, Mozart. In his statements about the book, Sendak has frequently acknowledged that "right in the middle of *Outside Over There,* everything turned Mozart. Mozart became the godhead."[24] It is not as though he was unaware of Mozart until that point in 1976 when the stage director Frank Corsaro called Sendak and asked him if he would like to design the sets and costumes for a new production of *The Magic Flute* that had been commissioned by the Houston Grand Opera to premiere in 1980. As we have seen, music "quickened" all of Sendak's fantasy sketches from the 1950s; many of these spontaneous works were drawn to Mozart, and Sendak had always had, it seems, a small portrait of Mozart hanging somewhere in his various studios. But the work on *The Magic Flute,* which Sendak refers to as his favorite opera and, for him, the

most sublime piece of music ever written, was catalytic to his creation of *Outside Over There.*

Sendak's desire to pay homage to the composer and his influence are evident in the book and throughout his statements about it. As he would also do a few years later in *Dear Mili,* Sendak placed a Mozart busily at work making music in the visual background of *Outside Over There;* he accompanies Ida on her return home with her baby sister. Mozart is on the other side of the river in his eternal *Waldhütte*—the creative cabin in the woods that is a recurrent and potent Romantic image for Sendak. In his 1980 poster for the Houston Grand Opera's production of *The Magic Flute,* Sendak also showed Mozart in his *Waldhütte* receiving his inspiration—in the form of a glockenspiel, a flute, and a flower from the three celestial children who appear at key moments in the opera either to transport the characters or to save them from destroying themselves (Fig. 97). One of these instants, when the heroine Pamina is on the verge of suicide and these three genie appear to encourage her to "hold on" is, for Sendak, an overwhelming scene, and his comments on it reveal the depth of his admiration for the composer: "That small thing of Mozart having three children tell this distraught almost grown-up woman to stay alive. I don't know any other person or any other artist or any other moment in art that is like that or that affects me so much." [25] For *Outside Over There,* Sendak insisted that he "wanted only the sound of Mozart. . . . This is Grimm country; this is the eighteenth century; Mozart died in 1791; it's proper the music should be only Mozart." And then he adds the only half-humorous aside: "Since I am running the show, I can do things any way I like. . . . These are the games that you play; after long hours by yourself you've got to do something to entertain yourself." [26]

Thus, Mozart—the music, the man, and the symbol of the man as a creative genius—is central to the conception of *Outside Over There* and needs to be kept in mind throughout any discussion of the book. Shortly after the publication of the book, Sendak explained Mozart's connection to the book:

> In some way, *Outside Over There* is my attempt to make concrete my love of Mozart, and to do it as authentically and honestly in regard to his time as I could conceive it, so that every color, every shape is like part of his portrait. The book is a portrait of Mozart, only it has this form—commonly called a picture book. This was the closest I could get to what he looked like to me. It's my *imagining* of Mozart's life. [27]

A few years later when Sendak was profiled for the Public Broadcasting System's "American Masters" series about important figures in our culture, the documentary about him was called "*Mon Cher Papa,*" borrowing its salutation from Mozart's letters to his father and thus affirming Sendak's own connection with Mozart as his spiritual mentor. Mozart became "someone to look up to, someone to think about—a god I really could respect because he was an artist." [28] Not incidentally, Mozart was also a child artist as well as an artist who had remained engaged with

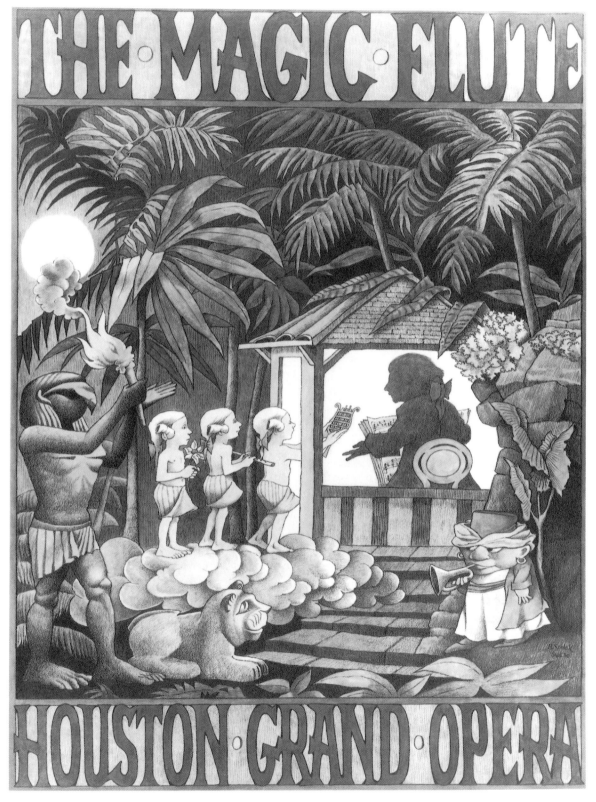

Fig. 97. "The Magic Flute," from *The Posters of Maurice Sendak*

his child spirit throughout his work, facts that were especially significant to Sendak given his own frequent celebrations of the child artist and the animating influence of the child archetype.

Sendak had "found" Mozart in the mid-1970s, he relates, not realizing at the time that he was looking for such a divinely guiding, inspiring figure. "I need somebody to help me, really," Sendak confessed during the course of the interviews interspersed throughout the PBS program, and about the same time that the documentary was being filmed he told another interviewer:

> If anybody could prove to me that Mozart was God, I would believe in God forever. But I do believe in Mozart as though he were God. If God is someone that's supposed to give you comfort, I think of him and I listen to him when I'm in trouble. When my dog died last summer, and I couldn't bear it, it was only *The Marriage of Figaro* that got me through the last two weeks of August. Because there is [in Mozart] a truth, a revelation, spirituality, humor, and earthiness.[29]

Jonathan Cott has argued that Sendak's affinity for Mozart lies "in the way that Mozart synthesizes and reconciles the sacred and the profane, the serious and the comic, and the elevated and the popular," much in the same way that Sendak blends harmonically together "the most disparate kind of materials from creators as diverse as Caldecott and Walt Disney, Dürer and Winsor McCay, Mozart and Carole King."[30] Accurate as it is, such an explanation rests too heavily, perhaps, on rationalistic formulations. Sendak's own insights into the importance of Mozart in particular and music in general suggest something far more irrational and emotional, intuitive and instinctive than these words can reach. For Sendak, Mozart is also the archetypal creator of that "mystic babble" called music that we respond to from our earliest years of life; it "is bone close to you, it's your primal state of being. It's a language you once understood thoroughly . . . as a child, as a baby."[31]

In depth psychology, the result of having probed, with the help of the anima (that animating feminine energy in the male psyche), to "the innermost nucleus of the psyche" is that another symbolic figure, the Self, appears to guide the male "dreamer" who has embarked on this personal journey of discovery. For men this archetype appears as "a masculine initiator and guardian . . . a wise old man, a spirit of nature," and, often one must add for Sendak, a master artist.[32] Surely, the arrival of Mozart on the scene in Sendak's life had the same transformative effect that von Franz insists will occur after an individual has done the substantial hard work of exploring his unconscious. The appearance of the Self brings with it a "renewal of life, a creative *élan vital*, and a new spiritual orientation by means of which everything becomes full of life and enterprise." Again she could have been describing the process for Sendak and the burst of new energy that he experienced in the 1980s when she observes that: "If a man devotes himself to the instructions of his own unconscious, it can bestow this gift, so that suddenly life, which has

been stale and dull, turns into a rich, unending inner adventure, full of creative possibilities."[33]

Sendak brought this sense of renewed possibilities to the dust jacket painting that introduces *Outside Over There* (Color Plate 7); the "mystic babble" of its music washes over us with the calm, pale lavender that serves as background for the cover and the fantasy that is about to unfold.[34] Given this quiet color quality, the earnestness of Ida's face is set in subtle but contradictory tension. Sendak wished to capture in Ida some of the qualities that made the performance of Ana Torrent, the young child actress from the Spanish movie *The Spirit of the Beehive* (1973), so moving to Sendak when he saw this film—a portrait of a child who is plagued by fantasies in which she imagines threatening, "menacing" qualities in the everyday world around her. She "sees everything, wears a look of grave intelligence," Sendak explains, *"but gets it all wrong.* My drawings of Ida were based on my visual memories of Ana Torrent and Maria Callas," the famous opera singer who, in her tragic personal life, also "[got] it all wrong."[35] We can see that Sendak means to confer on Ida a sensitivity that is lacking in Rosie and Pierre, Max and Mickey: she is not another kid who might some day appear in a cartoon. As opposed to the comparatively flat, two-dimensional surfaces of the majority of his other child characters, Sendak is interested and asks us to respond at once to Ida's, as well as her baby sister's, depth of person, to her enigmatic complexity.

Ida's baby sister points at and reaches—for what? A flower, perhaps, or something only she can see. We understand so little about babies, Sendak maintains, and we don't credit them with "instantly beginning in as complicated a form as the moment we die."[36] The baby's is the other storyline in the book, and Sendak will be concerned with demonstrating in his pictures of the "mystic babble" of the baby's gestures that "there's an infinitude of meaning in every body movement [babies] make."[37] In this first view that we have of the baby, Sendak leaves off the child's fingernails, as Jane Doonan notes, thus making the baby figurative, an abstraction, a more generically presented organic form, corresponding to the petals on the flowers she is about to touch. She reaches to the reader's left, subtly suggesting the dark unconscious qualities associated symbolically with that "side" that etymologically refers to sinister portents and lurking dangers.[38] Yet the child is not afraid. Instead, her face is alive with curiosity. She is ready to move; her pose cannot be held for long. Something seems to beckon the child. Already, huge flowers—part daisy, part sunflower—have begun to overtake the picture. Wildness again. Nature will have its way and give us the unpredictable, despite all our attempts at order (the fence, the smoothly shaped metal of Ida's horn, the crisp outline of the letters of the title, the textual "window" that introduces language with its chiseled codes).

Paradoxically, the cover evokes both endings and beginnings—the pause before the storm of the story and the tranquillity that is reached after its dramatic tensions have been safely negotiated. Since the book is almost certainly going to be read more than once, this initial picture becomes a point of reflection for the

reader, a way to remind us, on successive readings, of the book's contemplative end, even as we are about to embark again on the seething, unsettling, multileveled adventure for which this visual prelude is preparing us.

Fittingly, too, Sendak brings two children into this picture—an older and a younger child, thus representing the age "limits" of the archetypal child—the one at its ineffable beginnings in babyhood and the other at its full power in the person we may call the mature child, who is just on the verge of leaving childhood. Once more, we remember Jung's identification of the child archetype as symbolizing "the all-embracing nature of psychic wholeness," and here Sendak is suggesting that same wholeness in this carefully balanced, while at the same time fluid, composition.[39] With his emphasis on two children, Sendak has moved his representation of the archetypal child beyond the one-dimensionality of Max or Mickey. This musical scoring of the two narrative lines of Ida and her sister, of an older child and a baby, are stories, Sendak says, "[he has] felt . . . most all of [his] life. And maybe they're the stories [he] wanted to tell most all the time."[40] One thinks, for instance, of his tender scenes between older and younger children in *A Hole is To Dig,* which are not called for by Ruth Krauss's text but rather issue from the same primal concern that Sendak revisits in *Outside Over There.*

As Robert Rosenblum, Jane Doonan, and others have pointed out, a major inspiration for Sendak's cover of the book (a white picket fence, a towering stand of sunflowers, and children staring out at the audience) is from a painting entitled *The Hülsenbeck Children* (1805–6) by the German Romantic artist Philipp Otto Runge. In *Outside Over There* and, a few years later, *Dear Mili,* Runge became a touchstone visual artist for Sendak because of his concern with portraying children as "organic mysteries," with "a kind of Romantic vitalism in which children are at one with the magical energies of sunlight and burgeoning landscape."[41] In describing the intensity of the bodily gestures and the expressions on the children's faces of Runge's famous portrait, Rosenblum notes that "nothing prepares us for this urgent and total immersion into the separate and private mysteries of a child's own domain" in which "the children rather [than] being dwarfed by adult carpentry and architecture, loom over us like rapidly growing giants."[42] Sendak's opening portrait of Ida and her sister achieves a similar effect: it fills the page and thus the consciousness of the reader with a sense of mysterious possibilities, of only barely contained potential—for both action and feeling—in their momentarily delayed dance.

While one can follow the inspirational roots of *Outside Over There* back to Mozart and Runge, the narrative origins for the story are contained in a short fairy tale that Sendak and Lore Segal had included in their two-volume collection of Grimm's fairy tales *The Juniper Tree* (1973) that Sendak had illustrated. The most arresting picture in this compelling series of black and white illustrations is that of a huge baby being carried away by six bearded, struggling, little men for the tale "The Goblins" in which a changeling child ("with thick head and staring eyes who did nothing but eat and drink") is substituted for a real baby until the mother

discovers how to reverse the process and recover her child.[43] The brief story was, Sendak recalls, the spark, the inspirational "*Thrmmmmmm!*" that kindled the work on the book that would become *Outside Over There* nearly seven years later.[44]

In "The Goblins" a mother—as opposed to a child like Ida—has had this malicious trick played on her, though the story never blames the mother for ignoring the child and thus making the theft possible. But even closer to the spirit of Sendak's story than the Grimm vignette is a Russian fairy tale, "The Magic Swan Geese," in which a young girl is told by her parents to look after her brother while they go off to work in the fields. The older child neglects her sibling, running off to play instead, and returns to the yard to find that he has been taken away by the swan-geese. The rest of the story focuses on the girl's desperate, guilt-propelled search to find and bring back her baby brother before her parents return home. During the course of her adventures, she also must learn humility: she must ask for help and she must learn to eat the simple foods that she disdains on the first half of her journey.[45]

Both *Outside Over There* and "The Swan-Geese" are, of course, expressing the ancient problem of sibling antagonism that can arise when one child is given the task of looking after another. The lore of lullabies reveals a similar motif in the form of an "inward" lullaby in which the child nurse's song is meant to ventilate her emotions rather than to soothe the infant she is rocking to sleep. Take, for example, "a typical lullaby" that contains the first, horrifying verse:

> Siembamba, Mama's little child,
> Wring his neck, throw him in the ditch,
> Trample on his head.
> Then he is dead.

The singer's gruesome wish-fulfillment is quickly followed by the morally corrective stanza:

> That I shall not do.
> I like to keep my little child,
> So why should I cut his head off?[46]

Other kinds of children's folklore, such as skip rope rhymes, contain and help children to vent similar hostilities in a ritualized form that is not subject to adult supervision or censorship, as we hear in the well-known rhyme:

> I had a little brother,
> His name was Tiny Tim
> I put him in the bathtub,
> To see if he could swim.
> He drank up all the water,
> He ate up all the soap,

He died last night
With a bubble in his throat.

Sendak himself added his own chapter to these annals of babysitting when he described a scene that he witnessed one day as he was walking through New York City. A mother had left a young child in a stroller in the care of her older brother while the mother went into a store to make a quick purchase. Meanwhile, Sendak stood by, watching as the older child

> waited a moment, looked into the store, and sure enough her back was to him, and he turned around and whacked her—just whacked her right in the face. She was just stunned, but perhaps it had happened already. But he whacked her in such a way that he tilted the mechanism of the stroller, so that instead of being upright . . . she was . . . tilting quickly. Well, he couldn't quite figure out how to tilt her back, so he found the next best thing. [The stroller] had a plastic holder with a plastic bottle in it . . . and he pulled that [bottle] out and jammed it into her mouth. Well, now she's halfway on her head, so, of course, she's drowning. And it's coming out of all the visible orifices. I was terrified . . . [and] would have interceded, did I hear a death rattle, but short of that, it was really none of my business. But I approached to be ready just in case. And then, when she didn't take to the milk, when she started sputtering and crying and choking, [he] pulled it out [and] hit her again, because she was doing nothing right. She was tilting and choking. And at this point the mother came out, finally. It seemed like eight hours had gone by. And there is the baby, covered in milk, tilted. She took out a napkin or something, dried the baby, straightened it out, never yelled at the kid. Went off. And I guess she was grateful that the baby wasn't dead. And I thought, well, this is the life, the ordinary life—an afternoon shopping trip with Mummy. And [*Outside Over There*] is Shirley Temple compared to that. But it seems to me kids have to be this tough, because they would be destroyed very early on by the most loving care. And that's all I have to go on, is watching and seeing and feeling about things like that.[47]

Ida, then, belongs to a long-established, continuous tradition of older sibling caretakers, a tradition that is distinguished not by its uniqueness but instead by its quotidian nature. Thus, Sendak refers to the event that precipitates the story as "not a tremendous occasion or crisis, but an ordinary occasion." When we turn to the inside title and dedication pages and on to the first two pages of the book itself, we see how determined Sendak is to emphasize the ages-old task that is entered into by Ida and her sister. In the first of these short scenes, we see Ida coaching the baby on her first hesitant steps. Sendak holds us on the page with this small drama, especially since he is not compelling our eye to move to the right margin of the page. Rather, we are poised with expectation. Ida's hand is raised

like that of an orchestra conductor; it is letting go of her sister's hand and with it the safety of not having to take that step, of *not* beginning.

Then, on the dedication page, the scene changes again, and with it the relationship between the two children has become increasingly tense (Fig. 98). We see Ida from behind, trying to hold her upset sister who has begun to cry. Clearly the child is an armful, and she kicks out against the white blanket Ida has wrapped around her feet. In the background one of the hooded creatures is stalking them. Whether or not it is this specter that has upset the baby we cannot say, but the clear focus of the story is on the disintegrating relationship between the two children and the inability of the older child to cope with the role she has been assigned as the caretaker of the younger child. One can sense Ida's frustration building in the rigidity of her back and the downward cast of her face.

When we finally leave the peritext and enter the book, we gain a clue to why Ida and her sister are both in such an incompatible emotional predicament together: the whole family is experiencing a painful separation. The father of the children, the husband of their mother, has gone to sea. Ida and her mother stand next to each other, their backs to the reader, and watch as a group of ships, one of which may contain "Papa," has set sail. Meanwhile, the baby, looking heavier by the minute and still being held by Ida as she balances

Fig. 98. Dedication page from *Outside Over There*

barefoot on one of the large rocks that line the shore, has grown even more diffi-cult. Ida's large bare feet suggest not only her strength and her rootedness to the substantial realities of the earth but also her expectant size: these are feet that she will grow into, like a puppy into hers, and were it not for their sturdiness she would never be able to bear the weight of her sister. The baby looks at the reader, but also slightly to the left at the two hooded presences that are watching the scene. Their sail is set, too, but their journey is taking them in the opposite direction—inland toward Ida and her sister. They are shadow figures, unacknowl-edged, unconfronted, threatening. The romantic landscape—with its rough peaks and castle towers, its rocky shore, and wind-twisted tree beloved by the German Romantics and so admired by Sendak—opens to let a golden sky flood across the water, to hold back these shadows for a time, though we can see them encroaching on the boundaries of the composition.

Again, Sendak has borrowed a scene from the German Romantic painters, this time from Caspar David Friedrich and paintings like his *Moonrise by the Sea* (1821) in which the viewer is asked to contemplate, from the point of view of the solitary observers standing on the rocks of its shoreline, an awe-inspiring infinity of light. Friedrich brings us to "the very edge of the natural world. . . . [where] figures who stand mesmerized, singly or in pairs, before these mirages, their backs to the spectator, reinforce this experience of having arrived at the last outpost of the terrestrial world, beyond which there are only spiritual means of transporta-tion."[48] Sendak plays his own variation on Friedrich's theme by filling in the back-ground behind the boats, giving them a snug harbor, rather than an unlimited, allegorical vista against which it might seem unlikely that Ida's father ever could or would return. There is enough romantic yearning in the picture as it is—whether the picture is depicting Ida's father's departure or a visit to the shore to watch hopefully for his ship to return. Perhaps Ida's mother is trying to wave, awkwardly, toward the departing boats—we cannot tell since her face, along with Ida's, is hidden from the reader. We are left with ambiguous emotions while Ida still must contend with the burden of caring for the baby.

On the next double-page spread we see just how paralyzed her mother has become by her husband's absence. She sits in an arbor, staring off over a stone wall at a view of a river where a boat is making a solitary journey as she sings her internal, unvoiced aria of longing. Sendak draws her basic shape—with its left hand that rests on her extended left leg, the foot just showing from beneath the folds of the long gown, and its flowing coils of hair—from one of William Blake's group of twelve pictures for Milton's "L'Allegro" and "Il Penseroso" that he had examined at the Morgan Library in New York City in 1977 during the early stages of his work on the pictures for *Outside Over There*.[49] Seeing Blake's pictures in-spired Sendak and provided him with another spark for his own paintings; he borrowed Blake's technique of stippling to achieve the effect of multilayered tex-tures in his grass, water, clouds, walls, and other surfaces in the book. He also reinterpreted the particular pose that he selected for Ida's mother as she sits in the arbor from Blake's *The Spirit of Plato,* in which Blake depicts the philosopher

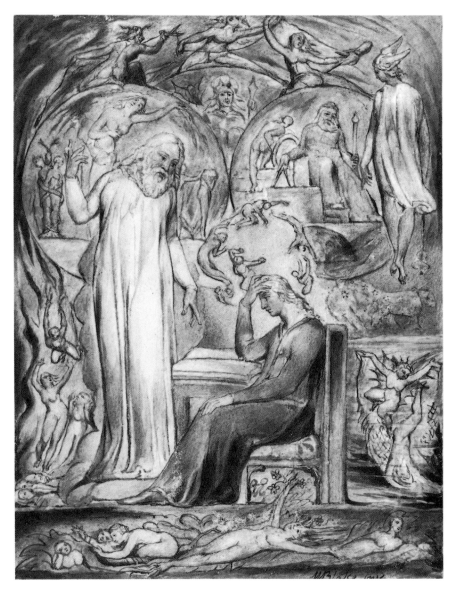

Fig. 99. William Blake, *The Spirit of Plato*

deep in thought while visions of the ideal swirl about his head in a cosmic dance (Fig. 99). But Sendak's image also reminds us of Milton's poem that mythologizes Melancholy as the "pensive Nun, devout and pure, / Sober, steadfast, and demure, / All in a robe of darkest grain, / Flowing with majestic train." Melancholy is a goddess born to Vesta and Saturn in a golden age prior to Saturn's overthrow by Jove, and Milton places the home of the goddess "in glimmering Bow'rs and glades" and "in secret shades" of the "inmost grove" of—synchronistically—Mt. Ida in Crete. Sendak has given us his version of one of those bowers in the first picture of Ida's forlorn mother, and he has placed Ida as a key figure in its landscape.

An enormous German shepherd occupies the center of Sendak's picture. The pet and watchdog for the family, it is also a stately reference to the presence of the animal world in the form of the dogs that continued to populate Sendak's studio and life after the death of Jennie. This dog, however, seems majestically and ambiguously unalarmed by the two cloaked figures that are now taking a ladder toward the left side of the picture, indicating, among a number of possibilities, that the danger is internal, a fantasy that would not attract its attention; whatever is going to happen seems, like fate, beyond the dog's capacity to intervene. As becomes clear in the next picture, the figures have moved on, undetected by the dog, to the house where they will use the ladder to climb into the room where Ida takes her sister.

There is nowhere else for Ida to go. She and her charge have been effectively forced off the page both graphically and psychologically while her mother is lost in moody contemplation, oblivious to the baby's crying, numb to Ida's needs for reassurance, help, and emotional contact. The baby's bonnet has fallen to the ground, but Ida, her hands locked under the baby's arm, her chin buried in her gown, cannot hope to pick it up. She has been pushed to her limit; and once again Sendak has brought his child heroine to an explosive point when, quite suddenly, it is possible for a fracture to undermine Ida's normally placid, if burdened experience—a schism that Ida will have to find a way, like both Max and Mickey, to bridge.

The basic conflict that now emerges for Ida is how to balance her responsibility of caring for her sister while her own needs, represented by her desire to play her "wonder horn," go unmet. A deliberate indifference gets the better of her for the moment, and she turns away from her sister in order to sound her own magical song. Ida is another one of Sendak's child artists; Sendak has made this point by providing her with an instrument that connects her with the German folk songs from the Romantic period that were collected by Clemens Brentano in the famous anthology *Des Knabens Wunderhorn (The Youth's Magic Horn)*. These same songs provided Gustav Mahler (whom Sendak also placed like Mozart in a *Waldhütte* surrounded by musical spirits when he designed the cover for a recording of Mahler's *Third Symphony*) with the lyrics for a famous cycle of art songs. Ida has already mastered a notoriously difficult instrument to an amazing degree of proficiency. She can draw sunflowers and roses into the room and hold her baby sister utterly entranced. Truly, it is an astonishing instrument; in Ida's hands it has the powers to tame like Tamino's magic flute. The younger child is transfixed in her cradle by the sound of the music; the tears from the previous page are gone. Yet, ironically, in that same instant when Ida is able to finally give herself over to the freedom of her playing instead of having to tend her sister, the hooded creatures, whom Sendak will finally identify as "the goblins" in the text on the next page, have their opportunity—and they are waiting in the window, their hands raised, ready to strike, which they will do—in the next picture (Fig. 100). They are, of course, the other shadow side of this loving, caring sister—a side that the dutiful child can only bring to light in some externally detached form. Ida is stuck

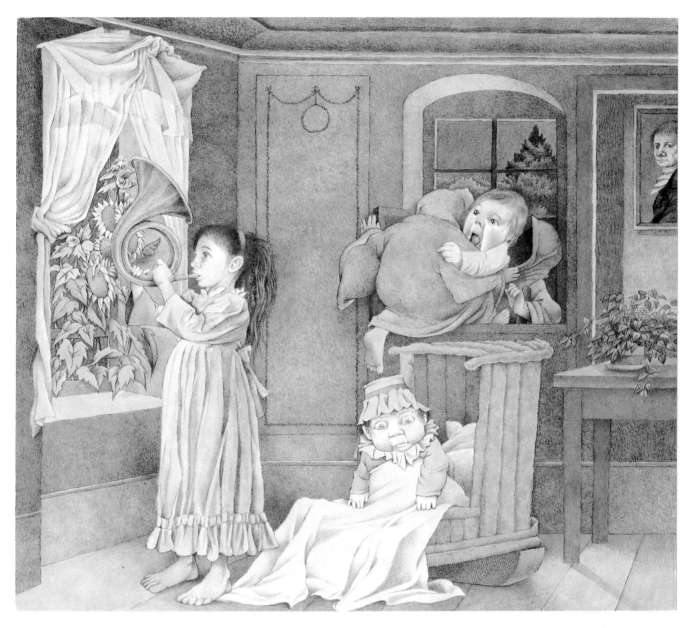

Fig. 100. From *Outside Over There*

in a moment of love and hate, the paradoxical human moment that Sendak's myth-making in the story will be shaped to address and resolve. How can a child incorporate those two, contradictory emotions at the same time on this "ordinary day when the kid's playing . . . [and] there was a collision, and an eruption, nobody could have foreseen it."[50] Sendak goes on to summarize Ida's predicament:

[Ida's] stuck with taking care of her sibling which she loathes like rat poi-

son. She's stuck with this Mama who's in a dream and papa who's away at sea, and this happens in most families, or in many families where the oldest child is dumped. Okay, she'll bear with it, she's brave, she's normal, but there comes that moment when she hates the little bugger, and she wishes her dead. And there's this instant where the mother isn't looking and when she wishes this kid dead, and the fantasy occurs, just like that—it's over in two minutes, and she's back in the arbor with her mother—her mother never noticed; the baby's safe.[51]

Though Sendak's Mozartian story was set in the time and place of the German Romantics, the roots of *Outside Over There* extend deeply into that subsoil of Sendak's own 1930s Brooklyn, though he was only partially aware during the time of the book's composition of some of the memories that had been exerting their influence upon him. One key recollection concerned Sendak's own sister, Natalie, who at nine years of age was asked to take care of Sendak while their mother went out to work. It was the Depression, and Sendak's father's dressmaking business had failed in the stock market crash of 1929, the same year that Sendak was born. Years later, after the publication of *Outside Over There*, Sendak reports that when he asked his sister she did not recall anything unusual happening during those days when she looked after him. But Sendak humorously remembers sensing as an infant the "raging psychopath" in her because, as he put it, "she was stuck with me and I knew she was out to kill me."[52]

As with Ida, the "raging psychopath" was the lesser, shadowy part of Natalie's relationship with her sibling. In fact, quite the opposite sorts of recollections remain in her memories. Sendak told an interviewer that when he showed Natalie the book "she was touched that I had recorded that relationship, especially the part about the arbor." It seems that

> Natalie had a friend Roseanne, an Italian girl, whose father had a small garden with a grape arbor in Brooklyn. My sister used to wheel me over there in my carriage and she and Roseanne would play movies with me, under the arbor. Roseanne would be Janet Gaynor, Natalie would be Charley Farrell and I was their baby. My sister said I always was crazy with joy, staring up at the sky, trying to grab the leaves and the grapes. That experience I didn't hear about until the book was finished. But it must have surfaced during the writing and drawing.[53]

The arbor that Ida returns to was, then, as much an act of "homecoming" for Sendak, who was unconsciously connecting early moments from his past with the literal action of the book. It brought him "home" to the origins of his consciousness.

Another childhood event played an important role in shaping one of the incidents of the book: the kidnapping of the Lindbergh baby in 1932, when Sendak was nearly three years old. In this, one of the most celebrated crime cases from the

1930s, the kidnapper had entered the sleeping child's window by means of a make-shift ladder that resembles the one Sendak has the goblins use in *Outside Over There*. The event had terrified Sendak as a child, especially as the search for the child dragged on for months before the infant's body was finally found. Fifty-some years after these events, Sendak has interpreted the kidnappers as another, more tangible form of the fear of death that he experienced as a "sickly child [who] might be 'taken' in a number of ways, this being one of them."[54] He recalls how impressed and comforted he was by the reassuring sight of his father "sleeping in his underwear on the floor" of Sendak's bedroom to keep any lurking kidnappers away. "I wasn't smart enough, nor, indeed, was my father, to realize that nobody wanted to steal a poor Jewish child."[55]

One of the important artistic events of Sendak's childhood was seeing *The Wizard of Oz* (1939), which had, like Disney's animated films, profoundly affected Sendak; he would, for instance, go on to borrow the color of Ida's dress from the blue of Judy Garland's.[56] But the effects of the movie were registered with even more immediacy in the next sequence of pictures in *Outside Over There*. Here Ida, realizing she has not been looking after her sister, stops playing and returns to hug her, only to discover the ice child that the goblins have substituted for the real baby. Sendak had elaborated on the original Grimm's story by adding the melting changeling child, extrapolating from the famous scene in the *Wizard of Oz* in which the wicked witch is "melted" by Dorothy. (There will be another "melting" scene later in the book when Ida finally disappears the goblins.) To this he also added a window in Ida's room, another of Sendak's thresholds into fantasy, an opening into the unconscious that also serves as a screen on which Ida's tumultuous emotional state may be projected, and an exact parallel of the use made of the window in Dorothy's room when she is skyborne in the midst of the tornado in *The Wizard of Oz*.

As Ida discovers the abduction of her sister, and her anger grows, nature (in the form of the sunflowers) expands further into the room while other natural forces are overwhelming another human structure, which is going down in the uncontrollable storm: the sailing ship of civilization, of Apollonian constructs, a symbol of rational purpose, the ship that may contain Ida's father. Like Max and Mickey, Ida is granted enormous emotional power, as we see when the sunflowers of her fantasy, like Max's forest, grow further and further into this carefully proportioned, restrained eighteenth-century room, setting its balance spinning. These are energies that don't obey the laws of reasonableness. Sendak depicts this "frenzied" music with a highly theatrical, indeed, an operatic pose: Ida balls up her fists as she "sings" her realization of what has happened (she is, after all, a child of these Grimm times, and so she is well aware of goblin lore—or, at least, what *she* imagines goblins might do): "'They stole my sister away!' she cried, / 'To be a nasty goblin's bride!'"

In the final picture of this sequence, Ida has donned her mother's raincoat, taking on in this symbolic act what is normally thought to be an adult role, in order to go searching for the lost child—like Demeter for Persephone. Yet, despite

these external trappings of adulthood, Ida remains a vulnerable child; she is swimming in the fabric of the rain cloak. It is clearly not a proper fit, and she is overwhelmed by it. A Freudian reading is irresistible: she cannot fill her mother's cloak, much as she might wish to try. Still, Sendak lets her have her chance in the Oedipal arena. Her mother is, after all, paralyzed and has abdicated her parental responsibilities. We admire Ida's determination and courage, even though it leads almost immediately to a "serious mistake." She should, presumably, look before she leaps; but, as Mickey did, as every child (or questing hero or heroine) does, she *needs* to make a mistake in order to find her way. One of the qualities about children that fascinates Sendak and that he has often commented on is the child's ability to find solutions that work despite having, from an adult perspective, all the "wrong" information. Certainly without "mistakes" there would be no tension to the story at all. Certainly that mythic Melvillean flash of insight would never be possible if the child did not try to find her way in an impossible tangle of metaphoric fabric.

Like Max walking into the forest of his room or Mickey tumbling out of his bed and through the floor, Ida "falls backward" from her apparently stable world into fantasy. But the phrase that names this fantasy world "outside over there," Sendak explains, should be read like a mirror reflection that spells out the real psychological location of the book: "inside in here."[57] Again, this is to be a child's internal journey, which thus allows Sendak immediate imaginative license. While her baby sister is being carried, gasping in terror it seems, to the goblin's boat and the storm still rages in one of the grottoes formed by the arches of trees and masonry that have appeared in this suddenly subterranean world, Ida is inexplicably airborne in this underworld, like Mickey flying through the netherland of his dream. Her vehicle is the yellow raincoat that, Sendak would tell Walter Clemons, is like the "yellow brick road" from *The Wizard of Oz* spread across the sky of *Outside Over There*. The raincoat's complexly folded material echoes the circularity of the clouds that surround Ida; neither suggest the linear artifice of the road, a route over and through nature and back home. Things are more amorphous, unknown, and unknowable at this point in Ida's journey: the feminine moon has once again risen on the expedition a Sendak child takes into the unconscious, and Sendak nearly has Ida rest her hand on it as though to get from it the bearings she needs to make her way through this unfamiliar world.

The image of Ida in flight in the folds of her yellow rain cloak has suggested sources other than L. Frank Baum to the book's interpreters. Jane Doonan sees in Ida's floating search for her sister parallels to the many hovering forms in Blake's "L'Allegro" and "Il Penseroso" paintings, and Michael Steig persuasively traces the compositional elements of Sendak's picture to that of Diamond being swept up by the North Wind in Arthur Hughes's engraving for George MacDonald's *At the Back of the North Wind*. Sendak himself claims the seed for the image came from a book that was shown to him when he was four or five years old by a friend named Selma with whom he shared an early love of books. This particular book, the title of which Sendak cannot remember, was one that they frequently looked

at together. But he never forgot one of its key scenes when the child heroine of the story

> takes a walk and is caught in a storm. She is wearing her mother's raincoat which is far too big for her, and she is carrying an umbrella. Then, suddenly, there is a juxtaposition of her walking in this flowing garment in clear weather, and the very next picture—which, to me, seemed miraculous, like a transformation scene—the sky is dark; the wind is blowing against her; she is billowing out like a great yellow cloud, her umbrella is inside out, and she has a look of dismay on her face.[58]

Years later Sendak transposed this moment of "dismay" into Ida's dreamlike, "foolish" predicament. She is no longer so powerful that she can make nature respond to her music; now she is a vulnerable child being moved along without the capacity to steer her own course, without the ability to see what any child reading the book certainly can. Through a cutaway view below Ida, Sendak reveals, using a technique that is again reminiscent of Blake, the interior depths of the earth and the chthonian caves that contain Ida's sister, who is struggling to get free from the goblins; a ship (presumably their father's, which is now sailing calmly in the background); and a lamp that sheds symbolic and needed light on this subterranean scene.

Ida is "foolish" because she leaps impulsively, intuitively, instinctively across the threshold of fantasy—such leaps lead, at least initially, to problems, as we have seen with Jennie and Mickey. Sendak compresses this experience of testing, of mistakes and corrections into one scene in *Outside Over There*. On the next page Ida hears "her Sailor Papa's song" coming to her "from off the sea":

> If Ida backwards in the rain
> would only turn around again
> and catch those goblins with a tune
> she'd spoil their kidnap honeymoon.

Once again, as with Mickey's proclamation "I'm not the milk and the milk's not me," Sendak finds in words and the spell that words can cast the key that offers a seeming rational way out of the child's dilemma, which is made all the more irrational by the increasingly hallucinatory quality of Sendak's images. Sendak, the Apollonian writer-father, has, literally, stepped in, using a kind of cinematographic "voice-over" to unravel the overwhelming sensory predicament created by the Dionysian visual artist. Sendak even recalls having gotten these lines during a plane flight as he was thousands of feet above the earth. It seems masculine logos has its place in this surreal world; it serves as an inner regulator, a solver of cognitive puzzles, an objectifier of the subjective and chaotic.

Having said all that, the aria that Sendak gives to Ida's father also makes little

rational sense on its surface: it, too, is "mystic babble." To go forward and "catch those goblins," it tells Ida (who is floating "backwards"), she must "turn around again." This is, of course, what Johnny discovers in *One Was Johnny,* and it is often the advice of the mentoring figure: rather than continue to fly aimlessly, turn and face whatever it is you are flying *from,* which is to say, turn and face yourself. But these directions in the Sendakian underworld do not always correspond to the compass bearings of everyday existence, nor do the rules of visual perspective or proportional representation necessarily apply. The world of Ida's fantasy, like that of the dream, insists on its own physical laws: here it flattens depth of field in the double-page spread in which Ida floats "backwards in the rain," so that Ida, her baby sister, two of the goblins, her mother in the arbor, two sailors (her Papa and one of his shipmates?), and a sleeping shepherd with his sheep all seem to inhabit the same plane, commingling their voices in this unexpected chorus. It is unexpected because we have not seen a number of these characters before, nor will we see them again after their appearances here. We can only guess at how they are related to Ida's journey and what individual stories and references they may contain. This is Sendak's and, by extension, Ida's visionary dream work, and it defies sequential, linear analysis. Yet this paratactic ensemble demonstrates most dramatically Sendak's intention to have the book "play" like musical "lines" that are singing their parts simultaneously, as though performing some grand octet of images that has the startling effect of making the words appear as though they were the imperfectly translated subtitles to an opera being sung in another language.

In his *Poetics of Reverie,* Bachelard offers an interpretation of that domain of interior experience to which Sendak has taken us with Ida at this point in the book. It is a distant, otherworldly place that is

> beyond all family history; after going beyond the zone of regrets, after dispersing all the mirages of nostalgia, we reach an anonymous childhood, a pure threshold of life, original life, original human life. And this life is within us—let us underline that once again—remains within us. A dream brings us back to it. The memory does nothing more than open the door to the dream. The archetype is there, immutable, immobile beneath memory, immobile beneath the dreams. And when one has made the archetypal power of childhood come back to life through dreams, all the great archetypes of the paternal forces, maternal forces take on their action again. The father is there, also immobile. The mother is there, also immobile. Both escape time. Both live with us in another time. And everything changes; the fire of long ago is different from today's fire. Everything which welcomes has the virtue of an origin. And the archetypes will always remain origins of powerful images.[59]

Here those images are brought together in a strangely disassociated family at a moment when Ida discovers that she must turn further inward and downward to meet and connect these divided archetypal forces. The child once more serves as

guide to this terrain of origins in the dark, rich ground of fantasy that Sendak has created for and revealed to the reader.

We do not know how charms work; it is their magic that they do, like Ida's father's song. With his advice, Ida "tumbled right side round" into that eternal nursery of origins—the goblins' cave. It reminds one of the cave at the center of the earth in MacDonald's *The Golden Key,* where he places the figure that is for him the most ancient and most powerful of all—a small, naked child, who provides the crucial guidance to the heroine of the story. In the next picture of *Outside Over There,* Sendak amplifies that experience fivefold in his goblin's grotto, as he builds to the "orgiastic" finale of his opera. At this place of origin the goblins' cloaks fall away revealing them to be "just babies like her sister." Ida's sister is being "married" and thus merged into that anonymous, undifferentiated mass of babies who cannot be distinguished from one another. When she saw the book, Sendak's sister pointed out the similarity between the five babies in *Outside Over There* and the Dionne Quintuplets, the most famous babies of the 1930s, a time which Sendak has called "that baby-crazy decade." The quintuplets were born to a poor farm family in rural Canada on 28 May 1934, and popular consciousness at the time was deluged with newspaper and magazine articles, newsreel reports, and a steady stream of product endorsements that followed and tried to capitalize on every minute detail of the children's development. The "fascination [bordered]

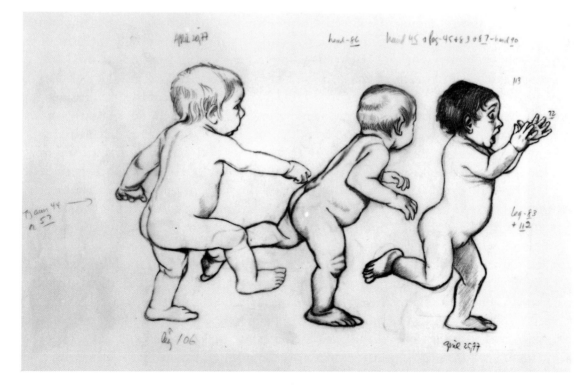

Fig. 101. Preliminary drawings of the babies for *Outside Over There*

on the mythological," one recent commentator wrote.[60] Sendak, however, claims that he had not meant to make any conscious reference to the quintuplets when he put these five infants into the work; it was simply another one of those coincidences that his unconscious had yielded up during the course of his "dreaming" the book.

But Sendak was aware of his own fascination with babies and saw in *Outside Over There* an opportunity for him to "delineate the baby" (Fig. 101).[61] Babies were among the first children that Sendak drew, and he has kept coming back to them throughout his career, most recently in the many babies he included among his illustrations for Iona and Peter Opie's collection of children's folklore *I Saw Esau* (1992). In the baby goblins, though, Sendak was interested in presenting the mysterious essence of babies that he found embodied in their indecipherable complexity—a cryptic language of gesture and emotion that adults tend to disregard because the baby's more subtle forms of communication have, Sendak believes, gone largely unlistened to.[62] To this end Sendak gives the babies four large paintings extended over eight pages—a "wild rumpus" of babies—to reveal their voices and their range of expressions, their supple, quicksilver presence, while Ida plays her orphic, "captivating" tune that gathers speed until it "churned" them "into a dancing stream" (Color Plate 8).

There are few sequences more unusual and unsettling, or more hauntingly beautiful and transcendent in the modern picture book than these eight pages in which Sendak once again (as in *In the Night Kitchen*) returns the reader to primal origins, sending the shadow baby from the present "here" back to the eternal "everywhere" in the "dancing stream" of oblivion, which contains both the source and the end of time. Life continues and depends upon difference, not the obsessive sameness of the underworld. The problem for Ida is to separate the real and known from the obscure and unknowable. As we have seen so often in Sendak's children, her solution is the practice of her art. Hers is a vigorous coming to terms with those nightmarish elements of a child's emotional experience that can, like so many selfish babies, take over and, ultimately, confute the sources of patience, self-sacrifice, love, forgiveness—qualities that we wish to instill in our children but that, Sendak argues, children will somehow find instinctively on their own in their moving, mythological struggles to survive life's daily hazards. One means children adopt for their survival are the charms, those internalized governing authorities that they will seize at critical moments like life preservers to stay afloat and eventually reach a safe shore.

Ida's initial weakness proves to be her strength when she relies on her music to drive away the kidnapping babies, and now her playing makes them dissolve and, with them, her angry frustration, her guilt, her icy inattentiveness. Art can, in fact, bring the true baby back from the primal underworld. Her reward, and the exquisite, poignant chord that lies at the heart of *Outside Over There*, is the moment when Ida finds her sister once more, "cozy in an eggshell, crooning and clapping as a baby should." Rather than try to illustrate a joyful reunion, Sendak holds the children in suspension as Ida reaches out for her sister and the baby

extends her hand to Ida in a gesture of reconciliation. Ida hesitates; perhaps she is not wholly sure that this is in fact her sister. The baby points at Ida—in recognition, in accusation, in tentative forgiveness? They have, after all, had a schism, and a fragment of that innocent trust might reasonably be assumed to be lost. Still, even as they are poised to touch, renewal is already occurring: the sun is shining, bathing the cave with its pink light; the clouds of the past storm have parted, the sea is once more calm; the baby has been released from her imprisoning shell, the egg that symbolized for the alchemists "the *prima materia* containing the captive world-soul." [63] Indeed, the spirit of the world of *Outside Over There* has been refreshed by Ida's capacity, through both her psychological and artistic inventiveness, to recover the original child from its chaotic, chthonic depths. And that bright spirit is again a part of her human family.

Ida returns heroically, with her baby sister once more in her arms, along a path that winds through a dark forest next to a riverbank, past Mozart in his creative *Waldhütte* just a few stepping stones away if one wishes to visit him. In one respect Mozart is Ida's spiritual father in the book; for he is the master of variations who through his musical genius gives the child the melody, the "frenzied jig," that aids her in her moment of need. Mozart is the reliable father who offers access to the powerful, healing world of art—not the one who carelessly "dumps" responsibilities on a child in his absence while he seems imprisoned in a grotto beneath the ground, or the other fatherly figure who merely hangs as a static, stern portrait on the wall of Ida's house.

Following the path provided by Mozart's music, Ida and her sister return back to their mother, who is again alert, having just received a letter from their father who charges "brave, bright Ida" to "watch the baby and her Mama for her Papa, who loves her always." Ida receives the first human contact from her mother who puts her arm over the girl's shoulder as the child listens intently to these "real" words from her father; and in the next picture—the last scene of the book—she continues with the walking lesson that she was giving her baby sister at the beginning of the story. Life has returned to normal; goblins no longer lurk at the end of the fence. Even the sunflowers seem more ordered, less wild, as Ida and the baby settle back into their daily ritual.

Yet as Geraldine DeLuca and others have noted, *Outside Over There* refuses to manufacture a happy ending for the reader (Fig. 102). Nothing at all seems to have changed: Ida resumes the same duties that pressed on her at the beginning of the book. She is anything but liberated—in fact, she has even more weight heaped upon her shoulders by her father's instructions. Like Blake's chimney sweeper in the *Songs of Innocence,* Ida "[gets] with" her "brushes to work." In the last image Sendak paints of Ida, as he is panning back from her story, she is once again small—touchingly, surprisingly small. She seems too fragile to have gone on such a demanding internal adventure. And this is Sendak's point, it seems to me, in the book's closing picture: we are left to consider just how vulnerable, in the context of the "real" world, even magical children like Ida and her sister finally are.

Ida's appearance in the closing scenes with her sister and her mother had been

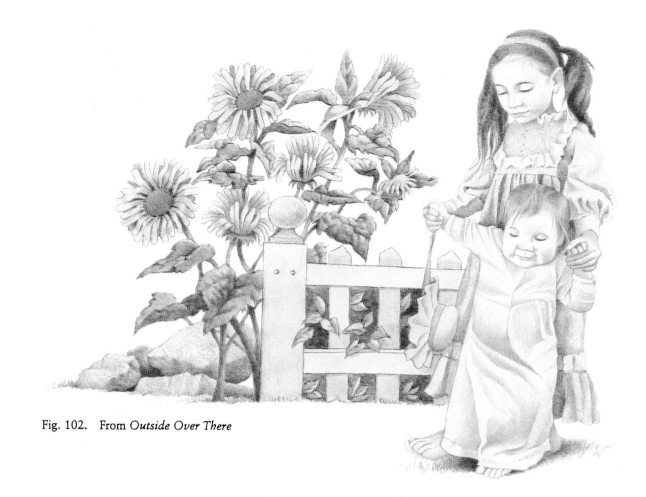

Fig. 102. From *Outside Over There*

inspired by Judy Garland's final, anguished look in *The Wizard of Oz:*

> I thought of Judy Garland when I painted [Ida's] face. I wanted to express
> . . . that she was dependable and she would bring the baby back, but the
> eyes are filled with tragedy at the fact that she will always live in a home
> where there is another child, and that her mother never, ever will give her
> the time of day. And it's all written on her face. . . . it's suffering in the way
> children suffer. . . . Parents . . . place these [enormous] burdens on [chil-
> dren], and they do the best they can. That's what moves me about children,
> immensely.[64]

This feeling for the plight of the child, whether archetypal or real, leads
Sendak to construct a work that may not be "satisfying" in the sense that it pro-
vides the reader with a happy resolution of the tensions in a child's life but that
arrives at a no less worthy and a much more difficult and unanticipated conclu-
sion, especially in a work that will be read by children. Ida's predicament is that
of oppressed, repressed, dismissed children everywhere; in many respects, hers is
a common condition of childhood, and through his depiction of her Sendak pro-

vides us with, as Joseph Schwarcz suggests, "a concept of childhood" as much as a view of any one particular child.[65] "Brave, bright," she acts capably and imaginatively *despite* the controlling limitations that the adult world places upon her. At the end of the book the older child accepts that she must nurture her younger sister, since mother or father won't always be (and usually aren't) around to perform that function for either of the children. The child, in short, must nurture the child.

We see the tragic images of the adult abandonment of children relayed to us from distant places on the earth and from next-door neighborhoods nightly on the evening news. Though not overtly spoken, these hard truths are implicit in *Outside Over There,* and they inform the book with its poignant beauty. Like Mozart in his G Minor Quintet, Sendak finds a way to lead the reader through dark, disturbing recesses and back to the tender light of morning—an end that, because a child is there, is also a beginning, by its very nature alive with new possibilities, which we hold like Ida teaching her baby sister to walk. We are all parents to our own archetypal children, and like the mother and father in *Outside Over There,* we, too, have abandoned these children, promising to "be home one day," but meanwhile leaving them to fend for themselves. *Outside Over There* reminds us of this loss as well as the capacity of the child to accept and press on, to score some sense of harmony from these individually disquieting notes. In the end, Ida and her sister turn back into the book and thus complete the circle they began in its opening pages; they continue the eternal round of their lives, isolated dreamers, momentarily empowered and empowering to the larger psyche that dreams them, animating spirits that are nevertheless detached from their preoccupied adult "parents." Forever young, they are forever other. It is not a buoyant vision of real or archetypal childhood, but it is utterly, movingly honest.

A few years later, in *Dear Mili,* Sendak would work with a constellation of forces similar to those that he brought to *Outside Over There.* Set in the same historical time as Ida's story, Wilhelm Grimm's tale concerns a child who is told to go into the woods by her mother to escape an approaching war and the atrocities that await children during such times of crisis. We see the grave importance of that moment reflected in the strength of Sendak's lines in a preliminary drawing for that scene of parting (Fig. 103). As Mili wanders through the forbidding woods, she eventually encounters her "guardian angel who, unseen, guided her over cliffs and past deep chasms." At first Sendak has the angelic child appear in trees and bushes, hovering close to Mili. But Sendak's point here is that even this divine child is powerless to halt or to completely protect Mili from the ravages that the world metes out to children. (In an early dummy for the book, while Mili rested in the forest in the foreground of a picture, Sendak depicted children being marched by Nazi soldiers in the background into a building that takes its outline from the shape of the infamous main entrance to Auschwitz. In the final version of the book, Sendak has left in a short line of people crossing a bridge in front of the concentration camp, but he has taken out the Nazi guards.) The spirit child can merely accompany the real child through this journey, sometimes helping, some-

Fig. 103. Mili and her mother. Preliminary drawing for *Dear Mili*

times sleeping while danger threatens, sometimes appearing in angelic form to the child, sometimes serving as the child's reflection of herself to herself.

Dear Mili is ultimately about a child's finding her way back to the mother she left at the beginning of the book. The story's complication is that Mili has in actuality died in the forest, and she goes to live in a house in the woods with an old man whom we later discover is St. Joseph. After spending the prescribed three days of allegorical time (which translates into thirty years of real time) with St. Joseph, she is sent back to see her mother who has now grown quite old and is waiting to have her last wish granted—that she will be able "to see [Mili] once again before [she dies]." Mili, then, becomes the psychopomp to escort her mother to heaven, to the afterlife where the child has played with her angelic counterpart in a paradise that includes Mozart, a chorus of children who were killed by the Nazis during World War II and have now joined the composer, and a graveyard replete with tombstones, their Hebrew inscriptions and iconography reminding us of the ancient source of the Judeo-Christian tradition.

But before returning Mili and her mother to this ecumenical paradise, Sendak offers an image of youth and age, of the child and the adult seeking to embrace each other over the expanse of this two-page Romantic landscape. At the center of the composition Sendak places an even more ancient symbol of the ripening fruits of this relationship—a tree of life that holds, impossibly and wonderfully, both golden apples and heavy, ripe clusters of grapes. The book ends on the verge of an embrace—this time between the child and the aged adult, between archetypal beginnings and real human ends, evoking once again the child's role as the "bringer of healing."

Outside Over There offered a different form of unity. Fathers, the book seems to say, may stay "away at sea," and mothers may be unreliable. "This is the story of a child's life always," Sendak insists. "They scream for help; the parent is in the room, and the parent doesn't know how to help. This is my vision of childhood: children are so close to security, but they are profoundly alone. . . . and they don't know how to communicate the particular terror that's eating them."[66] But the myths that Sendak creates for children and adults, in his trilogy and throughout his books, asks both child and adult to trust themselves and their imaginative powers, to rely on their ability to get to the fantastical bottom of things with Mickey or Ida and fashion solutions from what they find there. These answers may not last for more than a few seconds; but, as we also know, these instants hold eternities—and infinite possibilities.

In *Outside Over There,* Sendak touches the profound capacity of the child as a source of courageous, inventive power, as well as of sustaining, resilient grace. Like the three boys in Mozart's *Magic Flute,* Ida and her sister-in-spirit Mili offer that solace to the soul that can be consumed, stranded, or abducted by life's sometimes overwhelming events. These Sendak children serve as guides to that core of our spirits; they help us to reach that "home" of the soul. This mythic child waits to be rescued from its abandonment so that we can reclaim, along with its burdening vulnerability, its creative possibilities and its compelling inner harmonies.

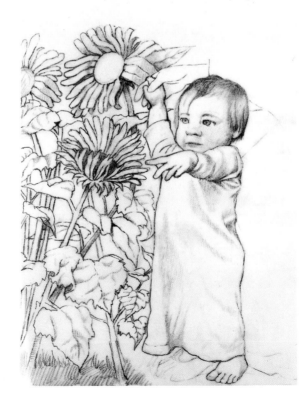

ONE

TWO

THREE

FOUR

FIVE

SIX

SEVEN

DREAMING THE MYTH ONWARD

A man's work is nothing but a slow trek to rediscover,
through the detours of art, those one or two images
in whose presence his heart first opened.
 —Albert Camus

ENDAK RETURNED TO A FREQUENT SUB-
JECT in his own reflections on his creative quali-
ties in a magazine profile that appeared just after the release of
Outside Over There. Again he stressed his lack of uniqueness:
"There are artists who invent form and others who use it. I am
not an inventor. I am a scavenger. I take whatever is at hand, what-
ever has been done well by others, and will push my own material
onto it. I'm perfectly aware of my limitations. I'm like a bird of
prey. There are artists who create new molds, who establish entire
territories. I'm not one of those."[1] Yet there are many—indeed,
most of those who follow and write about children's books—who
would disagree completely with this limiting self-assessment. Al-
though Sendak may have borrowed ideas extensively from a host
of writers and artists over the course of his career, the results have
been unexpectedly fresh and distinct—anything but mere scav-
enged parts that have been somehow haphazardly stitched to-
gether into a crazy quilt of associations, references, and homages.

To be sure, Sendak's restless ransacking of previous styles and
images and his use of pastiche as a way to record these references
may seem to make him the epitome of the postmodern artist: all
allusion and collage with an elusive central point—a point that
this obscurity helps him, by its nature, to evade. But Sendak, as
we have seen, has a distinct vision that he has depicted with coher-
ence and unique expressiveness throughout his books, so much so
that an assessment of his work as derivative (even if this is, at
times, his own self-deprecating conclusion) misses the point that

restatement and quotation is, when done as Sendak does it, an act of recovery and an expansion of the art forms—particularly the picture book—in which he has worked.

Indeed, without Sendak, an enormous void would exist in contemporary American (and, for that matter, international) children's books. One can only try to imagine what the landscape of children's literature would be like without Sendak's fantasies and the characters and places visited in them. These fantasies essentially broke through the relatively unperturbed surfaces of postwar American children's literature, sending his children—Rosie, Max, Mickey, Jennie, Ida—on journeys into regions of the psyche that children's books had not dared visit before. Today the visitations are frequently made, and few publishers' lists appear without several fantasies that have their origins in Sendak's work. A younger generation of writers and artists has followed Sendak's lead; most notable among these new fantasists are Chris Van Allsburg and the writer/artist team of Arthur Yorinks and Richard Egielski. But there are many others, too numerous to mention here, who have accepted as a given the proposition that Sendak pioneered in *Where the Wild Things Are,* that a picture book could effectively represent and contend in the form of a fantasy with an intense, psychologically transformative moment. In dozens of books published every year in this country, young children move effortlessly into reveries and dreams, they ride magical beasts into the underworld and project themselves into strange, surrealistic situations. Most of all, perhaps, in books for younger children today, the audience is free to imagine, adults and children alike, in texts and illustrations that are richly suggestive and graphically sophisticated and in ways that owe their license if not their actual inspiration to Sendak.

Clearly, Sendak was not the first children's book writer or illustrator to be moved, personally and continuously, by the child archetype, or to try to embody this figure in his work, making it his central, consuming concern. Lewis Carroll and George MacDonald, A. A. Milne, Antoine de Saint-Exupéry, J. M. Barrie, Ludwig Bemelmans, Jean de Brunhof, Dr. Seuss, E. B. White, Ruth Krauss, Tomi Ungerer, Russell Hoban, Ezra Jack Keats, and William Steig are just a few of the widely diverse writers and illustrators who have explored this psychological terrain from a variety of perspectives, responding in their own ways to the fluid nature of the child archetype. But Sendak brought to this continuum of interest in the symbolic state of the child a new look—the mythic fantasy journey told in the form of a picture book—and he fueled the genre with an energy that was not present before.

Sendak has been part of a time and of an intellectual, artistic, and social movement in America following World War II that had turned inward, that was, as Sendak was writing the precedent-setting books of his trilogy, just beginning to explore the individual psyche through visionary journeys into the unconscious. As we have seen, Sendak helped to accelerate the process and to legitimize those voyages of psychic self-discovery for children by taking these trips himself, through the descents and flights of his own child archetype (Fig. 104). As he has said in his later interviews, these were personal journeys that left him transformed. Some of

Fig. 104. Drawing for "The Found Boy," from *Somebody Else's Nut Tree* by Ruth Krauss

these voyages may have constituted mini-nervous breakdowns, but they were, above all, breakthroughs. His books, with the attention they paid to these individual explorations, were very much affected by the cultural climate of their time. But Sendak's books also affected this climate, providing it with images that sustained, on both literal and subliminal levels, the transformations, the shift in consciousness that was beginning to take place from the 1960s on. That Sendak waves aside these social and cultural connections does not, as we have seen, abnegate their vital presence in his works.

In fact, in his latest book, *We Are All in the Dumps with Jack and Guy* (1993), published as this study was going to press, Sendak has dropped any pretense of political neutrality. Once again he has written a book about "how children survive," reminding us that "children surviving childhood is [his] obsessive theme and . . . life's concern."[2] However, this time that enduring capacity in children is not seen through the filters of eighteenth- or nineteenth-century settings or in the context of the psychological terrain of a distant dream world. Rather, Sendak places *We Are All in the Dumps with Jack and Guy* on the blighted streets of a contemporary America which, as Sendak notes in his many interviews about the book, like streets in Rio or Bombay, are populated by groups of homeless children, quite literally trying to make it through a day. "It's 1993," Sendak observes, "and children get shot on the way to school, children contract AIDS, children are in the most vulnerable position imaginable." He is outspokenly outraged with the years of indifference and greed that characterized the Reagan-Bush decade, in which it became a national policy to neglect children, and Sendak warns: "If we don't look, and if we don't listen, and if we don't do something, kids will be lost."[3] Although he qualifies his remarks with the disclaimer, "I'm not a political person," he quickly adds: "but at this point I do not see how it is possible to do any work that isn't relevant to what is going on around us."[4]

In his urgent concern to link the book with the immediate reality of the reader, Sendak has filled *We Are All in the Dumps with Jack and Guy* with allusions to the "dumps" that exist not only in much of the Third World but on the other side of the tracks of most American cities as well. In this dark landscape, shoeless children have built their own community out of the scraps society has left them— cardboard boxes, pieces of crates, tents made from castoff sheets and blankets— as the curtain rises on the title page of the book (Fig. 105). Some of the children are dressed in rags, some are naked and wrap themselves in garments made from newspapers like the *New York Times,* Sendak's daily paper. The headlines on these clothes are legible and serve as a chorus, commenting on "real" events, often ironically proclaiming the latest economic news and current events—the ups and downs of the real estate market, soaring unemployment, the "leaner and meaner" times that have arrived, the "chaos" of the homeless shelters, the famine in the world— as though anyone had to inform these children, who have been discarded by society, about the nature of their reality. Many of the children have lost their hair, like the little black child (bald-headed, beaten up, naked except for the ragged swatch of white cloth wrapped around his waist) who wanders into this shantytown in

search of help on the title page of the book. These little waifs suggest the children of Bosnia and Somalia, the children of AIDS wards—victims of that modern plague that Sendak reminds us of through headlines on the newspaper clothes.

The moment that catalyzed Sendak's creative process in *We Are All in the Dumps with Jack and Guy* came late one night several years ago on a chic boulevard of Beverly Hills when Sendak saw, to his shock and horror, "a kid lying in a box on the street, with his bare feet sticking out. The juxtaposition of this luxury-ridden street with a kid sleeping in a cardboard box inspired a fantasy—a city of homeless children"—that would provide the location and the major characters of the book.[5] For Sendak, this nocturnal vision also evoked immediately the verbal image of houses "built without walls" from a traditional nursery rhyme, "We Are All in the Dumps," that he had been trying to make sense of since the mid-1960s, when he first came across the verse while gathering Mother Goose rhymes for a possible collection that he would illustrate. It is one of the more impenetrable examples of a genre whose texts steadfastly defy rational explication:

> We are all in the dumps
> For diamonds are trumps
> The kittens are gone to St. Paul's!
> The baby is bit
> The moon's in a fit
> And the houses are built without walls.

The "houses" in his story would be refigured as the cardboard boxes and roofs made of newspapers (Fig. 106) in the city of children we meet as we enter the twelve double-page pictures that Sendak uses to tell the first half of the story. He had employed a similar technique in *Hector Protector* and *As I Went Over the Water* (1967) to decipher the Mother Goose rhymes in that book. But these earlier, Caldecott-inspired experiments cannot match the harrowing tale that Sendak wishes to tell in *We Are All in the Dumps with Jack and Guy*.

After being told to "Beat It!" by Jack, one of the two toughs who seem to run the shantytown and who will be one of his rescuers in the second half of the book, the little black child is suddenly abducted by two enormous rats. They hold the little boy hostage, along with a litter of kittens who inhabit the dumps, in a rigged game of bridge (in which "diamonds are trumps"). Pushed by the other children to do something about the kittens and the kidnapping, Jack and Guy try, unsuccessfully, to beat the rats at their game, playing their hands out beneath the shadow of a building that resembles Trump Tower, that notorious symbol of the ostentatiousness and conspicuous consumption of the 1980s. Jack and Guy lose, and the rats haul a cart loaded with the kittens and the wailing child off "to St. Paul's," biting the boy when he tries to escape. But not to the London cathedral. Instead, the child and the kittens are dragged to a building that is deceptively and incongruously called, on a nearby road sign, an "orphanage and bakery," complete with

Fig. 105. Title page from *We Are All in the Dumps with Jack and Guy*

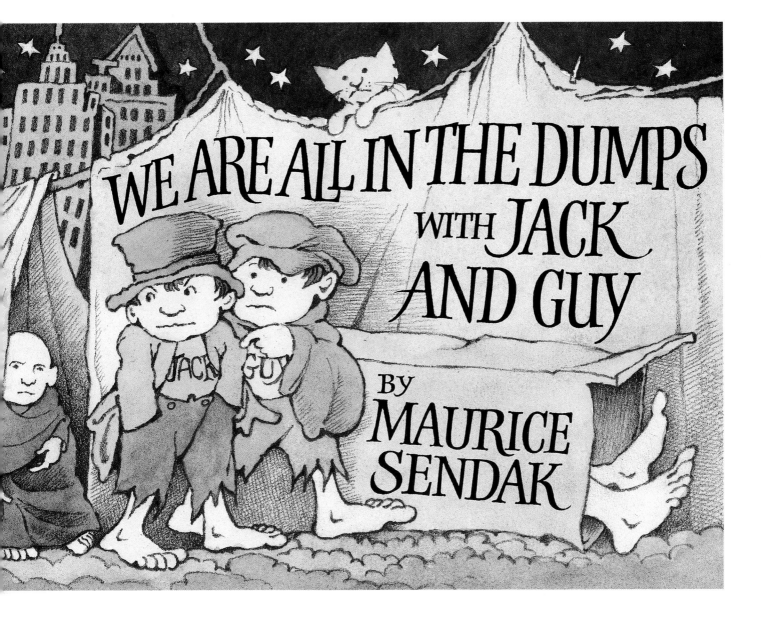

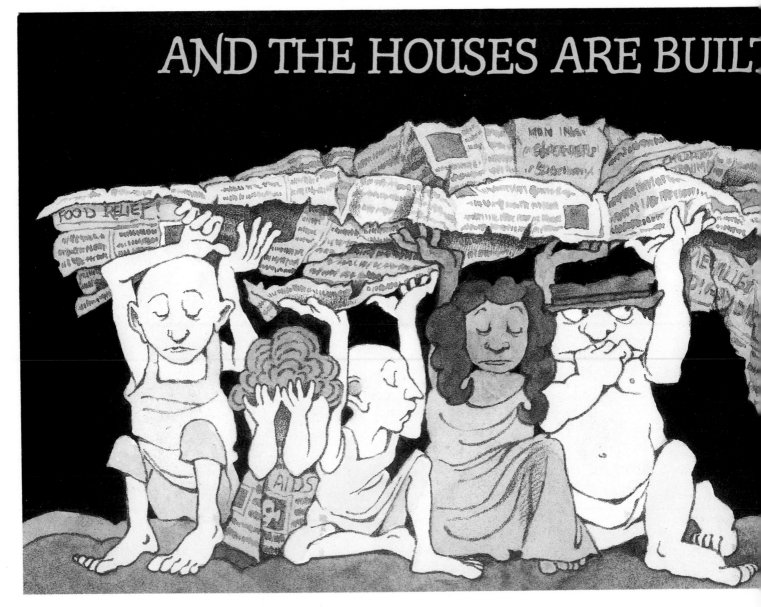

Fig. 106. From *We Are All in the Dumps with Jack and Guy*

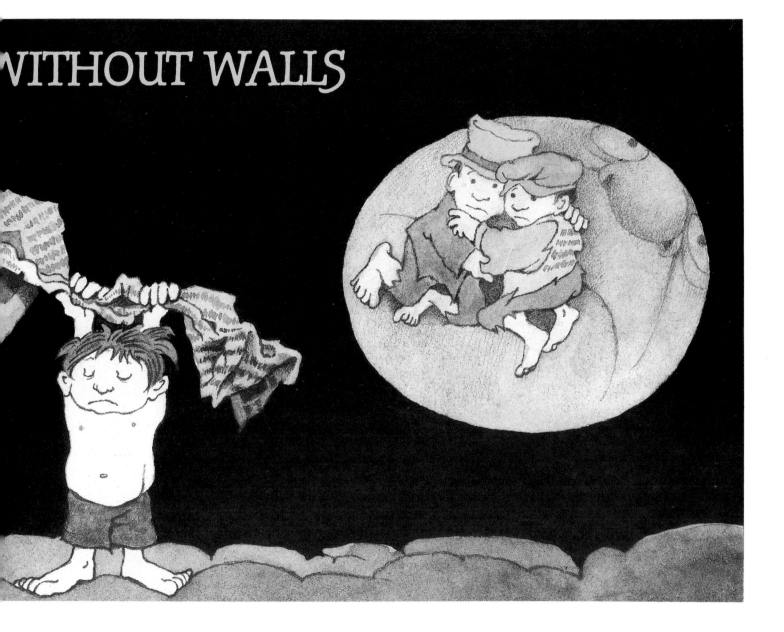

WITHOUT WALLS

menacing smokestacks that have reminded many reviewers of the chimneys of the Holocaust death camps.

The second Mother Goose rhyme from which Sendak fashions his text (and spends the next fifteen double-page pictures of the book telling) is equally as enigmatic on its surface as the first:

> Jack and Guy
> Went out in the rye
> And they found a little boy
> With one black eye.
> Come, says Jack, let's knock him on the head
> No, says Guy, let's buy him some bread
> You buy one loaf
> And I'll buy two
> And we'll bring him up
> As other folk do.

Jack and Guy are dropped into a field of waving stalks of rye by a huge, angry moon ("the moon's in a fit"), who has been watching the proceedings in the first verse and pushes the two boys on a heroic and humanitarian course of action in the second. Jack and Guy stumble upon the kidnapped child in the field of grain; obviously he's been beaten by the rats, but he has somehow managed to escape. At first Jack behaves reflexively, brutishly rejecting the child's need for consoling, human contact with a threat of violence ("let's knock him on the head"). But the kinder of the boys, Guy, prevails; and together with the little black child and a moon that has now turned into an enormous white mother cat, they storm the "orphanage and bakery," destroy the rats, liberate the kittens (who are shelved on bunks that resemble those on which the prisoners of the Nazis awaited their fates), and pass out crusty, golden loaves of free bread.

Then, riding again on the silvery surface of the cat-turned-moon once more, the three boys, asleep together with the kittens, return home to the dumps, where they gently welcome the little black child into their community and where they will, we see, be true to the promise of the last lines of the verse to "bring him up as other folk do." That the baby has endured, Sendak insists, is testimony to "the tenacious need children have to survive. They will survive given half a chance, and the children in this book are out to make it, so they're not feeling pathetic or sentimental about their plight. They're just busy wanting to live, and a baby is busy looking for a family. Doesn't care what kind of family, just a family that's going to nourish it, take care of it, keep it warm and, if possible, love it. That is the purpose of the book, but actually that has been the subject of everything I've ever done."[6]

Because of its intentional mirrorings of our contemporary reality and, more specifically, because the artist is Sendak, the book has attracted widespread attention, some of it negative—the book has been accused of a host of wrongs, from

unnecessarily frightening children through its stark images of poverty and violence to a politically incorrect representation of an African American child. But most commentaries on the book have been overwhelmingly positive about Sendak's having dared to call attention to a number of the central problems affecting our society, among them poverty, homelessness, the abuse of children, and the AIDS epidemic. For Sendak, depicting these facts of life became a crucial, responsible course of action after a decade of watching the global suffering of children and the unraveling of our society, and of "watching friends die of AIDS." One casualty of this epidemic, the children's book author and illustrator James Marshall, was Sendak's close friend, and he marks Marshall's death in the fall of 1992 with the headline "Jim Goes Home" in the newspaper held by one of the children.[7] To expunge or obscure these allusions to current problems from *We Are All in the Dumps with Jack and Guy,* Sendak feels, would be tantamount to lying to the children reading the book. As he has so many times in the past, Sendak argues that children require honesty in the books written for them because they "actually see the world as it is. They go back and forth from school. They walk in the cities, and they see all these things happening in the cities and people curled up in doorways, so this is not something that they're unaware of. And I don't think it frightens them, I think it puzzles them, and I think what might frighten is us not telling them what's going on."[8]

Yet this process of informing, for Sendak, does not remain at the level of contemporary concerns, however pressing. As we have see in his other books, Sendak engages the reader simultaneously on multiple levels of meaning that ultimately reach for universal depths. It must be said that, after we have worked our way through many of the allusive details of the book, these remain strange and wonderful, disturbing and transcendent pictures. Occasioned by an esoteric text, they too do not yield themselves to easy answers. Sendak's pictures here seem free and spontaneous like his fantasy sketches and in the highly energized style of those he did for Iona and Peter Opie's *I Saw Esau.* Sendak reported to Art Spiegelman in a now much-quoted *New Yorker* interview that Sendak and Spiegelman drew together as a cartoon strip, that the illustrations were done without redoing "a single picture . . . just—Gagoomba!—from start to finish. I did a picture a night, just like when I was 12 years old."[9] But despite Sendak's and the reviewers' cataloging of influences, despite the seemingly simpler style in which they are drawn and painted, they are decidedly mysterious pictures, as enigmatic as the Mother Goose rhymes that they presumably decipher.

Again, Sendak touches deeper chords than those that are played in our everyday reality and its field of references. Historically, we know that the suffering of children has been universal and constant. Visual moments from *We Are All in the Dumps with Jack and Guy* remind us of scenes from Dickens or Blake and the brutal world they described for the orphans and chimney sweepers of the nineteenth century. Throughout that century, American children also lived in equally unspeakable misery, especially in the cities of the Northeast that were being flooded by waves of immigrants in the late 1800s. A well-known photographer

of those then-mean streets and the newcomers who peopled them, Jacob Riis, took many photos of children huddled together in Manhattan alleyways or asleep under its stoops and over its gratings. Several of these pictures bear an uncanny resemblance to Sendak's pictures of the sleeping street children of *We Are All in the Dumps with Jack and Guy,* as one sees when Riis's photograph entitled *Street Arabs in Area of Mulberry Street* (Fig. 107) is placed next to Sendak's closing image of the three sleeping boys in *We Are All in the Dumps with Jack and Guy* (Color Plate 9). For their respective audiences, each picture tenderly and powerfully testifies to the perilous vulnerability of children and to their unselfconscious embrace of those who can offer them some comfort, some sheltering warmth in their precarious existence. In Sendak's construction of this imaginative world, as in *Outside Over There,* adults are aloof, distant, unreachable at best (if they are not cruelly exploitative): children, then, must care for other children and depend on other children for survival. Sendak ends his book on that moving note of sleep and rest for the children of this nighttown. Only the robed, monklike figure stares out at the audience, from between the tents and cartons and clotheslines, alert, peacefully gazing into the night, asking us to join with him in pondering these events which have traveled from such violence and disruption to such tranquillity.

A key to Sendak's mystery in *We Are All in the Dumps with Jack and Guy* is to be found on the dust jacket of the book, as Peter Neumeyer has astutely pointed out in his review of the book.[10] This painting is unusually done; Sendak has placed the actual title on the back cover while a wordless picture appears on the front (Color Plate 10). Spreading out the dust jacket reveals that it is composed of one whole, double-page painting, the back leading to the front, as the end of the story in effect leads the reader, circularly, back to its beginning. The front cover shows the little black child emerging from the open mouth of the full moon, carrying a long stalk of rye like a staff (the "staff of life" that grain represents). Two children dressed in newspapers seem to be running from the little boy, the headlines on their papers reflecting an apparent contradiction: "Leaner Times, Meaner Times" on the one hand, and "Children Triumph," "Kid Elected President" on the other. They are running, it seems, not out of terror (their faces are too composed to call it that) but out of some other fear—perhaps out of agape, the "holy dread" brought on by a meeting with the divine. Jack and Guy, who we see from behind, appear to be awaiting the child as he climbs up into their world; indeed, Guy is waving to him, while Jack also holds a stalk of grain that arches over both of them. Another black child at the far right of the picture is seen in profile running toward the little boy, her hand outstretched expectantly, her mouth ready to smile, her visible eye widened in wonder. The whole of the scene is framed by the arching vault of the moon's open mouth. Above the mouth, we see the bulbous nose and bulging eyes of the moon watching as this baffling entrance unfolds.

This baffling image begins to make more sense if we regard it as another arrival of the archetypal child we have seen so often in Sendak's work. Here the bruised, battered, helpless child is shown whole, a serene Gandhian child with his

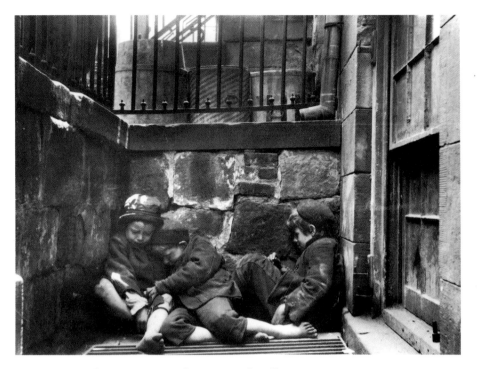

Fig. 107. Jacob Riis, *Street Arabs in Area of Mulberry Street,* 1889

stalk of grain, emerging like some small god from the grottolike mouth of the moon, which resembles one of the huge, fantastical sculptures from the sixteenth-century Italian garden of Bomarzo. Mythologically, in *We Are All in the Dumps with Jack and Guy,* Sendak presents the reader with a vision of the mother goddess offering to the world her child, a figure of peace and reconciliation, a symbol that bridges beginnings and endings, a source of healing. In an ancient bas-relief that provides the mythic background for the rituals of the mysteries of Eleusis, Demeter, the goddess of cereal and the moon, and her daughter Persephone, also returned from the underworld, present "primordial man," in the form of the hero, Triptolemos, with a stalk of grain to carry with him out into the world as a symbol of continuing, nourishing life and of her covenant with humanity.[11]

In Sendak's archetypal poetics the exchange between the realms of the mythological and of his own contemporary creation are instantaneous and reciprocal: at the same time that this child is ancient he is modern as well, emerging like Pierre and Jennie from the Lion's mouth, like Mickey from the oven of the Night Kitchen, like Ida from the subterranean caves of *Outside Over There.* The child has once more managed to remain uneaten by the devouring circumstances of life; this time he bears a gift of seeds that are the sustaining source of life itself. And again Sendak has made the figure of the rescued child a vessel of mystery, awe, and contemplation (watched over, protected, and brought to us by the Mother Goose Moon,

who, as she does in *Higglety Pigglety Pop!*, looks like Sendak's own mother Sadie)—a source for hope in the eternal drama of the literal and archetypal child's survival in a hostile world.

We Are All in the Dumps with Jack and Guy marks Sendak's engagement with that world as, he feels, "a more social, political animal," and it comes as a result of a decade of more outwardly directed creative activities in Sendak's life, which has also led to the founding of a national children's theater, The Night Kitchen Theatre, as a way that he could work with younger artists. "I needed to be around people. I wanted to mentor young artists, to help train them as I had been trained."[12] A series of films based on his story ideas, which he also has in the development stages with a major Hollywood studio, offers yet another avenue for this more social, political engagement and a way in which Sendak's creative powers can expand upon the legacy that has already accrued in his books.

Sendak's legacy, however, needs to be continually reaffirmed, especially considering the attacks against fantasy that are currently occurring in this country. Elementary school teachers, media specialists, librarians and editors all report that they are under considerable pressure from highly vocal, aggressive individuals and groups who have attempted to remove from library shelves and curricula works that ask a child to "imagine," or "pretend," another state of being or an imaginary world. In public schools across the country, for instance, parent groups have combed kindergarten bookshelves, eliminating, among others, the works of Sendak. The battle of today's books has once more been cast, as it was in seventeenth-century America, as a struggle for the control of the child's mind, if not the salvation of the child's soul. How far have we come, one may well wonder, since the cry of the students on the Left Bank from the late 1960s, in liberating the imagination in our own land. Regardless of how we may wish to measure the distance we have covered in this journey of liberation, much of it has been traveled in Sendak's company. In the end, we will all need to insist, passionately and uncompromisingly, that Sendak's books, as well as those of other explorers of the soul, remain to offer their light for future generations.

In one of the earliest articles about Sendak, Brian O'Doherty referred to Sendak as an "alchemist";[13] and Sendak has since gone on to describe how, like the alchemist, he mixes together the strange components of his life and enthusiasms, his memories and obsessions in the dark "soup" of his imagination, all of which eventually is refined in the form of a book. Each of these books, as we have seen, is a materialization of something intangible and personal, an inner journey that is expressed in the outward form of the fantasy of the archetypal child, whose shimmering presence turns whatever "base" materials it touches, in Sendak's incomparable art, into the most prized of substances, those radiant essences, those unforgettable children (Fig. 108). Sendak has made these children our guides to the depths of this other world and to its soulful wellsprings, and these children will continue to move our own imaginations onward if we will listen for their stories and welcome those small, mercurial messengers who bring them and who may be wearing yellow raincoats or wolf suits.

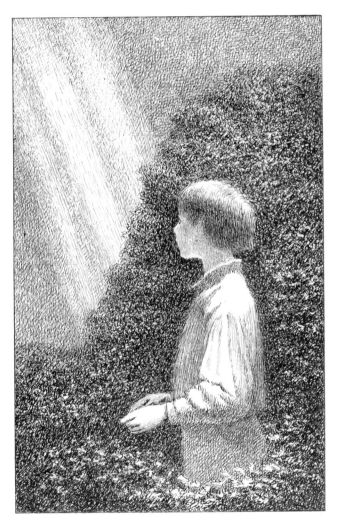

Fig. 108. Drawing for *The Golden Key* by George
MacDonald

NOTES

Notes to Introduction

1. Maurice Sendak, "Caldecott Award Acceptance," *The Horn Book Magazine,* August 1964, 348.

2. Mary Long, "Why Children Love Maurice Sendak's Books," *Family Weekly,* 5 March 1978, 21.

3. Sendak's first illustrations appeared in *Atomics for the Millions* by M. C. Eidinoff et al. (New York: McGraw-Hill, 1946).

4. Publicity release for the Night Kitchen Theatre, December 1991.

5. Bernard Weinraub, "Sendak Turns to Films but Not to the Glamour," *New York Times,* 25 April 1992, 10.

6. See, respectively, "Happy Year to Be Grimm," *Time,* 10 December 1973, 96; Barbara Bader's discussion of Sendak in *American Picturebooks from Noah's Ark to the Beast Within* (New York: Macmillan, 1976), 513; and Brian O'Doherty's "Portrait of the Artist as a Young Alchemist," *New York Times Book Review,* 12 May 1963, 31.

7. Sendak's work in opera in the early 1980s led to at least six feature articles about this new direction of his creative energies.

8. Steven Heller, ed., "Maurice Sendak," in *Innovators of American Illustration* (New York: Van Nostrand Reinhold, 1986), 80–81.

9. *Sendak,* a documentary film directed by Morton Schindel (Weston, Conn.: Weston Woods Studios, 1987).

10. Saul Braun, "Sendak Raises the Shade on Childhood," *New York Times Magazine,* 7 June 1970, 34.

11. See Perry Nodelman's *Words About Pictures: The Narrative Art of Children's Picture Books* (Athens: University of Georgia Press, 1988); Joseph H. and Chava Schwarcz's "Sendak's Trilogy: A Concept of Childhood," in *The Picture Book Comes of Age: Looking at Childhood through the Art of Illustration* (Chicago and London: American Library Association, 1991), 194–205; Jean Perrot's "Deconstructing Maurice Sendak's Postmodern Palimpsest," *Children's Literature Association Quarterly* 16, no. 4 (Winter 1991-92): 259–263; and Maria Tatar's chapter on Sendak and Grimm, "Wilhelm Grimm / Maurice Sendak: *Dear Mili* and the Art of Dying Happily Ever After," in her *Off with Their Heads! Fairytales and the Culture of Childhood* (Princeton: Princeton University Press, 1992), 70–93.

12. Carl Kerényi, "Prolegomena," in *Essays on a Science of Mythology: The Myth of the Divine Child and the Mysteries of Eleusis,* ed. Carl Gustav Jung and Carl Kerényi (Princeton: Princeton University Press, 1969), 5.

Notes to Chapter 1

1. William Goldstein, "Jacket Is Overture: The Musical Achievement of Maurice Sendak's 'Dear Mili,' " *Publishers Weekly,* 20 May 1988, 48.

2. Ibid., 49.

3. Jonathan Cott, *Pipers at the Gates of Dawn: The Wisdom of Children's Literature* (New York: Random House, 1983), 47.

4. Selma Lanes, *The Art of Maurice Sendak* (New York: Harry N. Abrams, 1980), 26.

5. Telephone interview with Maurice Sendak, 4 August 1987.

6. *In Conversation with Maurice Sendak*, a video interview, no. 28 in the Contemporary Writers series (London, 1988).

7. *Maurice Sendak and All His Wild Things*, directed by Herbert Danska, a video documentary in the Arts and Entertainment "Biography" series, 1985.

8. Gaston Bachelard, *The Poetics of Space* (Boston: Beacon Press, 1969), 70.

9. Lanes, *Art of Maurice Sendak*, 171.

10. John Lahr, "The Playful Art of Maurice Sendak," *New York Times Magazine*, 12 October 1980, 53.

11. Alexander Liberman, *The Artist in His Studio* (New York: Viking Press, 1960), 9.

12. Bachelard, *The Poetics of Space*, 12.

13. Saul Braun, "Sendak Raises the Shade on Childhood," *New York Times Magazine*, 7 June 1970, 52.

14. Barnaby Conrad, "Maurice Sendak," *Horizon*, May 1981, 24.

15. Lanes, *Art of Maurice Sendak*, 9.

16. See Carl Kerényi, "The Primordial Child in Primordial Times," in *Essays on a Science of Mythology: The Myth of the Divine Child and the Mysteries of Eleusis*, ed. Carl Gustav Jung and Carl Kerényi (Princeton: Princeton University Press, 1969), for a general discussion of Hermes and other ancient child gods.

17. Gaston Bachelard, *The Poetics of Reverie: Childhood, Language, and the Cosmos* (Boston: Beacon Press, 1971), 100.

18. Braun, "Sendak Raises," 12.

19. Cott, *Pipers*, 65.

20. Lanes, *Art of Maurice Sendak*, 27, 85.

21. Ibid., 85.

22. *Maurice Sendak and All His Wild Things*.

23. Cott, *Pipers*, 65.

24. Carl Gustav Jung, "Psychology and Literature," in *The Creative Process: A Symposium*, ed. Brewster Ghiselin (New York: New American Library, 1952), 222.

25. Cott, *Pipers*, 79.

26. Ibid., 67.

27. Reinbert Tabbert, "Sendak in Bologna: Remarks at a Symposium on 4 August 1988" (privately distributed offprint), 1.

28. Lanes, *Art of Maurice Sendak*, 248–249.

29. See Marie-Louise von Franz's *Patterns of Creativity Mirrored in Creation Myths* (Zurich: Spring Publications, 1971).

30. Cott, *Pipers*, 60.

31. Ibid.

32. Lanes, *Art of Maurice Sendak*, 85.

33. Nat Hentoff, "Among the Wild Things," in *Only Connect: Readings on Children's Literature*, ed. Sheila Egoff et al. (New York: Oxford University Press, 1969), 329.

34. Ibid., 346.

35. *Chicago Tribune*, 23 June 1988, 10A.

36. James Hillman, "Abandoning the Child," in *Loose Ends: Primary Papers in Archetypal Psychology* (Irving, Tex.: Spring Publications, 1978), 24.

37. Bachelard, *The Poetics of Reverie*, 108.

38. Carl Gustav Jung, "Approaching the Unconscious," in *Man and His Symbols*, ed. Carl Jung et al. (New York: Doubleday, 1971), 96.

39. Ibid., 103.

40. Ibid., 82.

41. Marie-Louise von Franz, "The Process of Individuation," in *Man and His Symbols*, 161–166.

42. Ibid., 163.

43. Jung, "Approaching the Unconscious," 103.

44. Ibid., 81.

45. Jung, "The Psychology of the Child Archetype," in *Essays on a Science of Mythology*, 98.

46. Ibid.

47. James Hillman, "The Children, The Children," in *Children's Literature*, vol. 8 (New Haven: Yale University Press, 1979), 3.

48. James Hillman, "A Note on Story," *Children's Literature*, vol. 3 (Storrs, Conn., 1974), 10.

49. Telephone interview with Maurice Sendak, 28 April 1981.

50. Bachelard, *The Poetics of Reverie*, 20.

51. *In Conversation with Maurice Sendak*.

52. Ibid.

53. Lanes, *Art of Maurice Sendak*, 13.

54. Braun, "Sendak Raises," 36.

55. Goldstein, "Jacket Is Overture," 49.

56. Peter Coveny, *The Image of Childhood* (Baltimore: Penguin Books, 1967), 37.

57. Jung, "Psychology and Literature," 220.

58. Jennifer R. Waller, "Maurice Sendak and the Blakean Vision of Childhood," in *Reflections on Literature for Children*, ed. Francelia Butler and Richard Rotert (Hamden, Conn.: Library Professional Publications, 1984), 267.

Notes to Chapter 2

1. Maurice Sendak, *Caldecott and Co.: Notes*

on Books and Pictures (New York: Farrar, Straus and Giroux, 1988), 183.

2. Public address given at the University of Florida, Gainesville, 10 February 1982.

3. Maurice Sendak, *Really Rosie: A New Musical* (New York: Samuel French, n.d.), 21. All other references to and quotations from this stage production are based on or drawn from this edition.

4. Selma Lanes, *The Art of Maurice Sendak* (New York: Harry N. Abrams, 1980), 33.

5. *Mon Cher Papa*, a documentary film directed by Christopher Swann for the "American Masters" series (Corporation for Public Broadcasting, 1987).

6. *In Conversation with Maurice Sendak*, a video interview, no. 28 in the "Contemporary Writers" series (London, 1988).

7. Lanes, *Art of Maurice Sendak*, 22.

8. Maurice Buxton Forman, *The Letters of John Keats* (New York: Oxford University Press, 1952), 71.

9. Public address at the University of Florida.

10. Lanes, *Art of Maurice Sendak*, 34.

11. Joseph Campbell, *The Power of Myth* (New York: Doubleday, 1988), 118.

12. Public address at the University of Florida.

13. Ibid.

14. Lanes, *Art of Maurice Sendak*, 22.

15. News conference at the University of Florida, 10 February 1982.

16. Lanes, *Art of Maurice Sendak*, 46.

17. Ibid.

18. Ibid., 211.

19. Ibid., 69.

20. *Caldecott and Co.*, 181.

21. This unpublished manuscript is in the Sendak archives of the Rosenbach Museum and Library, Philadelphia, Pennsylvania. The abbreviations and other unique, orthographic features are reproduced as they are in Sendak's original.

22. *Caldecott and Co.*, 180.

23. Public address at the University of Florida.

24. The *Declaration of the Rights of the Child* was passed by the General Assembly of the United Nations in 1957.

25. Lanes, *Art of Maurice Sendak*, 42.

26. Ibid.

27. Steven Heller, ed., "Maurice Sendak," in *Innovators of American Illustration* (New York: Van Nostrand Reinhold, 1986), 73.

28. Ibid.

29. Lanes, *Art of Maurice Sendak*, 42.

30. George R. Bodmer, "Ruth Krauss and Maurice Sendak's Early Illustration," *Children's Literature Association Quarterly* 11, no. 4 (Winter 1987–88): 181.

31. Perry Nodelman, "Afterword: Propaganda, Namby-Pamby, and Some Books of Distinction," in *American Writers for Children Since 1960: Fiction*, vol. 52 of *The Dictionary of Literary Biography*, 420.

32. Constance Rourke, *The Roots of American Culture* (Port Washington, N.Y.: Kennikat Press, 1965), 9.

33. Brian Attebery, *The Fantasy Tradition in American Literature: From Irving to Le Guin* (Bloomington: Indiana University Press, 1980), 185.

34. Ibid., 16.

35. Ibid., 183.

36. Ibid., 87; Lanes, *Art of Maurice Sendak*, 111.

37. Jane Werner, *Walt Disney's Alice in Wonderland Meets the White Rabbit* (Racine, Wis.: Golden Press, 1951).

38. Benjamin Spock, *Baby and Child Care* (New York: Simon & Schuster, 1957), 362–363.

39. Ibid., 362.

40. Joan Friedberg, "Garth Williams," in *American Writers for Children, 1900–1960*, vol. 22 of *The Dictionary of Literary Biography*, 369.

41. Ibid.

42. Maurice Sendak, *Very Far Away* (New York: Harper & Brothers, 1957). All quotations are from this edition.

43. Maurice Sendak, *Kenny's Window* (New York: Harper & Row, 1956). All quotations are from this edition.

44. Barbara Bader, *American Picture Books from Noah's Ark to the Beast Within* (New York: Macmillan, 1976), 504; Lanes, *Art of Maurice Sendak*, 63.

45. Dorothy W. Baruch, *One Little Boy* (New York: The Julian Press, 1952), viii.

46. Ibid., 241.

47. Lanes, *Art of Maurice Sendak*, 63.

48. Heller, ed., "Maurice Sendak," 78.

49. Ibid.

50. Ibid.

51. Maurice Sendak, *Fantasy Sketches* (Philadelphia: The Rosenbach Museum and Library, 1970).

52. Baruch, *One Little Boy*, 238.

53. Lanes, *Art of Maurice Sendak*, 63.

54. Andreas Lommel, *Shamanism: The Beginnings of Art* (New York: McGraw-Hill, 1967), 148.

55. Ibid.

56. *Caldecott and Co.*, 152.

57. Unpublished manuscript in the Rosenbach Museum and Library.

58. *Caldecott and Co.*, 152.

59. George MacDonald, *The Golden Key* (New York: Farrar, Straus and Giroux, 1967), 60.

60. *Caldecott and Co.*, 84.

61. James Hillman, "Abandoning the Child," in *Loose Ends: Primary Papers in Archetypal Psychology* (Irving, Tex.: Spring Publications, 1978), 42.

62. Ibid., 46.

63. *Really Rosie*, 7.

64. *Caldecott and Co.*, 181.

65. Maurice Sendak, "Picture Book Genesis: A Conversation with Maurice Sendak," in *Proceedings of the Fifth Annual Conference of the Children's Literature Association*, ed. Margaret P. Esmonde and Priscilla A. Ord (Villanova, Pa.: Villanova University / Children's Literature Association, 1979), 38–39.

66. *Maurice Sendak and All His Wild Things.*

67. For an account of the development of the play see Bill Powers, *Behind the Scenes of a Broadway Musical* (New York: Harper & Row, 1983).

68. *Sendak*, directed by Morton Schindel (Weston, Conn.: Weston Woods Studios, 1987).

69. *Really Rosie*, 8.

70. Lanes, *Art of Maurice Sendak*, 17.

Notes to Chapter 3

1. *Sendak*, directed by Morton Schindel (Weston, Conn.: Weston Woods Studios, 1987).

2. See Steven Heller, ed., "Maurice Sendak," in *Innovators of American Illustration* (New York: Van Nostrand Reinhold, 1986), 76.

3. Ibid.

4. Ruth Krauss, *Open House for Butterflies*, illustrated by Maurice Sendak (New York: Harper & Row, 1960), unpaged.

5. See Kurt Lewin, *Principles of Topological Psychology* (New York: McGraw-Hill, 1936).

6. Convocation address given upon the receipt of an honorary doctoral degree from the University of Connecticut, September 1990.

7. Ibid.

8. Ibid.

9. Ibid.

10. Heller, ed., "Maurice Sendak," 74.

11. Ibid.

12. Selma Lanes, *The Art of Maurice Sendak* (New York: Harry N. Abrams, 1980), 71.

13. Schindel, dir., *Sendak.*

14. Convocation address.

15. Ibid.

16. Susan Stewart, *On Longing: Narratives of the Miniature, the Gigantic, the Souvenir, the Collection* (Baltimore: Johns Hopkins University Press, 1984), 39.

17. Ibid.

18. See Alison Lurie, *Don't Tell the Grown-Ups: Subversive Children's Literature* (Boston: Little, Brown & Company, 1990).

19. Theodore Giesel, *Dr. Seuss's ABC* (New York: Random House, 1963), unpaged.

20. See *Publishers Weekly*'s "all-time best-selling" list for October 1989. Also, Maurice Sendak, "The Aliveness of Peter Rabbit," *Beatrix Potter: A Centennial Tribute* (Hartford, Conn.: Trinity College Library Associates, 1966), 2–3.

21. Stewart, *On Longing*, 43.

22. *Peter Piper's Practical Principles of Plain and Perfect Pronunciation* (Lancaster, Mass.: Carter Andrews and Company, 1830; reprint ed., New York: Dover Publications, 1970), unpaged.

23. For a number of versions of the alphabet, see Ruth M. Baldwin's *One Hundred Nineteenth-Century Rhyming Alphabets in English* (Carbondale: Southern Illinois University Press, 1972). See, too, Cecil Baring-Gould, *The Annotated Mother Goose* (New York: Clarkson M. Potter, 1962), 241–243.

24. Charles Jencks, quoted in Jim Collins, *Uncommon Cultures: Popular Culture and Post-Modernism* (New York: Routledge, 1989), 144.

25. Stewart, *On Longing*, 43.

26. Yi-Fu Tuan, *Space and Place: The Perspective of Experience* (Minneapolis: University of Minnesota Press, 1977), 55.

27. Robert Bly, *Iron John: A Book About Men* (New York: Addison-Wesley, 1990).

28. From "The Dangers of the Streets," quoted in Arnold Arnold, *Pictures and Stories from Forgotten Children's Books* (New York: Dover Publications, 1969), 20.

29. This Belloc story has been republished separately with illustrations by Victoria Chess (Boston: Little, Brown & Company, 1987).

30. Arnold Gesell and Frances L. Ilg, *Child Development: An Introduction to the Study of Human Growth* (New York: Harper & Row, 1949), 88–89.

31. Ibid., 91.

32. Ibid., 92.

33. Ibid., 109.

34. "Maurice Sendak," an audio tape interview in the "Tapes for Readers" series (1978).

35. "Revis. chap. 2—Pierre—Dec. 9. '61." Unpublished manuscript in the Rosenbach archives.

36. Geselle and Ilg, *Child Development*, 126.

37. So much so that by the early 1970s M. Rudman was offering a text entitled *Children's Literature: An Issues Approach* that contained a section on death and dying.

38. Carl Gustav Jung, *Psychology and Alchemy* (Princeton: Princeton University Press, 1968), 331.

39. Ibid., 333.

Notes to Chapter 4

1. Unpublished manuscript of 26 August 1963 in the Rosenbach Museum and Library.

2. Steven Heller, ed., "Maurice Sendak," in *Innovators of American Illustration* (New York: Van Nostrand Reinhold, 1986), 79.

3. Michael di Capua, quoted in Saul Braun, "Sendak Raises the Shade on Childhood," *New York Times Magazine,* 7 June 1970, 40.

4. Anne Scott McLeod, "An End to Innocence: The Transformation of Childhood in Twentieth-Century Children's Literature," in *Opening Texts: Psychoanalysis and the Culture of the Child,* ed. Joseph H. Smith and William Kerrigan (Baltimore: Johns Hopkins University Press, 1985), 106.

5. Jason Epstein, " 'Good Bunnies Always Obey': Books for American Children," in *Only Connect: Readings on Children's Literature,* ed. Sheila Egoff et al. (New York: Oxford University Press, 1969), 81.

6. Ibid., 79.

7. Anthony Storr, *The Dynamics of Creation* (New York: Atheneum, 1985), 81.

8. Alison Lurie, "Vulgar, Coarse, and Grotesque: Subversive Books for Kids," *Harper's,* December 1979, 66.

9. Selma Lanes, *The Art of Maurice Sendak* (New York: Harry N. Abrams, 1980), 104.

10. Braun, "Sendak Raises," 40.

11. Lanes, *Art of Maurice Sendak,* 106.

12. Bruno Bettelheim, *Ladies Home Journal,* March 1969, 48.

13. Bruno Bettelheim, *The Uses of Enchantment: The Meaning and Importance of Fairy Tales* (New York: Alfred A. Knopf, 1976), 120.

14. Brian O'Doherty, "Portrait of the Artist as a Young Alchemist," *New York Times Book Review,* 12 May 1963, 3.

15. Brian O'Doherty, *Book Week* supplement, *Washington Post,* 28 November 1965, 20.

16. In an episode that aired on the CBS program "Howie" on 8 July 1992, Bobby sings a blues song about being bad while surrounded by a rock group that magically appears in his bedroom to accompany his account of why he got sent to bed without any supper.

17. William Goldman, *Brothers* (New York: Warner Books, 1986), 233.

18. Michael O'Donoghue and Wall Neibart, "Where the Weird Things Are," *National Lampoon,* October 1972, 55–60.

19. Carl Gustav Jung and Carl Kerényi, eds., *Essays on a Science of Mythology: The Myth of the Divine Child and the Mysteries of Eleusis* (Princeton: Princeton University Press, 1969), 7.

20. For a general discussion of the various theories of myth through Lévi-Strauss, see G. S. Kirk's *Myth: Its Meanings and Functions in Ancient and Other Cultures* (Berkeley and Los Angeles: University of California Press, 1970). Another survey is needed to update these theories to account for such additional insights as those of Roland Barthes in his *Mythologies* (New York: Hill & Wang, 1972).

21. Joseph Campbell, *The Power of Myth* (New York: Doubleday, 1988), 4.

22. James Oliver Robertson, *American Myth, American Reality* (New York: Hill & Wang, 1980), xvii.

23. Barbara Bader, *American Picture Books from Noah's Ark to the Beast Within* (New York: Macmillan, 1976), 514.

24. Kirk, *Myth,* 268.

25. Robertson, *American Myth,* xvii.

26. Ibid.

27. Lanes, *Art of Maurice Sendak,* 85.

28. Ibid., 85, 227.

29. Unpublished manuscript of 26 August 1963 in the Rosenbach archives.

30. Arnold Gesell and Frances L. Ilg, *Child Development: An Introduction to the Study of Human Growth* (New York: Harper & Row, 1949), 290–291.

31. Telephone interview with Maurice Sendak, 7 August 1987.

32. Lanes, *Art of Maurice Sendak,* 18.

33. Erik H. Erikson, "Eight Ages of Man," in *Childhood and Society* (New York: W. W. Norton, 1963), 247–274.

34. Ibid., 256.

35. Maurice Sendak, *Caldecott and Co.: Notes on Books and Pictures* (New York: Farrar, Straus and Giroux, 1988), 151.

36. The original pictures are in the Rosenbach Museum and Library.

37. Erikson, "Eight Ages of Man," 256.

38. Ursula K. Le Guin, *The Language of the Night: Essays on Fantasy and Science Fiction* (New York: G. P. Putnam's Sons, 1980), 63–64.

39. Ibid., 65.

40. See Nodelman's discussions of *Where the Wild Things Are,* which run throughout his *Words About Pictures: The Narrative Art of Children's Picture Books* (Athens: University of Georgia Press, 1988).

41. Heller, ed., "Maurice Sendak," 78.

42. Ibid.

43. *In Conversation with Maurice Sendak,* a video interview, no. 28 in the Contemporary Writers series (London, 1988).

44. Ibid.

45. Roger Ricklefs, "Scary Stories: Maurice Sendak's Pen Strips Children's Books of Their Innocence," *Wall Street Journal,* 20 December 1979, 26.

46. Sendak, *Caldecott and Co.,* 97.

47. Anthony Storr, *Churchill's Black Dog, Kafka's Mice, and Other Phenomena of the Human Mind* (New York: Grove Press, 1988), 157.

48. Ibid., 168.

49. Part of the dummy is reproduced in its original size in Lanes, *Art of Maurice Sendak,* 81.

50. Sendak, *Caldecott and Co.,* 4.

51. Ibid.

52. Unpublished manuscript of 16 April 1963 in the Rosenbach Museum and Library.

53. Ibid.

54. Ibid.

55. Lanes, *Art of Maurice Sendak,* 92.

56. Charles Olson, *The Maximus Poems* (New York: Jargon/Corinth Books, 1960), 1.

57. Maurice Sendak, libretto for the opera *Where the Wild Things Are* (London: Faber Music Ltd., 1985), 35.

58. Campbell, *The Power of Myth,* 21.

59. Benjamin Spock, *The Common Sense Book of Baby and Child Care* (New York: Duell, Sloan and Pearce, 1946), 268.

60. Sally Allen McNall, "American Children's Literature, 1880–Present," in *American Childhood: A Research Guide and Historical Handbook,* ed. Joseph M. Hawes and N. Ray Hiner (Westport, Conn.: Greenwood Press, 1985), 409.

61. Leslie Fiedler, "The Eye of Innocence: Some Notes on the Role of the Child in Literature," in *No! in Thunder: Essays on Myth and Literature* (London: Eyre & Spottiswoode, 1963), 262.

62. Ibid., 263.

63. William Nicholson, *The Pirate Twins* (London: Faber and Faber, 1924).

64. Hilaire Belloc, *The Bad Child's Book of Beasts* (New York: Dover Publications, 1961), 5.

65. *Maurice Sendak,* directed by Morton Schindel (Weston, Conn.: Weston Woods Studios, 1967).

66. Epstein, "Good Bunnies."

67. Wilhelm Busch, *Max and Moritz, With Many More Mischief Makers More or Less Human or Approximately Animal* (New York: Dover Publications, 1962).

68. Leslie Fiedler, *Freaks: Myths and Images of the Secret Self* (New York: Simon & Schuster, 1978), 154. Fiedler notes in his chapter "Wild Men and Feral Children" that Lucien Malson's 1964 study *Les Enfants sauvages* cites fifty-three "attested cases of such children" (155).

69. Ibid.

70. Ibid., 156.

71. Annemarie de Waal Malefijt, "Homo Monstrosus," *Scientific American,* October 1968, 113.

72. Richard Bernheimer, *Wild Men in the Middle Ages: A Study in Art, Sentiment, and Demonology* (Cambridge, Mass.: Harvard University Press, 1952), 3.

73. Ibid.

74. Ibid., 20.

75. Ibid.

76. Ibid., 48.

77. Ibid., 20.

78. *Sendak,* directed by Morton Schindel (Weston, Conn.: Weston Woods Studios, 1987).

79. Lanes, *Art of Maurice Sendak,* 88.

80. Theodore Thass-Thienemann, *The Subconscious Language* (New York: Washington Square Press, 1967), 309–311.

81. Ibid., 310.

82. Ibid.

83. In the program for the 1985 Glyndebourne premiere of the opera, Sendak gave names to the Wild Things: Tzippy, Moishe, Bruno, Emile, and Bernard. Elsewhere he has recalled that one of the relatives who pinched his cheek the hardest was his Aunt Golda. Future scholars will no doubt seek to unravel this mystery.

84. Jean Cocteau, quoted in *Child: A Literary Companion,* ed. Helen Handley and Andra Samelson (Wainscott, N.Y.: Pushcart Press, 1988), 23.

85. Sendak, *Caldecott and Co.,* 150–151.

86. Joseph Campbell, *The Hero with a Thousand Faces* (New York: World Publishing, 1969).

87. Campbell, *The Power of Myth.*

88. Joseph L. Henderson, "Ancient Myths and Modern Man," in *Man and His Symbols,* ed. Carl Jung et al. (New York: Doubleday, 1971), 112.

89. Ibid.

90. Carl Kerényi, "The Trickster in Relation to Greek Mythology," in Paul Radin's *The Trickster: A Study in American Indian Mythology* (Westport, Conn.: Greenwood Press, 1969), 185.

91. Ibid.

92. George Boas, *The Cult of Childhood* (London: The Warburg Institute, 1966), 20.

Notes to Chapter 5

1. Quoted in Marshal W. Fishwick, *Seven Pillars of Popular Culture* (Westport, Conn.: Greenwood Press, 1985), 160.

2. Maurice Sendak, *Higglety Pigglety Pop! Or, There Must Be More to Life* (New York: Harper & Row, 1967). All page numbers refer to this edition.

3. Gerald Howard, ed., *The Sixties: The Art,*

Attitudes, Politics, and Media of Our Most Explosive Decade (New York: Simon & Schuster, 1982), 197.

4. Maurice Sendak and All His Wild Things, directed by Herbert Danska, a video documentary in the Arts and Entertainment "Biography" series, 1985.

5. Sheila Egoff et al., eds., Only Connect: Readings on Children's Literature (New York: Oxford University Press, 1969), 344.

6. Saul Braun, "Sendak Raises the Shade on Childhood," New York Times Magazine, 7 June 1970, 34.

7. Selma Lanes, The Art of Maurice Sendak (New York: Harry N. Abrams, 1980), 156.

8. Ibid., 155.

9. Ibid., 171.

10. Anthony Storr, The Dynamics of Creation (New York: Atheneum, 1985), 194.

11. Maurice Sendak, directed by Morton Schindel (Weston, Conn.: Weston Woods Studios, 1967).

12. Jerome Griswold, The Children's Books of Randall Jarrell (Athens: University of Georgia Press, 1988), 13.

13. Randall Jarrell, The Bat-Poet, illustrated by Maurice Sendak (New York: Macmillan, 1963), 3.

14. News conference at the University of Florida, 10 February 1982.

15. Griswold, Children's Books, 10.

16. Nor Hall, The Moon and the Virgin: Reflections on the Archetypal Feminine (New York: Harper & Row, 1980), 5.

17. Carl Gustav Jung, Psychological Reflections (Princeton: Princeton University Press, 1970), 197.

18. Robert Phelps, "Fine Books for Children by a 'Secret Child': The Hidden World of Maurice Sendak," Life Magazine, 15 December 1967, 8.

19. Higglety Pigglety Pop! and Where the Wild Things Are (London: Faber Music Ltd., 1985), 5–6.

20. Joseph Campbell, The Hero with a Thousand Faces (New York: World Publishing, 1969), 77.

21. Lanes, Art of Maurice Sendak, 203.

22. The Juniper Tree and Other Tales from Grimm (New York: Farrar, Straus and Giroux, 1973), 150.

23. Ibid.

24. Theodor H. Gaster, The Holy and the Profane: Evolution of Jewish Folkways (New York: William Morrow, 1980), 21.

25. See R. Murray Schafer's Tuning of the World (New York: Alfred A. Knopf, 1977) and John Cech, "Singing the Songlines on the Porch,"

Child, May–June 1988, 72–77, 124.

26. Bruce Chatwin, The Songlines (New York: Viking, 1987).

27. Joseph Campbell, The Hero with a Thousand Faces (New York: World Publishing, 1969), 101.

28. Ibid.

29. Lanes, Art of Maurice Sendak, 111.

30. Jonathan Cott, ed. Victorian Color Picture Books, vol. 7 of Masterworks of Children's Literature (New York: Chelsea House, 1983), xi.

31. Cecil Baring-Gould, The Annotated Mother Goose (New York: Clarkson M. Potter, 1962), 145.

32. Barbara Bader, American Picture Books from Noah's Ark to the Beast Within (New York: Macmillan, 1976), 518.

33. Lanes, Art of Maurice Sendak, 162.

34. Patricia Demers and Gordon Moyles, eds., From Instruction to Delight: An Anthology of Children's Literature to 1850 (New York: Oxford University Press, 1982), 179.

35. Quoted in Cornelia Meigs et al., A Critical History of Children's Literature (New York: Macmillan, 1959), 143.

36. Samuel Griswold Goodrich, "Timothy the Terror," in Merry's Museum 7, no. 2 (New York: D. Mead, August 1846): 51–54.

37. Ibid., 54.

38. Johan Huizinga, Homo Ludens: A Study of the Play Element in Culture (Boston: Beacon Press, 1955), 4.

39. Ibid., 173.

40. Ibid., 6.

41. See Lisa See, "Where the Big Deals Are: Caldecott Medalist Maurice Sendak Inks a Film Deal with TriStar," Publishers Weekly, 8 June 1992, 26.

42. Huizinga, Homo Ludens, 10.

Notes to Chapter 6

1. Audio letter to Gene Deitch, 19 April 1984, in the Weston Woods Studios production archives.

2. "Questions to an Artist Who Is Also an Author: A Conversation between Maurice Sendak and Virginia Haviland," Quarterly Journal of the Library of Congress 28, no. 4 (October 1971): 278.

3. Barbara Bader, American Picture Books from Noah's Ark to the Beast Within (New York: Macmillan, 1976), 518.

4. Audio letter to Deitch.

5. Jonathan Cott, Pipers at the Gates of Dawn: The Wisdom of Children's Literature (New York: Random House, 1983), 79–80.

6. In his *Interpretation of Dreams,* Freud admitted the impossibility of ever being able to fully interpret a dream because, ultimately, "there is a tangle of dream-thoughts which cannot be unraveled. . . . This is the dream's navel, the spot where it reaches down to the unknown." See Sigmund Freud, *The Interpretation of Dreams* (London: Allen and Unwin, 1954), 525.

7. See William F. Touponce's "The Journey as Cosmic Reverie: A Reading of Maurice Sendak's *In the Night Kitchen,*" in *Proceedings of the Thirteenth Annual Conference of the Children's Literature Association,* ed. Susan R. Gannon and Ruth Anne Thompson (West Lafayette, Ind.: Children's Literature Association, 1988), 94.

8. Ibid., 80. This interview has been reprinted in Cott, *Pipers at the Gates of Dawn.*

9. See Linda Schele and Mary Ellen Miller, *The Blood of Kings: Dynasty and Ritual in Maya Art* (New York: George Braziller, 1986), 268, 282.

10. Carlos Castenada, *The Teachings of Don Juan: A Yaqui Way of Knowledge* (New York: Ballantine Books, 1969), 186.

11. For a discussion of these origins of the lullaby see Theodor H. Gaster's *The Holy and the Profane: Evolution of Jewish Folkways* (New York: William Morrow, 1980), 18–28.

12. Selma Lanes, *The Art of Maurice Sendak* (New York: Harry N. Abrams, 1980), 173–175.

13. Saul Braun, "Sendak Raises the Shade in Childhood," *New York Times Magazine,* 7 June 1970, 42.

14. James Hillman, *The Dream and the Underworld* (New York: Harper & Row, 1979), 133.

15. Ibid., 135.

16. Ibid.

17. "Trouble Cap," unpublished manuscript in the Rosenbach Museum and Library. Though it is undated, textual evidence suggests it is the first in a sequence of drafts for *In the Night Kitchen* begun in the first week of April 1969. The next draft of the story is dated "April 5, '69."

18. Margaret R. Higonnet, "The Playground of the Peritext," *Children's Literature Association Quarterly* 15, no. 2 (Summer 1990): 47.

19. Ibid.

20. "Questions to an Artist," 276.

21. Audio letter to Deitch.

22. Ibid.

23. *Mother Goose: Five of Her Books* (Akron, Ohio: The Saalfield Publishing Company, 1929). The illustrator for this boxed set is simply designated as "F.B.P."

24. "Questions to an Artist," 268.

25. Frances G. Wickes, *The Inner World of Childhood* (New York: Appleton-Century, 1966), 289.

26. Vernon Grant, *Tinker Tim the Toy Maker* (Racine, Wis.: Whitman Publishing Company, 1934), 6.

27. *Sendak,* directed by Mort Schindel (Weston, Conn.: Weston Woods Studios, 1987).

28. Lanes, *Art of Maurice Sendak,* 9.

29. This drawing has been reproduced in Lanes, 9.

30. Braun, "Sendak Raises," 46.

31. *Maurice Sendak and All His Wild Things,* directed by Herbert Danska, a video documentary in the Arts and Entertainment Biography series, 1985.

32. Maurice Sendak, *Caldecott and Co.: Notes on Books and Pictures* (New York: Farrar, Straus and Giroux, 1988), 78.

33. Ibid., 80.

34. "Little Nemo in Slumberland," 8 April 1908; see Woody Gelman, ed., *Little Nemo by Winsor McCay* (New York: Nostalgia Press, 1974), 39.

35. Gelman, ed., *Little Nemo,* 14.

36. Audio letter to Deitch.

37. Ibid.

38. Hillman, *Dream,* 170.

39. The libretto for the operatic version of *Higglety Pigglety Pop!* offers Sendak's send-up of this well-known nursery tale:

Did you ever hear of Chicken Little
How she thought the sky was falling down
And ran home all the way, in such a fuss
She simply couldn't eat!
Well wouldn't you know
It wasn't the sky making all that roar
But only a lion out hungry and hunting
And he chased Chicken Little and caught
 her quick
Then opened wide his reeking jaws!
Said Chicken Little: "Before I die
Oh sky—oh night"—
(she wasn't very bright)—
"Let me lay a little egg
I beg
To be remembered by."
And she did and he did
And here's the egg—Oh my!

See *Higglety Pigglety Pop! and Where the Wild Things Are* (London: Faber Music Ltd., 1985), 19.

40. Audio letter to Deitch.

41. Ibid.

42. "Questions to an Artist," 276.

43. *New Larousse Encyclopedia of Mythology* (New York: Paul Hamlyn, 1968), 278.

44. Wilhelm Busch, *Max and Moritz, With Many More Mischief Makers More or Less Human or Approximately Animal* (New York: Dover Publications, 1962), 43–50. In their "Sixth Trick," the boys fall into the baker's dough when they are trying to steal pretzels; he bakes them in an oven and sets them aside to cool. But the boys are none the worse for their experience: once the baker's back is turned, they eat themselves out of their dough and make their escape.

45. *Maurice Sendak and All His Wild Things.*

46. Ibid.

47. Sendak, *Caldecott and Co.,* 169.

48. Ibid.

49. Ibid., 169–170.

50. "Terrible cap," undated manuscript (ca. 5 April 1969) in the Rosenbach Museum and Library.

51. The traditional rhyme, which Sendak plays on several times in the book, is: "I see the moon, / And the moon sees me; / God bless the moon / And god bless me." See Lanes, *Art of Maurice Sendak,* 175.

52. "Terrible cap."

53. Audio letter to Deitch.

54. Ibid.

55. Ibid.

56. "Terrible cap."

57. C. A. Burland, *The Art of the Alchemists* (New York: Macmillan, 1968), 70.

58. Ibid., 71.

59. Ibid., 77.

60. Ibid., 72.

61. See Carl Gustav Jung, *Psychology and Alchemy* (Princeton: Princeton University Press, 1968), 414.

62. Walter A. Strauss, *Descent and Return: The Orphic Theme in Modern Literature* (Cambridge, Mass.: Harvard University Press, 1971), 18.

63. For a discussion of the linguistic fantasies of shaping, see Theodore Thass-Thienemann's *The Subconscious Language* (New York: Washington Square Press, 1967), 164–173.

64. Strauss, *Descent and Return,* 13.

65. Ibid, 12.

Notes to Chapter 7

1. For a discussion of the importance of Hughes's work to *Outside Over There,* see Michael Steig's "Coming to Terms with *Outside Over There*" in his *Stories of Reading: Subjectivity and Literary Understanding* (Baltimore: Johns Hopkins University Press, 1989), 202–220.

2. Ibid., 205.

3. Steven Heller, ed., "Maurice Sendak," in *Innovators of American Illustration* (New York: Van Nostrand Reinhold, 1986), 81, 80.

4. Perry Nodelman, "And Then to Do Variations," an unpublished paper given at the Modern Language Association annual conference, 29 December 1990.

5. Jonathan Cott, "Maurice Sendak, King of All Wild Things," *Rolling Stone,* 30 December 1976, 57.

6. Heller, ed., "Maurice Sendak," 80.

7. Ibid.

8. Ibid., 81.

9. Maurice Sendak, *Outside Over There* (New York: Harper & Row, 1981). All references are to this edition.

10. Geraldine DeLuca, "Exploring the Levels of Childhood: The Allegorical Sensibility of Maurice Sendak," in *Children's Literature,* vol. 12 (New Haven: Yale University Press, 1984), 22.

11. Ibid., 80.

12. Jonathan Cott, *Pipers at the Gates of Dawn: The Wisdom of Children's Literature* (New York: Random House, 1983), 74.

13. Marie-Louise von Franz, "The Process of Individuation," in *Man and His Symbols,* ed. Carl Gustav Jung et al. (New York: Doubleday, 1971), p. 177.

14. Ibid.

15. Christopher Swann, *Mon Cher Papa,* a video documentary in the American Masters series (Corporation for Public Broadcasting, 1987).

16. Von Franz, "Process of Individuation," 186.

17. "Sendak on Sendak as Told to Jean F. Mercier," *Publishers Weekly,* 10 April 1981, 46.

18. Jane Doonan, "*Outside Over There:* A Journey in Style," *Signal,* nos. 50 and 51 (May 1986): 92–103; (September 1986): 172–187.

19. Telephone interview with Maurice Sendak, 4 March 1981.

20. *Mon Cher Papa.*

21. Ibid.

22. Ibid.

23. Ibid.

24. Heller, ed., "Maurice Sendak," 81.

25. *Mon Cher Papa.*

26. Selma Lanes, *The Art of Maurice Sendak* (New York: Harry N. Abrams, 1980), 229.

27. Cott, *Pipers,* 74.

28. *Mon Cher Papa.*

29. Heller, ed., "Maurice Sendak," 81.

30. Cott, *Pipers,* 68.

31. Ibid., 84.

32. von Franz, "Process of Individuation," 196.

33. Ibid., 199.

34. See Perry Nodelman's discussion of shades of purple as one of the primary color indicators of fantasy in *Words About Pictures: The Narrative Art of Children's Picture Books* (Athens: University of Georgia Press, 1988), 62.

35. Walter Clemons, "Sendak's Enchanted Land," *Newsweek,* 18 May 1981, 108.

36. Telephone interview with Maurice Sendak, 4 March 1981.

37. Ibid.

38. See, for instance, the etymological references for "left" provided by *The American Heritage Dictionary* and Theodore Thass-Thienemann, *The Subconscious Language* (New York: Washington Square Press, 1967), 85–86.

39. Carl Gustav Jung, "The Psychology of the Child Archetype," in *Essays on a Science of Mythology: The Myth of the Divine Child and the Mysteries of Eleusis,* ed. Carl Gustav Jung and Carl Kerényi (Princeton: Princeton University Press, 1969), 97.

40. Telephone interview with Maurice Sendak, 4 March 1981.

41. Robert Rosenblum, *The Romantic Child: From Runge to Sendak* (New York: Thames & Hudson, 1988), 29.

42. Ibid., 29, 31–32.

43. Jacob and Wilhelm Grimm, *The Juniper Tree and Other Tales from Grimm,* selected by Lore Segal and Maurice Sendak, illustrated by Maurice Sendak (New York: Farrar, Straus and Giroux, 1973), 150.

44. "Sendak on Sendak," 45.

45. "The Magic Swan-Geese," in *Russian Fairy Tales,* collected by Aleksandr Afans'ev, translated by Norbert Guterman (New York: Pantheon, 1945), 349–351.

46. Leslie Daiken, *The Lullaby Book* (London: Edmund Ward, 1959), 19.

47. *In Conversation with Maurice Sendak,* a video interview, no. 28 in the Contemporary Writers series (London, 1988).

48. Robert Rosenblum, "Friedrichs from Russia: An Introduction," in *The Romantic Vision of Caspar David Friedrich* (New York: The Metropolitan Museum of Art, 1990), 9, 11.

49. In the dummy dated September 10–22 '76 in the Rosenbach Archives, one can certainly see in telling detail the absence of Blake's influence, or of Runge, Friedrich, or Mozart. In the opening illustrations that later become the title page, the Runge sunflowers have not yet appeared, nor has the small picket fence. Ida's horn is more like a trumpet; for reasons of size, it will become more rounded as the book progresses. The babies in this version, when they are revealed, are very ugly. They certainly don't have the Rungian beauty of the children that appear in the final version, and Ida's sister is certainly not a beautiful child either. Clearly, Sendak's focus in this version is on Ida. The baby hasn't entered yet as a real participant, someone with a story (unconscious, unstated) of her own. In this version Sendak hasn't begun to do anything with the windows: no sunflowers appear, there's no storm at sea, Mozart has not yet taken up residence along the riverbank, nor has the dog joined them and the baby been pacified at the end. When Ida returns and she and mother read father's letter, the baby is left alone, again temporarily, and is scowling on the bench in the arbor, ready to throw another tantrum by the looks of it. She doesn't stop playing with the dog, nor does Ida take care of her and teach her how to walk, as she does at the end of the final version. Mama, in the scene of this dummy, carries the baby. We see Mama from the back, with the child peeking over her shoulder while Ida follows behind, and we see her as well from the back. Life goes on, but the relationship between Ida and her sister is not explored, and it surely is not "resolved" as in the final version. Ida is still the odd one out in the mother-child configuration. She is isolated, as older kids in this situation would normally be, and our attention would be on mother and the baby if Sendak did not darken Ida's hair so that our eye would be drawn back to her.

50. *In Conversation with Maurice Sendak.*

51. Ibid.

52. Ibid.

53. "Sendak on Sendak," 45.

54. *Sendak,* directed by Morton Schindel (Weston, Conn.: Weston Woods Studios, 1987).

55. Ibid.

56. Clemons, "Sendak's Enchanted Land," 102.

57. Cott, *Pipers,* 75.

58. Maurice Sendak, "Picture Book Genesis: A Conversation with Maurice Sendak," in *Proceedings of the Fifth Annual Conference of the Children's Literature Association,* ed. Margaret P. Esmonde and Priscilla A. Ord (Villanova, Pa.: Villanova University/Children's Literature Association, 1979), 29–30.

59. Gaston Bachelard, *The Poetics of Reverie: Childhood, Language, and the Cosmos* (Boston: Beacon Press, 1971), 125.

60. "Dionne Quints," *Village Voice,* 23 May 1989, 39.

61. Telephone interview with Maurice Sendak, 4 March 1981.

62. Ibid.

63. Carl Gustav Jung, *Psychology and Alchemy* (Princeton: Princeton University Press, 1968), 202.

64. Telephone interview, 4 March 1981.

65. See Joseph H. Schwarcz and Chava Schwarcz, "Sendak's Trilogy: A Concept of Childhood," in *The Picture Book Comes of Age: Looking at Childhood through the Art of Illustration* (Chicago and London: American Library Association, 1991), 194–205.

66. Telephone interview, 4 March 1981.

Notes to Chapter 8

1. Michael J. Bandler, "Childhood Is Always with Him," *American Way*, May 1981, 75.

2. Maurice Sendak, interview with Katie Davis on "All Things Considered," National Public Radio, 30 October 1993.

3. Pamela Warrick, "Facing the Frightful Things: These Days Maurice Sendak's Wild Creatures Are Homelessness, Aids, and Violence: Big Issues for Small Kids," *Los Angeles Times*, 11 October 1993, 1.

4. Megan Rosefeld, "Maurice Sendak, Sunny Side Down," *Washington Post*, 12 October 1993, C1.

5. Bob Dart, "Sendak Makes Homeless Children the Stars of His New Kids' Book," *The Atlanta Journal and Constitution*, 22 September 1993, B5.

6. Maurice Sendak, interview with Donna Kelly on Cable News Network, 5 November 1993.

7. Mike Capuzzo, "Maurice Sendak Produces His Darkest Children's Book," *The Chicago Tribune*, 3 October 1993, C3.

8. Interview with Donna Kelly.

9. "In The Dumps," by Art Spiegelman and Maurice Sendak, *The New Yorker*, 27 September 1993, 80.

10. Peter F. Neumeyer, "What Shall We Tell the Children?" *Los Angeles Times Book Review*, 3 October 1993, 1.

11. Carl Kerényi, *Eleusis: Archetypal Image of Mother and Daughter* (New York: Random House, 1967), 125.

12. Capuzzo, "Maurice Sendak Produces His Darkest Children's Book."

13. Brian O'Doherty, "Portrait of the Artist as a Young Alchemist," *The New York Times Book Review*, 12 May 1963.

BIBLIOGRAPHY

Works by Sendak

Sendak, Maurice. *Fantasy Sketches*. Philadelphia: The Rosenbach Museum and Library, 1970.

———. *Hector Protector and As I Went Over the Water*. New York: Harper & Row, 1965.

———. *Higglety Pigglety Pop! Or, There Must Be More to Life*. New York: Harper & Row, 1967.

———. *Higglety Pigglety Pop! and Where the Wild Things Are*. (Opera libretti). London: Faber Music, Ltd., 1985.

———. *In the Night Kitchen*. New York: Harper & Row, 1970.

———. *Kenny's Window*. New York: Harper & Row, 1956.

———. *Maurice Sendak's Really Rosie Starring the Nutshell Kids*. New York: Harper & Row, 1975.

———. *The Nutshell Library*. New York: Harper & Row, 1962.

———. *Outside Over There*. New York: Harper & Row, 1981.

———. *Posters by Maurice Sendak*. New York: Harmony Books, 1976.

———. *Really Rosie: A New Musical*. New York: Samuel French, n.d.

———. *Seven Little Monsters*. New York: Harper & Row, 1975.

———. *The Sign on Rosie's Door*. New York: Harper & Row, 1960.

———. *Ten Little Rabbits*. Philadelphia: The Philip H. & A. S. W. Rosenbach Foundation, 1970.

———. *Very Far Away*. New York: Harper & Brothers, 1957.

———. *Where the Wild Things Are*. New York: Harper & Row, 1963.

———. *Where the Wild Things Are*. (Opera libretto). London: Faber Music, Ltd., 1985.

Works Illustrated by Sendak

Eidinoff, M. C., et al. *Atomics for the Millions*. New York: McGraw-Hill, 1946.

Grimm, Jacob, and Grimm, Wilhelm. *The Juniper Tree and Other Tales from Grimm*, selected by Lore Segal and Maurice Sendak. New York: Farrar, Straus and Giroux, 1973.

———, Wilhelm. *Dear Mili*. New York: Farrar, Straus and Giroux, 1988.

Hoffmann, E. T. A. *Nutcracker*. New York: Crown Publishers, 1984.

Jarrell, Randall. *The Animal Family*. New York: Random House, 1965.

———. *The Bat-Poet*. New York: Macmillan, 1963.

———. *Fly By Night*. New York: Farrar, Straus and Giroux, 1976.

Krauss, Ruth. *Charlotte and the White Horse*. New York: Harper & Row, 1955.

———. *A Hole Is to Dig: A First Book of First Definitions*. New York: Harper & Row, 1952.

———. *I'll Be You and You Be Me*. New York: Harper & Row, 1954.

———. *I Want to Paint My Bathroom Blue*. New

York: Harper & Row, 1956.

———. *Open House for Butterflies*. New York: Harper & Row, 1960.

———. *Somebody Else's Nut Tree and Other Tales from Children*. New York: Harper & Row, 1971.

———. *A Very Special House*. New York: Harper & Row, 1953.

MacDonald, George. *The Golden Key*. New York: Farrar, Straus and Giroux, 1967.

———. *The Light Princess*. New York: Farrar, Straus and Giroux, 1969.

Minarik, Else Holmelund. *Father Bear Comes Home*. New York: Harper & Row, 1959.

———. *A Kiss for Little Bear*. New York: Harper & Row, 1968.

———. *Little Bear*. New York: Harper & Row, 1957.

———. *Little Bear's Friend*. New York: Harper & Row, 1960.

———. *Little Bear's Visit*. New York: Harper & Row, 1961.

———. *No Fighting, No Biting!* New York: Harper & Row, 1958.

Sendak, Philip. *In Grandpa's House*. New York: Harper & Row, 1985.

Singer, Isaac Bashevis. *Zlateh the Goat and Other Stories*. New York: Harper & Row, 1966.

Stockton, Frank R. *The Bee-Man of Orn*. New York: Harper & Row, 1964.

———. *The Griffin and the Minor Canon*. New York: Harper & Row, 1963.

Tesnohlidek, Rudolf. *The Cunning Little Vixen*. New York: Farrar, Straus and Giroux, 1985.

Criticism, Interviews, and Commentary by Sendak

Cech, John. "Maurice Sendak: An American Master of the Children's Book." *Children's Video* 1 (1987): 9–12.

Heller, Steven, ed. "Maurice Sendak." In *Innovators of American Illustration*, 70–81. New York: Van Nostrand Reinhold, 1986.

In Conversation with Maurice Sendak. A video interview. No. 28 in the "Contemporary Writers" series. London, 1988.

Loraine, Walter. "An Interview with Maurice Sendak." *Wilson Library Bulletin*, October 1977, 152–157.

Marcus, Leonard S. "Something Wild." *Parenting*, November 1988, 96–104.

"Questions to an Artist Who Is Also an Author: A Conversation Between Maurice Sendak and Virginia Haviland." *Quarterly Journal of the Library of Congress* 28, no. 4 (October 1971): 263–280.

Sendak, Maurice. "The Aliveness of Peter Rabbit." In *Beatrix Potter: A Centennial Tribute*, 2–3. Hartford, Conn.: Trinity College Library Associates, 1966.

———. *Caldecott and Co.: Notes on Books and Pictures*. New York: Farrar, Straus and Giroux, 1988.

———. "Caldecott Award Acceptance." The Horn Book Magazine, August 1964, 344–351.

———. *Maurice Sendak*. Washington, D.C.: Tapes for Readers, 1978.

———. *Maurice Sendak*, with Paul Vaughn. Writers in Conversation, no. 28. Northbrook, Ill.: The Roland Collection, n.d.

———. "Picture Book Genesis: A Conversation with Maurice Sendak." In *Proceedings of the Fifth Annual Conference of the Children's Literature Association*, ed. Margaret P. Esmonde and Priscilla A. Ord, 29–40. Villanova, Pa.: Villanova University/Children's Literature Association, 1979.

———. "Sendak on Sendak as Told to Jean F. Mercier." *Publishers Weekly*, 10 April 1981, 45–46.

———. "Victorian Color Picture Books: A Dialogue with Maurice Sendak." In *Masterworks of Children's Literature*, ed. Jonathan Cott. Vol. 7. New York: Chelsea House, 1983.

———, and Frank Corsaro. *The Love of Three Oranges: The Glyndebourne Version*. New York: Farrar, Straus and Giroux.

Tabbert, Reinbert. "Sendak in Bologna: Remarks at a Symposium on 4 August 1988." Privately distributed offprint of Sendak's remarks.

Books, Essay Collections, Articles, and Criticism About Sendak

Arakelian, Paul G. "Text and Illustration: A Stylistic Analysis of Books by Sendak and Mayer." *Children's Literature Association Quarterly*, Fall 1985, 122–127.

Bader, Barbara. *American Picture Books from Noah's Ark to the Beast Within*. New York: Macmillan, 1976.

Bandler, Michael J. "Childhood Is Always with Him." *American Way*, May 1981, 71–76.

Bettelheim, Bruno. *Ladies Home Journal*, March 1969, 48.

Bodmer, George R. "Ruth Krauss and Maurice

Sendak's Early Illustration." *Children's Literature Association Quarterly* 11, no. 4 (1986–87): 180–183.

Braun, Saul. "Sendak Raises the Shade on Childhood." *New York Times Magazine*, 7 June 1970, 34–54.

Cech, John. "Maurice Sendak." *Child*, January–February 1988, 65, 106, 108.

———. "Maurice Sendak: Off the Page." *The Horn Book Magazine*, May–June 1986, 305–313.

———. "Sendak's Magical, Musical Illustrations." *Christian Science Monitor*, 11 May 1981, B1, B4.

———. "Sendak's Mythic Childhood." In *Children's Literature*, vol. 10 (New Haven: Yale University Press, 1982), 178–182.

Clemons, Walter. "Sendak's Enchanted Land." *Newsweek*, 18 May 1981, 102–105.

Coburn, Randy Sue. "Wonderful Wizard of 'Wild Things' Now Turns to Opera." *Smithsonian*, January 1982, 88–94.

Conrad, Barnaby. "Maurice Sendak." *Horizon*, May 1981, 24–33.

Cotham, John. "Maurice Sendak." In *American Writers for Children Since 1960: Poets, Illustrators, and Nonfiction Authors*, ed. Glenn E. Estes. Vol. 61 of *The Dictionary of Literary Biography*. Detroit: Gale Research, 1987.

Cott, Jonathan. *Pipers at the Gates of Dawn: The Wisdom of Children's Literature*. New York: Random House, 1983.

Danska, Herbert. *Maurice Sendak and All His Wild Things*. A video documentary in the Arts and Entertainment "Biography" series, 1985.

DeLuca, Geraldine. "Exploring the Levels of Childhood: The Allegorical Sensibility of Maurice Sendak." In *Children's Literature*, vol. 12 (New Haven: Yale University Press, 1984), 3–24.

———. "Progression Through Contraries: The Triumph of the Spirit in the Work of Maurice Sendak." In *Triumphs of the Spirit in Children's Literature*, ed. Francelia Butler and Richard Rotert, 142–147. Hamden, Conn.: Library Professional Publications, 1986.

Doonan, Jane. "*Outside Over There*: A Journey in Style." *Signal*, nos. 50 and 51 (May 1986; September 1986): 92–103; 172–187.

Fletcher, Connie. "Maurice Sendak Isn't Kidding!" *FamilyStyle*, May–June 1981, 19–25.

Goldstein, William. "Jacket Is Overture: The Musical Achievement of Maurice Sendak's

'Dear Mili.'" *Publishers Weekly*, 20 May 1988, 47–48.

Griswold, Jerome. *The Children's Books of Randall Jarrell*. Athens: University of Georgia Press, 1988.

"Happy Year to be Grimm." *Time*, 10 December 1973, 96–102.

Hentoff, Nat. "Among the Wild Things." In *Only Connect: Readings on Children's Literature*, ed. Sheila Egoff et al., 323–346. New York: Oxford University Press, 1969.

Kiefer, Barbara. "Looking beyond Picture Book Preferences." *The Horn Book Magazine*, November–December 1985, 705–713.

Lahr, John. "The Playful Art of Maurice Sendak." *New York Times Magazine*, 12 October 1980, 44–49, 52–60.

Lanes, Selma. *The Art of Maurice Sendak*. New York: Harry N. Abrams, 1980.

Long, Mary. "Why Children Love Maurice Sendak's Books." *Family Weekly*, 5 March 1978, 21.

Moseley, Ann. "The Journey through the 'Space in the Text' to *Where the Wild Things Are*." In Proceedings of the Thirteenth Annual Conference of the Children's Literature Association, ed. Susan R. Gannon and Ruth Anne Thompson, 96–101. West Lafayette, Ind.: Children's Literature Association Publications, 1988.

Nodelman, Perry. *Words About Pictures: The Narrative Art of Children's Picture Books*. Athens: University of Georgia Press, 1988.

O'Doherty, Brian. "Portrait of the Artist as a Young Alchemist." *New York Times Book Review*, 12 May 1963, 3, 31.

O'Donoghue, Michael, and Neibart, Wall. "Where the Weird Things Are." *National Lampoon*, October 1972, 55–60.

Perrot, Jean. "Deconstructing Maurice Sendak's Postmodern Palimpsest." *Children's Literature Association Quarterly* 16, no. 4 (Winter 1991–92): 259–263.

———. "Maurice Sendak's Ritual of Cooking the Child in Three Tableaux: The Moon, Mother, and Music." In *Children's Literature*, vol. 18 (New Haven: Yale University Press, 1990), 68–86.

Phelps, Robert. "Fine Books for Children by a 'Secret Child': The Hidden World of Maurice Sendak." *Life Magazine*, 15 December 1967, 8.

Ricklefs, Roger. "Scary Stories: Maurice Sendak's Pen Strips Children's Books of Their Innocence." *Wall Street Journal*, 20 December 1979, 26, 68, 70.

Rosenblum, Robert. *The Romantic Child: From Runge to Sendak*. New York: Thames & Hudson, 1988.

Roxburgh, Stephen. "A Picture Equals How Many Words?: Narrative Theory and Picture Books for Children." *The Lion and the Unicorn* 7/8 (1983/1984): 20–33.

Schindel, Morton. *Maurice Sendak*. Weston, Conn.: Weston Woods Studios, 1967.

———. *Sendak*. Weston, Conn.: Weston Woods Studios, 1987.

Schwarcz, Joseph H., and Schwarcz, Chava. "Sendak's Trilogy: A Concept of Childhood." In *The Picture Book Comes of Age: Looking at Childhood through the Art of Illustration*, 194–205. Chicago and London: American Library Association, 1991.

Steig, Michael. *Stories of Reading: Subjectivity and Literary Understanding*. Baltimore: Johns Hopkins University Press, 1989.

Swann, Christopher. *Mon Cher Papa*. A video documentary in the "American Masters" series. Corporation for Public Broadcasting, 1987.

Tabbert, Reinbert, ed. *Maurice Sendak: Bilderbuchkünstler*. Bonn: Bouvier Verlag Herbert Grundmann, 1987.

Tatar, Maria. *Off with Their Heads! Fairytales and the Culture of Childhood*. Princeton: Princeton University Press, 1992.

Touponce, William F. "The Journey as Cosmic Reverie: A Reading of Maurice Sendak's *In the Night Kitchen*." In *Proceedings of the Thirteenth Annual Conference of the Children's Literature Association*, ed. Susan R. Gannon and Ruth Anne Thompson, 92–95. West Lafayette, Ind.: Children's Literature Association Publications, 1988.

Waller, Jennifer R. "Maurice Sendak and the Blakean Vision of Childhood." In *Reflections on Literature for Children*, ed. Francelia Butler and Richard Rotert, 260–268. Hamden, Conn.: Library Professional Publications, 1984.

Weinraub, Bernard. "Sendak Turns to Films but Not to the Glamour." *New York Times*, 25 April 1992, 10.

Other Works

Arnold, Arnold. *Pictures and Stories from Forgotten Children's Books*. New York: Dover Publications, 1969.

Attebery, Brian. *The Fantasy Tradition in American Literature: From Irving to Le Guin*. Bloomington: Indiana University Press, 1980.

Bachelard, Gaston. *The Poetics of Reverie: Childhood, Language, and the Cosmos*. Boston: Beacon Press, 1971.

———. *The Poetics of Space*. Boston: Beacon Press, 1969.

Baldwin, Ruth M. *One Hundred Nineteenth-Century Rhyming Alphabets in English*. Carbondale: Southern Illinois University Press, 1972.

Baring-Gould, Cecil. *The Annotated Mother Goose*. New York: Clarkson M. Potter, 1962.

Barthes, Roland. *Mythologies*. New York: Hill & Wang, 1972.

Baruch, Dorothy W. *One Little Boy*. New York: The Julian Press, 1952.

Bernheimer, Richard. *Wild Men in the Middle Ages: A Study in Art, Sentiment, and Demonology*. Cambridge, Mass.: Harvard University Press, 1952.

Bettelheim, Bruno. *The Uses of Enchantment: The Meaning and Importance of Fairy Tales*. New York: Alfred A. Knopf, 1976.

Bly, Robert. *Iron John: A Book about Men*. New York: Addison-Wesley, 1990.

Boas, George. *The Cult of Childhood*. London: The Warburg Institute, 1966.

Burland, C. A. *The Art of the Alchemists*. New York: Macmillan, 1968.

Campbell, Joseph. *The Hero with a Thousand Faces*. New York: World Publishing, 1969.

———. *The Power of Myth*. New York: Doubleday, 1988.

Castenada, Carlos. *The Teachings of Don Juan: A Yaqui Way of Knowledge*. New York: Ballantine Books, 1969.

Cech, John. "Singing the Songlines on the Porch." *Child*, May–June 1988, 72–77, 124.

Chatwin, Bruce. *The Songlines*. New York: Viking, 1987.

Collins, Jim. *Uncommon Cultures: Popular Culture and Post-Modernism*. New York: Routledge, 1989.

Cott, Jonathan, ed. *Victorian Color Picture Books*, vol. 7 of *Masterworks of Children's Literature*. New York: Chelsea House, 1983.

Coveny, Peter. *The Image of Childhood*. Baltimore: Penguin Books, 1967.

Daiken, Leslie. *The Lullaby Book*. London: Edmund Ward, 1959.

Demers, Patricia, and Moyles, Gordon, eds. *From Instruction to Delight: An Anthology of Children's Literature to 1850*. New York:

Oxford University Press, 1982.

Epstein, Jason. " 'Good Bunnies Always Obey': Books for American Children." In *Only Connect: Readings on Children's Literature,* ed. Sheila Egoff et al., 70–90. New York: Oxford University Press, 1969.

Erikson, Erik H. *Childhood and Society.* New York: W. W. Norton, 1963.

Fiedler, Leslie. "The Eye of Innocence: Some Notes on the Role of the Child in Literature." In *No! in Thunder: Essays on Myth and Literature,* 251–291. London: Eyre & Spottiswoode, 1963.

———. *Freaks: Myths and Images of the Secret Self.* New York: Simon & Schuster, 1978.

Fishwick, Marshall W. *Seven Pillars of Popular Culture.* Westport, Conn.: Greenwood Press, 1985.

Freud, Sigmund. *The Interpretation of Dreams.* London: Allen and Unwin, 1954.

Friedberg, Joan. "Garth Williams." In *American Writers for Children, 1900–1960,* ed. John Cech, 367–375. Vol. 22 of *The Dictionary of Literary Biography.* Detroit: Gale Research, 1983.

Gaster, Theodor H. *The Holy and the Profane: Evolution of Jewish Folkways.* New York: William Morrow, 1980.

Gelman, Woody, ed. *Little Nemo by Winsor McCay.* New York: Nostalgia Press, 1974.

Gesell, Arnold, and Ilg, Frances L. *Child Development: An Introduction to the Study of Human Growth.* New York: Harper & Row, 1949.

Goldman, William. *Brothers.* New York: Warner Books, 1986.

Hall, Nor. *The Moon and the Virgin: Reflections on the Archetypal Feminine.* New York: Harper & Row, 1980.

Handley, Helen, and Samelson, Andra, eds. *Child: A Literary Companion.* Wainscott, N.Y.: Pushcart Press, 1988.

Henderson, Joseph L. "Ancient Myths and Modern Man." In *Man and His Symbols,* ed. Carl Gustav Jung et al., 104–157. New York: Doubleday, 1971.

Higonnet, Margaret R. "The Playground of the Peritext." *Children's Literature Association Quarterly* 15, no. 2 (Summer 1990): 47–49.

Hillman, James. "The Children, The Children." In *Children's Literature,* vol. 8 (New Haven: Yale University Press, 1979), 3–5.

———. *The Dream and the Underworld.* New York: Harper & Row, 1979.

———. *Loose Ends: Primary Papers in Archetypal Psychology.* Irving, Tex.: Spring Publications, 1978.

———. "A Note on Story." In *Children's Literature,* vol. 3 (Storrs, Conn., 1974), 9–11.

Howard, Gerald, ed. *The Sixties: The Art, Attitudes, Politics, and Media of Our Most Explosive Decade.* New York: Simon & Schuster, 1982.

Huizinga, Johan. *Homo Ludens: A Study of the Play Element in Culture.* Boston: Beacon Press, 1955.

Jung, Carl Gustav. *Psychological Reflections.* Princeton: Princeton University Press, 1970.

———. *Psychology and Alchemy.* Princeton: Princeton University Press, 1968.

———. "Psychology and Literature." In *The Creative Process: A Symposium,* ed. Brewster Ghiselin, 208–223. New York: New American Library, 1952.

———, et al., eds. *Man and His Symbols.* New York: Doubleday, 1971.

———, and Kerényi, Carl, eds. *Essays on a Science of Mythology: The Myth of the Divine Child and the Mysteries of Eleusis.* Princeton: Princeton University Press, 1969.

Kerényi, Carl. "The Trickster in Relation to Greek Mythology." In Paul Radin's *The Trickster: A Study in American Indian Mythology,* 173–191. Westport, Conn.: Greenwood Press, 1969.

Kirk, G. S. *Myth: Its Meanings and Functions in Ancient and Other Cultures.* Berkeley and Los Angeles: University of California Press, 1970.

Lewin, Kurt. *Principles of Topological Psychology.* New York: McGraw-Hill, 1936.

Liberman, Alexander. *The Artist in His Studio.* New York: Viking Press, 1960.

Lommel, Andreas. *Shamanism: The Beginnings of Art.* New York: McGraw-Hill, 1967.

Lurie, Alison. *Don't Tell the Grown-Ups: Subversive Children's Literature.* Boston: Little, Brown & Company, 1990.

McLeod, Anne Scott. "An End to Innocence: The Transformation of Childhood in Twentieth-Century Children's Literature." In *Opening Texts: Psychoanalysis and the Culture of the Child,* ed. Joseph H. Smith and William Kerrigan, 100–117. Baltimore: Johns Hopkins University Press, 1985.

McNall, Sally Allen. "American Children's Literature, 1880–Present." In *American Childhood: A Research Guide and Historical*

Handbook, ed. Joseph M. Hawes and N. Ray Hiner, 377–413. Westport, Conn.: Greenwood Press, 1985.

Malefijt, Annemarie de Waal. "Homo Monstrosus." *Scientific American,* October 1968, 112–118.

Meigs, Cornelia, et al. *A Critical History of Children's Literature.* New York: Macmillan, 1959.

Nodelman, Perry. "Afterword: Propaganda, Namby-Pamby, and Some Books of Distinction." In *American Writers for Children Since 1960: Fiction,* ed. Glenn E. Estes, 419–427. Vol. 52 of *The Dictionary of Literary Biography.* Detroit: Gale Research, 1986.

Olson, Charles. *The Maximus Poems.* New York: Jargon/Corinth Books, 1960.

Powers, Bill. *Behind the Scenes of a Broadway Musical.* New York: Harper & Row, 1983.

Robertson, James Oliver. *American Myth, American Reality.* New York: Hill and Wang, 1980.

Rosenblum, Robert. "Friedrichs from Russia: An Introduction." In *The Romantic Vision of Caspar David Friedrich.* New York: The Metropolitan Museum of Art, 1990.

Rourke, Constance. *The Roots of American Culture.* Port Washington, N.Y.: Kennikat Press, 1965.

Schafer, R. Murray. *Tuning of the World.* New York: Alfred A. Knopf, 1977.

Schele, Linda, and Miller, Mary Ellen. *The Blood of Kings: Dynasty and Ritual in Maya Art.* New York: George Braziller, 1986.

Spock, Benjamin. *The Common Sense Book of Baby and Child Care.* New York: Duell, Sloan and Pearce, 1946.

Stewart, Susan. *On Longing: Narratives of the Miniature, the Gigantic, the Souvenir, the Collection.* Baltimore: Johns Hopkins University Press, 1984.

Storr, Anthony. *Churchill's Black Dog, Kafka's Mice, and Other Phenomena of the Mind.* New York: Grove Press, 1988.

Strauss, Walter A. *Descent and Return: The Orphic Theme in Modern Literature.* Cambridge, Mass.: Harvard University Press, 1971.

Thass-Thienemann, Theodore. *The Subconscious Language.* New York: Washington Square Press, 1967.

Tuan, Yi-Fu. *Space and Place: The Perspective of Experience.* Minneapolis: University of Minnesota Press, 1977.

von Franz, Marie-Louise. *Patterns of Creativity Mirrored in Creation Myths.* Zurich: Spring Publications, 1971.

Wickes, Frances G. *The Inner World of Childhood.* New York: Appleton-Century, 1966.

Other Works for Children

Belloc, Hilaire. *The Bad Child's Book of Beasts.* New York: Dover Publications, 1961.

———. *Jim.* Boston: Little, Brown & Company, 1987.

Busch, Wilhelm. *Max and Moritz, With Many More Mischief Makers More or Less Human or Approximately Animal.* New York: Dover Publications, 1962.

Giesel, Theodore. *Dr. Seuss's ABC.* New York: Random House, 1963.

Goodrich, Samuel Griswold. "Timothy the Terror." In *Merry's Museum* 7, no. 2 (New York: D. Mead, August 1846): 51–54.

Grant, Vernon. *Tinker Tim the Toy Maker.* Racine, Wis.: Whitman Publishing Company, 1934.

"The Magic Swan-Geese." In *Russian Fairy Tales,* collected by Aleksandr Afans'ev, translated by Norbert Guterman, 349–351. New York: Pantheon, 1945.

Mother Goose: Five of Her Books. Akron, Ohio: The Saalfield Publishing Company, 1929.

Nicholson, William. *The Pirate Twins.* London: Faber & Faber, 1924.

Peter Piper's Practical Principles of Plain and Perfect Pronunciation. Lancaster, Mass.: Carter Andrews and Company, 1830. Reprint. New York: Dover Publications, 1970.

Werner, Jane. *Walt Disney's Alice in Wonderland Meets the White Rabbit.* Racine, Wis.: Golden Press, 1951.

INDEX

Page numbers in bold type refer to black-and-white illustrations.

influence of, in *Outside Over There*, 217–18, 220, 222
Mr. Hyde, 121
Mr. Rabbit and the Lovely Present (Zolotow), 78, 80
Mt. Ida, Crete, 227
Muppets, 2, 112
musée imaginaire, 88
Mussino, Attilio, 132
Mussorgsky, Modest, 126
myth(s), 22, 28, 114, 115, 123, 128
 American, 130
 of creation, 204
 of hero, 139–41
 in *In the Night Kitchen*, 211
 Melville's definition of, 154
 of mischievous children, 130–31
 of monsters in *Where the Wild Things Are,* 138
 role in culture, 114
 in Sendak, 114
 as "solutions," 115
 as temporal construction, 141
mythology
 Greek, 17
 Teutonic, 199

names, as "sacred" words in *In the Night Kitchen*, 203
Navigator, The (film), 203
Nazi(s), 239, 240, 252
Neumeyer, Peter, 254
Newbery, John, 87
New England Primer, 87
New York City, 38, 70, 83, 150, 198, 200, 226, 224
 influence on *In the Night Kitchen*, 199
New Yorker, 4, 23, 25, 253
New York Times, 112, 246
Newsweek, 216
Nicholson, William, 131–32
Night Kitchen Theatre, The, 2, 256
night, and the unconscious, 122
Nijinsky, Vaslav, 114
Nodelman, Perry, 49, 122, 161, 214
 on use of purple in fantasy, 267
No Exit (Sartre), 60
No Fighting, No Biting (Minarik), 85
Nordstrom, Ursula, 43, 44, 45, 46, 57, 66, 77, 78, 109, 111, 112, 195
 importance in Sendak's artistic development, 79–81
Norns, the (Teutonic mythology), 199
nursery rhymes, 168
 in *Hector Protector* and *As I Went Over the Water,* 150
 importance of, 158–59
 as stimulus in Sendak's cretive process, 164–65
 violence in, 167
"Nursery Rhymes: A Dialogue" (Goodrich), 168
Nutcracker, The (Tchaikovsky), 2, 70, (Hoffmann), 14
Nutshell Library, The, 18, 67, 68, 78, **83**, 94, 96, 103, 107, 150
 archetypal child in, 82
 Brooklyn and, 83
 concept books and, 81, 84
 and the miniature, 84
 nineteenth-century elements of, 83, 87
 sources for, 87, 88
 size of, 81

O'Doherty, Brian, 112, 256
objective correlative, 103
Odense, Denmark, 18
Odets, Clifford, 42

ogre, 138
Oh, Calcutta! (musical), 195
Oldenburg, Claes, 197, 204
"Old Man's Comforts and How He Gained Them, The" (Southey), 98
Olson, Charles, 128
One Little Boy (Baruch), 55
One Was Johnny, 67, 81–82, 88, **89**, 90–91, **92**, 93, 96, 234
 archetypal child in, 93
O'Neill, Eugene, 42
Open House for Butterflies (Krauss), 46, 78, **79**, 80
Opie, Iona and Peter, 69, 236, 253
oral/aural culture, 197
Orpheus (Greek mythology), 179
 as artist, 208
 as "reconciler of opposites," 209
orphic
 journey in *In the Night Kitchen*, 208–9
 poet, tasks of, 209
Our Gang, 67, 131
Outside Over There, 5, 10, 23, 70, 115, 126, 155, 176, 177, 213, 222, 223, **225**, **229**, 235, 236, **238**, 243, 254, 255, 267
 archetypal child in, 215, 239, 241
 as musical composition, 234
 babies in, 221, 235–36
 caves in, 14
 child's inner journey in, 232
 creative process in, 20
 critical reception of, 214, 216
 fantasy in, 32, 221, 233, 235
 idea of home in, 216
 individuation in, 215
 influence of: Blake on, 226–27; childhood memories on, 230–31; German; Romantic painters on, 226, 230; Grimms' fairy tales on, 10; Mozart on, 217–18, 220, 228, 237; *Wizard of Oz* (film) on, 231, 232
 Sendak's comments on, 3, 10, 214–15, 216
 sibling antagonism in, 223–25, 228–30
 windows in, 159

Pacal (Mayan god-king), 179, **180**
painters, German Romantic, 213, 222
Palenque, Chiapas, Mexico, **180**
parents
 in *Pierre*, 103
 as symbolic agents of personality, 103
Paris, France, 26
paté imaginaire, 177
Peck's Bad Boy, 131
Perles, Ida, 93
Persephone (Greek goddess), 231, 255
personality, conscious and unconscious aspects of, 107
Peter Pan (Barrie), 25
Peter Piper's Practical Principles of Plain and Perfect Pronunciation, 87
Phelps, Robert, 151–52
Pierre, 18, 81–82, 88–89, 96–98, **99**, 100, **101**, 102–3, **104**, 105–7, 164
 parody of fables in, 96
 rebirth in, 106
 Sendak's comments on, 101
Pinocchio (Collodi), 43, 82, 132, (Disney), 200
Pinwell, George, 170
Pirate Twins, The (Nicholson), influence on *Where the Wild Things Are*, 131–32

APR 2 2 1996		
APR 2 4 1996		
AUG 1 2 1996		
AUG 1 5 1996		
NOV 2 4 1997		
APR 2 8 2000		
APR		
APR 1 3 2000		
APR 2 7 2004		
JUN 1 1 2004		

DEMCO 38-297